WORLD-CHANGING WOMEN

150
WOMEN WHO REWROTE THE HISTORIES OF ANCIENT EGYPT, ISRAEL, GREECE and ROME

PAUL CHRYSTAL

PEN & SWORD
HISTORY

AN IMPRINT OF PEN & SWORD BOOKS LTD.
YORKSHIRE – PHILADELPHIA

First published in Great Britain in 2024 by
PEN AND SWORD HISTORY
An imprint of
Pen & Sword Books Ltd
Yorkshire – Philadelphia

ISBN 978 1 39905 646 5

Typeset in Times New Roman 10/12 by
SJmagic DESIGN SERVICES, India.
Printed and bound in the UK by CPI Group (UK) Ltd.

Pen & Sword Books Limited incorporates the imprints of Atlas, Archaeology,
Aviation, Discovery, Family History, Fiction, History, Maritime, Military,
Military Classics, Politics, Select, Transport, True Crime, Air World, Frontline
Publishing, Leo Cooper, Remember When, Seaforth Publishing, The Praetorian
Press, Wharncliffe Local History, Wharncliffe Transport, Wharncliffe True Crime
and White Owl.

For a complete list of Pen & Sword titles please contact
PEN & SWORD BOOKS LIMITED
George House, Units 12 & 13, Beevor Street, Off Pontefract Road,
Barnsley, South Yorkshire, S71 1HN, England
E-mail: enquiries@pen-and-sword.co.uk
Website: www.pen-and-sword.co.uk

or

PEN AND SWORD BOOKS
1950 Lawrence Rd, Havertown, PA 19083, USA
E-mail: uspen-and-sword@casematepublishers.com
Website: www.penandswordbooks.com

Contents

◇◇◇

Contents

About the author

◇◇

I was educated at the universities of Hull and Southampton, where I took degrees in classics (BA Hons and MPhil), and at Sorbonne University, Paris. Then for the next 35 years I worked in medical publishing and pharmaceutical company sales.

More recently I have owned and run a bookshop, been history advisor to various Yorkshire visitor attractions, written features for national newspapers, and broadcasting on talkRadio, History Hack, BBC local radio, on Radio 4's PM programme and on the BBC World Service.

I have contributed to a number of history and archaeology magazines, and to TV and radio programmes, and am the author of over 160 books published on a wide range of subjects including classical history.

I am past editor of *York History*, journal of the York Archaeological & York Architectural Society and of *Yorkshire Archaeological Journal*. I am contributor to and a regular reviewer for 'Classics for All', an editorial advisor to Yale University Press and a contributor to the classics section of OUP's 'Bibliographies Online'. My books have been translated into Chinese and Japanese.

By the same author

For a full list please go to www.paulchrystal.com

Introduction

◇◇

The aim of this book is to demonstrate how women significantly influenced, informed and changed the histories and legacies of pre-classical civilisations, of ancient Israel, Greece and Rome. We show how a small, disparate body of women in each of these periods, united by their determination and strength of mind, were able to break free from the norms and values of the patriarchal societies which confined and restricted them to make a valuable difference to their individual societies, cultures, politics and foreign policies; in so doing they have changed perceptions of women and the role women were subsequently allowed to play.

Some were imperious and ambitious, others gifted and highly intelligent, some we would call saintly – paragons of virtue indeed – while others, were evil, witchy and monstrous. What is unquestionable is that they all made a difference, and that is one reason why they are still remembered today.

Some are well known, others less so. The book reinforces the reputations of those who have endured popularity over the centuries and, where necessary, realigns those reputations after years of prejudice and the vicissitudes of sexism, misogyny, Hollywood and sensationalist literature. For those who have been written out of mainstream history and relegated to footnotes at best, this is a chance to re-introduce them and the impact they have made on our world.

So, we tell the story of 150 of these remarkable women in order to define, or redefine, their impact on and influence over a number of the world's greatest, most creative, influential and powerful civilisations.

For example, the typical male gaze is usually fixed on the ideal women in both ancient Greek and Roman society stereotyped as unobtrusive, compliant and subservient – secluded even in the case of Greece – women who dutifully and without complaint busied themselves with the housework, kept on top of the homespun and, with what little time they had left, passed their days in serial pregnancy and raised the children resulting from their fertility. *Domum servavit lanam fecit* goes the clichéd epigraph – neatly capturing the unremarkable and monotonous daily grind for the vast majority of Greek women and their Roman sisters.

In general, women in Egypt, those in biblical Israel and thereabouts, and women in pre-classical civilisations also led lives of drudgery and serial child production devoid of rights or opportunities but characterised by illiteracy and, it seems not a little domestic and sexual abuse. This is, of course, the inviolable lot of the woman in ancient patriarchal cultures.

However, there were plenty – from the pre-classical age to the end of the Roman period – who spurned the accepted social norms and values of their day and rose

above the type-casting, the pigeonholing, the conventional and the stereotypical to make a real and significant difference to their particular circumstances and the circumstances of their fellow females, indeed of their very cultures, politics and military regimes. These are the women who, at the same time, helped change the direction and histories, the norms and values of their countries. These are the women celebrated in the following pages; we give them voice and attempt to allow the traditionally silent women to speak for themselves. As Mary Beard points out, Western culture has had thousands of years of practice gagging them[1].

They demonstrate how women can escape from or excel even in the most male-dominated and misogynistic of societies; how they can infiltrate and thrive in the most male of male bastions.

So, we will meet women warriors, military strategists and brave leaders of men; orators, lawyers, poets, philosophers, midwives and doctors; Christian martyrs, sly politicians, ruthless murderers and those consumed by obsessive ambition. Conversely, we will see saintly and devoted women, those paragons of virtue and integrity, the best of mothers and wives. And then there are the witches and purveyors of the black arts from which no one was safe.

Many of these women suffered abuse of one kind or another and unspeakable calumnies – verbal, reputational, domestic, sexual – the victims of a hostile press (male), of often unfounded defamation – the price they paid for having the temerity to excel as a woman in a man's world. Indeed, we will find that those that did rise above their allotted station were usually described by men throughout ancient history as exhibiting *andreia* or *virtus*, with all the connotations these epithets convey of manliness and bravery. While men conceded that they were women they were consistently being damned with faint praise: yes, they were women masquerading as men, as part-time men. How could a woman this impressive possibly be a woman? – she exhibits all the qualities which are the exclusive preserve of men!

The majority of the 150 are individual women but we also include a number of groups of women, for example, the Kandakes of Kush, the Lemnian Women, the Vestal Virgins, wild Bacchantes, Isis adherents and the brave and outstanding women catalogued by Plutarch and in the anonymous *Tractatus de Muliebris*. This is because individual actors in this group, may not be known but their collective action is nevertheless significant.

Each of the entries comes with historical and social context, clarifying the historical, political, or social situations each of the individuals or groups emerged from, excelled in or simply found themselves in. In doing this we provide a rich and valuable backdrop to each of the civilisations and societies from pre-classical times to the late Roman period. This is substantiated with footnotes citing references ancient and modern.

In male-dominated, patriarchal cultures, the primary sources often describe the women they talk about as being defined by their husband, father or brother or some other such male relative or associate; this is obviously understandable to a degree as it is important to establish each woman's lineage and relationship which, along with nepotism, may well may have had a bearing on their daughter's, wives' or sister's actions in later life. I therefore make a conscious effort to describe our women as being personally responsible for what they did as individuals in their own right.

Gifted, strong and successful as these women are – for good or for evil they are frequently seen as socially and politically disruptive, turning the established world on its head, challenging cultural norms. Herodotus is staggered to report that Egyptians are all crazy: why? 'The women go to market and men stay at home and weave [the exact opposite to Greek practice]. Women even urinate standing up and men sitting down.' A tongue-in-cheek Aristophanes has his Lysistrata protest that war is as much the responsibility of women as of men, she turns the running of state upside down when she dresses up the πρόβουλος (*proboulos* – magistrate) in women's clothes and teaches him the ways of wool while she and her comrades take over the administration of the city, the complicated affairs of which include the prosecution of the Greek equivalent of a world war – the Peloponnesian War (431–404 BCE), a conflict which can be disentangled as easily as a ball of wool (*Lysistrata* 567ff). Elsewhere, an armoured Athena, female goddess of war and of common sense, protects Athens while effeminate statesman Cleisthenes (*c.* 570 – *c.* 508 BCE) spends his time working with his shuttle; Diodorus (3, 53) reports that the Amazon men of Libya stay home, weave and look after the children while the women go out fighting wars and killing their enemies; Pindar's Cyrene also eschews the loom and prefers to slay wild beasts with her sword (*Pythian* 9, 19–22); Euripides' Ague goes one better, getting self-fulfilment by destroying animals with her bare hands (*Bacchae* 1236). The Bacchants too have abandoned the shackling loom for a life much more challenging; when he observes Artemisia's military skills and belligerence, an incredulous Xerxes (d. 465 BCE), ruler of Greece's arch enemy, Persia, reflects that his men are acting like women and she like a man.

At the same time, we see many of our women, notably those in patriarchal Greece and Rome, operating in worlds in which sexism and misogyny are embedded and are the accepted societal norm. In elite Republican ancient Rome, pursuit of the *mos maiorum*, 'the way our ancestors did things', was the inviolable route to the top through prescribed political and military offices and oratory. To the average Greek and Roman no woman, of course, ever embarked on that journey (*pace* Hortensia and others), but their successors were able to wield significant political power in the various imperial dynasties that followed in the Roman Empire – but only a very small few who were the mothers, wives, sisters or mistresses of the emperors of the day. Before that in Egypt women were pharaohs and in Assyria and Sumeria, for example, they achieved high political status and authority. Biblical women demonstrated rare bravery and rarer violence while the Christian martyrs were similarly courageous facing death for their faith.

It is this gulf between the norm and the reality of ancient life, this 'world-on-its-headness', that provides the essence of this book: women fighting to rise out of the eternal doldrums to make a tangible and history-making difference, be it for good or be it for bad.

The book features women from the 24th century BCE right through to the end of the Roman period. To help the reader who wants to know more there is a Further Reading section at the end listing the more general books and academic papers on the subject while most of the sections on individual women have more specific reading suggestions germane to each of those women.

Chapter 1

Before and beyond the Classical World

◇◇◇

Ever since man first picked up a rock or a club and assaulted his fellow man, it is probably true to say that women were involved and implicated in some way, either as causes of territorial disputes and wars, or as victims of those disputes or wars. If nothing else, early man was, by nature, anxious to preserve his life and his livelihood: to that end he used conflict as a means of defending his home, his land, his crops and his livestock. Women, of course, played a key existentialist and societal role in survival, the extension of his family line and the preservation of his homestead: early man, therefore, also defended early woman.

Men, of course, have usually been the protagonists in the waging of war, but it may be a surprise to learn just how frequently women have, down the centuries, assumed a bellicose role as *casus belli*, combatant, strategist or foreign-policy maker. As this chapter will show, women have always been victims of war – as slaves or prisoners, as rape victims or as the casualties of devastation, defeat, displacement and destitution. Tragically, in the early 21st century CE all of this remains true: while arguments relating to the active role of women in war as combatants are becoming increasingly tense[1], rape, mass rape and sexual mutilation all remain ever constants[2] – often with the connivance of dissimulating, prevaricating politicians and sometimes of self-serving military men with a career and a pension to worry about.

Thankfully, it is not all about war. Ancient eastern societies such as the Akkadians, Hittites, Assyrians and Persians relegated women to an inferior and subordinate position. One of the few exceptions are the 3rd millennium BCE Sumerians who invested women with a status bordering on equality with men. However, by the 2nd millennium, the rights and status of women even there were reduced to type.

Nevertheless, we will encounter women who were actually queens or who rose above the oppressive societal norms under which they lived. There are those who also showed excellence and expertise in, for example, business and economics, international diplomacy, state religion and in the law. As such they are commendable for the simple fact that they have risen to heights normally unheard of, indeed prohibited in patriarchal societies.

Baranamtarra (24th century BCE) – *prominent landowner and businesswoman*

Baranamtarra, as Queen of Lagash, wielded exceptional power and responsibility and is the first extraordinary woman we know about in the history of the world.

In 2384 BCE during the first dynasty of Lagash (*c*. 2500–2300 BCE) Baranamtarra and her husband, Lugalanda, seized power in a coup in Lagash, one of the oldest cities in Sumer. The couple became the largest landholders in the city, while Baranamtarra managed her own private estates and those of the temple of the goddess Bau. She bought and sold slaves and sent diplomatic missions to neighbouring states.

We have records which reveal private business activities of the Queen wife during Lagash's golden age of international trade and prosperity. Baranamtarra sent woolen clothes and silver to Dilmun and sold copper imported from Dilmun in the neighbouring city of Umma. For her estates, which marketed milk products, Baranamtarra purchased cattle in Elam. The expression 'property of Baranamtarra' is found on lists of people, animals, estates, and various objects.

The political instability of the time ensured that she and her husband were overthrown by Urukagina, in 2378 BCE.

Tabur-damu of Ebla – *another powerful queen*

Amanda Podany (2022) tells of the marriage of another powerful queen (*c*. 2300 BCE), Tabur-damu of Ebla:

> The marriage of King Irkab-damu and Queen Tabur-damu of Ebla provides insights into the administration, beliefs, and economy of a Syrian kingdom in the Early Dynastic period … explores the stages in the royal marriage, including gifts given and received (some from distant lands), sacrifices to the gods and to dead kings, anointing of the bride, processions, and appearance of the couple before the city gods.

Podany shows how in Mesopotamia and Syria, queens played important roles, alongside kings, in governing city-states. She focuses on her role, like that of Baranamtarra, in administration, diplomacy, and religion and examines the veneration of queens in the statuary after death.

Further reading

Jackson, Guida M. (1999). *Women rulers throughout the ages: an illustrated guide* (2nd rev., expanded and updated ed.). Santa Barbara, CA

Podany, Amanda H. (2022). *Weavers, Scribes, and Kings: A New History of the Ancient Near East*. Oxford

Ku-Baba (*c.* 2350 BCE) – *a woman listed in the 'King List'*

A legendary Mesopotamian queen who, according to the *Sumerian King List,* ruled over Kish for a hundred years before the rise of the dynasty of Akshak. Being a woman, her inclusion is unusual: while some modern authors refer to her as a queen, the Sumerian title applied to her is *lugal* ('king'), which had no feminine equivalent. She is the only ruler from the third dynasty of Kish listed and is described as an innkeeper; it credits her with 'strengthening the foundation of Kish' and attributes a 100-years-long reign culminating in a temporary transfer of power from Kish to Akshak before it was regained by Puzur-Suen.

Further reading
Stol, Marten (2016). *Women in the Ancient Near East.* De Gruyter

Enheduanna (2285–2250 BCE) – *the earliest known named author in world history*

We celebrate Enheduanna, daughter of Sargon of Akkad founder of the Akkadian Empire, as the world's earliest known named author: a number of works in Sumerian literature, such as the *Exaltation of Inanna*, feature her as the first-person narrator, and other works, like the *Sumerian Temple Hymns*, give her as their author although there is ongoing controversy over this. Irene J. Winter records that Sargon appointed Enheduanna to an important position in the native Sumerian moon god cult.

 Enheduanna has achieved some fame amongst feminist historians: American anthropologist Marta Weigle introduced Enheduanna to an audience of feminist scholars as 'the first known author in world literature' with her essay 'Women as Verbal Artists: Reclaiming the Sisters of Enheduanna' after which the 'feminist image of Enheduanna... as a wish fulfilment figure' gathered traction. Assyrianologist Eleanor Robson asserts that the picture of Enheduanna from the surviving works of the 18th century BCE is one of her as 'her father's political and religious instrument' and as the high priestess and daughter of Sargon of Akkad; Enheduanna was 'probably the most privileged [and powerful] woman'; she is also recognised as an early rhetorical theorist.

Further reading
Binkley, Roberta A. (2004). 'The Rhetoric of Origins and the Other: Reading the Ancient Figure of Enheduanna'. In Lipson, Carol; Binkley, Roberta A. (eds). *Rhetoric before and beyond the Greeks.* Albany Press. pp. 47–59
Godotti, Alhena (2016). 'Mesopotamian Women's Cultic Roles in Late 3rd – Early 2nd millennia BCE'. In Budin, Stephanie Lynn (ed.). *Women in Antiquity: Real Women across the Ancient World.* Routledge
Hallo, William W.; van Dijk, J.J.A. (1968). *The Exaltation of Inanna.* Yale

Pryke, Louise M. (2017). 'Enheduanna and Ancient Literature.' In *Ishtar: Gods and heroes*. London

Pryke, Louise (12 February 2019). 'Hidden women of history: Enheduanna, princess, priestess and the world's first known author'. *The Conversation.*

Wagensonner, Klaus (2020). 'Between History and Fiction – Enheduanna, the First Poet in World Literature'. In Wisti-Lassen, Agnete. *Women at the dawn of history.* New Haven. pp. 39–45.

Weigle, Marta (1978). 'Women as Verbal Artists: Reclaiming the Sisters of Enheduanna'. *Frontiers: A Journal of Women Studies.* 3 (3): 1–9.

Vishpala – *Indian warrior woman with a prosthetic leg*

In the ancient Indian Vedic period (*c.* 1500–500 BCE) the *Rigveda* refers to a female warrior called Vishpala[1]; she lost a leg in battle, had an iron prosthesis made when the wound had healed, and returned to the fray, thus making her not only one of the earliest women warriors but one of the first recorded casualties of life-threatening trauma and a pioneer patient in battlefield and prosthetic medicine[2].

Further reading
Thapar, Romila (2004). *Early India: From the Origins to AD 1300*. University of California Press

Puduḫepa (*c.* 1275 – *c.* 1250 BCE) – *diplomat and co-ruler*

Puduḫepa was a Hittite queen, married to King Hattusili III. She has been called 'one of the most influential women known from the Ancient Near East'. Her father Bentepsharri was the head priest of Shaushka, and Puduḫepa grew up as priestess of this same goddess.

For Puduḫepa her marriage was a good match. When Hattusili successfully rose to the Hittite throne by defeating his nephew Mursili III in a civil war instigated by Hattusili around 1286 BCE, Puduḫepa ascended the throne with him, becoming *tawananna*, or queen.

Puduḫepa had a vital role in the Hittite court and international diplomacy. She was always by the side of her spouse as he made rulings and decisions and is portrayed reigning hand in hand with the king, rather than subservient. Puduḫepa used her own seal, controlled the domestic arrangements of the royal palaces, and judged court cases. With a blend of religion and politics, she reorganized the vast pantheon of Hittite deities. Puduḫepa used her sons and daughters to ensure Hittite ascendancy and to cement alliances, a role never performed by a Hittite queen before. She played an important role in diplomacy with Egypt.

Further reading

Gold, Claudia (2 April 2015). *Women who ruled: history's 50 most remarkable women*. London. p. 18

Darga, Muhibbe (1993). 'Women in the Historical Ages'. In *Women in Anatolia, 9000 Years of the History of the Anatolian Woman*. Istanbul. p. 30.

Jackson, Guida M. (2003). *Women Rulers Throughout the Ages: An Illustrated Guide*. Santa Barbara. p. 336

Chrysame of Thessaly (*c.* 1200 BCE) – *herbalist and witch*

In Ancient Greece, Chrysame (Χρυσάμη) was a Thessalian priestess of Enodia. She is remembered for using herbs to defeat the Ionians at Erythraea and allowing Cnopus of Codridae victory in the battle. As such, Chrysame is the first woman known to us who excelled in the pseudo-medicinal arts and operated on the fringes of witchcraft. Thessaly, indeed, was well known for witchcraft, especially the use of herbs in magic potions and even drawing down the moon[1].

According to Polyaenus, a commander by the name of Cnopus of Codridae was fighting with the Ionians at Erythrai after the recent Ionian colonisation of Asia Minor. Cnopus received an oracle one day telling him[2] 'to take as your general the priestess of Ennodia from the Thessalians. An embassy was sent to retrieve the priestess'.

Chrysame takes control and wins the day with judicious use of herbal magic:

> When the Ionian colonists came to Asia, Cnopus, who was descended from the family of the Codridae, started a war on the Erythraeans. He was directed by the oracle to send an expedition to a Thessalian priestess of Hecate Enodia which returned with the priestess Chrysame. Possessing great skill in the occult qualities of herbs, she chose out of their herd a large and beautiful bull, gilded his horns, and decorated him with garlands, and purple ribbons embroidered with gold. She mixed in his fodder a medicinal herb that would drive him mad; the efficacy of this medicine was so great, that not only the beast was seized with madness but also anyone who later ate its meat. When the enemy camped opposite, Chrysame raised an altar in their line of sight: the bull was ushered out, let loose and ran amok into the plain, roaring, and tilting at everything he met. The Erythraeans saw the bull that was intended for the enemy's sacrifice, running towards their camp, and thought it a good omen. They seized the beast, and offered him up in sacrifice to their gods; everyone, as part of the sacrifice, ate some of the flesh. The whole army was soon afterwards seized with madness, and exhibited the same wildness and frenzy as the bull. When Chrysame saw this, she directed Cnopus immediately

to unleash his forces, and charge the enemy. Incapable of putting up any defence, the Erythraeans were cut to pieces; Cnopus took control of Erythraea.

<div align="right">

– Polyaenus, *Strategemata* 8, 43

</div>

Further reading

Ogden, D. (2009). *Magic, witchcraft, and ghosts in the Greek and Roman worlds: A sourcebook.* Oxford

Edmonds, R.I.G.G. (2019). *Drawing Down the Moon: Magic in the Ancient Greco-Roman World.* Princeton

Chrystal, Paul (2018). *Women in Ancient Greece.* Stroud

Graninger, C.D. 'The Regional Cults of Thessaly' (2006 PhD University of Cornell dissertation)

Graninger, C.D. 'Apollo, Ennodia, and fourth-century Thessaly'. *Kernos.* 22: 109–124.

Queen Gwendolen (11th century BCE) – *drowning the competition*

Gwendolen was a legendary ruler of ancient Britain. Geoffrey of Monmouth, in his *Historia Regum Britanniae*, tells how she was rejected by her husband King Locrinus but she defeated him in battle at the River Stour. She then took over the leadership of the Britons, becoming our first queen regnant.

When her father, Corineus, died, Locrinus divorced Gwendolen in favour of his Germanic mistress, Estrildis (by whom he already had a daughter who was named Habren). Gwendolen then fled to Cornwall, where she amassed a large army and waged war against her ex-husband; Locrinus was killed. The first thing she did was have Estrildis and Habren drowned in the River Severn; she then reigned peacefully for fifteen years before abdicating in favour of her son and lived out the remainder of her life in Cornwall.

She is mentioned in Spenser's poem *The Faerie Queene* (1590) as Gwendolene, and features in William Blake as one of the twelve Daughters of Albion. Feminists have cited her as an example of a powerful woman healing a fractured Britain with her steady rule.

Further reading

Olson, Katherine (2008). 'Gwendolyn and Estrildis: Invading Queens in British Historiography'. *Medieval Feminist Forum.* 44 (1): 36–52.

Semiramis (ruled *c.* 811–806 BCE) – *'Nature made me a woman, but I have raised myself to rival the greatest of men.'*

> *She is Semiramis, of whom we read*
> *That she succeeded Ninus, and was his spouse;*
> *She held the land which now the Sultan rules.*

<div align="right">

– Dante, *Divine Comedy*, Canto V, lines 60–62

</div>

The real and historical Shammuramat (the original Akkadian and Aramaic form of the name) was the Assyrian wife of Shamshi-Adad V (ruled 824 BCE – 811 BCE), king of Assyria and ruler of the Neo-Assyrian Empire; she was its regent for five years until her son Adad-nirari III came of age and assumed power. This detailed inscriptional information recorded by Polyaenus, reads like an extract from her glowing *curriculum vitae* – the complete military all-rounder:

> Semiramis received intelligence of the revolt of the Siraads while she was having a bath; and without waiting to have her sandals put on or her hair done, she got out immediately and took to the battle field. Her exploits are recorded on pillars, in these words: "Nature made me a woman, but I have raised myself to rival the greatest of men.... I have built walls which are impregnable; and with iron forced a way through inaccessible rocks. At great expense I have made roads in places which before not even the wild beasts could cross."
> — Polyaenus, *Strategemata* 8, 26

As well as being a roadbuilder of some note, she is one of the first known women to rule an empire; we assume that she wielded military power in carrying out her rule. The empire was extensive, extending from the Caucasus Mountains in the north to the Arabian Peninsula in the south, and western Iran in the east to Cyprus in the west. **Shammuramat** is often associated with Semiramis, the legendary wife of King Ninus, succeeding him to the throne of Assyria. Diodorus Siculus writing in the 1st century BCE, reveals her to be one of the first women to be used as a pawn in the political machinations of ruling men and as a cause of conflict.

Semiramis married Onnes, one of Ninus' generals, and fought with him at the capture of Bactria. Ninus was so taken by Semiramis' bravery there that he compelled Onnes to 'willingly give her to him, offering in return for this favour, his own daughter Sonanê as wife'. Onnes was not impressed – so Ninus 'threatened to put out his eyes unless he immediately complied with his commands'. Onnes was now terrified, 'fell into a kind of frenzy and madness' and hanged himself. Ninus then married Semiramis; she bore him a son called Ninyas.

What exactly was it that attracted both Onnes and Ninus to Semiramis? Diodorus Siculus (Book 2, 1–22) describes her as 'endowed ... with understanding, daring, and all the other qualities which contribute to distinction' – qualities which she was able to apply in a military context:

> When Semiramis arrived in Bactria and observed how the siege was going, she noted that all the attacks were being made on the plains and at vulnerable positions, but that no one ever assaulted the acropolis because of its strong position, and that its defenders had left their posts there to reinforce those who were under pressure on the walls below. Consequently, taking with her soldiers trained in scaling rocky heights, and making her way with

them up through a difficult ravine, she seized part of the acropolis and gave a signal to that effect to those who were besieging the wall down on the plain. The defenders of the city, terrified at the seizure of the acropolis, deserted the walls and gave up all hope of saving themselves.

Ninus went on to conquer Asia but was fatally wounded by an arrow. Semiramis then masqueraded as her son and fooled her late husband's army into following her because they believed they were following Ninyas. She reigned as queen regnant for forty-two years, conquering much of Asia in that time.

Her duping of the Assyrian army is one of the first examples we have of a woman apparently acting like a man to achieve masculine power and authority, as perfected later by many others. Often, as we shall see, the illusion of masculinity was thrust upon women by incredulous men struggling to equate or reconcile what they believed to be exclusively masculine achievements with a woman.

Diodorus Siculus tells how Semiramis was hungry for more: she took on the monumental task of founding the city of Babylon:

> and after securing the architects of all the [known] world and skilled artisans and making all the other necessary preparations, she gathered together from her whole kingdom two million men to complete the work[1]

and reinforced it with a high brick wall surrounding the city. She built several palaces in Persia, along the Euphrates and Tigris rivers including Ecbatana, and annexed Libya and Aethiopia. Somewhat bored with peace, Semiramis declared war on king Stabrobates of India, 'since she had great force and had been at peace for some time she became eager to achieve some brilliant exploit in war'.

Well aware that she was at a strategic disadvantage because she had no elephants in her army, she inventively and ingeniously had her engineers create a herd of fake elephants to deceive the Indians into thinking she was deploying the real thing. Camels and river boats were also used to good effect. She laughed off Stabrobates' slander when he called her a whore – another common theme we will meet many more times when men call into question a women's sexual *mores* in order to discredit them – and his threats to crucify her when he had secured victory. Semiramis' strategy worked, but she was wounded in the counter-attack and her army retreated west of the Indus. Even in retreat she remained resourceful, causing the slaughter of many Indians on an overcrowded pontoon bridge:

> she cut the fastenings which held the bridge together; …the pontoon bridge, having been broken apart at many points and bearing great numbers of pursuing Indians, was brought down in chaos by the violence of the current and caused the death of many of the Indians.

Semiramis gets the credit for inventing the chastity belt while the late Roman historian Ammianus Marcellinus (*c.* 330 CE – 395 CE) records (Book XIV) that she was the first person to castrate a male youth and thus create a eunuch. The Armenians portrayed her as a whore and a homewrecker. One of their legends involved King Ara the Handsome after whom Semiramis allegedly lusted: she asked Ara to marry her, but he refused. Indignant at this regal snub, she assembled her armies and invaded Armenia; during the battle she slew Ara. The tabloid reports got even worse when Pliny (*Natural History* 8, 155) and Hyginus (*Fabulae* 243, 8) both record that Semiramis's sexual voracity extended into bestiality when she had sex with a horse.

Sexual slurring apart, Semiramis also earned a reputation for being a witch – another frequent and effective way of disparaging a prominent and successful woman. Making the most of this, though, she responded by pretending to raise Ara's body from the dead. When the enraged Armenians attacked to avenge their dead leader, she disguised one of her lovers as Ara and convincingly spread the rumour that the gods had brought Ara back to life. This was enough to end the war.

According to Gwendolyn Leick, 'This woman achieved remarkable fame and power in her lifetime and beyond. According to contemporary records, she had considerable influence at the Assyrian court' (155).

This would explain how she was able to retain the throne after her husband's death. In the Assyrian Empire women were not admitted to positions of authority, and for a woman to be a ruler would have been extraordinary unless that particular woman harnessed enough power to take and hold it. She was evidently sufficiently important to merit an obelisk prominently sited and inscribed in the city of Ashur.

Susan Wise Bauer adds:

> Sammu-Ramat's hold on power was so striking that it echoed into the distant historical memory of a people just arriving on the scene. The Greeks remembered her, giving her the Greek name Semiramis. The Greek historian Ctesias says that she was the daughter of a fish-goddess, raised by doves, who married the king of Assyria and gave birth to a son called Ninyas...Diodorus, tells us Semiramis convinced her husband to give her power just for five days, to see how well she could manage it. When he agreed to the trial, she had him executed and seized the crown for good. (349)

Further reading

Bauer, S.W. (2007). *The History of the Ancient World.* W.W. Norton

Boccaccio, Giovanni (2003). *Famous Women.* I Tatti Renaissance Library. Vol. 1. Trans. Virginia Brown. Cambridge, MA

Leick, G. (2010). *The A to Z of Mesopotamia.* Scarecrow Press

McLeod, Glenda (1991). *Virtue and Venom: Catalogs of Women from Antiquity to the Renaissance.* University of Michigan Press, 66

Nyssia of Lydia, *wife of the 'dog throttler' with deviant sexual behaviour*

Candaules, also known as Myrsilos, was a king of Lydia from 735 BCE to 718 BCE. Herodotus (1, 7, 2–13) says his name meant 'dog throttler'. In telling this story he gives us a tale of caution in which a vengeful woman takes centre stage: Candaules was murdered by his wife, Nyssia, tired of his arrogance. For Herodotus, she was responsible for allowing the Lydian throne to pass out of the hands of the Heraclid dynasty – after 505 years and twenty-two generations – to the Mermnceae dynasty in the guise of Gyges. How? Candaules was in the habit of boasting about his wife's prodigious beauty to his bodyguard, Gyges; she took exception to such inappropriate and disrespectful behaviour when he made her nudity a public spectacle. This is what he said to Gyges:

> If you don't believe me when I tell you how lovely my wife is, a man always believes his eyes more than his ears; so do as I tell you –get an eyeful of her taking her clothes off.

At first Gyges was outraged and refused, only too aware of the taboos surrounding nudity in Persian society and concerned how unpredictably Candaules might actually react if and when the seedy deed was done (1, 8, 2; 1, 10, 3):

> Gyges cried out in horror. "Master," he said, "what an unseemly suggestion! Are you actually telling me to look at the queen when she has no clothes on? [Candaules replied:] No, no: 'off with her shirt, off with her shame' – you know what they say about women. We must learn from experience. Right and wrong were sorted out ages ago – and I'll tell you one thing that is right: a man should mind his own business. [Gyges concluded:] I do not doubt that your wife is the most beautiful of women, so for goodness' sake do not ask me to act like a criminal."

Candaules did eventually persuade him, by asserting that Nyssia knew no shame when her clothes were off. He revealed a plan in which Gyges would lurk behind a door in the royal bedroom to watch Nyssia undressing; Gyges would then steal away unnoticed while the queen's back was turned with no one any the wiser.

> Near the door there's a chair on which she will put her clothes as she takes them off, one by one. You will be able to watch her with perfect ease. Then, while she's walking away from the chair towards the bed with her back to you, slip away through the door – and watch she doesn't catch you.

So, that night, Gyges took up his position and leered as planned, but the queen caught a glimpse of him and realised in an instant that she had been betrayed,

shamed and humiliated by her own husband. Nyssia swore revenge, and formulated her own plan. Next day, she summoned Gyges and confronted him: 'One of you must die. Either my husband, or you, who have violated convention by seeing me naked.' Eventually, Gyges, quite understandably, chose to betray the king and save his own skin. Nyssia's scheme involved an element of *déjà vu,* literally: Gyges hid behind the door of the bedroom again, this time armed with a knife provided by the queen, and slew Candaules in his sleep. Gyges married the queen and became king.

Candaules did not pay just with his life. He has the dubious privilege of lending his name to *candaulism,* a deviant sexual practice in which a man exposes his (usually) female partner, or images of her, to other people for their voyeuristic pleasure. The term is also applied to the practice of undressing or exposing a female partner's body to others, or forcing her into having sex with a third person, into prostitution or pornography. Today all of this is very familiar: the term is increasingly applied to the posting of revealing images of a female partner on the internet, or forcing her to wear sexually suggestive clothes for depraved and prurient public consumption. There is clearly nothing new in the world.

Nyssia was clearly a dignified and shrewd woman, a fact which, for the average Greek, makes Herodotus' story all the more disturbing – and persuades him to be all the more careful to keep his women under wraps and shielded from the prying eyes of strangers. Nyssia defends the conventions that her husband spurned and proved him wrong when he insinuated that women lose their shame when naked. She punishes the violation and restores normality: in the end, only her husband had still ever seen her naked, even if that necessitated a radical change of spouses.

Cheilonis (8th century BCE) – *a paragon of conjugal devotion*

Cheilonis uses cross-dressing to effect the release of her imprisoned husband:

> When Cheilonis, the daughter of Cleadas, and wife of Theopompus, learnt that her husband was taken as prisoner-of-war by the Arcadians, she went to Tegea, one of the most ancient and powerful towns of Arcadia to visit him. The Arcadians, seeing the affection she had shown, allowed her to see him in his cell; once there she changed clothes with him, and so he made his escape masquerading as Cheilonis, while she remained in prison. Before long the liberated Theopompus had the chance to seize a priestess of Artemis while she was celebrating in a procession at Pheneus; the inhabitants of Tegea released Cheilonis in a prisoner exchange for the priestess.
>
> – Polyaenus, *Strategemata* 8, 34

Another Cheilonis (or is it the same one, just confused in the sources?) from around the 7th and 8th century BCE is revered as another conspicuous example of conjugal affection:

> Daughter of Leonidas II king of Sparta, and wife to Cleombrotus II. When Leonidas, alarmed at the prosecution instituted against him by Lysander, took refuge in the temple of Athena Chalcioecus, Cheilonis left her husband, who was made king on the deposition of Leonidas, and, preferring to comfort her father in his adversity, accompanied him in his flight to Tegea. Afterwards, when Leonidas was restored, and Cleombrotus in his turn was driven to take refuge in the temple of Poseidon, Cheilonis joined him in his altered fortunes, saved his life by her entreaties from her father's vengeance, and, again refusing to share the splendour of a throne, went with him into banishment; "so that, had not Cleombrotus," says Plutarch, "been spoilt by vain ambition, his wife's love would have made him deem his exile a more blessed lot than the kingdom which he lost."
>
> – Plutarch. *Agis* 11, 12, 16–18.

Šamši – *'wild she-ass of the desert'*

In the 8th century BCE an Arabian woman called Šamši reigned as queen; she bravely rebelled against Tiglath-Pileser III the king of Assyria, who became the first foreign ruler to subdue the Arabs when he attacked and defeated Šamši.

When Šamši rebelled against him by joining an alliance led by Rakhianu of Damascus, Pileser forced her surrender and imposed on her a tribute to enable her to remain in power as a puppet queen, which she did for the next twenty years. That tribute included gold, silver, prisoners of war, 30,000 male and female camels, and 20,000 oxen, as well as 5,000 bags of various lucrative spices. An inscription tells us that 9,400 of her soldiers were killed, sacred religious icons, and armaments and her estates were seized. Assyrian chroniclers tell us that when she fled to the desert, Tiglath-Pileser set fire to her remaining tents and she was said to have fled the battlefield like a 'wild she-ass of the desert'. Comprehensive as this defeat was, it shows clearly the military power and wealth she formerly enjoyed and the magnitude of the armed forces she commanded.

Further reading
Eph'al, Israel (1982). *The Ancient Arabs: Nomads on the Borders of the Fertile Crescent, 9th–5th Centuries B.C.* Leiden

Retso, Jan (2013). *The Arabs in Antiquity: Their History from the Assyrians to the Umayyads.* London

Pheretima (*c.* 500 BCE) – *brilliant commander eaten by worms*

A cautionary tale involved Pheretima (d. 515 BCE), wife of the Greek Cyrenaean King Battus III the Lame and the last queen of the Battiad dynasty in Cyrenaica (present day northern Libya). Herodotus tells us that when Battus, (the grandfather of Pheretima's son Arcesilaus), died in 530 BCE, Arcesilaus III became king but was defeated in a civil war after 518 BCE and exiled to Samos while Pheretima went to the court of King Evelthon in Salamis, Cyprus[1]. Evelthon showered Pheretima with gifts, but would not give her an army, arguing that such a command was simply not right for a woman.

Neither Pheretima nor Arcesilaus, however, took this lying down: he recruited an army in Samos, returned with it to Cyrenaica, and regained his position by murdering and exiling his political opponents – urged on no doubt by Pheretima. When Arcesilaus left Cyrene for Barca, Pheretima ruled the city but Arcesilaus was murdered by exiled Cyrenaeans intent on revenge.

Pheretima went hot-foot to Arysandes, the Persian governor of Egypt, to get help in avenging the death of her son; Arysandes loaned her Egypt's army and navy. She marched to Barca and demanded the surrender of those Barcaeans responsible for the murder of Arcesilaus; when the Barcaeans refused insisting that they were all complicit, Pheretima laid siege to Barca for nine months. Amasis, her Persian commander, played a trick on the Barcaeans in which he ordered his soldiers to dig a large trench in front of the city camouflaged with wooden planks and earth; he then lured the Barcaeans out of the city with a promise of a well-rewarded armistice. They literally fell into the trap: Pheretima ordered the Barcaean wives' breasts be cut off and nailed on the city walls, and enslaved the rest of the Barcaeans to the Persians.

So Pheretima avenged her son, returned to Egypt, and returned the army and navy to the governor. However, while in Egypt, Pheretima contracted a contagious parasitic skin disease, and died in late 515 BCE. Herodotus tells us that she was eaten alive by worms – punishment by the gods for her butchery of the women of Barca?[2]. She lives on in the name of the worm which infested her.

Queen Tomyris of the Massagetae (*c.* 500 BCE)

> *'I give you more blood than you can drink ... and off with your head!'*

Cruel and unusually militaristic are two ways to describe Queen Tomyris of the Scythian Massagetae; at the same time, though, when it comes to Cyrus, her actions may be seen as just desserts for Cyrus's duplicity[1].

Strabo, Polyaenus, Cassiodorus, and Jordanes, as well as Herodotus, all reference her. She is famous for slaying King Cyrus the Great (*c.* 576 – 530 BCE), the founder of the Persian Achaemenid Empire, after he invaded her country. Herodotus shows his audience how Tomyris easily saw through the king's proposal

of marriage as an ill-disguised desire to topple her and enslave the Massagetae; she wisely rejected him. As Herodotus concluded: 'she was aware that it was her kingdom, and not herself, that he courted'.

Tomyris showed more wisdom and foresight when Cyrus began building bridges in order to cross the frontier river dividing their territories; she warned him off three times to end the campaign against her country (1, 206, 1).

Cyrus then made the mistake of duping Tomyris' army, which was under the command of her son, Spargapises, into drinking copious amounts of wine while at battle readiness; Cyrus had slyly left a stash behind on the battlefield when his army withdrew. Scythians, however, were not used to drinking wine, being much more partial to hashish and fermented mare's milk (in common with many Iron Age steppe nomads); accordingly, they became seriously intoxicated and incapacitated – and, while under the influence, one third of the army was subdued by Cyrus' Persians. Spargapises was captured; Tomyris warned that her patience was running out, and that she would give Cyrus his fill of blood if he did not release her son (1,212, 3). But when Spargapises had persuaded Cyrus to remove his bonds, Spargapises promptly committed suicide. When Tomyris learned of the death of Spargapises, she sent Cyrus a vitriolic message in which she called the wine, which had caused the destruction of her army and her son, a drug which made those who consumed it so mad that they spoke evil words, and demanded him to leave his land or else she would, swearing upon the Sun, 'give him more blood than he could drink.'[2]

A vengeful Tomyris challenged Cyrus to a second battle, promising him that fill of blood. Herodotus melodramatically describes it as the 'fiercest of all the battles waged between the barbarians'. Tomyris was victorious: Cyrus was killed and Tomyris had his head cut off and his corpse crucified; she then shoved his head into a wineskin full of human blood:

> I live and have conquered you in fight, and yet by you am I ruined,
> for you took my son with guile; but thus I make good my threat, and
> give you your fill of blood.

Further reading
Faulkner, Robert (2000). 'CYRUS iiia. Cyrus II as Portrayed by Xenophon and Herodotus'. In *Encyclopædia Iranica.*

Onomaris – *if no man will step up, get out of the way!*

Onomaris was a distinguished Galatian; the Galatians were a Gaulish-Celtic tribe. She lived around the 4th century BCE; the only source for her is *Warrior Women: The Anonymous Tractatus De Mulieribus;* she showed great leadership and military prowess.

When her country was beset by 'scarcity' she took control of events because no man was willing to lead the Galatians to a new, more rewarding life elsewhere. In this

respect she is reminiscent of Artemisia I who also came forward to take up power in the absence of any man. To foster a community spirit Onomaris pooled all the resources owned by her tribe, in order presumably to deter envy and superiority, and led her people over the Ister in a mass emigration; she then defeated the locals there and ruled the new land. Onomaris typifies how Celtic women enjoyed high social status, some of whom rose to prominence as leaders of men: Boudica and Cartimandua are famous examples. Four out of Plutarch's twenty-six women are Celts.

Further reading

Ellis, Peter Berresford (1995). *Celtic women: women in Celtic society and literature.* London

Rankin, H.D. (1996). *Celts and the classical world.* London

Atossa (*fl.* 486 BCE – 476 BCE) – *she has become emblematic of breast cancer sufferers through history*

Atossa, according to Hellanicus, 'was most warlike and brave in every deed'. More than that, though, she was brought up by her father, Ariaspes, as a man – and inherited his kingdom; she was the first queen to sport a tiara, and the first to wear trousers; she could write and she introduced eunuchs to the world[1].

Atossa, however, was actually the daughter of Cyrus the Great, wife of two Achaemenian kings, Cambyses and Darius, and mother of Xerxes is the most prominent woman in the history of ancient Iran. We know that she witnessed the reign of the four first Achaemenian kings and that she played a decisive role in the long period of turbulence.

In pre-Islamic era Iran, on the one hand marriage to close relatives, including daughters and sisters, was a common practice in order to keep up the blood line in royal and aristocratic families. On the other hand, the enlightened and progressive Persian habit of educating their children and young adults, as recorded in Xenophon's 4th century BCE *Cyropedy*, probably meant that Atossa had learned how to write and read, and went on to play a crucial role in educating and training her own children as well as those of other aristocrats and courtiers[2].

According to Hellanicus, Atossa wrote the first documented letter when she was around fifty years old. Unfortunately, there is no record of its contents. However, Prof. McGrath stated it was important because it 'established the genre'.

It made letters a 'normal and effective' form of long-distance communication, says McGrath. Over time, it created whole industries for the manufacture of writing materials and eventually formed the basis for postal services that still flourish today.

To the Greeks, women and war simply did not mix. Herodotus' rather sensational telling of these escapades was designed not just to illuminate what he saw as the perverse and blood-thirsty behaviour of barbarian women compared with the so-called civilised women of Greece but also to demonstrate just how far removed

from Greek women they were. His fanciful and slightly prurient descriptions of the permissive sexual mores of barbarian women are manifestations of Greek man's attack on the soft underbelly of his enemy by denigrating and slurring the alleged sexual behaviour of their women. According to Herodotus, members of the Massagetae were sacrificed and cooked and eaten with the meat of sacrificial animals. Members of the Massagetae who died of illness were sometimes left as food for wild animals. Herodotus records that Atossa was troubled by a bleeding lump in her breast. A Greek slave, Democedes, excised the tumor: this is the first recorded case of mastitis. In his history of cancer, *The Emperor of All Maladies*, Siddhartha Mukherjee imagines Atossa traveling through time, encountering different diagnoses and treatments for her breast cancer. Atossa becomes emblematic of cancer sufferers through history.

Further reading

Sancisi-Weerdenburg, H. (1993). 'Exit Atossa: Images of Women in Greek Historiography on Persia'. In Cameron, A. (1993). *Images of Women in Antiquity* (London). pp. 20–33

The anonymous warrior woman of the Isles of Scilly – *and Pictish warrior women*

If proof were needed of the innate belligerence of some pre-classical women then we need look no further than what we now know to be a woman who was found buried with a sword and a mirror and other accoutrements.

In 1999, archaeologists found a grave dated 2,000 years old or so on Bryher on the Isles of Scilly resulting in years of controversy: is it a man or is it a woman? No other Iron Age grave in Western Europe has been found to offer up both seemingly gender conflictive items. It was remarkable for the richness and type of metal objects it contained.

Now, according to a recent article it is almost definitely a woman[1]. Here are the salient findings of the paper:

- A 1st century BCE burial has grave goods with oppositional gender associations.
- The highly degraded skeletal remains have hitherto precluded sex determination.
- We now determine sex as female using dental enamel peptides (with *c.* 96% probability). Tooth enamel contains a protein, amelogenin, that varies with X and Y chromosomes. They only found the kind of amelogenin associated with the X chromosome, so this was a woman. Original attempts to establish sex by traditional methods, such as DNA analysis, failed because of disintegration of the bones. All that could be seen of the skeleton was a dark soil stain where the body had once lain, with only small pieces of bone and teeth amounting to about 150g recovered.
- She may have had a leading role organising / participating in raiding-type warfare.
- Alternatively, it is possible that grave goods may not symbolise social roles.

Caroline Davies reveals that

> Excavations revealed a sword in a copper alloy scabbard and a shield alongside the remains of the sole individual, objects commonly associated with men. But a brooch and a bronze mirror, adorned with what appears to be a sun disc motif and usually associated with women, were also found. The grave is unique in iron age western Europe for containing both mirror and sword[2].

Sarah Stark, a human skeletal biologist at Historic England and co-author, concludes that 'Our findings…provide evidence of a leading role for a woman in warfare on Iron Age Scilly', adding:

> The combination of a sword and a mirror suggests this woman had high status within her community and may have played a commanding role in local warfare… This could suggest that female involvement in raiding and other types of violence was more common in iron age society than we've previously thought, and it could have laid the foundations from which leaders like Boudica would later emerge.

Rebecca McPhee, in her article 'Warrior Buried with Sword and Mirror was a Woman[3]', adds that

> The grave contained other objects besides the mirror and the sword. There was also a shield, a metal brooch, and a ring. While the shield and sword clearly go with warfare, mirrors had many uses during the Iron Age, including reflecting light for warriors to follow. Researchers believe they were also used in rituals to ask the supernatural for victory and for the safe return of warriors.

The Bryher sword and mirror are on display at the Isles of Scilly Museum.

In her article 'Shield-Wielding Women and Scottish Archaeology' curator Claire Mead identifies our problem neatly when she asks

> Who gets to be a warrior? And why can't that warrior be a woman? The image of the warrior woman still fascinates us – but we sometimes have trouble believing she could be more than a rare exception to the rule in a battlefield full of men. Historical and cultural records can worsen this gender bias by erasing traces of these women having ever existed[4].

In support she cites Scáthach, a legendary Scottish warrior woman and martial arts instructor who trained the legendary Ulster hero Cú Chulainn in the arts of combat[5]. Claire Mead adds that Scáthach

was also a magician, and made the magical spear Gae Bulg that she would give to her most notorious student – the legendary Cúchulainn from the Ulster cycle of Irish Mythology. He later would use that very weapon to defeat Ferdiad, his one-time friend, and, according to many interpretations, his lover. Scáthach's training was not a one-time event: she was a regular "coach" for Celtic mythical heroes and her warrior women rivals suggest she was certainly not a unique mythical exception to an all-male rule.

The Isle of Eigg may also be testament to the existence of warrior women since its Gaelic name: Eileannam Ban Mora translates as 'the Island of the Big Women'; archaeological remains reveal that the Picts, a group of Celtic-speaking people who settled in parts of Scotland over 1,100 years ago from around 300 CE until 900 CE, lived here.

Claire Mead regales us with another important revelation:

> One story goes that a clan of powerful warrior women resided on An Sgùrr, Eigg's highest hill. Around AD 617, the Pictish Queen of Moidart sent them to attack the monks converting Eigg's inhabitants to Christianity. At midnight, lights and strange voices appeared where the monks were killed. They charmed the warrior women, guiding them into the island's loch...never to be seen again.

Mead adds

> The 1,200-year-old Hilton of Cadboll Stone discovered in Easter Ross in the Highlands seems to debunk the idea that traditionally masculine acts such as fighting and hunting were the realm of men alone. It shows a hunting scene in which a more distinctly feminine figure is riding side saddle.

In 697 CE a text known as *Adomnann's Law of Innocents* reveals that Pictish women, children and monks were barred from military service. It comes after the legend of St Donnán's death ordered by the Pictish Queen of Moidart, and the real massacre it was inspired by. Mead asks 'Was *Adomnann's Law* a preventive measure – or does the law's very existence suggest women were previously enrolled in the Pictish military?'

Chapter 2

Ancient Egypt

◇◇◇

Comparatively speaking the status of Egyptian women was high, and their legal rights approached equality with men throughout the last three millennia BCE. Egyptian women could own and run their own businesses, own and sell property, and serve as witnesses in court cases. Unlike most women in the region, they were even allowed in the company of men. They could escape bad marriages by divorcing and remarrying. Women were entitled to one third of the property their husbands owned. The political and economic rights Egyptian women enjoyed made them the most liberated females of their time.

As we shall see, a few women even ruled as pharaohs and enjoyed high status in the military. However, crucially, her position never empowered her female subjects. It was to be a few more millennia before the Egyptian Muslim Sisterhood was to see the light of day.

Nitocris of Egypt – *'braver than any man of her time'*

Nitocris, if indeed she was an historical figure, was the first female ruler of Egypt, possibly was the last queen of the Sixth Dynasty (2181 BCE) and concluded the period of the Old Kingdom (*c.* 2613–2181 BCE). Her name crops up in a major chronological documentation of the reigns of the kings of ancient Egypt composed in the 3rd century BCE by Manetho, an Ancient Egyptian priest who dubbed her 'braver than any man of her time'. She also goes by the name Addagoppe of Harran.

The *Tractatus* tells us that she exacted revenge on her brother's murderers by inviting them to an entertainment in a large, sealed hall and drowned them by diverting the Nile through the hall. She then 'flung herself into a room full of ashes'. Another source is Herodotus 2, 100:

> ... [Nitocris] succeeded her brother. He had been the king of Egypt, and murdered by his subjects, who then placed her upon the throne. Determined to avenge his death, she devised a cunning scheme by which she constructed a spacious underground chamber and, pretending to inauguratie it, threw a banquet, inviting all those whom she knew to have been responsible for the murder of her brother. Suddenly as they were feasting, she let the river in upon them by means of a large, secret duct.

Peter Janosi explains for us how the scant records of Egyptian queens in the literature are an early example of high status women being erased from history:

> The nearly complete lack of historical records for queens is due to their status and relationship to the king: the institution of queenship during the Old Kingdom was only possible through the male counterpart. Except for the reign of Queen Nitocris at the end of the Old Kingdom, for whom no contemporary evidence is known, independent female sovereigns did not exist. As far as we know, it would have contradicted the Old Kingdom institution of kingship. Within this royal institution queens only played a fixed role. A simplified definition of kingship is that the king was the overall power of order in the world. His wife was his female counterpart (but without royal power) and mother of the future king. In contradiction to this definition is the fact that a king could have had more than one wife who carried the titles of queenship.

Further reading
Janosi, Peter (1992). 'The Queens of the Old Kingdom and Their Tombs'. *Bulletin of the Australian Centre for Egyptology*. 3: 51–58
Newberry, Percy Edward (1943). 'Queen Nitocris of the Sixth Dynasty'. *Journal of Egyptian Archœology*. 29:51–54
Raffaele, Francesco, 'Royal Women in Early Egypt and Early Old Kingdom Egypt', https://xoomer.virgilio.it/francescoraf/hesyra/archaic-queens.htm
Ryholt, Kim (2000). 'The Late Old Kingdom in the Turin King-list and the Identity of Nitocris'. *Zeitschrift für ägyptische*. 127 (1): 87–119
Tyldesley, Joyce (2006). *Chronicle of the Queens of Egypt*. London
Watterson, B. (2011). *Women in Ancient Egypt*. Stroud
Zivie-Coche, Christiane M. (1972). 'Nitocris, Rhodopis et la troisième pyramide de Giza'. *Bulletin de l'Institut français d'archéologie orientale*. 72: 115–138.

Sobekneferu or Neferusobek ('beauty of Sobek') (*c.* 1800 BCE)

She was the last ruler of the Twelfth Dynasty of the Middle Kingdom. She ascended to the throne following the death of Amenemhat IV, who may have been her brother or husband. Her reign lasted three years, ten months and twenty-four days, according to the *Turin King List.*

According to Kara Cooney[1], Sobekneferu was one of the few women who ruled in Egypt, and the first to adopt the full royal titulary, distinguishing herself from any prior female rulers.[2] She was also the first ruler associated with the crocodile god Sobek by name, whose identity appears in both her birth and throne names.[3] Kara Cooney views ancient Egypt as unique in allowing women to acquire formal – and absolute – power. She posits that women were elevated to the throne during

crises to guide the civilization and maintain social order. Though, she also notes that, this elevation to power was illusory. Women acquired the throne as temporary replacements for a male leader; their reigns were usually erased by their successors; and generally, Egyptian society suppressed women.[4]

In ancient Egyptian historiography, there is some evidence for other female rulers. As early as the First Dynasty, Merneith may have ruled as regent for her son.[5] In the Fourth and Fifth Dynasties (*c.*2613 – 2494 BCE) **Khentkawes (Khentkaus I)** ruled as a queen if the scripts on her tomb are anything to go by. In the Fifth Dynasty, Setibhor may have been a female king regnant given that her monuments were destroyed after her death[6]. Nitocris (see above), is generally considered to have ruled in the Sixth Dynasty, though there is little proof of her historicity and she is not mentioned before the Eighteenth Dynasty. The kingship of Nitocris may actually be a Greek legend[7].

Further reading

Cooney, Kara (2015). *The Woman Who Would be King.* Oneworld Publications
Cooney, Kara (2018). *When Women Ruled the World: Six Queens of Egypt.* Washington DC
Gillam, Robyn (2001). 'Sobekneferu'. In Redford, Donald B. (ed.). *The Oxford Encyclopedia of Ancient Egypt, Volume 3*. Oxford
Robins, Gay (2001). 'Queens'. In Redford, Donald B. (ed.). *The Oxford Encyclopedia of Ancient Egypt, Volume 3*. Oxford
Roth, Ann Macy (2005). 'Models of Authority: Hatshepsut's Predecessors in Power'. In Roehrig, Catharine (ed.). *Hatshepsut From Queen to Pharaoh*. New York
Ryholt, Kim (2000). 'The Late Old Kingdom in the Turin King-list and the Identity of Nitocris'. *Zeitschrift für Ägyptische Sprache und Altertumskunde.* 127 (1): 87–119
Wilkinson, Toby (2010). *The Rise and Fall of Ancient Egypt.* London
Zecchi, Marco (2010). *Sobek of Shedet: The Crocodile God in the Fayyum in the Dynastic Period.* Studi sull'antico Egitto. Todi: Tau Editrice

Ahhotep I (*c.* 1560 BCE) – *notable military commander*

An Egyptian queen, she was the daughter of Queen Tetisheri (Teti the Small) and Senakhtenre Ahmose, and may have been the sister, as well as the queen consort, of Pharaoh Seqenenre Tao ll. She enjoyed a long and influential life ruling as regent for her son Ahmose I. A *stela* at Karnak dating from the 16th century BCE gives us our first evidence of an Egyptian woman excelling in a military capacity: on it, Ahhotep I is described as 'having united Egypt, having cared for its army, having guarded it, having brought back those who fled, gathering up its deserters, having pacified the South, subduing those who defy her'. These, of course, are attributes usually the preserve of kings.

When the now adult Ahmose expelled the Hyksos, he led his army to Nubia to regain lost territories. While he was gone, a group of Hyksos sympathisers tried to usurp him[1].

Ahhotep it was who foiled this attempt, and was awarded the 'golden flies of valour' by her son. He also gave her a cache of beautiful jewellery and ornamental weaponry which was found in a tomb at Dra Abu el-Naga near the Valley of the Kings.

Ahhotep II (*c.* 1555 BCE) – *also a distinguished military woman*

Ahhotep II was the daughter of Ahmose I and Ahmose-Nefertari and was the wife of the Eighteenth Dynasty king Amenhotep I who ruled 1525–1504 BCE. She was the sister of Amenhotep and was his ranking consort throughout her life. The records listed her as 'King's Daughter, King's Wife, King's Mother'.

The tomb of Ahhotep II contained her now destroyed mummy, and gold and silver jewellery as well daggers and an inscribed ceremonial axe blade made of copper, gold, electrum and wood; three golden flies were found too: these were usually awarded to people who served with distinction in the army.

Further reading
Dodson, A. (2004). *The Complete Royal Families of Ancient Egypt,* London
Grajetzki, W. (2005). *Ancient Egyptian Queens: a hieroglyphic dictionary*
Robins, Gay (1993). *Women in Ancient Egypt*
Sidpura, Taneash (2022). 'Flies, Lions and Oyster Shells: Investigating Military Rewards in Ancient Egypt from the Predynastic Period to the New Kingdom'. (University of Manchester: PhD thesis.) pp. 93–98

Hatshepsut (d. 1458) – *attained unprecedented power for a woman, adopting the full titles and regalia of a pharaoh*

Hatshepsut, female king of Egypt (reigned in her own right *c.* 1473–58 BCE) who attained unprecedented power for a woman, adopting the full titles and regalia of a pharaoh. She was Egypt's second certain queen regnant, the first being Sobekneferu/ Nefrusobek in the Twelfth Dynasty.

Hatshepsut, the elder daughter of the Eighteenth Dynasty king Thutmose I and his consort Ahmose, was married to her half-brother Thutmose II. Thutmose II inherited his father's throne about 1492 BCE, with Hatshepsut as his consort. Hatshepsut bore one daughter, Neferure, but no son. When Thutmose II died about 1479 BCE, the throne passed to his son Thutmose III. Thutmose III was an infant so Hatshepsut acted as regent.

The early years of her stepson's reign were uneventful but, by the end of his seventh regnal year, she had been crowned king and adopted a full royal titulary – the royal protocol adopted by Egyptian sovereigns making Hatshepsut and Thutmose co-rulers of Egypt, but with Hatshepsut very much the dominant king. Until now Hatshepsut had been depicted conventionally as a typical queen, with a female body and female garments. But now, in order to establish herself in the Egyptian patriarchy her formal portraits began to show Hatshepsut with a male body, wearing

the traditional regalia of kilt, crown or head-cloth, and false beard. This is an example of the Egyptian artistic convention whereby things are portrayed not as they were but as they should be. In allowing herself to be depicted as a traditional king, Hatshepsut thereby ensured that this is what she would in fact become.

Artistic convention apart this is a variation on the tradition which masculinised capable women by endowing them with male characteristics and thereby explaining away their abilities.

Hatshepsut's reign was largely peaceful with foreign policy weighted towards trade rather than war. But scenes on the walls of her Dayr al-Baḥrī temple, in western Thebes, suggest that she began with a short, successful military campaign as well as Hatshepsut's seaborne trading expedition to Punt, a trading centre on the East African coast at the end of the Red Sea. Gold, ebony, animal skins, baboons, processed myrrh, and live myrrh trees were all brought back to Egypt, and the trees were planted in the gardens of Dayr al-Baḥrī

Hatshepsut embarked on an extensive building program. For example, in Thebes this focused on the temples of her divine father, Amon-Re. At Karnak, she remodeled her earthly father's hypostyle hall, added a barque shrine (the Red Chapel), and erected two pairs of obelisks. At Beni Hasan in Middle Egypt, she constructed a rock-cut temple Artemidos. Her tour de force, however, was the Mortuary Temple of Hatshepsut at Deir el-Bahari, designed as a funerary monument for Hatshepsut herself, dedicated to Amon-Re with a series of chapels honouring Osiris, Re, Hathor and Anubis. Located opposite the city of Luxor, it is considered to be a masterpiece of ancient architecture.

But things did not end well with this powerful, enlightened and civilising queen. Joyce Tyldesley tells how

> Toward the end of her reign, Hatshepsut allowed Thutmose to play an increasingly prominent role in state affairs; following her death, Thutmose III ruled Egypt alone for 33 years. At the end of his reign, an attempt was made to remove all traces of Hatshepsut's rule. Her statues were torn down, her monuments were defaced, and her name was removed from the official king list[1]. Early scholars interpreted this as an act of vengeance, but it seems that Thutmose was ensuring that the succession would run from Thutmose I through Thutmose II to Thutmose III without female interruption. Hatshepsut sank into obscurity until 1822, when the decoding of hieroglyphic script allowed archaeologists to read the Dayr al-Baḥrī inscriptions. Initially the discrepancy between the female name and the male image caused confusion, but today the Thutmoside succession is well understood.
> – https://www.britannica.com/biography/Hatshepsut

Further reading

Arnold, Dieter (2005). 'The Temple of Hatshepsut at Deir el-Bahri'. In Roehrig, Catharine (ed.). *Hatshepsut From Queen to Pharaoh*. New York

Cooney, Kara (2015). *The Woman Who Would be King.* Oneworld Publications.

Cooney, Kara (2018). *When Women Ruled the World: Six Queens of Egypt.* Washington DC

Dell, Pamela (2008). *Hatshepsut: Egypt's First Female Pharaoh,.* Capstone

Naville, Édouard (1895–1909). *The Temple of Deir el-Bahari. Vol. I–VI.* London: Egypt Exploration Fund

Salisbury, Joyce E. (2001). *Encyclopedia of Women in the Ancient World.* Santa Barbara, CA.: ABC-CLIO.

Szafrański, Zbigniew (2001). *Queen Hatshepsut and her temple 3500 years later.* Warsaw

Szafrański, Zbigniew E. (2014). 'The Exceptional Creativity of Hatshepsut'. In Galán, José M.. (ed). *Creativity and Innovation in the Reign of Hatshepsut.* Chicago, IL

Tyldesley, Joyce (1996). *Hatchepsut: The Female Pharaoh.* London

Nefertiti (*c.* 1370 – *c.* 1330 BCE) – *powerful, intelligent and beautiful*

Nefertiti was a queen of the Eighteenth Dynasty (1549–1292 BCE), 'the great royal wife of Pharaoh Akhenaten'. The couple were known for their root and branch overhaul of state religion, in which they promoted the earliest known form of monotheism: Atenism, centered on the sun disc and its direct connection to the royal household.

With her husband, she reigned at what was probably the wealthiest period of ancient Egyptian history. Some scholars believe that Nefertiti ruled briefly as Neferneferuaten after her husband's death and before the reign of Tutankhamun. Egyptologist and archaeologist Zahi Hawass suggests that if Nefertiti did rule as Pharaoh her reign was marked by the fall of Amarna and relocation of the capital back to the traditional city of Thebes.

As noted, it is likely that Nefertiti, just like her female predecessor Hatshepsut, assumed the kingship under the name Pharaoh Neferneferuaten after her husband's death. It is also possible that, in a similar fashion to Hatshepsut, Nefertiti disguised herself as a male and assumed the male alter-ego of Smenkhkare; in this instance she could have elevated her daughter Meritaten to the role of great royal wife.

Donald Reford tells how during the early years in Thebes, Akhenaten (still known as Amenhotep IV) had several temples erected at Karnak, one of which, the Mansion of the Benben was dedicated to Nefertiti. In scenes found on the talatat, Nefertiti appears almost twice as often as her husband[1]. She is shown appearing behind her husband the pharaoh in the role of the queen supporting her husband, but she is also depicted in scenes that would have normally been the preserve of the king. She can be seen doing battle with the enemy, riding a chariot while captured enemies decorate her throne.[2] We also see her worshipping the Aten as a pharaoh would.

In Egypt, war was prevalent in the portfolios of the female deities, as it was to be in the Greek and Roman pantheons: Bast was a cat-headed goddess linked with war, the sun, perfumes, ointments, and embalming among other things; Menhit was goddess of war, 'she who slaughters'; Neith, goddess of war, hunting, and wisdom;

Pakhet, goddess of war; Satis, deity of the floods of the Nile River and a war, hunting, and fertility goddess; Sekhmet was goddess of warfare, pestilence, and the desert; Set, god of chaos in war; Sobek was god of the Nile, the army, military, fertility and of crocodiles.

These goddesses surely underscore the importance to, and ubiquity of, war in Egyptian culture, and the comparatively prominent part played by women.

Further reading
Dodson, Aidan (2016). *Amarna Sunrise: Egypt from Golden Age to Age of Heresy.* Cairo

Arsinoe III Philopator – *father-loving and war woman*

Arsinoe was a true woman warrior. She was queen of Egypt from 220 BCE to 204 BCE, and a daughter of Ptolemy III Euergetes and Berenice II; she was married to her brother, Ptolemy IV, and took an active part in the government and military affairs of the country[1].

In 217 BCE, she accompanied Ptolemy IV along with 55,000 troops at the Battle of Raphia (Gaza) in Palestine against Antiochus the Great with 68,000 troops.[2] According to Reina Pennington[3], Arsinoe may have commanded a section of the infantry phalanx. Both sides deployed cavalry, elephants, and special forces such as archers, as well as the traditional Macedonian phalanx. When the battle was obviously not going well, she appeared before the troops and exhorted them to fight to defend their families. She also promised two minas of gold to each of them if they won the battle, which they did[4].

She married Ptolemy after the battle and gave birth to the future Ptolemy V Epiphanes about 210. After that she was isolated in the palace very much in the Greek way, while Ptolemy's debauched male and female favourites brought ruin on both king and government. Although Arsinoe disapproved of the depravity of the court, she was unable to make any difference.

The dissolute Ptolemy IV died in 204 BCE. His two favourites, Agathocles and Sosibius, fearing that Arsinoe would inherit the regency, had her murdered by Philammon in a palace coup even before she heard of her husband's death, thereby securing the regency for themselves[5].

The Kandakes of Kush – *powerful women rulers all*

Kandake or Kentake was the title bestowed on queens of the ancient Kingdom of Kush in the Nile Valley. It is a derivative of Candace, a Meroitic language term for 'queen' or 'queen-mother'. Pliny (*Natural History* 6, 35) records that the 'Queen of the Ethiopians' bore the title Candace. The Kingdom of Kush was an ancient Nubian kingdom on the confluences of the Blue Nile, White Nile and River Atbara in what is now roughly Sudan.

The Kandakes (Candaces) of Kush were powerful women rulers; they all governed as queens but the following are the ones whom we know had a specific prominent, militaristic dimension to their rule. In the hierarchy of Kush, the mothers would rule and then install their sons as rulers, but they also deposed their own sons and could order a son-king to commit suicide to terminate his rule. W.Y. Adams tells us that there are at least ten regnant Meroitic queens during the 500 years between 260 BCE and 320 CE, and at least six during the 140 periods between 60 BCE and 80 CE[1]. Twenty-one queens are recorded as sole regent until the 9th century CE. Typically they are depicted a 'as women often alone and at the forefront of their stelae and sculptures and shown in regal women's clothing. Early depictions of Kushite queens typically do not have Egyptian elements making their appearance drastically different from their Kushite men and Egyptian counterparts'.

At El Kurru, six pyramids belong to royal women of the Twenty-Fifth Dynasty and a pyramid for queen Qalhata of the Napatan period[2].

The most important event that Kushite women participated in was ensuring the continuity of the kingship, where royal women were mentioned and represented in the royal ceremony[3]. The king's mother played an essential role in the legitimacy of her son as the king; textual evidence from Taharqo's coronation stelae represents inscriptional evidence suggesting that the king's mother travelled to her son's coronation. During the Kushite Twenty-Fifth Dynasty, the office that is known as God's Wife of Amun was established. The royal women in this role acted as the primary contact with the Kushite god Amun. They played a decisive role in the king's accession to the throne.

Nahirqo is the earliest known woman to have ruled the Kingdom of Kush, reigning in the middle 2nd century BCE. Before her own reign, Nahirqo is believed to have been the queen consort of King Adikhalamani[4].

According to the much embellished *Alexander Romance,* **Candace of Meroë** engaged Alexander the Great in battle, although it is doubtful if Alexander ever attacked Nubia or advanced much further south than Siwa in Egypt. Apparently, when Alexander tried to take her lands in 332 BCE, she drew her armies up to confront him, herself seated on a war elephant as he approached. Alexander, seeing the strength of her armies, apparently decided to withdraw from Nubia and headed back to Egypt instead. Strabo calls Candace 'a masculine sort of woman, and blind in one eye'[5].

Amanirenas was a queen of the Meroitic Kingdom of Kush from about 40 BCE to 10 BCE. She is notable for her role leading Kushite armies against the Romans in a war from 27 BCE to 22 BCE. According to Strabo (17, 1, 54) and Dio (54, 5), taking advantage of the absence of Aelius Gallus, Prefect of Egypt in 24 BCE, Amanirenas and **Akinidce** defeated Roman forces at Syene (Aswan) and Philae, and drove the Jews from Elephantine Island; they returned jubilantly to Kush with prisoners and loot, having destroyed several statues of Augustus, much to his embarrassment. Augustus retaliated by destroying the city of Napata, Amanirenas' capital.

The Kushites were expelled from Egypt by Gaius Petronius enabling the Romans to establish a new frontier with a garrison in Qasr Ibrim (Primis).

Amanikhatashan was queen of Kush from *c.* 62 CE – 85 CE); her pyramid is at Meroe in the Sudan. Amanikhatashan is noted for having sent her cavalry to support Roman emperor Titus during the Great Jewish Revolt in 70 CE.

Other Candaces included *Amanishakheto, Amanitore, Amantitere, Maleqorobar* and *Lahideamani.*

Further reading

Magak, Adhiambo Edith (2021-09-23). 'The One-Eyed African Queen Who Defeated the Roman Empire'. *Narratively.*

Snowden, Frank M. (1970). *Blacks in Antiquity: Ethiopians in the Greco-Roman Experience.* Harvard University Press

https://web.archive.org/web/20081204034536/http://guide2womenleaders.com/womeninpower/Womeninpowe-chronological1.htm

Cleopatra II – *her husband sent her her son's dismembered head, hands and feet as a birthday present*

Cleopatra II, Ptolemy VI and their brother, Ptolemy VIII, co-ruled Egypt from *c.* 171 BCE to 164 BCE. In 169 BCE, Antiochus IV of Syria (her maternal uncle) invaded Egypt; Ptolemy VI Philometor joined up with Antiochus outside Alexandria. Ptolemy VI was crowned in Memphis and ruled with Cleopatra II. Cleopatra II married her other brother, Ptolemy VIII Euergetes II in 145 BCE.

Cleopatra II later led a rebellion against Ptolemy VIII in 131 BCE, and drove him and Cleopatra III, her daughter, out of Egypt. Ptolemy VIII had his son, Ptolemy Memphites by Cleopatra II, murdered, dismembered and his head, hands and feet sent to Cleopatra II in Alexandria as a birthday present. Cleopatra II ruled Egypt from 130 BCE to 127 BCE when she was forced to flee to Syria. Cleopatra and Ptolemy VIII settled their differences in 124 BCE. After this she ruled jointly with her brother and daughter until 116 BCE when Ptolemy died, leaving the kingdom to Cleopatra III. Cleopatra II herself died soon after.

Chapter 3

Outstanding women in the Bible

◇◇◇

The Bible obviously features all types of women: here are wives, mothers and daughters, 'barren' women, servants, slaves and prostitutes. Some are victors, some are victims, some change the course of important events while others are powerless to such a degree that they cannot even influence their own destinies. Most women in the Bible are anonymous and unnamed. The New Testament introduces us to a number of women in Jesus' inner circle; generally speaking Jesus deals with women with respect and even equality.

As we have seen, ancient near eastern societies are traditionally patriarchal, and the Bible, given that it was written by men, has traditionally been interpreted as patriarchal in its general views of women.

Marital and inheritance laws in the societies described in the Bible favour men, and women in the Bible exist under much stricter laws of sexual behaviour than men. A woman in ancient biblical times was always subject to strict purity laws, both ritual and moral.

While women are not generally front of stage in the Bible, those women who are named are usually prominent for extraordinary reasons, often subverting power structures in a biblical literary device called 'reversal'. Abigail, David's wife, Esther the Queen, and Jael who drove a tent peg into the enemy commander's temple while he slept, are a few examples of women who turned the tables on powerful men.

Unsurprisingly, when we ask how many women are mentioned in the Bible by name, the answer is not very many. One study produced a total of 3,000–3,100 names, 2,900 of which are men with 170 of the total being women. However, duplication, gender neutral names and names in foreign languages for the same woman, reduced the total to 1,700 distinct personal names with 137 of them being women. But only 188 to 205 of the women have names, depending on which Bible you're reading. Compare that to the 1,181 named men, and women are less than 15% of the named characters. Indeed, as Toni Craven reports, 'Despite the disparities among these different calculations, ... [it remains true that] women or women's names represent between 5.5 and 8 percent of the total [names in the Bible] – a stunning reflection of the androcentric character of the Bible.'[1]

In her *Bible Women: All Their Words and Why They Matter* Lindsay Freeman reveals that of the ninety-three women whose spoken words are recorded, forty-nine are named[2].

Eve – *allegedly our first woman – or should that be Lilith?*

According to the creation story of the Abrahamic religions, Eve was the first woman, yet some debate within Judaism has also bestowed that position on Lilith. Eve is known also as Adam's wife and enters the world stage because the

> The Lord God said, 'It is not good for the man to be alone. I will make a helper suitable for him'... Then the Lord God made a woman from the rib he had taken out of the man, and he brought her to the man... That is why a man leaves his father and mother and is united to his wife, and they become one flesh. Adam and his wife were both naked, and they felt no shame." Eve is deceived, tempted and indulges, then shares with her husband who apparently neither questions nor argues. Their eyes are opened and they realize they are naked, and they make coverings from fig leaves. When God comes to the garden, they hide, and God knows something is wrong. Both attempt to shift the blame, but they end up bearing the responsibility, each receiving their own curses, and getting thrown out of the garden together.
>
> – Genesis 2:18–25

However we choose to interpret her precise role in the 'fall of man' Eve is important, obviously, as the first woman. As a result of her collusion with the serpent in the Garden of Eden Eve, and all womankind after her, is sentenced to a life of sorrow and labour in childbirth, and to be under the power of her husband. Adam and Eve had two sons, Cain and Abel – the first a ploughman, the second a shepherd. After the death of Abel, Eve gave birth to a third son, Seth, from whom Noah (and thus the whole of modern humanity) is descended. According to Genesis, Seth was born when Adam was 130 years old, 'a son in his likeness and like his image'.

While traditionalists held that the Book of Genesis was authored by Moses and has been considered historical and metaphorical, modern scholars consider the Genesis creation narrative as one of various ancient origin myths.

Lilith, on the other hand, features as a female figure in Mesopotamian and Judaic mythology, supposed to be the first wife of Adam and the primordial she-demon[1]. Lilith is cited as having been 'banished' from the Garden of Eden for not complying with and obeying Adam[2]. She is mentioned in the Book of Isaiah (34:14) and in late antiquity in Mandaean mythology and Jewish mythology sources from 500 CE onward. In Roman literature she appears as the child snatcher, Lamia[3].

Further reading
Flood, John (2010). *Representations of Eve in Antiquity and the English Middle Ages*. London
Humm, Alan (ed.) (2023). *Lilith Bibliography, Jewish and Christian Literature*

Miriam – *struck a first blow for women – and paid the price*

The Torah refers to her as 'Miriam the Prophetess' and the Talmud names her as one of the seven major female prophets of Israel. Scripture describes her with Moses and Aaron as delivering the Jews from exile in Egypt: 'For I brought you up out of the land of Egypt and redeemed you from the house of slavery, and I sent before you Moses, Aaron, and Miriam'. According to the Midrash, just as Moses led the men out of Egypt and taught them Torah, so too Miriam led the women and taught them Torah[1].

Miriam is the first woman ever to bear the epithet 'prophet' and thereby becomes the archetype of the female prophetic tradition. Studies show that the Song of Miriam belongs to a corpus of women's traditions that include the long Songs of Deborah (Judg. 5:1–31) and Hannah (1 Sam. 2:1–10).

Later, she and her brother Aaron challenge the actions and authority of Moses[2]. As far as Miriam is concerned leadership involves diverse voices, female and male – a modern attitude in a very ancient culture. She asks with some indignation, 'Has the Lord spoken only through Moses? Has he not spoken through us also?' (Num. 12:2).

But, according to the *Shalvi/Hyman Encyclopedia of Jewish Women,* God is none too pleased by such a progressive and inspired attitude in his world; he punished Miriam by rendering her eternally speechless and shunned by all – a kind of mute Cassandra. Notably, God only punishes Miriam – Aaron gets away with it. The *Encyclopedia* continues:

> Metaphorically, the divine nostril burns in anger to leave her stricken with scales like snow. Aaron pleads with Moses on her behalf, and Moses appeals to God. God responds by confining her outside the camp for seven days. This period of time verifies her cleanliness but does not restore her to wholeness. Whatever her particular disease [tzaraath] Miriam remains a condemned woman, a warning for generations to come (see Deut. 24:8–9). After her punishment, she never speaks, nor is she spoken to. Indeed, she disappears altogether from the narrative until the announcement of her death and burial at Kadesh (Num. 20:1)[3].

In the New Testament Miriam's afterlife continues through her name and her deeds. The Greek name Mary is the equivalent of the Hebrew Miriam.

Further reading
Brenner, Athalya (1985). *The Israelite Woman: Social Role and Literary Type in Biblical Narrative.* Sheffield

Deborah – *ruthless with a tent peg*

The Book of Judges tells us that in the 13th century BCE – Deborah, prophet of the god of the Israelites and the only ever female judge of Israel, led her ill-provisioned Israelite army on a military campaign in Qedesh where she spearheaded a successful counter-attack against the superior forces of Jabin, king of Canaan who had oppressed Israel for twenty years, and his general Sisera, enemy of the Israelites.

Her status as both prophet and judge places her alongside the only other biblical figures with these accreditations: Moses and Samuel. The only woman among the twelve judges in the Old Testament, her role shows that women were not always inferior to men since Deborah was called upon by God to deliver Israel.

At Judges 4:5–9 we read how Deborah sent for Barak and said to him,

> "The Lord, the God of Israel, commands you: 'Go, take with you ten thousand men of Naphtali and Zebulun and lead the way to Mount Tabor. I will lure Sisera, the commander of Jabin's army, with his chariots and his troops to the Kishon River and deliver him into your hands.'" Barak replied "If you go with me, I will go; but if you don't go with me, I won't go." "Very well," Deborah said, "I will go with you. But because of how you are going about this, the honour will not be yours, for the Lord will hand Sisera over to a woman."

This is how the 'God who Speaks' website describes what happened next:

> Barak chased the retreating enemy to the fortress base of Harosheth Haggoyim, where the Israelites slaughtered them. None of Jabin's army was left alive. Sisera had the weapons of mass destruction but Deborah possessed the armour of faith. In the heat of the battle, Sisera deserted his army and ran to the camp of Heber the Kenite, near Kedesh. Heber and King Jabin were allies so this would have made perfect sense. As Sisera staggered in, Heber's wife, Jael, welcomed him into her tent. The exhausted Sisera asked for water, but Jael gave him curdled milk, (a drink that would make him drowsy), and a rug to sleep under. Sisera asked her to guard the tent's door and divert any enemies. When he fell asleep, Jael crept in with a tent peg and a hammer. She drove the peg through Sisera's head. Then Barak arrived and Jael showed him the dead body of Sisera.

The 'Song of Deborah' (Judges 5:2–31) is a victory hymn, sung by Deborah and Barak, about the defeat of Canaanite adversaries by some of the tribes of Israel[1]. It is the earliest example of Hebrew poetry dating from about 1125 BCE, in which this exploit is narrated and is one of history's earliest passages that describes belligerent women[2]. Courageous, if ruthless, tent-maker Jael established the capacity for extreme violence in bellicose women.

> Extolled above women be Jael…She stretched forth her hand to the nail, Her right hand to the workman's hammer, And she smote Sisera; she crushed his head, She crashed through and transfixed his temples.
>
> – The 'Song of Deborah' (Judges 5:24–26)

Further reading

Bird, Phyllis (1974). 'Images of Women in the Old Testament'. In Ruether, Rosemary Radford (ed.). *Religion and Sexism: Images of Women in the Jewish and Christian Traditions.* New York

Brown, Cheryl Anne (1992). *No Longer be Silent: First Century Jewish Portraits of Biblical Women: Studies in Pseudo-Philo's Biblical Antiquities and Josephus's Jewish Antiquities.* Louisville, KY

Deen, Edith (1955). *All the Women of the Bible. New York*

Klein, Lilian R. (2003). *From Deborah to Esther: Sexual Politics in the Hebrew Bible.* Fortress Press

Lacks, Roslyn (1979). *Women and Judaism: Myth, History, and Struggle.* Garden City, NY

Otwell, John H. (1977). *And Sarah Laughed: the Status of Woman in the Old Testament.* Philadelphia.

Phipps, William E. (1992). *Assertive Biblical Women.* Westport, CT

Schroeder, Joy A. (2014). *Deborah's Daughters: Gender Politics and Biblical Interpretation.* New York

Williams, James G. (1982). *Women Recounted: Narrative Thinking and the God of Israel.* Sheffield

Judith – *military intelligence and ruthless slaughter*

The Book of Judith tells how Judith was a brave and beautiful widow who deployed her beauty and charm to slay an Assyrian general who had besieged her city, Bethulia. In doing so, she saved nearby Jerusalem from total destruction. The name Judith is the feminine form of Judah. She berated her Jewish compatriots for not trusting God to deliver them from the Assyrians, their foreign conquerors. Judith accordingly took matters into her own hands and went with her trusted maid to the camp of the enemy general, Holofernes, whose trust she gradually won, promising him secret intelligence on the Israelites.

She is allowed into his tent one night; as he lies in a drunken stupor she decapitates him and takes his head back to her anxious countrymen. The Assyrians, now leaderless, disperse, and Israel is saved.

Though courted by many, Judith remained unmarried for the rest of her life.

Judith gives us another example of extreme female violence, mixed with patriotism, guile, bravery and good use of military intelligence and a healthy impatience with drunken enemies.

Today, it is generally accepted that the Book of Judith is not historical. The fictional nature 'is evident from its blending of history and fiction, beginning in the very first verse, and is too prevalent thereafter to be considered as the result of mere historical mistakes.'[1]

Further reading
Knecht, Friedrich Justus (1910). 'The Heroic Judith'. *A Practical Commentary on Holy Scripture.* B. Herder.

Jezebel

Jezebel (d. *c.* 843 BCE) is described in the Book of Kings (1 Kings 16:31) as a Phoenician queen who was the daughter of Ithobaal I of Sidon and the wife of Ahab, King of Samaria, the northernmost kingdom of Israel. This is a good example of a woman being defined by her close male relatives. Josephus and other classical sources, says she was the great-aunt of Dido, Queen of Carthage (see below)[1].

As a worshiper of Baal, Jezebel had significant power and influence, which she used to both support Baal's cult and eliminate its rivals, using methods that the Bible describes in brutal terms. According to Kings, Jezebel incited her husband King Ahab to abandon the worship of Yahweh and encourage worship of the pagan deities Baal and Asherah instead.

Jezebel, a woman of some temper, persecuted and exiled the prophets of Yahweh, and, in one case, fabricated evidence of blasphemy against an innocent landowner who refused to sell his vineyard to King Ahab. When Naboth refused to part with his vineyard ('the inheritance of my fathers'), Jezebel falsely charged him with blaspheming 'God and the king,' which led to Naboth's death by stoning. His corpse was licked by stray dogs. Jezebel then informed Ahab that he was free to appropriate Naboth's vineyard. Elijah confronted Ahab in the vineyard, predicting that he and all his heirs would be destroyed and that dogs in Jezreel would devour Jezebel.

Elijah's successor, Elisha the prophet, equally determined to end the worship of Baal, appointed a military commander named Jehu king of Israel, an act that provoked civil war, for Jezebel's son Jehoram (Joram) was on the throne. Jehu killed Jehoram and then proceeded to Jezebel's palace. Expecting him, she beautified herself for the occasion with make-up and a wig. Looking down from her window, she taunted him, so Jehu ordered her eunuch slaves eject her from the

window. On the ground her blood splashed on walls and horses, and Jehu's horse trampled her corpse. He entered the palace where, after he had eaten and drank, ordered Jezebel's body be buried. However, his servants discovered her corpse had been eaten by feral dogs, as predicted.

Jezebel became associated with false prophets. In some interpretations, her dressing in finery and putting on makeup led to the association of the heavy use of cosmetics with 'painted women' or prostitutes. In the 20th century the Faces song 'Stay with Me' (Stewart – Wood, 1972) includes the derogatory, 'I hear you're a mean old Jezebel'.

Further reading
Bellis, Alice Ogden (2007). *Helpmates, harlots, and heroes: Women's stories in the Hebrew Bible*. Westminster John Knox Press
Quick, Catherine S. (1993). 'Jezebel's last laugh: the rhetoric of wicked women.' *Women and Language*. 16 (1): 44–49

Delilah – *Samson does not suspect her, perhaps because he cannot think of a woman as being dangerous*

> *I yielded, and unlocked her all my heart,*
> *Who with a grain of manhood well resolved*
> *Might easily have shook off all her snares:*
> *But foul effeminancy held me yoked*
> *Her bond-slave. O indignity, O blot*
> *To honour and religion! Servile mind*
> *Rewarded well with servile punishment!*
> — John Milton, *Samson Agonistes* lines 407–413)

Judges chapters 13 to 16 tell the story of Samson, a man with prodigious strength which he uses to fight the occupying forces of the Philistines; he meets Delilah, a meeting which eventually results in his death. Samson was a Nazirite, a specially dedicated individual from birth, yet his story indicates he violated every requirement of the Nazirite vow. Long hair was only one of the symbolic representations of his special relationship with God, and it was the last one that Samson violated. Nathan MacDonald explains that touching the carcass of the lion and Samson's celebration of his wedding to a Philistine can be seen as the initial steps that led to his end. Samson travelled to Gaza and

> fell in love with a woman in the Valley of Sorek whose name was Delilah. The rulers of the Philistines went to her and said, see if you can lure him into showing you the secret of his great strength and how we can overpower him so we may tie him up and subdue him. Each one of us will give you eleven hundred shekels of silver.

Samson lies to her twice then tells her the truth.

> Then the Philistines seized him, gouged out his eyes and took him down to Gaza. Binding him with bronze shackles, they set him to grinding grain in the prison. But the hair on his head began to grow again after it had been shaved.
>
> Now the rulers of the Philistines assembled to offer a great sacrifice to Dagon their god and to celebrate, saying, "Our god has delivered Samson, our enemy, into our hands." And they brought Samson out to entertain each other. But Samson prayed, "O Lord, remember me" and he pushed the columns holding up the Temple and killed everyone there.

In art Delilah is usually pictured as a type of *femme fatale*, but the biblical term used (*patti*) means to persuade with words. Delilah uses emotional blackmail and Samson's genuine love for her to betray him. No other Hebrew biblical hero is ever defeated by an Israelite woman. Samson does not suspect her motives, perhaps because he cannot think of a woman as being dangerous, but Delilah is determined, bold and very dangerous indeed. The entire Philistine army could not bring him down. Delilah did, but it was Samson himself who facilitated that.

Lyn Bechtel tells us how The Talmud says that Delilah deployed sex to get Samson to reveal his secret, in spite of the fact that the biblical text does not state that the two had a sexual relationship, while Midrash states that Delilah harassed Samson verbally and physically during sex to persuade him to reveal to her the source of his strength[1]. Midrashim on Delilah reveal negative attitudes toward non-Jewish women and are supposed to 'demonstrate the havoc that a foreign woman could wreak'. The Midrash says that Samson lost his strength because of his relationship with Delilah, a foreign woman, and not because his hair was cut, and that the angel who foretold Samson's birth to his mother knew that Delilah would cause him to break his Nazirite vow.

Most Christian commentary on Delilah condemns her. Saint Ambrose represents Delilah as a Philistine prostitute and declares that 'men should avoid marriage with those outside the faith, lest, instead of love of one's spouse, there be treachery.' Marbodius of Rennes uses the examples of Delilah, Eve, Lot's daughters, Herodias, Clytemnestra, and Procne to illustrate that women are a 'pleasant evil, at once a honeycomb and a poison'.[2]

Some Christians have compared her to Judas Iscariot and have noted similarities between Delilah and other violent women in the Bible, such as Jael and Judith, discussing the question of whether the story of Samson's relationship with Delilah displays a negative attitude towards foreigners. Notable depictions of Delilah include John Milton's (1608–1674) closet drama *Samson Agonistes* and Cecil B. DeMille's 1949 Hollywood film *Samson and Delilah*. Her name has become associated with treacherous and voluptuous women.

John Milton's *Samson Agonistes*, an allegory for the downfall of the Puritans and the restoration of the English monarchy, casts Delilah as an unrepentant, but sympathetic, deceiver and speaks approvingly of the subjugation of women.[3]

Further reading
Kranidas, Thomas (1966). 'Dalila's Role in Samson Agonistes.' *Studies in English Literature, 1500–1900.* 6 (1): 125–37

Mary, mother of Jesus

How we assess the importance of the mother of Jesus depends largely on whether we subscribe to the Christian faith, and particularly to Roman Catholicism. The latter hold Mary in high esteem while atheists will see in her little relevance.

The New Testament describes Mary as a young virgin chosen by God to conceive Jesus through the Holy Spirit. After giving birth to Jesus in Bethlehem, she raised him in the city of Nazareth in Galilee, and was in Jerusalem at his crucifixion and with the apostles after his ascension.

Surprisingly perhaps, Mary is hardly mentioned after the beginning of Jesus' public ministry. The gospels say Mary is the one 'of whom Jesus was born' (Matthew 1:16) and that she is the 'favoured one' (Luke 1:28). Some scholars believe the infancy narratives were interpolations by the early Church. Bart Ehrman says that Jesus is never mentioned in any Greek or Roman, non-Christian sources until eighty years after his death. This obviously has implications for the historicity of Mary. When she receives the announcement of Jesus' birth, she asks 'How can this be?' Then, '... let it be' (1:38). Ehrman also reminds us that Jesus is never mentioned by name in the Talmud.

In the Gospel of Luke, Mary visits Elizabeth, her cousin, twice, and twice Elizabeth calls her blessed (Luke 1:42, 45). Mary herself states all future generations will call her blessed (1:48). Mary 'ponders' Simeon's warning that 'a sword would pierce her soul' in Luke 2:34, 35. She is troubled by Jesus staying behind in the Temple at Jerusalem at twelve and his assumption his parents would know where he was (Luke 2:49). Mary 'ponders all these things in her heart.'

Mark Miravalle tells how Mary has been venerated since early Christianity, and is considered by millions to be the holiest and greatest saint. The Catholic Church holds distinctive Marian dogmas, namely her Immaculate Conception and her Assumption into heaven.[1] Many Protestants play down Mary's role, arguing that there is a lack of biblical support for any beliefs other than her status as the Mother of God and the virgin birth.[2] She is mentioned several times in the Quran, including in a chapter named after her, and has the highest position in Islam among all women.[3]

In all three gospels, Mark, Matthew and Luke, Mary and Jesus' brothers are disowned by Jesus. The Matthew version has it as

> Then one said unto him, Behold, thy mother and thy brethren stand
> without, desiring to speak with thee. But he answered and said unto

him that told him, Who is my mother? and who are my brethren? And he stretched forth his hand toward his disciples, and said, Behold my mother and my brethren! For whosoever shall do the will of my Father which is in heaven, the same is my brother, and sister, and mother.

In Luke the repudiation is even stronger, there Jesus says his disciples have to hate their mothers. 'If any man come to me, and hate not his father, and mother, and wife, and children, and brethren, and sisters, yea, and his own life also, he cannot be my disciple.'

The Gospel of John never identifies her by name, referring instead to 'the mother of Jesus'. She appears twice in John: first is the wedding feast at Cana where the wine runs out. Mary tells Jesus, and his response is 'Woman, what have I to do with you? My hour has not yet come.' In spite of this, Mary tells the servants, 'Do whatever he says.' Jesus orders six stone water jars filled with water, and then directs that it be taken to the steward who describes it as the 'best' wine.

Jesus' mother appears again in John (19:25–27) at the crucifixion, where Jesus makes provision for the care of his mother in her senior years (John 19:25–27). Mary speaks not a word and the narrator does not describe her.

The New Testament account of her humility and obedience to the message of God have made her an exemplar for all ages of Christians. Christian piety theology has constructed a picture of Mary that fulfils the prediction ascribed to her in the Magnificat (Luke 1:48): 'Surely, from now on all generations will call me blessed.'

Further reading

Brown, Raymond E. (1993). *The Birth of the Messiah: A Commentary on the Infancy Narratives of Matthew and Luke: New and Updated Edition.* Anchor Bible Reference Library/Doubleday

Brown, Raymond, E. (1978). *Mary in the New Testament.* Fortress/Paulist Press

Pelikan, Jaroslav (1998). *Mary Through the Centuries: Her Place in the History of Culture.* Yale University Press

Mary Magdalen

Mary Magdalene was a woman who, according to the four canonical gospels, travelled with Jesus as one of his followers and witnessed his crucifixion and resurrection. She is mentioned by name twelve times in the gospels, more than most of the apostles and more than any other woman in the gospels, other than Jesus's family.

Mary Ann Getty-Sullivan says Mary Magdalene is sometimes 'erroneously identified as the *sinner* who anointed Jesus according to Luke's description in Luke 7:36–50. She is at times also confused with Mary of Bethany, the sister of Martha and Lazarus (John 12:1–8)', and is sometimes assumed to be the woman caught in adultery (John 7:53–8:11), though there is nothing in the text to indicate that.

Luke qualifies her as 'one who was healed' but otherwise little is known about her. There is nothing to directly indicate Mary Magdalene was a former prostitute, and some scholars believe she was a woman of means who helped support Jesus and his ministry.

Now that we have cleared up the traditional slurring of Mary's character we can examine why she is important. She is obviously a key character in the immediate period following the death of Jesus and his ascension.

In John 20:1–13, Mary Magdalene sees the risen Jesus alone and he tells her 'Don't touch me, for I have not yet ascended to my father.' Ben Witherington III says John is the only evangelist with a 'keen interest' in portraying women in Jesus' story. Mary Magdalene and the other women go to anoint Jesus' body at the tomb, but find the body has vanished. Mary is inconsolable, but she turns round and Jesus speaks to her. He calls her by name and she recognizes him. Witherington adds that Mary is tasked to tell the disciples of this. 'There is little doubt that John's intent is to show Mary Magdalene as important, perhaps equally important for Jesus' fledgling community as Mother Mary herself.'

MacDonald sees the story of Mary as reflecting a challenge taking place within the Church of the 2nd century. This was a challenge to Mary's role as a woman disciple and to leadership roles for women in general.

The Gospel of Mary is the only surviving apocryphal text named after a woman. It contains information about the role of women in the early church[1]. The text was probably written over a century after the historical Mary Magdalene's death. The text is not attributed to her and its author is anonymous. Instead, it received its title because it is *about* her.[2] Unlike in the Gospel of Thomas, where women can only be saved by becoming men, in the Gospel of Mary, they can be saved just as they are.[3]

Further reading

Acocella, Joan (February 13 & 20, 2006). 'The Saintly Sinner: The Two-Thousand-Year Obsession with Mary Magdalene'. *The New Yorker*

Almond, Philip C. (2023). *Mary Magdalene: A Cultural History.* Cambridge

Brock, Ann Graham (2023). *Mary Magdalene, The First Apostle: The Struggle for Authority.* Cambridge, MA

Ehrman, Bart D. (2004). *Truth and Fiction in The Da Vinci Code: A Historian Reveals What We Really Know about Jesus, Mary Magdalene, and Constantine.* Oxford

Ehrman, Bart D. (2005). *Lost Christianities: The Battles for Scripture and the Faiths We Never Knew.* Oxford

Ehrman, Bart D. (2006). *Peter, Paul, and Mary Magdalene: The Followers of Jesus in History and Legend.* Oxford

Ehrman, Bart D. (2014). *How Jesus Became God: The Exaltation of a Jewish Preacher from Galilee.* New York

Chapter 4

Ancient Greece and Sparta

◇◇◇

Separate and secluded – subject to institutional misogyny

Ancient Greek women were, undeniably for the most part, socially, and sometimes domestically, separate and separated from their male counterparts: they had no formal role or place in public or, with the exception of Sparta, military life. They were political nonentities and cast no votes, their education was minimal and truncated, and their intellectual development or talents were largely suppressed. They exchanged their fathers as guardians on marriage with their husbands – lifelong subservience to a male. Prevailing philosophical beliefs and medical science (written by men although there was many a woman doctor) dictated that they were 'incomplete' versions of men and prone to womanly hysteria. According to the men, their primary role in life was to marry, look after the household, work away at the wool, and produce babies – preferably boys – just like Roman women over the sea would be required to do in Italy.

In the 2nd century CE Soranus of Ephesus, the eminent physician, was still telling people all around the Graeco-Roman world that women marry not for any kind of physical or conjugal pleasure but to produce children. Anything that disrupted this essential and elemental function was actively discouraged by the state and by the men who ran that state, even though it is doubtful that in the discharge of their onerous domestic duties most women would have had time for much else anyway. The only relief from and exception to this social, psychological and physical purdah was the undeniable fact that Greek women and girls did, on the other hand, enjoy an active and public community role in religion: they prepared the bodies of the deceased, attended funerals and tended tombs, they were at the forefront in various festivals and they were priestesses with the privileges those offices brought.

We get an idea of how singular important this religious role was to the Greek woman from Sophocles' *Antigone,* written around 441 BCE. The heroine was prepared to compromise her reputation and die in order to ensure that Polyneices, her brother, received proper funeral rites. The absence or neglect of such rites condemned the deceased to wander aimlessly round the banks of the infernal Styx for eternity; a fate, quite literally, worse than death. A woman's prominent real life role at funerals, burying and mourning their dead relatives, gave her a rare chance to do something important and lasting for their families.

But stereotyping, demoralisation, suppression and marginalising were never very far away and formed an insidious backdrop to one of the supposedly most civilised and civilising civilsations the world has ever seen.

Here are some of the sexist, misogynistic thoughts and opinions of some of the prominent men at the forefront of ancient Greek culture, philosophy and politics:

Aristotle: 'Man is naturally superior to women and so the man should rule and the woman should be ruled'[1].

Demosthenes: 'We keep *hetaerae* for pleasure, female slaves to look after us and wives to give us legitimate children and to take care of our households'[2].

Attributed to Menander: 'A man who teaches a woman how to write should know that he is giving poison to an asp'.[3]

Euripides armed his women characters with these self-deprecating or misogynistic poisoned arrows:

'I am only a woman, a thing which the world hates'[4].

'There is no known antidote for a woman's venom, it is worse than a reptile's. We are a curse to man'[5].

'Sensible men should never let gossiping women visit their wives, for the gossips are up to no good'[6].

Hipponax declared: 'There are two days on which a woman is at her most pleasing: the day when someone marries her, and the day when her husband carries out her dead body'[7].

Hyperides said, 'A woman who goes outside her house should be old enough for people to ask whose mother she is, not whose wife she is'[8].

Most famously and influentially Thucydides has Pericles say in his funeral speech:

Perhaps I should say a word or two on the duties of women to those among you who are now widowed. I can say all I have to say in a short word of advice. Your great glory is not to be inferior to what God made you, and a woman's reputation is highest when men say little about her, be it good or evil.[9]

Referring to women in general and to Helen of Troy in particular, 7th century BCE Semonides of Amorgos says bitterly: 'Yet, this is the worst plague Zeus has made, and he has bound us to them with a fetter that cannot be broken. Because of this some have gone to Hades fighting for a woman'[10].

He cranks up the misogyny with his iambic, satirical *Types of Women*; the premise within these 118 lines is that Zeus created men and women differently, specifically forging ten distinctive types of women based on the world of nature. Here are the ten types, nine of which are repugnant to him and paint a picture of a world half full of repellent women:

- the 'dirty woman' derives from a pig
- the 'cunning woman' originates from a fox
- the 'endlessly curious and high-maintenance woman' comes from a dog; the 'lazy or apathetic woman' is formed from earth or soil
- the 'capricious woman of mood swings' comes from sea water
- the 'stubborn woman' derives from a donkey
- the 'unreliable and uncontrollable woman' comes from a weasel or skunk
- the 'proud woman' comes from a mare
- and the 'worst and ugliest type of woman' comes from an ape or monkey.

The opening stanza gives a taste of the invective:

> In different ways god made the mind of woman in the beginning. He made one from the bristly sow through whose sty everything, caked in mud, lies in dishevelment and rolls on the ground. Filthy and in dirty clothes herself, she sits among the dunghills and grows obese.

The obligatory sexual slur highlighting woman's allegedly insatiable sexual appetite is, of course, there:

> Another was made from a skunk, wretched and baneful. Nothing beautiful, nothing nice about her, nothing pleasant, and nothing sexy, either. But she's mad for the bed and sex, and when he's around, she makes her husband feel sick. She steals from the neighbours and commits every possible evil. She even eats sacrifices that are waiting to be offered.

Only the bee woman is virtuous and has anything to commend her, according to Semonides, but she is, unfortunately, discounted as an impossible ideal. The bee reference echoes Hesiod in the *Theogony*. What a contrast to the other nine – and, as with Pandora, there is a glimmer of hope.

Such unhealthy *leitmotifs* emanated from ingrained stereotypes from the ancient past and went on to insinuate themselves into the male Greek psyche, influencing their thoughts on or about their women in the present and colouring the views of subsequent cultures and civilisations for centuries to come, right up to the 21st century CE. They became the paradigms, the examplars on which male views on women were to persist.

The Homeric epics and their spin-offs in the Homeric Cycle are generally considered to represent the dawn of Western literature, highly influential in many ways and from which much else of worth has since sprung. But some significant women come out of these grandiose works of art very poorly. For example, we have the put down by Telemachus, son of Odysseus, when the ever-patient and dutifully compliant to the norm Penelope tries to intercede with the mob of suitors clamouring after her hand, or more specifically her body. The young son tells the mature mother in no uncertain terms to be quiet and go to her room and get on with

her textiles – as if she was a naughty, precocious girl. Telemachus is insistent that he holds the power in the house of Odysseus, his long-absent father who has spent the last twenty years galavanting around the Aegean enjoying lots of horizontal recreation, and his men the recreational drugs proffered by a strange mystic witchy woman. Helen of Troy is vigorously sexually slurred as if the Trojan War was entirely her fault and the vainglorious heroes had little or nothing to do with it. And then there are the unfortunate slave women, Briseis and Chryseis, caught in the middle of the puerile spat between Agammenon and Achilles. Thankfully, these and other women occupying the Greek pantheon and mythology, have received some restitution in recent years with the much-needed reappraisals by enlightened authors such as Pat Barker, Kate Mosse, Madeline Miller, Margaret Attwood and others.

Soon after, the less well known but equally influential Hesiod piled on the hate through his highly symbolic portrait of the hapless Pandora in the *Works and Days* – the bane of all men for all time. In his depiction of women in the *Theogony* the account of the origin of woman and her character (lines 59–69) is misogynistic in the extreme: to Hesiod women are an eternal punishment and reflect the eternal blame Eve won for herself in the Garden of Eden:

> a bane for mortal men has high-thundering Zeus created women, a coven intent on making life difficult.

It may sound something of a paradox that there are so many women represented in Greek mythology and its expression through Greek drama. Take, for example, Clytemnestra, Antigone, Medea and Medusa – powerful women all, and conceived to bear monumental grudges against men (justified or otherwise) from which, in three cases at least, they achieve closure through terrible slaughter. By creating these tragic stories starring women as murderesses it seems likely the playwrights concerned were, to some extent at least, showing women in their worst possible light to warn men that women power was something to be stamped out:

> For the most part they are portrayed as abusers rather than users of power. They take it illegitimately, in a way that leads to chaos, to the fracture of the state, to death and destruction. They are monstrous hybrids who are not, in the Greek sense, women at all…they must be disempowered and put back in their place[16].

Even on the comic side there is no respite from this propaganda: Aristophanes' *Lysistrata* imagines a fantasy situation in which the women of Athens withdraw sexual favours until the Peloponnesian War is over; redolent with contemporary allusions at the end of the 5th century BCE the women take control of foreign policy and the defence budget but they make such a hash of it all that no man (or woman) would endorse woman power based on this experience.

Altogether a bad start and a bad press for the women of the Greek world, to say the least.

Women in Greek mythology

> Greek myths, early Roman history is configured around violence
> against women, And I think we need to get in there, get our hands
> dirty, face it and see why and how it was.
> – Mary Beard, *Women and Power: A Manifesto* (2018)

The word, *mythos*, originally meant word, speech or message. It later came to denote
a traditional story, particularly one concerning the early history of a people or race,
explaining a natural or social phenomenon, and typically involving supernatural
beings or events. Mythology gives us an important insight into real women in ancient
Greece: strong, inspirational and revolutionary women are represented exceedingly
well in the ancient Greek pantheon. As Dessa Meehan shows in her *Containing the
Kalon Kakon: The Portrayal of Women in Ancient Greek Mythology*[1]:

> In ancient Greece, the portrayal of women in mythology as deceitful,
> manipulative, and the downfall of men corresponded with oppressive
> treatment and forced seclusion, which mirrored Greek patriarchal
> society. Through a discussion of three case studies, the myths of
> Pandora, Aphrodite, and Helen of Troy, this paper argues that the
> depiction of women in Greek mythology perpetuated their treatment
> in society as elite men used these legends as instructions detailing
> the correct way to deal with their female counterparts. Women were
> viewed by men as examples of what would happen if an elite woman
> was given even just a modicum of independence... Texts that were
> often used as educational tools, like [Xenophon's] Oeconomicus
> or Homer's epic poetry, deliver themes of patriarchy and male
> domination that are hard to miss: men were in charge; women were
> always subordinate to their male counterparts.

Poets and playwrights developed mythological characters as potent vehicles by which
to remind their audiences of society's personal situations and experiences. Poetry and
drama gave their audiences pause for thought. Poetry was held in high esteem: no
less an influence and authority than Aristotle (*Poetics* 9, 1451b5-8) taught that it
was more important than historiography because history dealt in the particular while
poetry expatiated on universals: it showed people how their ancestors conducted
themselves – well and not so well – but in so doing provided a road map for
morality – outlining, according to the male population, how people should conduct
themselves. The way in which Greek poets portrayed mythical women has had
timeless consequences and repercussions for women which will continue to prevail
for as long as those poems, plays with their myths are read or performed.

The telling of myths was an important part of a child's education, just as bedtime
stories remain today (Euripides fragment 484 Nauck); the visual arts too reflect
mythology with women in abundance; women exchanged myths with each other while

working the wool, according to Euripides (*Ion* 196f). Essentially, myth was aetiological; it explained to successive generations of Greeks how the world got to be how it was, and, importantly for us, the reason behind the unchallenged supremacy of males in Greek society – a convenient necessity to cope with and restore order after the turmoil created by chaotic Pandora, the world's first woman. Here are some mythological women who broke the mould and operated outside the common norms and paradigms which demanded that women were inferior and were liminal to Greek life.

Gaia and Rhea – *how women put the fear of god in the gods*

Female resentment regarding woman's position in the Greek world starts in the beginning, in the creation myth. Gaia, the Earth goddess, rebels against her husband Ouranos, the Sky, who refuses to allow her children to be free. She orders her son Kronos to castrate his father and usurp him. Once Kronos takes power, however, he becomes obsessed with the fear that he too will be dethroned by his children, so he swallows all the babies his wife Rhea gives birth to.

Rhea recoils from this hideous act. On giving birth to Zeus she presents Kronos with a stone swaddled in a blanket to trick him into thinking that he is going to devour this 'baby' as well. Rhea then hides her child, the god Zeus, who grows up and eventually throws his father down into the depths of Hades. But history repeats itself, and Zeus fears that his wife may plot to overthrow him – he is paranoid in his fear of his wife, who exacts vengeance for all his transgressions, especially his serial adultery.

Hera – *threw her ugly son off Mt Olympus*

Hera is particularly important to us as she is Queen of the gods and the goddess of women, marriage and family; she was wife and sister of Zeus.

Hera was never going to be the ideal mother: having given birth to blacksmith god Hephaestus without any involvement by Zeus in an immaculate conception of sorts, she was so disgusted by Hephaestus' ugliness that she threw him off Mount Olympus; result: his characteristic hobble and limp. Hera went on to produce Hebe after being impregnated by a head of lettuce.

If Hera despised Hephaestus, Hera loathed Heracles, her stepson. When Heracles was still a baby, Hera sent two serpents to kill him as he lay in his cot; Heracles, though, showing signs of things to come, was unphased by this and simply throttled both. The Milky Way was formed when Zeus tricked Hera into nursing Heracles: when she realised who the baby he was she tore him from her breast, and a spurt of her milk projectiled and created the starry smear across the sky that we now know as the Milky Way.

Athena – *peaceful and creative – but what about that badge?*

Athena is something of a paradox: her divine portfolio included wisdom, inspiration, enlightenment, law and justice, mathematics, the arts, crafts, and skill – all peaceful,

all constructive and civilising. Moreover, she was patroness of weaving, that badge of the clichéd, ideal Greek wife, mother and homemaker. However, as goddess of military strategy as well, she takes credit, as Athena Hippeia, for inventing the war chariot, and was patroness of the metals used for weaponry, thus adding a bellicose aspect to her *currulum vitae*. Indeed, when Athena was born from Zeus' head, not only was she already fully grown, but she emerged wearing a full suit of armour. As Athena Promachos she was Athena 'who fights from the front'. When her attempts at diplomacy to prevent the Trojan war failed, she was on the side of the Greeks giving sound advice and encouragement, especially to Achilles; she saved Menelaos from the arrow of Pandaros, and diverted the spear of Diomedes to injure Ares.

The mighty bronze Athena Promachos statue fashioned by Pheidias from the Persian spoils at the battle of Marathon showed Athena standing with her shield resting upright against her leg, and a spear in her right hand; it towered between the Propylaea and the Parthenon on the Acropolis, a highly visible symbol of female belligerence at odds with the pacifist image noted above.

In contrast, however, to her more violent, blood-crazed brother, Ares, Athena showed a more considered and analytical attitude to war in her role as a military woman. Conflict and war were perhaps last options for Athena, deployed only when all diplomacy had proved unsuccessful, but that fails to explain Athena's wearing of a powerful badge centrally affixed on many depictions of her in her body armour. This shows the head of Medusa – a symbol of the angry, vengeful and terrifying woman. She is, through her various sculptors, discreetly but powerfully warning men to come near at their own peril: women are deceitful, dangerous and to be avoided at all costs.

Pandora – *all gifts to all men*

Pandora epitomises the ingrained misogyny which characterises the typical attitude of the Greek man to the Greek woman. Nevertheless, she was, in an oblique way, a powerful woman. As noted, right from the start Greek women suffered a bad press amongst the writing classes: women were just so much trouble, in mythology and in life. According to Hesiod, Greece's first woman, Pandora, was the embodiment of everything to dislike in a human being and she represented the penalty mankind had to pay because he had made the fatal and hubristic mistake of learning from Prometheus the secret of producing fire.

Pandora was fashioned out of the earth by Hephaestus, by command of Zeus; other gods and goddesses contributed all the other unhealthy physical attributes and characteristics of women traditionally loathed and feared by insecure and paranoid Greek men: seductive, dishonest, duplicitous, dangerous and manipulative. Confusingly, what you could see before your eyes was a truly beautiful woman, making Pandora irresistible to every man. On the other hand, it was, however, the invisible and inconspicuous features donated by the Olympian gods which allegedly constituted her true personality: these would bring endless grief, injury,

harm and much trouble to man[1]. Pandora also enjoys the dubious reputation for being one of the world's earliest scapegoats.

> Prometheus, surpassing all in cunning, you are glad that you have outwitted me and stolen fire – a great plague on you and to all future men. But for the price for fire I will give men an evil thing in which they may all be glad of heart while they embrace their own destruction.
> [Translation adapted from Evelyn-White, H.G. (1914).
> *Hesiod, Works and Days*. Cambridge, MA. 55ff]

Zeus mocks man's hubris:

> So said the father of men and gods, and guffawed. And he told famous Hephaestus to hurry up and mix earth with water and to put in it the voice and strength of human kind, and fashion a sweet, lovely maiden-shape, like an immortal goddesses to look at; and Athena to teach her needlework and weaving; and golden Aphrodite to shed grace upon her head and cruel longing and cares that weary the limbs. And he charged Hermes... to put in her a shameless mind and a deceitful nature...Athena girded and clothed her, and the divine Graces and queenly Persuasion adorned her with gold necklaces, and the rich-haired Hours crowned her head with spring flowers. And Pallas Athena bedecked her form with all manner of finery. Also Hermes gave her lies and crafty words and a deceitful nature ...the Herald of the gods put speech in her. And he called this woman Pandora, because all the Olympians gave a gift, a plague to men. [59ff].

Pandora: all gifts to all men.

Up until now all had been going quite well on earth and with man, but when Pandora undid the lid of the fateful jar given to her by Zeus she became the undoing of man:

> the tribes of men lived on earth remote and free from ills and hard toil and heavy sicknesses which bring the Fates upon men; for in misery men grow old quickly. But the woman took off the great lid of the jar with her hands and scattered the contents, all these and her thought caused sorrow and mischief to men. Only Hope remained there in an unbreakable home under the rim of the great jar... But the rest, countless plagues, wander amongst men; for earth is [now] full of evils, and the sea is full. Of themselves diseases come upon men continually by day and by night, bringing stealthy mischief to mortals.

With an air of weary resignation, Hesiod spoke for generations of Greek men when he concluded that 'men could not live with [women] and could not live without them'. Hesiod, apart from echoing the sentiments of his contemporary menfolk, influenced successive generations of men against women – projecting prejudice,

46

discrimination, misogyny, fear and distrust into one half of the population against the other. By opening that fateful jar, Pandora had taken the lid off the bad things in life; she had slammed the door on the Golden Age, brought a close to the good old days and ushered in a world which from now on was going to be much harder work. And whose fault was it? It was woman's fault. Before women arrived on the scene, everything was just fine. But the 'grim cares of mankind' were now in plain sight: all men could do now was hope against hope.

Bad news all round forever then for men... So much for woman's debut on the Greek stage.

The Fates – *'Weaver of life, let me look and see The pattern of my life gone by, Shown on your tapestry'.*

The Fates are usually depicted as a dreadful trinity – white-robed weavers of a tapestry on a loom, with the tapestry pronouncing the unalterable life span from birth to death of all men and women. Known also as the Moirae, they were Clotho (spinner), Lachesis (allocator) and Atropos (unturnable). Gods and mortals alike bowed to them according to Hesiod in the *Theogony* (221–5). Plato in his *Republic* (617c) says Lachesis sings the things that were, Clotho the things that are, and Atropos the things that are to be. Upset them at your peril.

Clotho spun the thread of life from her distaff onto her spindle. Lachesis, the drawer of lots, measured out the thread of life allotted to each person with her measuring rod. Atropos, 'inexorable' or 'inevitable', was the cutter of the thread of life. She chose how each person died; when their time was come, she cut their life-thread with what Milton called her 'abhorred shears', confusing her with that other fearsome cabal, the Furies:

> Comes the blind Fury with th'abhorred shears, / And slits the thin spun life.
>
> – John Milton, *Lycidas*, l. 75

As an indication of the enduring nature of the the Moirae and their life-work, they caught the imagination of various composers in the late 1960s and early 1970s. *The Three Fates* is a three-part 'pseudo suite' written and performed by Keith Emerson (Emerson, Lake and Palmer). It comprises three movements, one for each of the three Fates. Roger Chapman (of the band Family from the 1970s) caught the essence of the Moirae in his 'The Weaver's Answer':

> Weaver of life, let me look and see
> The pattern of my life gone by,
> Shown on your tapestry.
> Just for one second, one glance upon your loom
> The flower of my childhood could appear within this room...
> After days of wondering I see the reason why.
> You kept it to this minute, for I'm about to die.

The Lemnian Women I – *foul smelling patricides and viricides*

Apollodorus (1, 9, 17) gives us an explanation why Lemnos was, quite unusually, ruled by women:

> Led by Jason, the Argonauts first sailed to Lemnos, then totally devoid of men and ruled by Hypsipyle, daughter of Thoas. This state of affairs came about as follows: the women of Lemnos had neglected the cult of Aphrodite. As a punishment, the goddess afflicted them by causing them to give off a foul smell. The men found this repellent and took up with captive women from nearby Thrace. The Lemnian women were outraged at this humiliation and proceeded to murder their fathers and husbands. But not so Hypsipyle: she hid her father, Thoas, and spared him. The Argonauts, notwithstanding the smell, slept with the Lemnian women with Hypsipyle sharing Jason's bed.

Somewhat earlier, Apollonius of Rhodes in the 3rd century BCE, told us this is in his *The Voyage of the Argo* (1, 625 ff.), begging the question, no doubt inadvertently, who needs men anway?

> The Lemnian women found it easier to look after cattle, put on a suit of bronze, and plough the earth for corn rather than to devote themselves, as they had done before, to the tasks of which Athene is the patroness [handicraft and spinning]. Nevertheless, they lived in dire dread of the Thracians ... so when they saw the Argo rowing up to the island, they immediately got ready for war... Hypsipyle joined them, dressed in her father Thoas' armour.

She advised conciliation and provisioning the Thracians on their ships to keep them at bay. Elderly Polyxo spoke next with the wisdom and foresight that only comes from age and experience:

> ... The next to get up was her dear nurse Polyxo, an aged woman tottering on withered feet and leaning on a staff, but nonetheless determined to be heard... "Hypsipyle is right. We must accommodate these strangers ... there are many troubles worse than war that you will have to meet as time goes on. When the older ones among us have died off, how are you younger women, without children, going to face the miseries of age? Will the oxen yoke themselves? Will they go out into the fields and drag the plowshare through the stubborn fallow? Will they watch the changing seasons and reap at the right time?"

We meet the Lemnian women again in the section on Roman women.

Penelope – *ever patient in full knowledge of her errant husband's multiple adultery*

In Homer's *Odyssey*, ever-patient Penelope, dutiful wife of peripatetic, philandering Odysseus, represented the ideal Greek wife and woman. Circe, Calypso and Charybdis, her co-stars, on the other hand, were anathema to Greek men: they were seductive, duplicitous, witchy and dangerous. Likewise Clytemnestra, Electra, Antigone, Ismene, Deianeira, Iocasta, Medea, Alcestis, Phaedra, Iphigenia, Creusa, Hecuba, Andromache and Helen – all were seen as reflections, types of 'living Athenian women', good, bad and worse than bad. The way that they are drawn by the various dramatists and the roles they play tell us unequivocally that misogyny, male insecurity and paranoia were very much alive and well on the story boards and stages of Greek theatres. But the important thing to note is that, despite in the theatre being played by men, the women's parts were written in the first place, essential, integral and crucial roles in Greek epic, comedy and tragedy.

As far as real world marriage went, the inescapable onus was largely on the woman to make the marriage work, by always pleasing her husband in every way. There is little suggestion that the man has any responsibility in sustaining the relationship; if things fail to work out then the implication is that the woman is wholly to blame. Penelope, perfect as she was, was of course wedded in a one-sided marriage: while Odysseus was gadding about for ten years trying, half-heartedly, to reach home via the beds of Circe and Calypso, she was working the wool, running the house, raising Telemachus and discouraging a stream of obnoxious suitors with rival claims to her bed and body[1].

When Odysseus finally does reach home he wastes no time in getting Penelope into that bed. Here the pillow talk reveals her constancy and fidelity, in stark contrast to his confessed serial adultery, adultery which is accepted and tolerated, expected even, by Penelope, the model wife. Interestingly, the dalliance with Nausicaa is never mentioned. The double standard is hardly surprising coming from a man who advises duplicity: 'never be too kind to your wife or tell her all of your plans, however well you know them; tell her only a bit and conceal the rest' – disingenuous and dishonest by our standards and insensitive to the doubt relating to paternity that such permissiveness might engender: Telemachus asserts that 'my mother says that I am the son of Odysseus, but I don't know. No one can know his own seed by himself'. The suggestion is that such doubts were commonplace and maybe not freighted with the psychological and social consequences they can have today. In the *Iliad*, Agamemnon too advises a surreptitious approach: 'bring your ships back to your homeland in secret and not openly: you can never trust a woman'. He was right in his own case to be cautious...

Penelope is one of the many female victims of the war, all either waiting patiently like her, or widowed; she is destined to suffer anxiously at home, besieged herself by unsuitable suitors and working her wifely wool while crafty

Odysseus enjoyed ten years of tourism and horizontal collaboration with some of those witchy epic women.

Further reading
Zerba, M. (2009). 'What Penelope Knew: Doubt and Scepticism in the "Odyssey".'
 The Classical Quarterly, 59 (2): 295–316

Circe – *the ultimate witchy woman*

Magic was all around the Greek and Roman worlds. An example of Greek magic comes in the *Odyssey* when the hero meets Circe, a witchy kind of a woman, and one of the women with whom Odysseus takes time out from his journey home to wife Penelope and son Telemachus. Circe transforms Odysseus' crew into pigs with a wave of a wand and a potion; Odysseus himself is immune, because Mercury has presribed him *moly*, a snowdrop type of flower with protective and mystical properties[1]. Odysseus, be that as it may, nevertheless does succumb to Circe's considerable physical charms and the two embark on an affair during which she provides some useful information about the future, not least Odysseus' forthcoming appointment with the dead in his necromancy.

Circe is a *pharmakis* or *pharmakeutrika;* she is *polu pharmakos* and she uses *pharmaka,* and there lies the close tripartite association of drugs, spells and medicine in the ancient world. The Circe episode contains many of the elements of classical period magic and black arts: magical dexterity and occult accoutrements, weird mind-altering plants, witches, underworld divine intervention and eschatology. Over the next 500 to 600 years these motifs were developed and expanded on in Greek literature, religion, philosophy and science; they began to bind themselves to Roman culture and society and to appear in Roman literature.

Circe, aunt of Medea and daughter of Hecate as well as being sister of Pasiphaë, the wife of King Minos and mother of the Minotaur, was unsurprisingly taken to be the archetype of the predatory female. In the eyes of those from a later age, this behaviour made her notorious both as a magician and as a type of sexually permissive woman. She has been frequently depicted as such in all the arts from the Renaissance down to modern times. She, along with Erichtho (see below), is the paragon of the magical, the paradigm of shape-shifting, moon-disorbiting crazy women.

Helen of Troy – *'Was this the face that launch'd a thousand ships / And burnt the topless towers of Ilium?'*

Helen is an ambivalent figure, thanks to the contradictory sources. She has previous for running away with strange men in her elopement with Theseus when just twelve years old. Helen became embroiled in the Trojan war when Paris decided that Aphrodite (and not Hera or Athena) was the fairest goddess of them all, thus winning

for himself the prize of the most beautiful woman in the world – all this at the world-changing Judgement of Paris. The winning suitor was King Menelaus of Sparta who duly married Helen, beating off such peerless contenders as Odysseus, Menestheus, Ajax the Great, Patroclus, and Idomeneus. The victory came after the drawing of straws and a deal in which Odysseus secured not just an agreement in which all the suitors swore a solemn oath to defend the successful husband in any future dispute or complications with military force if necessary – the Oath of Tyndareus[1].

Homer is sympathetic to Helen up to a point, portraying her as sadly remorseful and regretting her precipitate actions. What has never been in doubt, though, is her manifest beauty, so well described in Christopher Marlowe's lines in his tragedy *Doctor Faustus* (1604): 'Was this the face that launch'd a thousand ships / And burnt the topless towers of Ilium?'

But it was not to be a happy marriage: while Menelaus was out of town attending a funeral, Helen fled to Troy with Paris, despite brother Hector's protestations, causing the Oath of Tyndareus to be invoked and a fleet of 1,000 ships to be launched in retaliation. The Trojan War had begun.

Helen assumes a prominent role in the progress of the war when, at the Skaian Gate, the very epicentre of the battle, she discusses how things are going with Priam and some other wise elders. Priam absolves her of any blame for the conflict and asks her to provide military intelligence regarding some of her ex-kinsmen, notably Agamemnon. She obliges, but not before wishing herself dead for causing so much trouble. One of the elders, Antenor, confirms the accuracy of her information, so validating her as a viable and reliable source of intelligence. Death, however, eluded her so she spent her time 'pining away, weeping'.

Homer adumbrates Helen's take on life as a military wife when he makes it clear that Helen, in her time with Menelaus, had been trapped in a loveless marriage and that Paris presented an opportunity for her to live a more settled married life. She explains to Paris that, while appreciative of Menelaus' prowess as a warrior, she had little interest in army life or in being an army wife – no more heroes for Helen. Helen wanted to grow old with Paris: every day she spent with bellicose Menelaus made her want to walk into the sea and end it all. Moreover, she confides in Hector that 'I can't ask anyone to fight for me; I am no longer queen of Sparta', thus parading the loss of self-esteem and guilt she now feels for being the one person responsible for the bloody regional conflict that was the Trojan War.

Helen comes out of the fall of Troy very badly: both Homer, and Virgil after him, paint a picture of a woman now shacked up with a Trojan warrior and so duplicitously and cruelly assisting the Greek military offensive. In the *Odyssey*, Homer describes how Helen circled the Trojan Horse three times, cruelly and maliciously imitating the voices of the Greek war wives left waiting anxiously at home and putting the men inside, which included Odysseus and Menelaus, through emotional agony as they envisaged their loved ones and their predicament. Helen effectively drove them to the brink of death: they had to be restrained by Odysseus from bursting out of the horse to certain massacre. In Virgil's *Aeneid*, Deiphobus recounts Helen's treachery: he tells a shocked Aeneas in the *katabasis* how, when the Trojan Horse was admitted into the city, she was at the head of a chorus of Trojan women feigning Bacchic rites,

and brandishing a torch from the citadel – the signal the Greeks were waiting for to launch their deadly attack[2].

Paris died later in the war and Deiphobus, his younger brother, married Helen, only to be slain by Menelaus during the sack of Troy when Helen, again acting treacherously as a fifth columnist, hid his sword and rendered him easy prey[3]. Virgil's graphic description of Deiphobus' mutilation serves only to magnify the enormity of Helen's crime, both as wife and as belligerent traitor to country:

> Priam's son, his body slashed to bits, can now be seen – his face mangled, his face and hands covered in blood, his head shockingly shorn of ears and nose. Aeneas could barely recognise this shivering shade as Deiphobus'; it struggled to hide its face and the scar of shame.

Indeed, Deiphobus is unequivocal about Helen's crime, in harsh words replete with and redolent of deceit and dishonour visited on him:

> This was my fate [*fata*], and that Spartan woman's murderous crime [*scelus exitiale*] to mire me in this mess [*his mersere malis*] – these are the souvenirs she has left me with. We spent that final night in false [*falsa*] joy... when the deadly [*fatalis*] horse leaped into impregnable [*ardua*] Pergamon, pregnant with infantry armed to the teeth; she led the Phrygian women in choral dance and false [*simulans*] Bacchanalean song.

In the aftermath of the fall of Troy, the double-dealing Helen is reduced to a cowering wreck, desperate to save her skin, deploying her most potent weapons – her beauty and sexuality. Sources differ on the exact details surrounding the reunion of Helen and Menelaus after the fall: one version has it that an angry Menelaus resolved to kill Helen himself but when he finds her and raises his sword he takes pity on her as she weeps, begging for her life. Menelaus' fury evaporates and he takes her back as wife. Another has Menelaus, again intent on slaying her, captivated by her beauty and sparing her life; he takes her back to his ship 'to punish her at Sparta'.[5]

The *Bibliotheca* (pseudo-Apollodorus), tells us that Menelaus raised his sword in front of the temple in Troy but his anger melted when she tore her clothes and revealed her breasts[6]. Stesichorus (*c.* 640 – 555 BCE), in his *The Sack of Troy,* reports that Menelaus gives her up to his soldiers so that they could stone her to death[7]; however, so stunned were they by her beauty when she ripped open her clothes, that the warriors dropped the stones from their hands, all agog.

Whatever happened to her, Helen remains for us a key player in the cause, progress and aftermath of the Trojan War. Indeed, things could have been much worse than events at Troy – she could have shared responsibility for igniting another much more serious war, the war to end all wars: according to Hesiod, Zeus planned to exterminate the race of men and heroes altogether and was going to use the Trojan war – triggered by the elopement of Helen – as the catalyst for this apocalyptic cataclysm.

The Amazons – *the epitome of woman warriors*

We are armed with the bow and javelin and we ride horses. We know absolutely nothing about women's work.
 – Herodotus 4, 114, 3 citing the Amazons' mission statement

Mention fighting women in the classical world and many people immediately think of the Amazons: they are the best known female wagers of war in classical mythology. However, the only sure thing that can be said about the Amazons is that nothing much about them can be said for sure. Much concerning the Amazons remains mired in controversy or shrouded in speculation, but the following shows what we can deduce with some confidence from the mythology, mindful at the same time that Amazons were not the classical world's only woman combatants.

 The Amazons (Ἀμαζόνες) were redoubtable woman warriors who commanded respect from their enemies. Herodotus believed them to be related to the Scythians and located them vaguely between Scythia and Sarmatia, roughly modern Ukraine[1]. Herodotus first mentions their capital Themiscyra, which Pliny locates near the Terme[2]. Wherever they were or wherever they came from, the important fact remains, in the words of Peter Walcott,

> Wherever the Amazons are located by the Greeks ... it is always beyond the confines of the civilized world. The Amazons exist outside the range of normal human experience.

They are then, strange, liminal and not normal. This is Hippocrates' description of the origins of the Amazons:

> And in Europe is a Scythian race, living around Lake Maeotis, which is different from the other races. Their name is Sauromatae. Their women, when they are still virgins, ride, shoot, throw the javelin on horseback, and fight with their enemies. They do not surrender their virginity until they have killed three of their enemies, and they do not marry before they have performed the traditional sacred rites. A woman who takes a husband no longer rides, unless she is compelled to do so by a general expedition[3].

How this came about is explained by Herodotus when he tells that the Sarmatians were descendants of Amazons and Scythians, and that their wives observed their ancient maternal customs, 'frequently hunting on horseback with their husbands; in war taking the field; and wearing the very same dress as the men'. He goes on to say how a group of Amazons was blown across the Maeotian Lake (the Sea of Azov) into Scythia (today's southeastern Crimea). They mastered the Scythian language and agreed to marry Scythian men, on the condition that they would not be required to follow the customs of Scythian women[4]. Dreaded domesticity springs to mind.

Despite their pugnacity, Scythian women were indubitably human, with human needs. Herodotus (4, 1–4) tells us how the Scythian men came home after a long campaign fighting the Cimmerians and the 'empire of the Medes'; but when they arrived home, they were confronted by another Scythian 'army'. Due to the lengthy absence of their men, the wives had been having sexual relations with the slaves; a battle between the offspring of the slaves and the original Scythians ensued in which the Scythians cleverly exchanged their weapons for whips: the slaves fled – an early example of psychological warfare. Later Herodotus explains how the Sauromates came about (4, 110–1): the Amazons escaped from the Athenians and ended up in Scythian territory where the Scythians mistook the Amazons for men and attacked them; it was only when they were examining the corpses that they realised that their enemy had, in fact, been women. They decided then not to fight them; sexual relations began and the Sauromates race was born.

Lysias, the 5th century Attic orator, describes the Amazons as the only women to wear iron armour and the first to ride horses; he adds 'they were seen as males because of their courage rather than females because of their nature' – an early instance of courage being seen as an exclusively male characteristic.

The most famous Amazons were undoubtedly Penthesilea, who served in the Trojan War, and her sister Hippolyta, whose magic belt, given to her by her father, Ares, god of war, constituted the ninth of the labours which exercised Hercules. Hippolyta was the founding queen of the Amazons; aptly for women very much at home on horseback, her name means 'unbridled mare'. So prominent were the Amazons in the Greek psyche, and powerful on the field of battle that the Greeks coined a word for conflict with Amazons – *amazonomachy*; their name has become a byword for female warriors in general. Their obvious battlefield skills apart, Amazons were great colonists and civilisers: they are said to have founded many cities, including Smyrna, Paphos, Ephesus and Magnesia; as natural horse-born fighters they are also credited with inventing cavalry.

The etymology of the word Amazon is disputed to this day: it may derive from a Greek word meaning 'without men or husbands'; alternatively, it is from ἀ- and μαζός, 'without breast', reflecting an aetiological tradition that Amazons cut off their right breast to facilitate their archery. Greek art does not support this, as Amazons are always depicted with both breasts intact. Hippocrates, though, is adamant[5]:

> They have no right breasts...for while they are still babies their mothers make red-hot a bronze instrument constructed for this very purpose and apply it to the right breast and cauterize it, so that it stops growing, and all its strength and mass are diverted up to the right shoulder and right arm.

Justin agrees 800 years later[6]:

> They exercised the virgins on weapon-wielding, horse-riding and hunting, and burned the children's right breasts, so that arrow-shooting wouldn't be impeded; and for such reason, they were called Amazons.

The 'right mastectomy theory' may have just been made up by men to deter women from taking up archery; whatever, women are of course perfectly capable of loosing an arrow with both breasts intact. The word may well be derived from *hamazakaran*, 'to make war', in Persian.

If the Amazons spurned men and they were 'really killers of men' (*androktones*), as Herodotus would have us believe, how then did their race survive? Apparently, once a year, the Amazons called on the neighbouring Gargareans and had sex with their men, for purposes of procreation. According to Hellanicus, any resulting male children were – in a reversal of Greek practice – either killed, sent back to their fathers or exposed; the girls, however, were retained and raised by their mothers with training in agriculture, hunting, and combat. Others explain the survival of the race by asserting that when the Amazons went to war they would spare some of the men they defeated and take them as sex slaves, having sex with them to produce the girls they needed to sustain the race[7].

Attempts to establish a historicity for the Amazons have been, and are, ceaseless. They are also rather pointless since their existence is quite probably a fabrication by the Greeks, sustained after them by the Romans, to create a race of women as a metaphor to illustrate the existential disadvantages of a world run by women and, indeed, to save the world from such a dystopia.

Penthesilea – *vowing to kill Achilles*

When Penthesilea, daughter of war god Ares, accidentally killed Hippolyta in a deer hunting accident, it foreshadowed Penthesilea's own death at the hands of Achilles[8]. Penthesilea was so distraught at this unintended sororicide that she wished only for death – but she had a problem. Being an Amazon, the only fitting way to die was to do so with honour and in battle. According to Quintus Smyrnaeus' *Posthomerica,* she saw the Trojan war as an opportunity to achieve this end and enthusiastically joined in on the side of Troy, vowing, somewhat overconfidently perhaps, to slay Achilles. Her military exploits were already widely famous, not least because of her much later appearance on the doors of the temple of Juno: Aeneas was as transfixed by her fierce combat skills, equal to any man's, as he was by her exposed naked breast; Penthesilea, like Camilla, was a *bellatrix*, a woman of war.

She arrived in Troy with twelve Amazon comrades, but the omens were not good[9]: Priam saw an eagle holding a dove, a sure sign that Penthesilea would soon die; Theano, priestess of Athena, argued that to fight would be suicidal, but Penthesilea carried on regardless. Achilles killed Penthesilea by impaling her and her horse with a single blow to her breastplate, knocking her to the ground; she begged for mercy but Achilles was unmoved, slew her, and scoffed over her corpse – until, that is, he removed her helmet and gazed on her beauty. It was at this point that he felt remorse for what he had done and realised that rather than kill her he should perhaps have married her.

The conflict between Achilles and Penthesilea is covered in the fragmentary *Aethiopis* written in the 7th century BCE. The death of Penthesilea was, according to Diodorus Siculus, the beginning of the end for the Amazons:

> Now they say that Penthesilea was the last of the Amazons to win distinction for bravery and that in the future the race diminished more and more and then expired; consequently in later times, whenever any writers recount their prowess, men consider the ancient stories about the Amazons to be pure fiction.[10]

Pseudo-Apollodorus in the *Bibliotheca*[11] says that Achilles, 'fell in love with the Amazon after her death and slew Thersites for mocking him about it'; in the early Roman empire Propertius, the elegiac poet, supports this notion[12] as does Pausanias, who describes the throne of Zeus at Olympia on which Panaenus' painted image shows the dying Penthesilea expiring and being supported by Achilles[13]. Thersites' cousin Diomedes was furious at Achilles for slaying the Amazon so he harnessed Penthesilea's corpse behind his chariot, dragged it and dumped it into the River Scamander. Someone, either Achilles or the Trojans, retrieved the body and gave it a proper burial.

Robert Graves has an interesting take on the incident in his *Penthesileia*:

> Penthesileia, dead of profuse wounds,
> Was despoiled of her arms by Prince Achilles
> Who, for love of that fierce white naked corpse,
> Necrophily on her committed
> In the public view.
>
> Some gasped, some groaned, some bawled their indignation,
> Achilles nothing cared, distraught by grief,
> But suddenly caught Thersites' obscene snigger
> And with one vengeful buffet to the jaw
> Dashed out his life.
>
> This was a fury few might understand,
> Yet Penthesileia, hailed by Prince Achilles
> On the Elysian plain, paused to thank him
> For avenging her insulted womanhood With sacrifice.

According to a lost poem by Stesichorus, Penthesilea killed Hector.

By and large, the Amazons received a good press when it came to assessments of their martial capabilities: when no less an authority than Priam related his earlier war experiences to Helen of Troy he, significantly in the sorry history of men's assessments of women's military prowess, concedes that the Amazons are the equal of men:

> Once before I visited Phrygia of the vineyards ... and I myself, a helper in war, was marshalled among them on that day when the Amazon women came, men's equals.

The 1st century Greek historian Diodorus describes their alien *modus vivendi*, showing that what few men and boys there were in the Amazon world had a distinctly hard time of it, swapping traditional female roles and mutilating them[4]:

> but to the men she assigned the spinning of wool and such other domestic duties as belong to women. Laws were also established by her, by virtue of which she led forth the women to the contests of war, but upon the men she fastened humiliation and slavery. And as for their children, they mutilated both the legs and the arms of the males, incapacitating them in this way for the demands of war.

Penthesilea comes in for special praise:

> In general, this queen was remarkable for her intelligence and ability as a general, and she founded a great city named Themiscyra at the mouth of the Thermodon river and built there a famous palace; furthermore, in her campaigns she devoted much attention to military discipline and at the outset subdued all her neighbours as far as the Tanaïs river ... and fighting brilliantly in a certain battle she ended her life heroically.

Her daughter, Artemis, carried on the fine Amazon tradition: training – 'she exercised in the chase the maidens from their earliest girlhood and drilled them daily in the arts of war' – and conquering as far as Thrace 'and subdued a large part of Asia and extended her power as far as Syria'. Some 200 years later Justin more or less endorses this.

Further reading
Chrystal, Paul (2017). *Women at War in the Classical World.* Stroud
Chrystal, Paul (2020). *War in Greek Mythology.* Barnsley
Chrystal, Paul (2020). *War in Roman Myth & Legend.* Barnsley
Mayor, Adrienne (2014). *The Amazons: Lives and Legends of Warrior Women across the Ancient World.* Princeton
Wilde, Lyn Webster (2000). *On the trail of the women warriors: The Amazons in myth and history.* London

Medusa – *don't look now!*

One of the three terrifying Gorgons, Medusa represents evil incarnate, a feminist symbol of female rage[1]. She, as Mary Beard points out, is another of those metaphors, created by influential men in Greece, to petrify (literally) god-fearing citizens into sticking with the status quo and rejecting any possibility of a woman led world[2]. As such, Medusa, like the Amazons, is an accidental advocate of the rule of men and a symbol of the lengths men would go to marginalise and suppress women.

Perseus slew her with a clever smoke and mirrors ploy to swerve round any need to look directly at her, the price of which gaze was immediate petrification,

even in death. The iconic image of her, as perpetuated throughout Western art, is as a mutilated, snake-writhing decapitated head triumphantly and fearsomely offered to anyone who dared look by a victorious Perseus.

The message is 'this is what happens when women assume power; thank God for Perseus and heroes like him'.

The appropriation of horrific images and epithets of Medusa has continued into the 21st century with malicious photoshopped pictures of Angela Merkel and Hillary Clinton superimposed onto Caravaggio's painting which depicts his own head in place of Medusa's. The former British Home Secretary Theresa May, former Prime Minister, was libelously rechristened the 'Medusa of Maidenhead' in a description published in the *Police Federation Magazine*.

Further reading
Garber, Marjorie (2003). *The Medusa Reader*. London
Walker, Barbara G. (1996). *The Women's Encyclopedia of Myths & Secrets*. New Jersey NY
Wilk, Stephen (2000). *Medusa: Solving the Mystery of the Gorgon*. New York

Myrina – *a builder of cities*

Another queen of the Amazons; Myrina not only showcases the military capabilities of the Amazons but demonstrates for us what great builders, town planners and civilisers the Amazons were. Her tomb in Troad is mentioned in the *Iliad* and according to Diodorus Siculus[1] she led a military expedition in Libya and was victorious over the Atlantians, laying waste their city, Cerne. Myrina was not so successful fighting the nearby Gorgons, failing to burn down their forests. She struck a peace treaty with Horus of Egypt, conquered the Syrians, the Arabians, and the Cilicians. She subdued Greater Phrygia, from the Taurus Mountains to the Caicus River, and several Aegean islands, including Lesbos; she discovered a previously uninhabited island which she named Samothrace, building a temple there and went on to found the cities of Myrina in Lemnos[2], another Myrina in Mysia, Mytilene, Cyme, Pitane and Priene[3]. Myrina died when her army was eventually defeated by Mopsus the Thracian and Sipylus the Scythian.

Greek tragedy and comedy

Greek mythology, of course, is inseparable from Greek epic poetry, tragedy and comedy.

Women loom large in Greek tragedy, for good or ill. Speaking generally, Sophocles (echoing Thucydides) in the *Ajax* (293), asserts that 'silence is a woman's glory', and then goes on, with Aeschylus and Euripides, to endow them with some of the greatest speaking parts in the history of Western drama.

Given that Greek drama was written by men for a predominantly male audience with male actors playing female parts, it is interesting to see Spyros Syropoulos point out:

> it is also a fact that dramatic convention allows theatrical women more freedom than what women enjoy in reality... it seems that female characters often have the chance to oppose counter-arguments against all that men charge them with and even blame men for their misfortunes[1].

This is what is important; this is what tells us that there was a school of thought amongst some men that women after all had their advantages, that their views were worth considering and that they deserved a voice.

Whatever, it remains a fact that the preponderance of women in the very public forum that is the *dramatis personae* of Athenian theatre is something of a paradox. Of the surviving thirty-two tragedies only one has no female characters: Sophocles' *Philoctetes*. Tragic choruses made up of women also outnumber male choruses twenty-one to ten. If women were that secluded, marginalised and unappreciated in the real world would they really have been the centre of so much attention, spotlighted to such an extent by tragedians and comedians for their audiences? A fascination for and mystery surrounding women intentionally closeted away cannot alone explain the Greek woman's starring role on the stage, nor her elevation there by Greek men; nor can it explain how and why woman made good crowd-pleasing material to satisfy the largely male gaze as the audiences continued to file in to the theatres year-on-year. Clearly, there was a body of opinion amongst influential men – and not just playwrights – that believed it important to showcase the whole range of universal human experience including fear, sorrow and rejection, and to do that they needed to cast women, give them a platform and lend them a powerful voice.

Antigone – *burying her brother at all costs*

While Helen exuded deceit and death, other Homeric women are the complete opposite: paragons of virtue, fidelity and constancy. The pathos in Andromache's lament as she prepares to part with her battlefield bound husband Hector is palpable in Pope's translation and clearly delineates the family values she holds so dear:

> Yet while my Hector still survives, I see my father, mother, brethren, all, in thee. Alas! my parents, brothers, kindred, all, once more will perish if my Hector falls. Your wife, your child, in your danger share; Oh prove a husband's and a father's care!

We get an idea of how singularly important the religious role was to the Greek woman from Sophocles' *Antigone,* written around 441 BCE. The heroine was

prepared to compromise her reputation and die in order to ensure that Polyneices, her brother, received proper funeral rites. As we have noted, the absence or neglect of such rites condemned the deceased to wander aimlessly round the banks of the infernal Styx for eternity; a fate, quite literally, worse than death. When Creon forbids the burial of Polyneices, he is denying Antigone the chance to do one of the few important things society allowed women to do. He is negating her and her role in life, and that is why she opposes him.

Andromache – *devoted wife, and military advisor*

Andromache's fame lies not just in being the devoted wife of Hector and loving mother of their son, Astyanax. She shrewdly uses a lesson in military strategy in an attempt to protect Hector from the worst dangers of the war raging around them.

She, like Penelope, was one of the thousands of army wives who waited patiently for her returning hero, buoyed up by hope and by an enduring love. Tragically, Andromache was about to welcome her hero home, ensconced in domestic security, when she was floored by the dreaded news that he had just been killed:

> She was at work in an inner room of the lofty palace, weaving a double-width purple tapestry, with a multi-coloured pattern of flowers. Totally unaware [of Hector's fate] she had asked her maids to set a great cauldron on the fire so that Hector would have hot water for a bath when he got back…

Andromache's tragic story began when Thebes, her home city, was sacked by Achilles, and her father and seven brothers died in the ensuing carnage. Her mother then succumbed to an illness and Andromache became just another piece of collateral damage and one of the countless spoils of war. But Hector had then come along to provide stability and love in a life rent asunder by conflict[1]. All the more bitter then is the tragedy when Andromache's life is ripped apart again at Troy: Achilles killed Hector – leaving her once again bereft, rootless and alone in the world, a displaced person relegated to the margins of society and a pathetic emblem of the fate that so often awaits conquered women in warfare[2].

Hector had foreseen all of this, the writing was on the walls of Troy: he bewailed the certain fact that Andromache would be forced into slavery – weaving at another woman's whim, fetching the water as a slave and wailing in captivity – for a second time.

Just before they part for the last time, the couple talk about the exposed and dangerous ramparts of Troy, 'the great wall of Ilios', a place generally inimical to a woman and certainly alien to a distraught Andromache. In contrast, though, to the martial environment, marital harmony prevails as Hector describes a typical scene with women weaving and men warring: in real life this is a metaphor for the one partner shoring up the *oikos*, the homestead, the other defending the *polis*, the city-state – both central and essential to the survival and continuation of normal Greek life. The pathos is palpable. Hector

laid his child in his dear wife's arms, and she held him to her fragrant breast, smiling through her tears; Hector was moved with pity when he looked at her, and he caressed her with his hand, and said: "My dear wife, do not be too upset... go home and busy yourself with your own tasks, the loom and the distaff, and tell your maids to get on with their work: war is for us men.

Many have read this a sexist statement, firmly putting women in their place and telling them bluntly to keep out of men's business. But it may also signify much more than that: if we go back to the protection just mentioned that Andromache gives to the *oikos*, it surely is a confirmation of her invaluable role, and the role of all other married women and mothers, in preserving and extending the homestead as a safe and nurturing environment in which to raise new generations and new citizens for the *polis*. Without a thriving and safe *oikos* there was no *polis* and nothing for the Hectors of the world to defend. Women like Andromache, then, were performing an important albeit indirect military role by providing something worth defending and fighting for. In addition, Hector's proprietorial words accurately reflect the situation in militaristic Greece at the time.

We have seen how Homer reinforced this important message by repeating the phrase on two occasions in the *Odyssey*, with slight variations[3]. The first, perhaps more insensitively, comes at the beginning of the poem where Odysseus' precocious son, Telemachus, asserts his authority in the fatherless/husbandless Odyssean household: he dismisses the grieving Penelope and tells her, and the slaves, to get on with the wool-working, making it abundantly clear, not least to his mother, that he is in charge and that he will conduct any negotiations with the suitors, for talking is man's work. The second echoes the first when Telemachus again rebukes Penelope, reminding her that he is the master of the house and that the bows and arrows are his province; Penelope is again ordered to go back to the wool work; she, somewhat meekly, retires to grieve over ever-absent Odysseus. Just as Hector was fighting to save his city, so Telemachus is talking, and shooting arrows, to save his household, his *oikos,* and his mother from the circling suitors?

Homer gives us the unconventional and extraordinary in the gender role-reversal implicit when Andromache offers Hector military advice. On one level, this a loving but astute wife's ploy to detain Hector with a lesson in military strategy, thus keeping him in the relative safety of the ramparts and out of the much more hazardous open fighting taking place down below[4]. On another level, it is nothing short of sound, calm-headed advice, emotional blackmail even, based on a woman's observation in a sea of confusion and panic:

Come on, show some pity, and stay here on the wall, in case you orphan your child and widow your wife. Post your army by that wild fig-tree, where the wall is most vulnerable to a scaled assault, and where the city is exposed....[the Greeks] have tried to get in there three times already.

Andromache is, like Penelope, the caring, loving mother and wife. She weaves a cloak for Hector in the domestic seclusion and safety of the interior rooms of the house and she runs that bath for him just before he is due home, sadly to no avail. She is, though, at the same time, a wise and perceptive woman who has obviously observed the military activity raging around her and feels confident enough to offer a strategy based on those informed observations in the male world of war. Indeed, the reason she is out on the battlements in the first place was because she heard that the Trojans were on the defensive, and that victory was in the grasp of the Achaeans. Most civilian Trojans would surely have fled in the opposite direction, not so steadfast, military-minded, 'white-armed' Andromache[5].

More generally, Homer's women in the *Iliad* are clearly shown as appreciating the fact that their men are obliged to fight – not least because of the inviolable treaty invoked at the snatching of Helen. The women never demand an end to hostilities, unpalatable as those hostilities are. Helen herself is never criticised by the Trojan women because by criticising her the Trojan women would be calling into question the validity of the war. The best they can do is encourage their warrior husbands to adopt a less hazardous approach to the conflict... and pray to Athena.

Euripides' *The Trojan Women*

Women suffer horribly in *The Trojan Women,* first produced in 415 BCE; the play is a tragic commentary on the capture of the Aegean island of Melos and the subsequent slaughter and subjugation of its inhabitants by the Athenians. The play opens with Athena and Poseidon discussing ways to proportionately punish the Greek armies for condoning the rape of Cassandra by Ajax the Lesser; she was the eldest daughter of King Priam and Queen Hecuba, after he had sacrilegiously dragged her off a statue of Athena.

Euripides shows us how much the now destitute Trojan women suffer: more grief is piled on when the Greeks coldly share out the women between them. The deposed queen Hecuba learns that she will be appropriated by Odysseus, while Cassandra is acquired by Agamemnon. Unsurprisingly, Cassandra had seen all this coming: she knows how Clytemnestra will slay both her and Agamemnon. Sadly, no one believes or listens to Cassandra when she offers sound counsel.

Cassandra has already bewailed the lot of the Greek wives, denied the privilege of burying their dead husbands, languishing in widowhood while their men lie rotting in a foreign field.

Things get much worse when Andromache, widow of Hector, tells Hecuba that her youngest daughter, Polyxena, has been killed as a sacrifice at the tomb of Achilles. Not only is Andromache destined to be the concubine of Achilles' son Neoptolemus but she is informed that her baby son, Astyanax, has been condemned to die because the Greeks are afraid lest the boy grows up to avenge his father, Hector; the plan is to hurl Astyanax from the battlements of Troy to his death.

The body of Astyanax is poignantly carried in on Hector's shield: Andromache naturally wished to bury her child herself with the proper rituals, but too late: her

ship had already set sail. Hecuba it is who prepares the body of her grandson for burial, before she is taken off in Odysseus' baggage train.

The play graphically highlights the fate of these women after a devastating ten-year-long war and the impact that war has on their later lives. They, along with countless others, are bereaved, homeless, deprived of their dignity and freedom and displaced; they are left with nothing apart from the prospect of lifelong slavery and the routine sexual abuse that comes with it. Hecuba, for whom Troy had been her lifelong home, has just seen Troy consumed by flames, she has witnessed the deaths of her husband, children and grandchildren; the former queen and everything she ever possessed that was left was now the property of Odysseus. More generally, it reminds us that the horrors of war 3,000 years ago are just as bad today and women's suffering as victims is just as terrible. What Euripides showed has an eerie resemblance to the scenes we have seen of refugee camps and urban destruction in and around Syria, and of the displacement and shelling in parts of Ukraine and of the fate of civilians in the war in Israel from October 2023. Euripides warns us that the more jubilant and triumphant war is, the more wretched and miserable is the fallout.

The women in the chorus sum up their desparate plight: these women can only foresee a life of dreaded nightly rape; they echo the words of Polyxena in the *Hecuba*: 'Shall I be a skivvy, or forced into the bed of Greek masters? Night is a queen, but I curse her!' (202–204). Profound thoughts and words that must have been repeated by women victims of war through the ages down to this very day.

Euripides' *The Phoenissae* and Jocasta

The Phoenissae is as close as we get for a template description of the suffering of women in war – then as now. The play gets its name from the chorus which comprises women from Phoenicia – war booty sympathetic to their Theban ancestors and on a one-way ticket to Delphi where their fate is to be sacrificial fodder to Apollo. Phoenicia is significant because it is the home of Cadmus and of that 'horned ancestor' Io, raped by Zeus and right there at the beginning of the tortuous sequence of events which led to the Trojan war and culminated in the curse of Oedipus bestowed on his two fratricidal sons.

The Phoenician women, though, are not the only powerful women in the play: Jocasta, until her suicide after the deaths of her two sons, and her daughter, Antigone, also figure large in the action. Indeed, importantly, they open the play: Jocasta, mother of Odysseus and wife of Laius, provides the back story by relating the history of the house of Cadmus and the origins of the curse of Oedipus and his descendants; Antigone has her *teichoscopy* in which she describes the army besieging her city from the terrace of her palace.

Jocasta soon takes control by taking command; only too aware of the fate which awaits her sons, she does everything she can to forestall the inevitable by trying to fix a last ditch meeting between Eteocles and Polyneices, the latter an unwilling exile in his own land. Assuming the role of a military commander

she, desperate for reconciliation, orders a truce between the opposing armies but Eteocles is intractable and refuses to compromise, adamant as he is that he will retain power in the land, Polyneices' power that is and Polyneices' land. Jocasta's sagacious appeal to fairness and equality falls on deaf ears[1]. Instead, she is forced to witness an unpleasant exchange in which the brothers verbally mutilate each other, both parting with the promise of killing the other in an impious and sacrilegious prayer which leaves Jocasta with nothing but the prospect of two dead sons and a ruined city. When she learns of the duel she is determined, with the help of Antigone, to battle her way between her sons but arrives too late. Seizing a 'bronze-hammered' sword found lying between the bodies of Eteocles and Polyneices, she stabs herself and dies a soldier's death as she falls on the bodies of her boys. This battlefield death in no-man's land between two armies, effected with a soldier's sword, is the death of a militaristic woman falling in battle.

Aristophanes' *Lysistrata*

Lysistrata, the name translates as 'army demobber', was performed in 411 BCE, and is the story of one woman's extraordinary but mad mission to end the Peloponnesian War. Lysistrata persuades the women of Greece to refuse sex with their husbands and lovers until they negotiate a peace; however, all the scheme does in the end is excite a battle between the sexes. However, it illustrates the ineptitude in some men and the theoretical ability of women to intrude onto the traditional territory occupied by men.

In the beginning, a solemn oath is struck over a wine bowl in which the women renounce all sexual pleasure, including the 'Lioness on the Cheese Grater', an obviously pleasurable sexual position. Early success comes in the capture of the Acropolis, home to the treasury; the women are now able to freeze the funds which are needed to finance the ongoing war. The magistrate turns up looking for a means to pay for oars and then proceeds to trot out the usual pejorative, misogynistic stereotypes – the hysterical nature of women, their bibulous behaviour, their predilection for promiscuous sex and attraction to strange and exotic cults; he also censures his fellow men for not controlling their women.

Lysistrata responds by delineating the frustration felt by women during war when the men make stupid decisions that affect the whole population while their wives' opinions are ignored. She feminises the magistrate, covering his head with her headdress, and giving him a basket of wool – traditional accoutrements of compliant women – and tells him that from now on war – man's work – is now woman's business. She explains the plight of young, childless women who sit at home, growing old while the men are away fighting endless campaigns, alluding to the double standard where women are obliged to marry very young and men can marry when they choose, having played the field to their heart's content. To Lysistrata, the magistrate, and everything he stands for, might as well be dead.

Nevertheless, reconciliation eventually ensues and everyone is happy. The war continues apace but Aristophanes has at least allowed the women a voice with which to adumbrate the inequalities they face in Greek society, to express an opinion about the war and the suffering it causes the women left at home, and to criticise the handling of the war by the men of Athens.

The *Lysistrata* was not the only comedy in which women were on top: we know of two plays called *Gynaikokratia,* one by Alexis (*PCG* 2, frr 42–43) and one by Amphis (*PCG* 2, fr.8); *Tyrannis* by Pherecrates (PCG 7, frr 150–154) and Theopompus' *Stratiotides* (PCG 7, frr 55–59).

In Aristophanes' *Birds* (829–831) Euelpides complains about a similar gender reversal when he moans that Athena, a female deity no less, protects the city in a suit of armour while so-called warrior Cleisthenes is portrayed as an effete man armed with his shuttle; Athena is also patron of wool working and other women's crafts. The line here is a parody of Euripides' *Meleager* fr. 522: 'if work with shuttles were to be the concern of men, while women were seized with the delights of weaponry'.

Three heroic mortal women who deserve mention are Epipole, Messene and Aglauros – the first for her exploits in the Trojan war. Although not mentioned by Homer, **Epipole** was a daughter of Trachion, of Carystus in Euboea. She so much wanted to fight with the Greeks against Troy that she bravely dressed up as a man and inveigled her way into the massed armies – a very early case of classical cross-dressing. Unfortunately, when Palamedes discovered her sex, she was stoned to death by the Greek army.

Messene was the daughter of Triopas, king of Argos; she was married to Polycaon, son of King Lelex, of Laconia. Messene was a very ambitious woman. After her father-in-law died, her husband's brother Myles assumed the throne of Laconia, thus overlooking Polycaon; but it was not in Messene's script to be married to a nonentity, so she set about raising an army from Argos and Laconia and invaded and occupied nearby territory. This territory was then named Messenia in her honour. The couple then went on to found the city of Andania, where they built their palace[2].

Aglauros was a brave virgin who stepped up to the plate when Athens, her city, needed someone to bring a protracted war to a successful conclusion. An oracle had pronounced that Athens would win the war if a citizen committed suicide for the sake of the city. Aglauros accordingly jumped off a cliff to her death; her reward was everlasting fame and a temple on the Acropolis built in her honour. It then became the custom for young Athenians, when they donned their first suit of armour, to swear an oath that they would always defend their country to the last[3].

Further reading
Facella, Margherita (2017). *TransAntiquity: Cross-Dressing and Transgender Dynamics in the Ancient World.* Routledge

Shopland, Norena (2021). *A History of Women in Men's Clothes*. Barnsley

Clytemnestra – *'a slag of a murderess'*

If Penelope was the role model for the good and virtuous Greek wife, then Clytemnestra was the exact opposite. No waiting patiently working the wool for her: Agamemnon bitterly and graphically describes to Odysseus during the necromancy in *Odyssey* 11 how the unexpected high point of his eventual return was him being butchered by his wife:

> Aegisthus and my wicked wife were the death of me between them. He asked me to his house, feasted me, and then butchered me most miserably as though I were a fat beast in a slaughter house, while all around me my comrades were slain like sheep or pigs for the wedding breakfast, or picnic, or gorgeous banquet of some great nobleman. You must have seen numbers of men killed either in a general engagement, or in single combat, but you never saw anything so truly pitiable as the way in which we fell in that cloister, with the mixing-bowl and the loaded tables lying all about, and the ground reeking with our blood. I heard Priam's daughter Cassandra scream as Clytemnestra slew her close beside me. I lay dying upon the earth with the sword in my body, and raised my hands to kill the slag of a murderess, but she slipped away from me; she would not even close my lips nor my eyes when I was dying, for there is nothing in this world so cruel and so sluttish as a woman when she has fallen into such guilt as hers was. Fancy murdering her own husband! I thought I was going to be welcomed home by my children and my servants, but her abominable crime has brought disgrace on herself and all women who shall come after – even on the good ones.

Indeed, as far as Agamemnon is concerned, Clytemnestra has unwittingly written the script for the male reception of women for ever. All women are blemished from now on; the eternal hostility, fear and suspicion begin here. In fact, so bitter is Agamemnon that, ironically, he warns Odysseus to beware Penelope when he arrives home, fearing a similar bloody and deceitful reception from her. From a distance we can know from the example of Penelope that by no means all women were bad: stereotyping Agamemnon naturally sees it very differently, and mud sticks.

It could be argued that there were some mitigation for Clytemnestra's odious behaviour – a life lived in a dysfunctional family torn apart with traumatic slaughter, fear and loathing? Her father, king Tyndareus of Sparta, betrothed her to Tantalus as a young girl; Tantalus was the son of Thyestes and king of Mycenae; Clytemnestra, therefore, on marriage, became queen; she gave Tantalus a son. Agamemnon murdered Tantalus because he was the son of Thyestes who had violated his mother. He also killed the baby son and acquired Clytemnestra who was quite simply the baggage of the man he had slain. Clytemnestra was queen of Mycenae, so Agamemnon became king.

Aegisthus and Clytemnestra lived together as king and queen until Orestes took vengeance on them and killed them both.

Aeschylus' Agamemnon in the eponymous play is of interest to us for another reason. As virtual Queen of Mycenae during the extended absence of her husband, Clytemnestra takes on a role typically the preserve of a man, that of a king. Aeschylus uses language imbued with maleness and masculinity in his descriptions of her and of her actions. She is *androboulon* which roughly and vaguely translates as 'physically a woman but psychological a man' to convey her contradictory and ambivalent characteristics. Aeschylus thus gives us an example of that universal paradox which perplexed Greek and Roman men: how can a woman so powerful, so violent so decisive be a mere woman? She must have appropriated masculine traits to account for her actions and intentions. Clytemnestra is, like many after her, in effect defeminised and psychologically masculinised.

Cassandra

Cassandra is one of history's great scapegoats. Cassandra was wronged by men and by gods – both of whom regarded her as something of a liability. She was a daughter of Priam and Hecuba, and was beautiful if a little crazy on account of her gift of prophecy. When she was a girl, she and her twin brother, Helenus, were left overnight in the temple of Thymbraean Apollo: next morning, the children were found entwined by serpents, which flicked their tongues into the children's ears, enabling Cassandra and Helenus to divine the future. Cassandra repeated the sleepover some years later only to be assaulted by Apollo. She resisted and was rewarded for her behaviour by having her prophecies, though true, forever and always disbelieved.

When the Trojan War began, Cassandra predicted the disasters lying in store for the Trojans. Nobody believed her of course but Priam, deciding she was not good for morale, locked her away, incarcerated like a lunatic. The highpoint of her chequered career came when she declared that there were men in the wooden horse – more ravings of a madwoman. When Troy fell, she took sanctuary in the temple of Athena where she embraced the statue of the goddess as a suppliant. Ajax found her there, dragged her from the temple but not before he had raped her in the sanctuary. The rape violated not only Cassandra but also one of the most powerful and inviolable rules in Greek religion. Cassandra was later awarded to Agamemnon who took her with him back to Mycenae; she became pregnant and bore twins – Teledamus and Pelops.

Damned by the gods, raped by a war hero in a sacred temple and considered mad by your father and by everyone else cannot have done much good for any issues Cassandra had with her mental health. The frustration of being damned to being disbelieved when you know you are right must have been devastating, particularly when the safety of your country and its citizens were at stake and their terrible fate could have been avoided. As Homer well knew, the truth is often unpopular and sometimes hurts: it was up to

subsequent generations to decide whether to place confidence in intelligent, slightly eccentric women like her or dismiss them as mad women.

Further reading

Schapira, Laurie L. (2023). *The Cassandra Complex: Living with Disbelief: A Modern Perspective on Hysteria*. Toronto

Medea – *expert jugulator and child murderer*

If Clytemnestra is bad, then Medea is worse still and must rank as one of literature's most repugnant and reprehensible mothers. She unequivocally declares her hatred for her children early on in the play that bears her name: 'You accursed sons of a mother who know nothing but hate, damn you, your father and your whole house'. (Euripides, *Medea* 112)[1].

Medea is the gold standard witch, the one to equal, to emulate and to echo. Others run her close – Circe and Lucan's Erichtho, for example – but Medea comes out top of the funeral pyre. Her meticulous instructions on how to rejuvenate through jugulation are beyond compare.

Rejuvenation and reanimation were important skills in the witch's armamentarium. Medea was an expert in making the young old – with devastating consequences. Lucan's Erichtho, as we shall see, performs what is probably one of history's most ghastly acts of reanimation, raising the black art to gruesome new heights, or rather plunging them to new depths[2]. She was also a dab hand at ad hoc blood transfusion, or jugulation – throat-cutting made simple.

Euripides opens his *Medea* with the nurse telling us that Medea is 'unhinged in her love for Jason'; up to this point she is the perfect Greek type of wife who did everything her husband asked, making great sacrifices for him. In return he cruelly betrayed her love, with shocking consequences for their children. For Medea, love was for life: in the *Argonautica* (3, 126–8) she swears, 'in our lawful marriage-chamber you shall share my bed, and nothing will separate us in our love until the appointed death enshrouds us'. Not so Jason.

Her rejection by Jason has sown an unnatural hatred in her heart which results ultimately in the infanticide of her children. She was, of course, a member of that satanic family, the unholy trinity, which boasted Hecate as Circe's mother and Circe as her sister[3]:

> [Medea] said [to the Argonauts] that she had brought with her many drugs of marvellous potency which had been discovered by her mother Hecate and by her sister Circe; and though before this time she had never used them to destroy human beings, on this occasion she would, and by means of them easily wreak vengeance upon men who were deserving of punishment.

Interestingly, Euripides in the same play shows us a rare woman's perspective on life (*Medea* 251):

What they say is that we women have a quiet time, staying at home,
while they are off fighting in war. They couldn't be more wrong. I would
rather stand three times in a battle line than give birth to one child.

This comes at the end of a speech which perfectly encapsulates all that is suffocating
and tedious for a woman in a loveless marriage to a hypocritical, insensitive husband:

> Of all things that are living and can form a judgment
> We women are the most unfortunate creatures.
> Firstly, with an excess of wealth [dowry] it is required
> For us to buy a husband and take one for our bodies
> A master; for not to take one is even worse.
> And now the question is serious whether we take
> A good one or bad one; for there is no easy escape
> For a woman, nor can she say no to her marriage.
> She arrives among new ways of behaving and manners,
> And needs prophetic power, unless she has learned at home,
> How best to manage him who shares the bed with her.
> And if this works out well and carefully,
> And the husband lives with us and lightly bears his yoke,
> Then life is enviable. If not, I'd rather die.
> A man, when he's tired of the company in his home,
> Goes out of the house and puts an end to his boredom
> And turns to a friend or companion of his own age.
> But we are forced to keep our eyes on one alone.

Euripides may have been more or less a lone voice in Greek society and culture,
for in articulating such sentiments he at least seems to understand and sympathise
with the tedium and marital iniquity tolerated by women; whether he actually
agreed with them, of course, is a different matter. Medea's perceptive analysis of
the imbalance between man and woman must be seen in the context of the play. A
fragment from Euripides' *Melannipe the Captive* has a more positive, but equally
contentious, message:

> Men's criticism of women is worthless twanging of bowstring and
> evil talk. Women are better than men, as I will show...women run
> households...without a woman no home is clean or prosperous.

Antiphanes, writing on *Women* about 300 BCE, has a decidedly brief catalogue of
good women to call on for his research:

> What! when you have a secret, will you tell it to a woman? You might
> as well tell all the criers in the public squares! It's hard to say which of
> them blares loudest. Great Zeus, may I perish, if I ever spoke against
> woman, the most precious of all acquisitions. For if Medea was an

objectionable person, surely Penelope was an excellent creature. Does anyone abuse Clytemnestra? I oppose the admirable Alcestis. But perhaps someone may abuse Phaedra; then I say, by Zeus! what a capital person was... Oh, dear! the catalogue of good women is already exhausted...

Apollonius of Rhodes depicts Medea and her *pharmaka* in detail in his epic poem the *Argonautica*. He ascribes to her the traditional nefarious skills of being able to pervert the course of nature, interfere with the moon and stars and tame snakes with a hypnotic melange of herbal drugs and spells. Medea's bewitching and wrecking of the bronze Talos is achieved through trance-like possession, incantations, invoking ghosts and an evil glare, indeed an early glimpse, or glance, of the evil eye; her instructions to Jason for the invocation of Hecate from Hades recalls the underworld myth of Orpheus and Eurydice: don't look back.

It is the Apollonius version which best illustrates Medea's superlative skills as a sorceress, a witch. Medea first became involved with Jason when he arrived from Iolcus at Colchis, to claim his inheritance and throne by retrieving the golden fleece. Medea fell hopelessly in love with him and promised to help him achieve his objective, on the condition that if he was successful, he would take her away with him and marry her. Jason agreed. Medea's father, Aeëtes, had his conditions too and promised to give Jason the fleece, on completion of some very challenging tasks:

- Jason was first tasked to plough a field with fire-breathing oxen – Medea provided a magic lotion as an antidote against the bulls' fiery exhalations;
- second, Jason was required to sow the teeth of a dragon in the ploughed field – teeth which inconveniently changed into an army of warriors: Medea advised Jason to hurl a rock into their midst which threw them into confusion so that they attacked and killed each other – ancient blue on blue;
- finally, Aeëtes demanded Jason fight and slay the sleepless dragon that guarded the fleece: Medea put the beast to sleep with a cocktail of her narcotic herbs.

All went well, Jason took possession of the coveted fleece and sailed off with Medea, as promised. Medea distracted the pursuing Aeëtes by killing her brother Absyrtus; she dismembered his corpse and scattered the body parts knowing full well that her father would delay to retrieve them for proper burial; in some versions, Medea and Jason stopped off at aunt Circe's so that Medea could be ritually cleansed after the murder, thus absolving her of blame for the deed. *En route* back to Thessaly, Medea prophesied that Euphemus, the helmsman on the *Argo*, would one day rule over all Libya. This transpired through Battus, a descendant of Euphemus.

The Argo then reached Crete, notoriously guarded by the bronze man, Talos, an oddity who had one vein extending from his neck to his ankle, plugged by a single bronze nail. Medea hypnotized him from on board the *Argo*, driving him so mad that he pulled out the nail causing ichor to gush from the wound; he bled to death, clearing the way for the *Argo* to land.

Jason celebrated in Crete with the Golden Fleece, but could not help noticing that his father, Aeson, was too old and ill to join in; Medea had a witchy solution: she drew out the blood from Aeson's body, infused it with magical herbs and transfused it back in to his veins – this is known in the witch trade as jugulating. Aeson was a new, revivified man: the daughters of king Pelias saw this and demanded the same restorative procedure for Pelias, their aging father – the very man who had despatched Jason to acquire the fleece in the first place in the hope that he would thereby not depose him. As it happened, Hera wished Pelias dead because he refused to give up his throne, so Medea conspired to have Pelias' own daughters kill him. This would be gorily achieved by transforming an old ram into a young ram simply through chopping up an old ram and boiling it in a cauldron stew of magic herbs. Sure enough the old ram was boiled up and a live, young ram sprang from the pot; the gullible girls then hacked their father into pieces and threw the body parts into a pot in the naïve hope of achieving the same result.

Jason and Medea fled to Corinth where he soon abandoned Medea for the king's daughter, Glauce. Horrified and distraught at this betrayal, Medea exacted her revenge when she sent Glauce a dress and golden coronet smeared with poison, killing both the princess and the king, Creon. According to Euripides, Medea did not stop there but continued on her road of revenge, brutally murdering two of her sons, Tisander and Alcimenes. It is probably this act – just one of many heinous deeds – that wins for Medea the reputation for being one of literature's most repugnant and reprehensible mothers. As we have noted, she unequivocally declares her hatred for her children early on in the play that bears her name: 'You accursed sons of a mother who know nothing but hate, damn you, your father and your whole house'.[4]

She then flew off to Athens in a golden chariot driven by dragons sent by her grandfather Helios, god of the sun.

Her murderous behaviour would go on to become the canonical version for later writers. Pausanias records no fewer than five different versions of the fate of Medea's children, reporting that he had actually seen a monument to them while travelling in Corinth.[5]

Medea eventually returned to Colchis only to find that her father Aeëtes had been deposed by his brother Perses, her uncle. She killed him and restored Colchis to her father.

Roman epic poet Ennius provided an early link between Greek and Roman Medeas with his adaptation of Euripides' *Medea*. She makes her final appearance in the classical period in the 4th century CE *Orphic Argonautica*: here Orpheus prepares a sacrifice to Artemis with the help of Medea's famous *pharmaka,* black poplars and sundry other trees and bushes, barley meal effigies, black puppies, the stomachs of which were filled with a mixture of their blood and various herbs. A whole cohort of hellish inhabitants are raised forth including Tisiphone and Hecate before Orpheus, still assisted by Medea and her 'baneful roots', charms the snake to sleep with his divine song. The Greek Medeas provided the Romans with a fertile basis on which to found their own reincarnations.

Ovid's *Metamorphoses* is rich in infernal and eschatological material: it describes Pythagoreanism, Orpheus' *katabasis* – and Medea. She re-emerges in the *Heroides* while in the *Fasti* he describes the rites of Tacita – the silent goddess of the dead. In the *Amores* we meet the witches Circe and Dipsas. Medea takes centre stage in his lost eponymous tragedy[6]. She also features in Ovid's tragic celebrity love letters, the *Heroides:* Hypsipile describes her typical witch-like characteristics: her ability to draw down the moon and meddle with nature, darkening the skies, damming rivers and rolling rocks and trees; she hangs around cemeteries – her hair and clothing in disarray, snatching the warm bones of the newly buried. She is an expert with *simulacra cerea* – waxen effigies – and the needles she drives into their livers; she perverts the course of true love with *herbae*[7]. Medea reappears in Ovid's *Metamorphoses* in a description which owes much to Apollonius of Rhodes' Medea in the *Argonautica*[8]. Likewise, Seneca's Medea is spurned in love; she curses Jason and wishes death on his family and the family of his new wife[9]. In a cauldron of occult materials, tools and incantations, she unleashes a menagerie of reptiles and dragons and draws down animals and snakes from the constellations to vent their poisons on Earth; she herself mixes toxic herbs and other venoms, invokes Dis and the shades of the dead and releases the long-term dead and damned – Tantalus, Ixion, Sisyphus – from their eternal infernal punishments. She can turn the world and nature upside down, and make it go backwards.

Philomena and Procne – *killed her son Itys and served him up as a meal for her husband for raping her sister*

Philomena was not a woman to be crossed, neither was her sister Procne. Philomena bore the indignity and horror of having been raped with fortitude and a determination to take revenge on her attacker, revenge which itself showed considerable ingenuity in bringing him to book.

Philomela was the younger of two daughters of Pandion I, King of Athens, and the naiad Zeuxippe. Her sister, Procne, was the wife of King Tereus of Thrace. One of the variants of the myth has Philomela, after being raped and mutilated by her sister's husband, Tereus, win her revenge and transforming into a nightingale, a bird noted for its melodious song.

Ovid (*Metamorphoses* 6, 424–674) tells us how Procne and Tereus travelled to Athens to visit Philomena, and how Tereus became crazed with desire for his sister-in-law – a passion which led to the rape. A furious Philomena enraged Tereus who cut out her tongue to silence her. Rendered mute, Philomela ingeniously wove a tapestry that told her story and sent it to Procne.

Procne was so incensed that she killed their son Itys in revenge. She boiled Itys and served him up as a meal for Tereus which he ate; the *coup de grâce* came when the sisters presented Tereus with the severed head of his son; Tereus pursued the sisters wielding an axe intending to kill them[1]. They fled and frantically prayed to the gods to be turned into birds. The gods transformed Procne into a swallow and Philomela into a nightingale. Then the gods changed Tereus into a hoopoe.

Historical (or hysterical if you believe Hippocrates) Greek women

Agnodice – *the first professional midwife of ancient Greece*

Women have always been healers. They were the unlicensed doctors and anatomists. They were abortionists, nurses and counselors. They were the pharmacists, cultivating healing herbs, and exchanging the secrets of their uses. They were midwives, traveling from home to home and village to village. For centuries women were doctors without degrees, barred from books and lectures, learning from each other, and passing on experience from neighbor to neighbor and mother to daughter. They were called "wise women" by the people, witches or charlatans by the authorities. Medicine is part of our heritage as women, our history, our birthright.

> – Barbara Ehrenreich Deirdre English,
> *Witches, Midwives and Nurses:*
> *A History of Women Healers* (1973)

Agnodice was the first professional gynaecologist and midwife of ancient Greece, practising around 500 BCE[1]. We know of her principally from Roman author Gaius Julius Hyginus in his *Fabulae*. Her desire to study medicine was ignited when she saw all around her more and more women dying in childbirth or undergoing unnecessarily painful deliveries. One of the problems was that women were embarrassed or disliked being treated by male doctors. In Hippocrates' day (*c.* 460 BCE – 375 BCE), women were allowed to learn and practice obstetrics and gynaecology and midwifery but when it was later discovered that some women were performing (illegal) abortions, it was made a capital crime for women to practice any form of medicine.

Agnodice, however, was determined to help her fellow women so she cut her hair and dressed as a man to pursue medical training leaving Athens to study medicine in Egypt. In Alexandria it was legal for women to study and practice medicine at that centre of medical excellence run by Herophilos, a leading gynaecologist who can lay claim to having discovered the ovaries. Once qualified Agnodice continued to masquerade as a man in order to treat the women back in Athens[2].

However, she became the victim of her own success when she was rejected by women patients because they thought she really was a man. Hyginus tells us how:

> she heard a woman crying out in the throes of labour so she went to her assistance. The woman, thinking she was a man, refused her help; but Agnodice lifted up her clothes and revealed herself to be a woman. Agnodice, as a man, was then tried by the Areopagus on behalf of jealous husbands and rival doctors on a charge of seducing the women of Athens.

To prove her true identity she lifted up her tunic (a gesture called *anasyrma* in Ancient Greek). Accused of illegally practising medicine as a woman,

she was defended by the women of Athens who praised her for her effective treatments. She was acquitted, and the law against female physicians in Athens was revoked.

Further reading

Flemming, Rebecca (2007). 'Women, writing, and medicine in the classical world'. *Classical Quarterly*. 57: 257–279

Green, Monica H. (2008). *Making Women's Medicine Masculine: the rise of male authority in pre-modern gynaecology*. Oxford

King, Helen (1986). 'Agnodike and the Profession of Medicine'. *Proceedings of the Cambridge Philological Society*. 32: 53–77

King, Helen (2013). *The one-sex body on trial: the classical and early modern evidence*. Farnham

Potter, John (1722). 'Of their Customs in Child-bearing, and managing Infants'. In *Archaeologia Graeca* vol. II. London

Retief, F. P. (2006). 'The Healing Hand: The Role of Women in Greco-Roman Medicine'. *Acta Theologica*. 26 (2)

Cynisca – *having babies to support the Spartan war machine*

Women played an active and vital role in keeping the renowned war machine at Sparta well-oiled and productive. Since Spartan men were preoccupied with military training, bonding with comrades in mess life and constantly doing battle, it fell to women to run the farms back home and keep the *polis* going in their absence. Working the wool was never as important a part of the Spartan woman's life as it was in the rest of Greece: she had many more important things with which to fill her day.

Women of childbearing age were essential in keeping that war machine in good working order. Indeed, the zeal with which they applied themselves to this work for the state, this war-related industrial baby production, may in fact have diminished the Spartan woman's natural maternal instincts if the following encounter is true; it occurred when a mother is told of the death of her five sons in battle and she retorts to the messenger:

> *'don't tell me about that you fool; tell me whether Sparta has won!'*
> *And when he declared that it was victorious, 'Then,' she said, 'I*
> *accept gladly also the death of my sons'.*
> <div align="right">Plutarch, Lacaenarum Apophthegmata 6, 7</div>

Just as 'sensitive' was the wife and mother who told her son or husband departing for yet another war to come home carrying his shield, or, if not, carried on it (*Lacaenarum Apophthegmata* 6, 16).

The bereaved mothers of the fallen at the battle of Leuctra in 371 BCE are said to have had smiles beaming on their faces out of sheer pride. In the early 4th century BCE, we have an example of the ideal active, competitive Spartan woman

in Cynisca[1]. She (born *c.* 440 BCE) was the wealthy daughter of the king of Sparta, Archidamus II[1].

Xenophon tells us that she was urged by her brother, Agesilaus II, to compete in the Olympic Games – in the prestigious four-horse chariot race as an owner and trainer of horses. Agesilaus was ever keen to instill bravery and belligerence in the Spartans, and to raise the profile of women. However, an alternative account is somewhat more sinister: he wanted to discredit the sport by having a mere woman win it[2]. Cynisca duly won the four-horse race (*tethrippon*: τέθριππον) in 396 BCE and in 392 BCE. She was honoured with a bronze statue of a chariot and horses in the Temple of Zeus in Olympia. The inscription read that she was the only woman to win in the chariot events at the Olympic Games. Pausanias reminds us that usually, only Spartan kings were honoured in this way.[3] This is what the statue tells us:

> My fathers and brothers were Spartan kings. I won with a team of fleet footed horses and put up this monument. I am Cynisca: I declare that I am the only woman in Greece to have won such a wreath.

Gorgo – *famed for her political and military wisdom*

Gorgo is notably one of the few female historical figures actually named by Herodotus, and is described in sources as resourceful and wise. The military achievements and aspirations of Sparta and the Spartans held such a fascination to other Greeks that Plutarch compiled a special book on the famous sayings of Spartan women, the *Lacaenarum Apophthegmata* in the *Moralia;* the wife of Leonidas I Gorgo was famed for her military and political judgement and wisdom. She was the daughter of a king of Sparta, the wife of another, and the mother of a third.

When she was about eighteen (Herodotus says eight or nine) Aristagoras, seeking allies after the Ionian revolt, came to Sparta to try to convince a vacillating Cleomenes to invade the Persian Empire. He learned that the journey to Asia would take three months by sea, however, Cleomenes turned down Aristagoras' proposal and told him to get out of Sparta. However, Aristagoras came to Cleomenes' home that evening, now offering increasing bribes as high as fifty talents of silver. It is here that Gorgo stepped in and told her father to leave the room lest Aristagoras' bribes corrupt him. Cleomenes listened to his daughter's advice and went out and Aristagoras left Sparta without success.

Unusually, the academic curriculum of Spartan women was at least as rigorous, if not superior, to that of Spartan males. It is because of this physical and mental training that Plutarch attributes an anecdote to Gorgo in which a foreign woman notes that 'You Spartan women are the only ones who rule their men.' To which Gorgo replies, 'Yes, we are the only ones that give birth to men.'

Arguably, Gorgo's most significant action occurred prior to the Persian invasion of 480 BCE. According to Herodotus, Demaratus, then in exile at the Persian court,

sent a warning to Sparta about Xerxes's pending invasion. In order to prevent the message from being intercepted by the Persians or their allies, the message was written on a wooden tablet which was then covered with wax. – Plutarch, *Sayings of Spartan Women* 3, 1; Cf Herodotus, 4, 51; 7, 239

The Spartans did not know what to do with what to all intents and purposes was a blank wax tablet, until Gorgo advised them to clear the wax off the tablet.[4] She is described by David Kahn in his *The Codebreakers* as one of the first female cryptanalysts whose name has been recorded[1]. Ancient world 'Etch A Sketch'?

Gorgo also had the good sense to make prudent plans for her later life as a war widow. Before the battle of Thermopylae, knowing that her husband's death was inevitable, Gorgo asked him how she should spend her widowhood. A charitable and affectionate Leonidas replied 'marry a good man who will treat you well, bear children for him, and live a good life'.

Timycha (early 4th century BCE) – *biting her tongue, literally*

Timycha of Sparta and her husband, Myllias of Croton, were part of a group of Pythagorean pilgrims who were attacked by Syracusan soldiers on their way to Metapontum, in defiance of the tyrant Dionysius the Elder.

Beans were taboo and off limits to Pythagoreans, so when they had the option of running through a field of beans to escape, they declined. Instead they fought, lost and died, with the exception that is of the pregnant Timycha and her husband, who were taken prisoner. Dionysius interrogated her about the taboo.

> For he thought, that as she was a woman, pregnant, and deprived of her husband, she would easily tell him what he wanted to know, through fear of the torture. The heroic woman, however, grinding her tongue with her teeth, bit it off, and spat it at the tyrant.
> – Iamblichus, *Life of Pythagoras*

Tymicha was not the only woman to bite her tongue – sometime in the 10th century CE the astrologer and poet **Khana** had her tongue cut out for the heinous crime of teaching, on the orders of either her husband or father who felt insecure and overshadowed by her excellence[1]. This shocking lingual mutilation would have immediately put an end to her teaching career.

Artemisia I – *supreme naval warfare tactitian*

Artemisia I, Queen of Halicarnassus and commander of the Carian navy, acquitted herself very well, indeed with bravery, *andreia*, at the battle of Salamis in 480 BCE – an epithet Herodotus uses only here for a woman when she and her navy supported the Persians against the Greeks. Indeed, Artemisia had won a hard-earned seat

on Xerxes' councils of war dispensing the best of advice and winning the epithet *androboulos* – advising like a man. Before Salamis, Xerxes summoned together all his naval commanders and sent Mardonios to ask whether or not they thought he should fight the battle. All advised him to fight except Artemisia:

> Tell the King to spare his ships and not do a naval battle because our enemies are much stronger than us in the sea, as men are to women. And why does he need to risk a naval battle? Athens for which he did undertake this expedition is his and the rest of Greece too... If Xerxes chose not to rush into a naval encounter, but instance kept his ships close to the shore and either stayed there or moved them towards the Peloponnese, victory would be his. The Greeks can't hold out against him for very long. They will leave for their cities, because they don't have food in store on this island... But if he hurries to engage I am afraid that the navy will be defeated and the land forces will be weakened as well. In addition, he should also consider that he has certain untrustworthy allies, like the Egyptians, the Cyprians, the Kilikians and the Pamphylians, who are completely useless.

Xerxes, though impressed, fought the battle anyway. Xerxes watched Artemisia being pursued by the ship of Ameinias of Pallene: to shake him off she attacked and rammed another Persian vessel fighting on her side and so convinced the Athenian captain that her ship was an ally; quite reasonably, Ameinias gave up the chase. The friendly victim was manned by people of Persian allies Calyndos and unfortunately went down with all hands. Xerxes, looking on, realised that she had successfully attacked an enemy Greek ship, and seeing the indifferent performance of his other commanders, commented 'My men have become women, and my women men'. A baffled Xerxes summed it all up with:

> And even in the heat of the action, observing the manner in which she distinguished herself, he exclaimed: "O Zeus, surely you have formed women out of man's materials, and men out of woman's."

Xerxes was not the only one that day who had his eyes opened by a woman's sterling action: Herodotus says:

> Now if [Ameinias] had known that Artemisia was sailing in this ship, he would not have given up until either he had captured her or had been taken himself; for orders had been given to the Athenian captains, and moreover a reward was offered of 10,000 drachmas for the man who should take her alive; since they thought it intolerable that a woman should make an expedition against Athens.

Artemisia also made inspired use of the Persian and Greek flags she stowed on board:

> Artemisia always…carried on board with her Greek, as well as barbarian, colours. When she chased a Greek ship, she hoisted the barbarian [Persian] colours; but when she was chased by a Greek ship, she hoisted the Greek colours; so that the enemy might mistake her for a Greek, and give up the pursuit.

More tactical wizardry followed, in the words of Polyaenus:

> Artemisia…found that the Persians were defeated, and she herself was near to falling into the hands of the Greeks. She ordered the Persian colours to be taken down, and the master of the ship to bear down upon, and attack a Persian vessel, that was passing by her. The Greeks, seeing this, supposed her to be one of their allies; they drew off and left her alone, directing their forces against other parts of the Persian fleet. Artemisia in the meantime sheered off, and escaped safely to Caria.

After the battle, Xerxes rewarded her outstanding performance – the best of all his commanders – with a complete suit of Greek armour; rubbing salt in male wounds and exemplifying hurt pride he simultaneously presented the captain of her ship a distaff and spindle! Xerxes and Artemisia, like Herodotus' Egyptians before him, were turning the world on its head.

More sound Artemisian advice ensued when Xerxes asked her whether he should now lead his troops to the Peloponnese himself, or withdraw from Greece and leave his general Mardonius to do it. Artemisia replied that he should retreat back to Asia Minor and advocated the plan suggested by Mardonius, who requested 300,000 Persian soldiers with which he would defeat the Greeks.

According to Herodotus the reason for her considered response was:

> I think that you should retire and leave Mardonius behind with those whom he desires to have. If he succeeds, the honour will be yours because your underlings performed it. If on the other hand, he fails, it would be no great matter as you would be safe … In addition, if Mardonius were to suffer a disaster who would care? He is just your inferior officer and the Greeks will have but a poor triumph. As for yourself, you will be going home with the object for your campaign accomplished, for you have set Athens alight.

Xerxes took her advice this time, leaving Mardonius to pursue the war in Greece. He sent her to Ephesus to take care of his illegitimate sons, a task considerably less challenging (and somewhat demeaning) than fighting in the battle of Salamis and being chief military advisor to Xerxes.

Artemisia II – *concocted and drank a potion made up with her husband's bones and ashes*

In Halicarnassus (modern Bodrum in Turkey and birthplace of Herodotus) King Mausolos (r. 387–353 BCE) ruled in consort with his wife Queen Artemisia II, a woman whom Herodotus described as 'wondrous'. Decrees and laws were issued in joint names and honours were heaped on them, as an egalitarian regal couple.

When Mausolos died, Artemisia ruled on her own for some years. Her expressions of grief for her husband were legendary: she is even reputed to have concocted and drunk a potion comprising her husband's bones and ashes. She organised poetry and oratory competitions to honour her dead husband and completed the building of his mausoleum which became one of the Seven Wonders of the World, known as the Mausoleum of Halicarnassus. Our word mausoleum derives from this. She embarrassed the people of Rhodes when she beat off their attack; the Rhodians found it hard to accept that they had been repelled by a woman.

Artemesia also gives us an example of the pen being mightier than the sword, in the words of Polyaenus:

> Artemisia planted soldiers in ambush near Latmus; and herself, with a large train of women, eunuchs and musicians, celebrated a sacrifice at the grove of the Mother of the Gods…When the inhabitants of Latmus came out to see the magnificent procession, the soldiers entered the city and took possession of it. So did Artemisia, by flutes and cymbals, possess herself of what she had in vain endeavoured to obtain by force of arms.

Herodotus praises Artemisia, despite her being on the side of Persia. He extolled her decisiveness and intelligence, and emphasised her undoubted influence on Xerxes.

Polyaenus says that Xerxes praised her gallantry. Justin remarked that she 'was fighting with the greatest gallantry among the foremost leaders; so that you might have seen womanish fear in a man, and manly boldness in a woman.'

However, Thessalus, a son of Hippocrates, described her as a 'cowardly pirate' informing us that that the King of Persia demanded earth and water from the Coans in 493 BCE but they refused, so he gave the island to Artemisia to be devastated. Artemisia led a fleet of ships to Cos to slaughter the Coans, but the gods intervened. After Artemisia's ships were destroyed by lightning and she hallucinated visions of great heroes, she fled Cos. However, she later conquered the island.

Due to Artemisia's grief for her brother-husband, and the weird forms it took, she became to later ages 'a lasting example of chaste widowhood and of the purest and rarest kind of love', in the words of Giovanni Boccaccio.

Further reading

Boccaccio, Giovanni (2001). *De mulieribus claris.* Trans Virginia Brown. Harvard University Press. pp. 115–118

Salisbury, Joyce (2001). *Encyclopedia of Women in the Ancient World.* pp. 20–21

Telesilla of Argos – *soldier and poet*

The poet Telesilla (*fl.* 510 BCE) was from Argos; she is just as famous for her military prowess and soldierly activities as she is for her poetry. Apparently, as a young woman, Telesilla was so sickly she went to the Pythia for some medical advice: Pythia told her: 'τὰς Μούσας θεραπεύειν', 'serve the Muses', and so began Telesilla's career in poetry.

Pausanias describes the brave military action of this soldier-poet at Argos. After his invasion of Argive lands in 510 BCE the battle of Sepeia saw Cleomenes, king of Sparta, defeat and wipe out the hoplites of Argos and massacre all the survivors. So, when Cleomenes attacked Argos, there were no male warriors left to defend it. Telesilla took the initiative when she stationed on the city walls all the slaves and all the males normally exempt from military service because they were too young or too old. She collected weapons from sanctuaries and homes, armed the women and drew them up in battle positions.

The Spartans tried to terrify the Argive women with their battle cry but they remained unperturbed and fought bravely, standing their ground. The Spartans had realised that destroying the women of Argos would be a cheap success, while defeat would mean a shameful and ignominious disaster, so they left the city.

Plutarch (*Mulierum Virtutes* 4) adds some fascinating detail relating to cross-dressing and bearded women. He suggests that the battle took place on the first day of that month [the Fourth month or Hermaeus], 'on the anniversary of which they celebrate even to this day the "Festival of Impudence," at which they clothe the women in men's shirts and cloaks, and the men in women's robes and veils'. As for ethnic integration he tells us about some mischievious legislation:

> To rectify the scarcity of men they did not unite the women with slaves, as Herodotus records, but with the cream of their neighbouring subjects, whom they made Argive citizens. It was reputed that in their marriages the women showed little respect and obvious indifference to their husbands because they felt inferior. The Argives then enacted a law stipulating that married women sporting a beard must occupy the same bed with their husbands!

In another instance of the pen working against the sword, Pausanias concludes with a description of a statue at Argos in front of the temple of Aphrodite that is dedicated to Telesilla. It depicts a woman holding a helmet, which she contemplates and is about to place on her head; tellingly, there are books lying at her feet.

Herodotus only alludes to the incident when he tells us about an oracle, told by a Pythian priestess, which predicted that female should conquer male:

> But when the time shall come that the female conquers in battle, driving away the male, and wins great glory in Argos, then many wives of the Argives shall tear both cheeks in their mourning.

According to Tatian, Telesilla was commemorated by a statue in the Theatre of Pompey in Rome, made by Niceratus.

Hydna of Scione – *responsible for the almost single-handed destruction of the Persian fleet*

Also known as Cyana, (*fl.* 480 BCE) Hydna sounds like an early Royal Marine commando or a member of what was the Special Boat Squadron. Hydna was an accomplished swimmer and diver and was responsible for the almost single-handed destruction of the Persian fleet.

According to Pausanias (10, 19, 1), Hydna and her father volunteered to help in the war against the Persians during a critical battle. Hydna was schooled by her father, Scyllis of Scione, himself an expert diver and swimmer. When Xerxes' fleet was assailed by a violent storm off Mount Pelion, Hydna and Scyllis completed its destruction when they swam ten miles in stormy waters to where the Persian navy was moored for the night. Knives in hand, they silently swam among the boats, cutting their moorings: rudderless in the wind and waves, the ships crashed together; some sank; most were badly damaged.

The Amphictyons dedicated statues to them at Delphi. This fascinating story is more fully discussed by the United States Naval Institute (*Proceedings*, 68, 1942, p.662).

Further reading
Mark, Joshua (August 20, 2014). 'Ten Noble and Notorious Women of Ancient Greece'. In *World History Encyclopedia*.
Meijer, Fik (2014). *A History of Seafaring in the Classical World*. London

Herodotus is quite explicit in his telling of the decisive action taken by Athenian women against fellow Athenians; the first instance is in response to the treason advocated by Lycidas when he was disposed, possibly by bribery, to accept a proposal made by the Persian Mardonius to defect to the Persians and renounce Greece. This would be in return for autonomy, land and money for rebuilding wrecked temples. The Athenians were so angered by this preposterous suggestion that they surrounded Lycidas and stoned him to death. The women of the city then took it upon themselves to attack Lycidas' house and then stone his wife and children to death. Protection of the homeland was obviously the motivating factor; the incident demonstrates quite clearly how willing, and able, the patriotic women of Athens were to perpetrate terrible retribution in order to preserve their freedoms and honour in the face of a shameless enemy.

Herodotus gives another instance of Athenian female belligerence after the doomed expedition to Aegina when the Argives came to help the Aeginetans. Only one Athenian survived and returned safely to Attica. When the wives of the Athenian troops learned this they were outraged: they mobbed the man and stabbed him to death with the brooches from their clothing, each demanding from him to know where her husband was. The Athenian authorities were appalled and perplexed by this and could think of no other way to punish the women than flaccidly change their dress to the Ionian style. Until then Athenian women had worn Dorian dress but this was now changed to a style that would obviate the need for brooch-pins.

Elite Hellenistic women

By the time of the Hellenistic period (usually defined as running from the death of Alexander in 323 BCE to the Roman occupation of Egypt in 30 BCE) it is probably fair to say that women in Greek society, law and politics, were enjoying marginally greater freedoms and opportunities; education was more extensive and women 'got out more'.

The elite women of Macedonia in particular, like their Spartan counterparts in some respects, seem to have enjoyed greater liberty, greater respect from their men, and greater social and political responsibility than women in many of the Greek *poleis*, not least Athens. Nowhere is this more evident than in the elevation of women to the highest levels of state as queens, or regents in the various Macedonian dynasties. Some elite Macedonian women were more cosmopolitan, better travelled, more politically astute, and considerably more dangerous and volatile than their sisters elsewhere in ancient Greece. Some displayed a breathtaking knowledge of military matters and impressive skills in tactics and strategy. The ability of elite women to rise to the higher echelons of Macedonian society and power may have something to do with the hereditary basis of power there which permitted women to be honoured and pandered to in much the same way as their menfolk were. Elite women, as elite mothers, worked ceaselessly and sometimes ruthlessly to secure or seize power for their sons, not always with constitutional justification.

Roxana – *ruthless 'little star'*

Roxana's (*c.* 343 BCE – *c.* 310 BCE) reputation preceded her; she was considered to be the most beautiful woman in all of Asia and deserving of her Persian name, Rauxsnaka, meaning 'little star'. She was the daughter of Oxyartes, a Bactrian nobleman who served Bessus, the satrap of Bactria and Sogdia. Oxyartes had sent his wife and daughters, including fifteen-year-old Roxana, to take refuge in the Sogdian Rocks, the reputedly impregnable fortress which, with some foresight, had been provisioned for a long siege. When Alexander suggested that the defenders surrender, they refused, telling him that he would need 'men with wings' to capture the Sogdian rock. Nevertheless, Alexander found his winged men and took the rock and its defenders: among them was the family of Oxyartes, including Roxana. Roxana and Alexander were soon an item.

Love at first sight it may have been, but there was a political element to the match – Sogdiana had proved a somewhat intractable fortress so the political alliance can only have helped. Apart from a reference to a miscarriage in India there is no further mention of Roxana until Alexander's death.

When Alexander died in 323 BCE, Roxana was pregnant; quite simply, the sex of the baby was pivotal to the political history of the whole region: a son was born six months later; unsurprisingly, Roxana wasted no time in trying to ensure the succession of her infant son, also called Alexander (IV). After some hostilities he was declared joint king with a mentally challenged son of Philip II, Philip III

Arrhidaios. Perdiccas (*c.* 365 BCE – 321 BCE) was a general under Alexander who became regent of the Macedonian empire after Alexander's death.

Plutarch tells that with Perdiccas's support Roxana promptly murdered one of Alexander's other widows, Stateira, and her sister, Drypetis to clear the way for young Alexander IV, but this just made her and her son puppets in the ongoing power struggles. As a daughter of Darius, if Stateira should also fall pregnant, then any boy born might hold a stronger claim on Alexander's throne. Stateira and Drypetis were poisoned, and their bodies thrown down a well.

When Perdiccas was assassinated by his own soldiers in 320 BCE and Antipater died, mother and son passed into the ineffective and weak protection of Polyperchon, who was soon up against Cassander, Antipater's son. In 317 Alexander IV was stripped of his royal title, causing Roxana to flee with him to Olympias, Alexander the Great's mother, who was given the responsibility of raising her grandson as a true pedigree Macedonian: Roxana, on the other hand, was regarded by many as a barbarian. At this point Olympias was still the wife of Philip II, king of Macedonia while she was queen consort.

The army went over to Olympias who captured Philip II and his new wife Cleopatra (or Eurydice), and had them tortured and killed. Cassander invaded Macedonia, facing an army antagonised, and their morale weakened, by Olympias's cruelty. She, with Roxana and the young Alexander, took refuge in fortified Pydna. Polyperchon was abandoned by his troops, and Pydna was soon starved into surrender. Olympias gave herself up on promises of safety, but she was stoned to death on Cassander's orders, a fate which she faced with dignity and stoicism. Cassander compounded the atrocity by denying her funeral rites – literally, as we have seen, a fate worse than death itself. Roxana and her son were imprisoned at Amphipolis and finally murdered in 310 after Cassander had duplicitously promised to return the kingship to Alexander when he came of age.

Further reading
Badian, Ernst (2015). 'Rhoxane, Alexander's wife'. In *Encyclopædia Iranica*

Plutarch's brave women

In Plutarch's *De Mulierum Virtutibus*, a section of his *Moralia*, he deals with fifteen ethnic groups of women from various parts of Greece, and twelve individuals. Of the Trojan women, he emphasises the initiative they took in establishing a homeland for the Trojans in Italy:

> It suddenly occurred to the women that for a happy and successful people any sort of a settled habitation on land is better than all that wandering and voyaging, and that the Trojans must create a homeland, since they could not recover what they had lost. So, altogether, they burned their boats.
>
> – Plutarch, *De Mulierum Virtutibus*, 1

Of the plucky Persian women, he tells how they lifted up their clothes and made heroes out of their erstwhile cowardly warriors:

> When Cyrus incited the Persians to revolt from king Astyages and the Medes he was defeated in battle. The Persians fled to the city, with the enemy not far from forcing their way in with them, so the women ran out to meet them, and, lifting up their tunics, said, "Where are you rushing to so fast, you who are biggest cowards in the whole world? Surely you cannot, in your retreat, slink in here from out there." The Persians, mortified at the sight and the words, chided themselves for being cowards, rallied and, engaging the enemy once more, routed them.
> – Plutarch, *De Mulierum Virtutibus*, 5

Some inspired cross-dressing by brave and inventive Etruscan women:

> When the Etruscans took Lemnos and Imbros, they forcibly abducted Athenian women, to whom children were [later] born. The Athenians expelled these children from the islands on the grounds that they were half-barbarian; nevertheless, the refugees put in at Taenarum and made themselves useful to the Spartans in the war with the Helots. For this they received citizenship and the right of intermarriage...the wives of the prisoners came to the jail, and after many prayers and entreaties, were permitted by the guards to go just close enough to greet and to speak to their husbands. When they had gone inside the women made their husbands quickly change their clothes, leaving theirs for their wives; then, putting on their wives' clothes they walked out with their faces covered.
> – Plutarch, *De Mulierum Virtutibus*, 8

Plutarch's women are indeed well named by Plutarch. Their military talent extends to tactical excellence, clever deception, and other elements of psychological warfare – leading from the front, setting a good example, ruthlessness, compassion and modesty.

The brave women of Polyaenus

> Courageous **Leaena** renders herself speechless under torture: Aristogeiton had a mistress, whose name was Leaena. Hippias ordered her to be interrogated by torture, so as to determine what she knew of the conspiracy; after she had bravely endured the various tortures that were visited on her, she, reminiscent of Timycha, cut out her tongue with her own hand, lest any more pain should extort from her any information.
> – Polyaenus, *Strategemata* 8, 45

Proud and noble **Axiothea** prefers death to slavery:

> When Ptolemy, king of Egypt, sent a powerful force to dispossess
> Nicocles (*fl. c.* 374 BCE) of the kingdom of Cyprus, both Nicocles
> and his brothers, rather than submit to slavery, committed suicide.
> Axiothea the wife of Nicocles, wishing to emulate them... Axiothea
> first stabbed herself, and then threw herself into the fire to save even
> her corpse from falling into the hands of the enemy.
>
> – Polyaenus, *Strategemata* 8, 48

Mania was a woman warrior of the first order:

> Mania, the wife of Zenis prince of Dardanus, governed the kingdom
> after the death of her husband [around 399 BCE], with the assistance
> of Pharnabazus. She always went to battle drawn in a chariot; she
> shouted out orders while in action, formed her lines, and rewarded
> every man who fought well, as she saw he deserved. And – something
> that has scarcely happened to any general, except herself – she never
> suffered a defeat.
>
> – Polyaenus, *Strategemata* 8, 52

Sappho – *commonly regarded as one of the greatest lyric poets and was called 'the tenth muse' by Plato*

There are a number of ancient Greek women who were highly educated and excelled in the arts: poetry, philosophy, painting and sculpture, and in the sciences. Small numbers admittedly in terms of the general population over the years but significant all the same and more evidence that ancient Greek women were not always as socially or intellectually suppressed as is often argued.

The most famous of educated women we know of is Sappho. She was a Greek lyric poet (*c.* 620 – 570 BCE), born on Lesbos. She was the daughter of aristocratic parents, Skamandronymos and Cleis. Her poetry was well-known in classical times and admired, but most of her work has been lost; nevertheless her reputation endures through surviving fragments. Indeed, Sappho was commonly regarded in antiquity as one of the greatest lyric poets and was called 'the tenth muse' by Plato.

Details of her life are sketchy: she was probably married and had a daughter, Cleis; one story going back to Menander (Fr. 258 K) says that Sappho committed suicide by jumping off the Leuccian cliffs for love of Phaon, a ferryman. An attempt to heterosexualise her?

In her poetry Sappho focuses on love for both men and women. Of the 12,000 lines of poetry she is thought to have composed, many of which described her love for other women, about 600 lines have survived. As a result of her fame in antiquity, she and her island have become emblematic of love between women.

Our word lesbian derives from Lesbos, while her name is also the origin of the word sapphic; neither word was applied to female homosexuality until about 1890. Censorious and pious early Christians visited a kind of *damnatio memoriae* on her – attempting to extinguish all record of her poetic output.

What the surviving fragments do show is a unique intimacy inspired by a world from which men were excluded; 'Parting' (Frag. 94G) is typical and, significantly, not only written by a woman but written by a woman for a woman:

> "The truth is, I wish I were dead." She left me, weeping all the time, and she said, "Oh what a cruel fate is ours, Sappho, yes, I leave you unwillingly." And I answered her: 'Good-bye, go and remember me, for you know how we cared for you. 'If you do remember, I want to remind you ... and were happy ... of violets ... you set beside me and with woven garlands made of flowers around your soft neck 'and with perfume, royal, rich ... you anointed yourself and on soft beds you would drive out your passion 'and then ... sanctuary ... was ... from which we were away ...'

Sappho is believed to have run a *thiasos* – a community in which Greek girls could receive a basic education and in which they might be exposed to homosexual love; sometimes that love was directed towards their teachers and sometimes at each other.

Sappho's contemporary, Alcaeus, described her as 'Violet-haired, pure, honey-smiling Sappho' (Frag. 384).

Of the 200 or so fragments of Sappho's poetry, Fragment 16 and Fragment 44 are lyric retellings of Homer – both allude to scenes orginating in the *Iliad*, which Sappho expands on: Fragment 16 characterises Helen, while No. 44 describes the joy leading up to the wedding of Hector and Andromache.

As alluded to above Sappho's reception down the ages has sadly been hijacked by moralists and homophobes, most of whom have missed the finer points of her verse. The Poetry Foundation puts it well:

> Much of the history of Sappho's reputation, though, is the story of her appropriation by moralists. Those New Comedians who picked up the strain of abuse initiated by the Anacreontic fragment ... rendered the poet a popular burlesque comic figure on the stage. A good many plays centered around Sappho, though most were wholly unrelated to her life or her poetry. Later Christian censors in various ages in Alexandria, Rome, and Constantinople condemned her in words such as those of Tatian, who called her "a whore who sang about her own licentiousness." Saint Gregory of Nazianzus and Pope Gregory VII ordered her works to be burned.
>
> – http://www.poetryfoundation.org/bio/sappho

Parts of two previously unknown poems by Sappho were published in February 2014 in the *Times Literary Supplement*.

Further reading

Boehringer, Sandra (2021). *Female Homosexuality in Ancient Greece and Rome.* Trans. Anna Preger. London

Snyder, Jane McIntosh (1997). *Lesbian Desire in the Lyrics of Sappho.* New York

Ada of Caria (*fl.* 377 – 326 BCE) – *adopted Alexander the Great*

Ada was a member of the House of Hecatomnus and ruler of Caria – first as Persian Satrap and later as queen in her own right under the protection of Alexander the Great.[1] Interestingly, every one of Hecatomnus' children would govern over Caria at some point. Mausolus and Artemisia first ruled together, and after Mausolus' death, Artemisia ruled alone until her death in 344 BCE.

After the death of Idrieus, her husband, Ada became the sole satrap of Caria, but was expelled by her brother Pixodarus in 340 BCE. Ada took refuge in the fortress of Alinda, where she ruled in exile.

According to Matthew Sears, on Alexander the Great's arrival at Caria in 334 BCE, Ada adopted Alexander as her son and surrendered Alinda to him. Alexander gave Ada formal command of the Siege of Halicarnassus. After the fall of Halicarnassus, Alexander returned Alinda to Ada and made her queen of all of Caria. Ada's popularity with the Carians in turn ensured the Carians' loyalty to Alexander.

Further reading

Carney, E.D. (2005). 'Women and Dunasteia in Caria'. *American Journal of Philology.* 126

Chrystal, Paul (2018). *Women at War in the Classical World.* Barnsley

Sears, Matthew A. (2014). 'Alexander and Ada Reconsidered'. *Classical Philology.* 109 (3): 211–221

Hipparchia – *cross dressing Cynic whose eccentric husband called their marriage "dog-coupling" (*cynogamy*)*

Hipparchia of Maroneia (*fl. c.* 325 BCE) was a Cynic philosopher born in Maroneia; when her family moved to Athens she met Crates, the famous Cynic, fell in love with him and his strange ways and, despite her parents' opposition, married him. She left her parents little choice in the end, threatening to kill herself if they stopped her. Crates did not help matters: he stood in front of Hipparchia, took off all his clothes, and announced, 'Here is the bridegroom, and these are his goods.' Hipparchia obviously liked what she saw and embraced the Cynic *modus vivendi:* she took to wearing the same clothes as Crates – men's clothes – and appeared everywhere with him in public, even having the temerity to go out to dinner with him. Crates unflatteringly called their marriage 'dog-coupling' (*cynogamy*) which may say something about the passion with which they conducted their sex life together.

Hipparchia spurned all other suitors, eschewing their wealth, their family connections and their good looks – all consistent with Cynic doctrine. Moreover, Crates himself was no Adonis, so much so that people mocked him when they saw him doing his exercises.

Enforced destitution was the name of the Cynics' game: Diogenes Laertius (*fl. c.* 3rd century CE) in his *Lives and Opinions of Eminent Philosophers* (in which Hipparchia is the only woman with an entry, out of eighty-two entries) told that they scratched a living in the mean streets, stoas and porticoes of Athens; and the Roman novelist Apuleius (*c.* 124 – *c.* 170 CE) described how they routinely had sex in public. Public fornication chimed well with Cynic shamelessness (*anaideia*), but, added to Hipparchia's cross-dressing and the fact that she lived on equal terms with her husband, the couple's blatant rejection of conventional values would have outraged most of Athenian society. The role model was Diogenes the Cynic who is reputed to have practiced 'everything in public, both the works of Demeter and those of Aphrodite' and attracting censure not only for masturbating in public, but also for eating in the agora.

Hipparchia could clearly hold her own, even in a male-dominated environment. One time she went to Lysimachus' house for a symposium, where she floored Theodorus, nicknamed the Atheist, with the following argument:

> If it is not wrong for Theodorus to do a particular act, then it is not wrong for Hipparchia to do it. So, if Theodorus gives himself a slap he does nothing wrong: ergo, if Hipparchia slaps Theodorus she does nothing wrong either.

Theodorus was dumbstruck and reacted by trying to lift up Hipparchia's cloak. But Hipparchia refused to be intimidated 'as most women would have been'. Theodorus persisted with his attempt at humiliation by sneering:

> "Is this the woman 'who left her carding combs next to her loom'?"
> "Yes, Theodorus," she retorted, "it is I. But do you think I have made a bad decision if instead of wasting my time at the loom I have used it for philosophy?"

Exposing other people's genitals seems to have been a habit of the Cynics: Theodorus recalls Diogenes who refused to answer a question put to him by a smartly dressed student unless [s]he lifted his cloak to discern whether he was male or female.

Hipparchia had at least two children, a daughter and a son named Pasicles. When Pasicles came of age his father, Crates, took him to the house of a prostitute and told him, 'this is what your father's wedding was like'.

In the 1st century BCE Antipater of Thessaloniki describes Hipparchia's philosophy on life:

I, Hipparchia, have no use for the works of deep-robed women; I have chosen the Cynics' virile life. I don't need capes with brooches or deep-soled slippers; I don't like glossy nets for my hair. My wallet is my staff's travelling companion, and the double cloak that goes with them, the cover for my bed on the ground. I'm much stronger than Atalanta from Maenalus, because my wisdom is better than racing over the mountain.

Diogenes of Sinope (412 or 404 BCE – 323 BCE) – a founding Cynic – leaves us with this anecdote addressed to the people of Maroneia from the *Cynic Epistles* which, even if apocryphal, tells us something about the influence Hipparchia had:

You did well when you changed the name of the city and, instead of Maroneia, called it Hipparchia, its present name, since it is better for you to be named after Hipparchia, a woman, it's true, but a philosopher, than after Maron, a man who sells wine.

William Penn wrote about her in his *No Cross, No Crown*, which he wrote in prison in 1668. For Penn she was an example of puritan discipline and virtue:

I seek not the Pomp and Effeminacy of this World, but Knowledge and Virtue, *Crates*; and choose a Life of Temperance, before a Life of Delicacies: For true Satisfaction, thou knowest, is in the Mind; and that Pleasure is only worth seeking, that lasts for ever.

Further reading

Long, A. A. (1996). 'The Socratic Tradition: Diogenes, Crates, and Hellenistic Ethics'. In Bracht Branham, R. (ed.). *The Cynics: The Cynic Movement in Antiquity and Its Legacy*. University of California Press
Shopland, Norena (2021). *A History of Women in Men's Clothes*, Barnsley

Chapter 5

Ancient Rome and her enemies

◇◇

The story of women in ancient Rome provides for exciting and dramatic history. Apart from the glimpse it gives us into one of the world's greatest civilisations, it, as with the women of Greece, Egypt and the Mesopotamian civilisations, allows us to meet a host of good, bad, cruel, ambitious and dissolute women who had a huge impact on that civilisation and the men who ran it. As with their Greek sisters, women in Rome were, like slaves and children, usually second-class citizens, on the margins of society. They were – at least technically – always under the control of a man, be it father, husband, or guardian, depending on the time and their circumstances. They were barred from holding public office and had no role in the Roman war machine, they were politically invisible because they had no vote, and they had limited say in state religion. From what survives of Roman literature we deduce that they were largely silent; their education was often truncated by early marriage, by looking after the household and by serial childbirth.

John Chrysostom, the 4th century CE Archbishop of Constantinople, looked back on Greek, Roman and Christian attitudes to women in *The Type of Women Who Ought to be Taken as Wives* and came to the conclusion that a woman's role exclusively is to care for children, for her husband, and for her home... God assigned a role to each of the sexes: women look after the home, men take care of public affairs, business and military matters – in other words, everything outside the home[1]. He echoed the words of Livy at the end of the 1st century BCE. Livy exemplifies the standard male attitude when he describes the debate on the repeal of the Oppian Law in 195 BCE – a rare example of female power exerting itself in Roman politics:

> Women cannot hold magistracies, priesthoods, celebrate triumphs, wear badges of office, enjoy gifts, or booty; elegance, finery, and beautiful clothes are women's emblems, this is what they love and are proud of, this is what our ancestors called women's world of adornment[2].

'Let them go shopping,' no less. According to Philo of Alexandria, who was writing soon after Livy, woe betide any woman who acts immoderately – indeed, acts like a man – even in defence of a husband under attack:

> If any woman, hearing that her husband is being assaulted out of her affection for him, be carried away by love for her husband,

should yield to the feelings which overpower her and rush forth to help him, still let her not be so audacious as to behave like a man, forsaking the nature of a woman; but even while aiding him let her still be a woman. For it would be a very terrible thing if a woman, wanting to deliver her husband from an insult, should expose herself to insult, by exhibiting human life as full of shamelessness and liable to great reproaches for her incurable boldness; for shall a woman utter abuse in the marketplace and give vent to unlawful language? And if another man uses foul language, will not she block her ears and run away?

For Philo, things have already gone too far: the gods forbid she grabs a man by the balls:

> But as it is now, some women are advanced to such a pitch of shamelessness as not only, though they are women, to give vent to intemperate language and abuse among a crowd of men, but even to strike men and insult them, with hands practised rather in works of the loom and spinning than in blows and assaults … but that is a shocking thing if a woman were to proceed to such a degree of boldness as to seize hold of the genitals of one of the men quarrelling…. And let the punishment be the cutting off of the hand which has touched what it ought not to have touched[3].

Plautus, writing comedic plays, had earlier said that there was nothing more miserable than a woman: *miserius nihil est quam mulier*. One assumes that this raised a laugh, and (as he was a well-to-do Roman man) that he was referring to a woman's psychological mood rather than her social situation – although both are probably appropriate, with the latter often accounting for the former.[4] A nostalgic Cicero had already famously said: 'Our ancestors, in their wisdom, wanted all women, because of their feebleness, to be in the power of guardians'[5].

All the more impressive, then, the achievements and impacts of the women who did break through this ancient glass ceiling. These women were paradoxes; they were conspicuous, assertive and influential, all the things that Roman women were not supposed to be. By the end of the Republic and the beginning of the Empire, they assumed levels of power and responsibility – either directly or indirectly, through male politicians and Emperors – which were unimaginable less than a century beforehand.

There are multiple examples of charges of immorality, sexual slurring, made against prominent women, many of which are pure calumny. Similarly, as with their predecessors, exceptional achievements by women are often explained away as masculine behaviour – the outstanding woman is exceptional because she exhibits male qualities, and she is, therefore, effectively defeminised, as much a man as a woman. The women in question may be seen as promiscuous viragos but, in the eyes of the commentators, their eminence is unquestionably due to their immoderate, non-*matrona*, masculine behaviour.

Our knowledge of influential women is by necessity, largely confined to elite women, or women from the upper and middle classes. We do have a limited amount of information about how the vast majority of the women in the lower classes lived – mainly from epitaphs – but, as may be expected, in the main these women are anonymous and silent. If they were influential in any way then their influence was restricted to the home, and it has therefore, for the most part, gone unrecorded. The paradigm and essence of Roman womanhood lay in the *matrona*: the wife and woman of the household. The *matrona* was the glue which held the Roman family together, and provided the offspring essential to the running of the farm or business, the recruits needed for bar and battlefield, and the ever-burgeoning administration at home and in overseas provinces and dependencies. So, the qualities expected of a *matrona* are best identified in the inscriptional evidence, where there are multiple examples of *pudicitia* (sexual propriety, probity, almost the opposite of *stuprum*), modesty, virtuousness, loyalty, docility, unobtrusiveness, strength of character and fortitude, *pietas* towards the family – stay-at-home, one-man women (*univira*), devoted to their children. The ability to run the home (*domum servat*) and work the wool (*lanem fecit*) became badges of the *matrona*, and symbolised her domesticity and management of the household.

War was a fact of life and a constant at Rome, a *sine qua non* in the Roman journey towards regional domination, so it is no surprise that many of the Roman myths and legends, not least the foundation myths, are myths of war. The belligerence of the state was always integral to Roman political life; Roman bellicosity shaped their economy and defined their society. Josephus, writing in the 1st century CE, stated that the Roman people emerged from the womb carrying weapons. Centuries later, F. E. Adcock echoed these words when he said 'a Roman was half a soldier from the start, and he would endure a discipline which soon produced the other half'. Fighting wars was often an important part of the *cursus honorum*, that road to the highest echelons of Roman politics for the elite man.

The women described in the wars of Virgilian and later epic embrace a number of functions, derived in part from their roles in Greek epic, and no doubt, non-extant earlier Roman epic. They are *causae bellorum*, like Helen and Lavinia; they are victims of war like Dido (also a cause); they are combatants like Camilla or they stoke the fires of war and impel it forward, as with witches, goddesses and Furies.

One of the consequence of serial warfare was an increase in widowhood caused by increasing numbers of war casualties. In addition, husbands were absent for extended periods of time, fighting increasingly distant wars and organising overseas territories, and this inculcated burgeoning levels of independence amongst the women left behind to head the family. Another consequence of the warring was the influx of foreign booty, wealth, and slaves with all sorts of skills; these included doctors, midwives, astrologers, prostitutes, and teachers. Exotic culture began to percolate into the hoary Roman traditions, as Spanish dancers, Greek actors and mimes, musicians, multilinguists, and educated and urbane women (*doctae puellae*) all started to assert themselves, with minds, bodies, and opinions of their own. The old way of doing things (the *mos maiorum*) was becoming seriously compromised,

despite the best efforts of conservatives like Cato the Younger to shore it up. All this opened the doors for elite and determined no-nonsense women to express themselves, exerting a degree of independence and public conspicuousness that would have been unheard of a few years earlier.

Legendary and mythical women

The Sibyl of Cumae (*c.* early 500 BCE) – *clever book saleswoman and the voice of the future*

Women were always at the centre of Roman *divinatio*, divination, in no small part by virtue of the Sibyl at Cumae, her *Sibylline Books*, the *libri Sibyllini,* and the *Sibylline Oracles*. The Cumaean Sibyl was the priestess presiding over the Apollonian oracle at Cumae, a Greek colony near Naples. The originals of the *Books* were a collection of oracular responses in three books brought to Rome by Tarquinius Priscus, the fifth king of Rome (*fl.* 6th century BCE), after some haggling about their value with the Sibyl. Tarquinius was anxious to get his hands on the information contained within the books. Dionysus of Halicarnassus has the story[1]:

> Centuries ago, concurrent with the 50th Olympiad, not long before the expulsion of Rome's kings, an old woman "who was not a native of the country" arrived incognita in Rome. She offered nine books of prophecies to King Tarquin; and as the king declined to purchase them, owing to the exorbitant price she demanded, she burned three and offered the remaining six to Tarquin at the same stiff price, which he again refused, whereupon she burned three more and repeated her offer. Tarquin then relented and purchased the last three at the full original price, whereupon she "disappeared from among men".

Virgil dignifies them by including them in the religious initiatives Aeneas will take when he establishes Rome:

> A great sanctuary awaits you too in our kingdom; for this is where I will put your oracles and the mysterious prophecies told to my people; here I will ordain chosen men, propitious Sibyl.

The *Books* were kept underground in a stone chest under the temple of Jupiter Optimus Maximus on the Capitoline guarded by ten men; they could only be accessed by fifteen specially appointed augurs, *quindecimviri sacris faciundis*. Consultation took place by Senatorial decree at a propitiatory ceremony in times of civil strife, external threat, military disaster or on the appearance of strange prodigies or phenomena.

Unfortunately, the temple and the oracles were lost in a fire in 83 BCE. A new collection was compiled from various sacred sites and kept by Augustus in the temple of Palatine Apollo. They were last consulted in 363 CE. *The Sibylline Oracles*, on the other hand, are a random 5th century CE compilation (of dubious authenticity) of Jewish and Christian portents of future calamities.

The Sibyl achieved prominence in Christian literature and art due to her pronouncements in Virgil's fourth *Eclogue*, the *Messianic Eclogue*, which was assumed by Lactantius and Augustine to predict the coming of Jesus Christ[2].

Heraclitus, writing in the 5th century BCE, gives us the standard definition of a Sibyl:

> The Sibyl, with frenzied mouth speaking words of profound seriousness, plain and unperfumed, yet speaks to a thousand years with the help of the god.

It is from Virgil that we get our most vivid description when she greets Aeneas at the entrance of Avernus and later guides him through the Underworld, revealing the future destiny of Rome. Her pivotal function here demonstrates the reverence with which the Sibyl was held and the political and religious importance of the *Sibylline Books* to Rome.

Further reading
Adams, Henry Gardiner (ed.) (1857). 'Amalthæa'. In *A Cyclopaedia of Female Biography*. 35

Camilla – *peerless woman warrior*

Camilla is the Roman woman warrior *par excellence* – effective, successful, competent, a leader of men and women and a reliable second-in-command. She only dies when, in a momentary lapse of battlefield concentration, she is distracted and tempted by the spoils of war. Virgil suggests that she was intent on plundering the corpse of Chloreus either to dedicate Trojan weapons in a temple, or else to have them to wear herself. Either way, the temptation is to dismiss or diminish Camilla by comparing her to an Amazon: while there are undeniable parallels, both are *bellatrices* and both expose a breast for example, and although Virgil calls her 'Amazon', Camilla is her own woman-warrior and she should be treated as such. Homogenising her does her little justice[1].

We first meet her as the final warrior in the parade of Italian allies in Book 7 of the *Aeneid*, a privileged position; as noted, she is a *bellatrix*, a woman warrior[2]. Not for her womanly wool-working or baskets of wool – Camilla's forté was battling hard and speeding, fleet-footed, after the enemy. Young men and *matronae* were agog in admiration at her splendour, her aura and her charisma as she rode by. Her position at the end of Virgil's procession emphasises her martial expertise and closes the catalogue on a high note, a morale booster for the people.

She reappears in *Aeneid* Book 11 in the thick of battle,[3] but before that a short biography describes her early childhood as a semi-feral daughter in a one-parent family, living and hunting in the woods, trained by her father. The shadow of war informs her life right from the start when her father ties her, a baby, to a spear and shoots her over a river to escape a pursuing foe. Camilla thus becomes a weapon of war, a metaphor for war[4]. Her beauty, however, would remain undiminished as later she was much in demand as a wife for many a mother's son[5].

Her battlefield prowess is second to none:

> She rains down from her hand volleys of pliant shafts, or whirls with tireless arm a stout battle-axe; her shoulder bears Diana's resounding weapons and golden bow. Sometimes retreating when forced to flee, this maiden shoots arrows with a rearward-pointing bow as she flies.

Her comrades are hand-picked, armed to the teeth, just like Amazons:

> Around her move her chosen peers, Larina, virgin brave, Tarpeia, brandishing an axe of bronze, and Tulla, virgins from Italy whom the divine Camilla hand-picked to share her glory, each a faithful servant in days of peace or war. The maids of Thrace ride along Thermodon's frozen flood, and fight with emblazoned Amazonian arms around Hippolyta; or when Penthesilea returns in triumphal chariot amid shrill shouting, and all her host of women clash the moon-shaped shield in the air[6].

Further reading

Boyd, Barbara Weiden (1992). 'Virgil's Camilla and the Traditions of Catalogue and Ecphrasis (Aeneid 7.803–17)'. *The American Journal of Philology.* 113 (2): 213–234

Keith, A.M. (2000). *Engendering Rome: Women in Latin Epic.* Cambridge

Viparelli, Valeria (2008). 'Camilla: A Queen Undefeated, Even in Death'. *Vergilius.* 54: 9–23

Lavinia – *instrumental in the very birth of Rome*

Lavinia was the second wife of Aeneas, founder of Rome. When she was widowed by Aeneas's death, Lavinia took on the role of regent until Ascanius, her stepson, was old enough to rule independently. Indeed, when he did finally assume full regal responsibility, one of his first acts was to found a new settlement in the Alban Hills, leaving Lavinia to rule Lavinium. Livy tells us that *tanta indoles in Lavinia erat*, that she was a very gifted woman. Obviously she was just that if she was able to govern in such a bellicose and unpredictable environment. Significantly, Lavinia, a capable and strong woman, was instrumental in the very birth of Rome

and joins that small, exclusive club which numbers Argia, Lucretia and Verginia in its exclusive membership of women who influenced the early constitution and political history of Rome.

As a young woman, Lavinia had always been a desirable match; when she was old enough for a husband, *matura viro, (Aeneid* 7, 53) she was pursued by Turnus no less, Aeneas' arch enemy. However, her father, King Latinus, had been warned by the gods that a Latin husband was not an option and that she should marry a foreign warrior. The prophecy was reinforced when Lavinia's hair burst into flames and the seer predicted great glory for her but terrible wars for Italy – the very same *magnum bellum* pronounced by the Cumaean Sibyl to Aeneas in the underworld in *Aeneid* book 6.

Dido – *deep down among the dead men*

Dido is both a tragic victim of war and a potent catalyst of future war. Betrayed by Aeneas and cruelly sidelined by his dedication to his mission to fight for and found Rome, we find Dido in *Aeneid* Book 4 incandescent with rage and in a pit of misery and despair: 'she rages, out of her mind, and rushes through the city, mad as a Bacchant.' She confronts the treacherous Aeneas and promises to haunt him for eternity in a threat reminiscent of a *defixio,* a spell:

> When I'm gone I'll follow you into the black fire of Hell, when icy death draws out the spirit from my limbs; my ghost will be everywhere; you'll pay the price, you traitor, and I will hear about it – the news will reach me deep down among the deadmen.

Dido had seen the future and the future frightened her; when she made offerings to the gods on the incense-burning altars, the milk turned black and the wine she poured congealed into an obscene gore. *Horrendus dictu:* 'shocking to say it', she resolved to take her own life. She can hear the ghost of Sychaeus, her late husband, and a solitary owl wails its song of death; Dido recalls the warnings of the *pious* priests who correctly predicted that her relationship with Aeneas would all end in tears. She instructs her sister, Anna, to build a pyre and enlist the services of the remarkable Massylian priestess, the Sibyl; she will erase the memory of Aeneas with her spells; his things will burn on the pyre. By implication, Aeneas is *impious*; he is subjected to a kind of *damnatio memoriae* in which he is wiped from Dido's memory, as befits a traitor.

Virgil's audience would have understood only too well the potency of Dido's threats: Rome did indeed pay the price for Aeneas' duplicity, with three devastating Punic Wars, one of which was nearly terminal for Rome; Aeneas was indeed haunted by Dido in their frosty meeting in the underworld. The Dido episode resonates uncomfortably with the political upheaval caused so recently in Virgil's time by Cleopatra VII, a foreign queen eerily reminiscent of Dido, whose facility for global power-play would be viewed as comparable to the unnatural skills of a sorceress.

Alecto – *her mission is to wreak havoc amongst the Trojans and bring about their defeat*

Alecto (the 'implacable' or 'unceasing anger') is one of the Erinyes, or Furies. Her credentials for evil are impeccable: Hesiod says that she was the daughter of Gaea, fertilized by the blood spilled from Uranus when Cronus castrated him; she is the sister of Tisiphone (Vengeance) and Megaera (Jealousy). Her job is to punish crimes like anger, especially if they are against other people; as such, she functions like Nemesis who castigates crimes against the gods.

In the *Aeneid* she is ordered by Juno in Book 7 to prevent the Trojans from currying favour with King Latinus either by marriage or militarily; her mission is to wreak havoc amongst the Trojans and bring about their defeat. To do this, Alecto possesses Queen Amata (wife of Latinus, king of the Latins), who incites all of the Latin mothers to riot against the Trojans. She disguises herself as Juno's priestess, Calybe, and comes to Turnus in a dream, persuading him to begin the war against the Trojans. Turnus ridicules her so she attacks him with a flaming torch, causing his blood to 'boil with the passion for war'. Alecto cannot be sated in her war-mongering and so impudently asks Juno if she can provoke more strife by sucking in bordering towns to the conflict. Juno replies archly that she will manage the rest of the war herself.

Juno – *another thorn in the side for Aeneas and Rome*

Like Alecto, Juno bears Aeneas and the Trojans a monumental grudge which manifests itself throughout the *Aeneid* as she tries ceaselessly to thwart Aeneas' destiny to found Rome and attempts to confound him at every opportunity. Juno had remained implacable and bitter after the insult meted out to her when Paris overlooked her in the divine beauty contest in favour of Aphrodite. Juno favours Carthage and Dido, both slighted and doomed to destruction by Aeneas and his descendants, and she backs Turnus in the wars against Aeneas in Italy. She is, then, a prime and avid mover of war, a major dynamic force in stoking the *arma* and confounding the *vir* that are the opening lines of Virgil's *Aeneid*: *arma virumque...*

Right from the start of his odyssey, Aeneas' progress is dogged by this persistent and determined Juno. She makes a dramatic entrance into the action when she persuades Aeolus the storm god to raise a storm to blow him, literally and figuratively, off course (1, 50ff). She conspires to have Dido detain him in Carthage and she arranges for the scuttling of the Trojan fleet (5, 680ff) to try and get a marooned Aeneas to found his homeland in Sicily. Luckily, Jupiter and rain save the day. By Book 7 she has accepted Fate and restates her determination to at least delay Aeneas (313–16). As we have seen, she possesses Amata through Alecto and turns her against Aeneas and his desire to marry Lavinia; and she inspires Juturna to save the life of Turnus, her brother and Aeneas' enemy.

Further reading
Farrell, Joseph (2021). *Juno's Aeneid: A Battle for Heroic Identity*. Princeton
Wildman, B.J. (1908). 'Juno in the Aeneid'. *The Classical Weekly*. 2(4): 26–29

Asbyte – *like other warrior women, she is never much bothered by traditional women's work; she is a huntress and a virgin*

Asbyte (died 219 BCE) was a Libyan princess in the Carthaginian army before the Second Punic War, according to Silius Italicus's *Punica*. Silius Italicus (*c.* 28 – *c.* 103 CE) is the author of the 12,202 line epic *Punica*, the longest surviving poem in Latin from antiquity. Book 2 opens with Hannibal dismissing Roman envoys from Saguntum and addressing his troops with a threat to Rome. The siege of Saguntum continues, during which the warrior princess Asbyte is killed by Theron, who in turn is slain by Hannibal and mutilated.

A Camilla-type figure, Asbyte hails from Libya and, like other warrior women, she is never much bothered by traditional women's work; she is a huntress and a virgin. She is bold, *audax*, and has a band of sisters to follow her in battle; she has the characteristics of an Amazon, including the bare right breast.

Her arrows whizz into the citadel she is attacking while one of her comrades, Harpe, saves her from certain death when she stands before the flight of an arrow loosed by Mopsus and in mid shout takes it in her open mouth, from where it passes right through her. The battle raged on but Asbyte's time on Silius' blood-soaked battlefield is short: the warrior maiden, *belligera virgo,* is targeted by Theron; she escapes one attack but returns to the fray, at which point she is tipped out of her chariot and

> as Asbyte tried to flee from the fight, he [Theron] sprang up to stop her, and smashed her with his club between her two temples; he spattered the shiny wheels and the reins, tangled up by the terrified horses, with the brains that gushed from her broken skull... he then cut off the head of the maiden when she rolled out of her chariot. His rage was still not sated, for he fixed her head on a long stake for all to see, and made men carry it in front of the Punic army.

Further reading
Penrose Jnr, Walter Duvall (2016). *Postcolonial Amazons: Female Masculinity and Courage in Ancient Greek and Sanskrit Literature.* Oxford

Argia – *'cultivates a sudden passion for courage that is not a woman's courage'*

Argia exhibits shades of masculine militarism as portrayed in Statius' epic *Thebaid,* written between 80 and 92 CE. Statius' narrative is, of course, familiar to us from Greek tragedy, in particular from the *Phoenissae* and the *Suppliants* by Euripides. We pick up the story where Eteocles and Polyneices have slain each other in battle and their mother, a distraught Jocasta, commits suicide. Argia is the wife of Polyneices and graduates in the action of the poem from deserted, *relicta,* army wife to heroine and female warrior.

Argia was a catalyst for war well before she knew it herself. It all began with her marriage to Polyneices which Statius describes as *semina belli*, seeds of war, contrived by Jupiter to enable him to launch the seven against Thebes. Argia is soon abandoned as Polyneices heads off to his unjust war; at first she is fearful but soon is asking her father, Cerastus, to bring on the war[1].

The crucial moment for Argia comes in the final book of the epic when Creon, recently installed as the new tyrant of Thebes, defies all convention and the rules of war and religion by denying Argia the right to bury Polyneices. Meanwhile, the Argive women, acting as ambassadors, appealed to Theseus, king of Athens, for military aid; Argia, meantime, has left for Thebes to resolve the issues over Polyneices' burial despite the possibility of a cruel death at the hands of Creon.

Argia moves from being one of the inferior sex, men supposedly being the better sex, *melior sexus*, to a *matrona virilis*, a matron with strong, masculine qualities, who has deserted her gender: *sexu relictu*. According to Statius her *virtus* is definitely not a woman's – *non feminea* – and she later 'cultivates a sudden passion for courage that is not a woman's courage': *non femineae subitum virtutis amorem colligit Argia*[2].

Women generally can also exhibit *virtus,* despite its explicit connotations of manliness (*vir*) and traditional male attributes of strength and bravery, as well as of virtue. From Seneca we hear about the conspicuous valour of Cornelia and Rutilia described as *conspecta virtus*; in the *Ad Marciam* he spells out his belief that women are just as capable of displaying *virtutes* as men. Argia's *virtus* brings her up against Creon. Her decision to defy Creon's orders is a huge undertaking – *immane opus* – it is an *arte dolum* – a crafty strategy and it is driven by chaste love and *pietas*, a duty to her son carried out in the face of the *fulmina regni*, the thunderbolts of the king, a blood-stained king, an abominable king. The three times repetition of the word king would have resonated with Statius' audience, still mindful of the monarchy from the early days of Rome. Argia is, therefore, linked with Lucretia and Verginia – the two virtuous *matronae* who stood up to tyranny and who, in so doing, paved the way for the Roman republic and Roman democracy. But she is better than that even: she is more than a match for the Amazons, those celebrated female warriors who became, for many, the role models for the fighting woman in classical times. Belligerent woman as she is, Argia's chutzpah is, nevertheless, founded on sound *matrona* values, as we see when she poignantly recognises Polyneices' body on the battlefield by the clothes which she herself had devotedly woven for him[3].

The Lemnian Women II – *blood flows in the bedrooms and gurgles and foams in the chests of the slain Lemnian men*

We have met the Lemnian women already – in the section on Greek women.

A Lemnian deed or crime is defined as a deed or crime of exceptional barbarity and cruelty. The phrase originates from two shocking massacres perpetrated by the Lemnians: one was the extermination of all the men and male children on the

island by their outraged women; the other was the infanticide by the men of all the children born of Athenian parents in Lemnos.

The epic poet Valerius Flaccus (died *c.* 90 CE) describes the first for us, leaning heavily on a long literary tradition:

> The day arrived when the Thracian men were massacred by the women in this internecine war: *Thracas qui fuderat armis*; ominously, the returning Thracian boats approached Lemnos laden with the spoils of war, *praemia belli,* which included livestock – and foreign women. Venus – angry that the Lemnians did not pay her honour – fired up Rumour to spread the word that the Lemnian warriors were bringing back Thracian women to share their beds; Venus aimed to inflict pain on and incite the Thracian women into a frenzy. Rumour ran from house to house, comparing the local Lemnian women's beauty, their patient chastity, their wool-working as good *matronae* – comparing them with these foreign immigrants with painted faces. The poet describes the Lemnians as Penelopes and Lucretias, paragons of female virtue, while the Thracians are depicted as whores. Further rumours have it that the Lemnian women will be exiled, their places taken by these Thracians incensing the Lemnians yet further. They feign a welcoming homecoming for their husbands and then retire with their husbands to eat and make love.

Venus then takes on the role of commander and incites a terrible revenge: covered in blood she rushes into a house clutching a still pulsating decapitated head; Venus is the first avenger: she forcibly arms the women with swords and they fall on their once-loved husbands, many of whom are paralysed by fear at the butchery going on all around them, perpetrated by their own wives, mothers and daughters. Blood flows in the bedrooms and gurgles and foams in the chests of the slain Lemnian men; the women add to the atrocity when they torch their houses and block the exits.

In Statius (45–96 CE), Hypsipile's description of the carnage is, unbelievably, even more gruesome than that given by Valerius:

> And we made our way through the deserted streets of the city, concealed in the dark, finding everywhere the heaped corpses from the night's massacre, where cruel twilight had seen them slain in the sacred groves. Here were faces pressed to beds, sword-hilts erect In wounded breasts, broken fragments of huge spears, knife-rent clothes among corpses, upturned wine-bowls, entrails drenched in blood, and bloody wine pouring over the wine cups out of severed throats.

Statius even mentions some of the women by name. In the 3rd century BCE Apollonius Rhodius had given us more precise reasons why Lemnos came to be

ruled by women; Apollonius also tells us of the Lemnians subsequent belligerence and rejection of traditionally female activities:

> The mass androcide committed by the Lemnian women has led to a race without men, thus introducing the need for the women to adopt traditionally male functions: working the fields instead of the wool and defending their homes in war, rather than managing the *oikos* in domestic peace. Avoiding extinction was, as with the Amazons, a chronic problem, eased here, on the advice of the wisest of Lemnian heads, by the chance visit of the Argonauts.

Valerius Flaccus has the women state the crisis bluntly: 'Venus herself wishes us to join our bodies with theirs, while our wombs still remain strong and we are not beyond childbearing age'.

The Roman novel too featured women caught up in the shadowy and disturbing world of war; this from Heliodorus:

The Old Woman of Bessa – *she is so desperate for news of one son that she resorts to the black arts in a necromancy with the other.*

Heliodorus of Emesa, in the 3rd century CE, describes a necromancy conducted by a witch, an old woman of Bessa, in his *Aethiopica*. Calasiris, a priest of Isis, and Charicleia, the heroine of the novel, come across the aftermath of a battle between the Persians and the Egyptians, a battlefield strewn with corpses. The only living soul is an elderly Egyptian woman mourning her dead son; she invites the couple to pass the night there with her.

During the night Charicleia witnesses a shocking scene: the old woman digs a trench, lights two pyres on either side and places the body of her son between them. She pours libations into the trench and throws in a male effigy fashioned from dough. Shaking, and in a trance, the old woman cuts her arm with a sword and drips her blood into the trench uttering wild and exotic prayers to the moon. After some magic she chants into her son's ear and makes him stand up; she then questions him about the fate of her other son, his brother. The corpse at first says nothing but, because his mother persists, rebukes her for sinning against nature and breaking the law with her necromancy when she should have been organising his burial.

He reveals not only that his brother is also dead but that she too will soon die violently because of her life of lawlessness. Before collapsing again the corpse reveals the awful truth that the necromancy has been witnessed not only by a priest beloved by the gods but also by a young girl who has travelled to the ends of the earth looking for her lover. A happy outcome is promised for both; the old mother is outraged by this intrusion and, while pursuing Calasiris and Charicleia, is fatally impaled on a spear The old woman exemplifies the victim of war: in this case a mother bereft of her two sons slain in battle; she is so desperate for news of the one who is missing that she resorts to the black arts in a necromancy with the other.

The Sabine women – *pragmatic and skilled in diplomacy*

The Sabines presented a real problem for the early Romans. The first significant contact between the two is the legendary incident in 750 BCE: the 'rape' of the Sabine women. Livy tells us all about it:

> Rome was by now strong enough to hold her own in war with any of the adjacent states; but owing to the shortage of women a single generation was likely to see the end of her expansionism, since she had neither prospect of posterity at home nor the right of intermarriage with her neighbours. So, on the advice of the senate, Romulus sent envoys to all the nearby nations to solicit an alliance and the privilege of intermarrying... Romulus' explained that the neighbours should not be reluctant to mingle their stock and their blood with the Romans, whose men were just as good as theirs. Nowhere did the embassy receive a friendly hearing. In fact they were spurned on the grounds that everyone was nervous about that great power which was growing up on their borders.
>
> This was a bitter insult to the Romans, and the matter seemed certain to end in violence. Romulus, concealing his resentment, prepared sacred games in honour of the equestrian Neptune, which he called Consualia. He then announced the spectacle to the surrounding tribes, and his subjects prepared for the day. Many people – for they were also eager to see this new city – gathered for the festival, especially those who lived nearest, the inhabitants of Caenina, Crustumium, and Antemnae. The Sabines, too. They were hospitably entertained in every house, and when they had looked at the site of the city, its walls, and its many buildings, they marveled that Rome had so rapidly grown so great.
>
> When the time came for the celebrations, a pre-planned attack began. At a given signal the Romans darted this way and that, to seize and carry off the Sabine maidens. In most cases these were taken by the men as they found them but some, of exceptional beauty, had been marked out in advance for the senators, and were carried back to Roman territory. The mayhem broke up in a panic with the parents of the girls fleeing in distress. They accused the Romans with the serious crime of violating hospitality, and invoked the gods to whose solemn games they had come only to be deceived in violation of religion and honour.
>
> Romulus spoke to the abducted maidens who were furious and unhappy about their new plight. He explained that it was all their parents' fault when they had refused Rome the right to intermarry; nevertheless, the daughters would be married off and would become Roman citizens enjoying the rights and privileges that brought.

Generous as this might sound, Romulus was essentially warning them to be pragmatic and get used to it. He added that he understood the girls' sense of injury but they would find their future husbands the kinder for this reason, that every man would try hard not only to be a good husband, but also to console his wife for the home and parents she had lost.

> – Livy 1, 9, adapted from trans. B.O. Foster,
> Cambridge, MA, 1919

But that was by no means the end of the Sabine women: they were to go on to display impressive diplomacy and pragmatism when they interceded between the aggrieved Sabines and the aggressive Romans.

The Sabine women bravely threw themselves into the battling and persuaded Tatius and Romulus to bury their differences, leading to their joint rule over the Romans and Sabines. Livy gives us the details:

> [They] went boldly into the midst of the flying missiles with disheveled hair and ripped garments. Running into no-man's land they tried to stop any further fighting and calm excited passions by appealing to their fathers in the one army and their husbands in the other to avoid bringing upon themselves a curse by staining their hands with the blood of a father-in-law or a son-in-law, nor the taint of parricide. "If," they cried, "you are so weary of these family ties, these marriage-bonds, then turn your anger upon us; it is we who are the cause of the war, it is we who have wounded and slain our husbands and fathers. Better for us to die rather than live without one or the other of you, as widows or as orphans".
>
> – Livy, *Ab Urbe Condita* 1, 11

Further reading
Brown, Robert (1995). 'Livy's Sabine Women and the Ideal of Concordia'. *Transactions of the American Philological Association.* 125: 291–319

Tarpeia – *wide-eyed Tarpeia could not see beyond the gold bracelets and bejewelled rings*

After their women had been abducted by the Romans, according to Livy, the Sabines declared war on Rome. They were helped by Tarpeia, a disaffected Roman woman who opened the city gates to the Sabines when she had ostensibly gone outside the walls to fetch water for a sacrifice.

Tarpeia was daughter of Spurius Tarpeius, the commander of the Roman citadel. Why she betrayed Rome we do not know for sure. Some say that she was bribed by Tatius, the Sabine king, with the enigmatic promise of rewarding her with what

the Sabine soldiers wore on their shield arms, their left arms. A wide-eyed Tarpeia could not see beyond their gold bracelets (*armillae*) and bejewelled rings; the Sabines, unfortunately, had a different view and simply crushed her to death with their shields. Others give an aetiological explanation and maintain that the Sabines killed the treacherous Tarpeia by pushing her off a twenty-five metre high cliff on the Capitol which later took her name (*Rupes Tarpeia* or *Saxum Tarpeium)* and became notorious as a terrifying place of execution for murderers, traitors, the mentally and physically disabled. The Latin proverb, *arx Tarpeia Capitoli proxima,* 'The Tarpeian Rock is close to the Capitol', means one's fall from grace can happen all too quickly.

Lucretia (510 BCE) – *her suicide precipitated a rebellion that led to the transition of Roman government from a kingdom to a republic*

Lucretia was a noblewoman in ancient Rome, whose rape by Sextus Tarquinius and subsequent suicide precipitated a rebellion that overthrew the Roman monarchy and led to the transition of Roman government from a kingdom to a republic.

This distasteful episode firmly implicates matronly *pudicitia* (sexual virtue and modesty) and valour (*virtus)* in the traditional foundation of Rome. Livy tells how a dissolute Tarquinius blackmailed Lucretia by threatening to put it about that she had been *in flagrante delicto* with a slave; his plan was to have her and a slave killed, their corpses placed alongside each other in bed, if she did not yield to him.

Lucretia could not live with the shame that such a calumny would bring on her and succumbed; consequently her body is defiled but, she protests, her mind remains pure. Despite the unconditional forgiveness offered by her father, Lucretius, and of Collatinus, her husband, Lucretia commited suicide. This brave and virtuous woman is now eternally and inextricably linked with Rome's proud early beginnings. The Roman kings are, by the same token, denigrated as the malevolent despots they often were.

Livy describes the scene during the Romans' siege of Ardea:

> It chanced, as they were drinking in the quarters of Sextus Tarquinius, where Tarquinius Collatinus, son of Egerius, was also a guest, that the subject of wives came up. Every man fell to praising his own wife with enthusiasm, and, as their rivalry grew hot, Collatinus said that there was no need to talk about it, for it was in their power to know, in a few hours' time, how far the rest were excelled by his own Lucretia. "Come! If the vigour of youth is in us let us mount our horses and see for ourselves the disposition of our wives. Let every man regard as the surest test what he sees when the woman's husband enters unexpectedly." They were wine-fuelled: "Agreed!" they all cried, and clapping spurs to their horses were off for Rome.

They arrived at Collatia, where Lucretia was found in a very different situation to the daughters-in-law of the king who were enjoying a luxurious, boozy banquet with their young friends; but Lucretia, though it was late at night, was up busily working her wool, while her slaves worked around around her in the lamplight.

So, the winner of this contest in womanly virtues was clearly Lucretia. It was then that Sextus Tarquinius was seized with a wicked desire to have Lucretia; it was not only her beauty, but her demonstrable chastity as well that excited him. However, they returned to camp.

A few days later, Sextus Tarquinius, without letting Collatinus know, went to Collatia where he was welcomed and put up in a guest room. Burning with lust, he waited until everyone was asleep, then, drawing his sword, he came to the slumbering Lucretia. Holding her down with his left hand on her breast, he said, 'Stay still, Lucretia! It's me, Sextus Tarquinius. I have my sword here. Utter a sound, and you're dead!' Terrified the woman was startled out of her sleep. No help was at hand, only imminent death. Then Tarquinius began to declare his love, to plead, to mingle threats with prayers, to bring everything he could to bear upon her woman's heart. When he found her obdurate and not to be moved even by fear of death, he went farther and threatened her with shame, saying that when she was dead he would kill his slave and lay him naked by her side, that she might be said to have been put to death legally in adultery with a man of the lower orders. At this dreadful prospect her resolute modesty was overcome, as if with force, by his conquering lust. Tarquinius left, exulting in his victory over a woman's honour.

> Lucretia, grieving at her great calamity, sent the same message to her father in Rome and to her husband at Ardea: that they should each take a trusted friend and come to her; that they must do this and do it quickly, for a terrible thing had happened. Spurius Lucretius came with Publius Valerius, Volesus' son. Collatinus brought Lucius Junius Brutus.
>
> They found Lucretia sitting distraught in her room. When her friends came in, it brought the tears to her eyes, and to her husband's question, "Are you OK?" she replied, "Far from it; for what can be well with a woman when she has lost her honour? The imprint of a strange man, Collatinus, is in your bed. Yet my body only has been violated; my heart is guiltless, as death shall be my witness. But pledge your right hands and your words that the adulterer shall not go unpunished. Sextus Tarquinius it was who last night exchanged hostility for hospitality, and forcibly brought ruin on me, and on himself no less – if you are men – when he took his pleasure with me." They give their pledges, every man in turn and try to comfort her, sick at heart as she is, by diverting the blame from her who was forced to the wrongdoer. They tell her it is the mind that sins, not the body; and that where purpose has been wanting there is no guilt. "It is for you to determine," she answers, "what is due to him;

> for my own part, though I acquit myself of the sin, I do not absolve myself from punishment; not in the future will any unchaste woman ever live through the example of Lucretia." Taking a knife which she had concealed beneath her dress, she plunged it into her heart, and sinking forward upon the wound, died as she fell.
>
> – Adapted from Livy 1, 57–8;
> Livy Books I and II Cambridge, MA, 1919

Lucretia, nevertheless, despite her commendable qualities and the reverence in which she has been held for centuries, does not escape the defeminisation suffered by all her sex, which tells us how ingrained and permanent it was in the male mind. Lucretia, that paragon of female virtue, is defeminised by both Ovid and Valerius Maximus who, in praising her, ascribe masculine qualities to her and to her actions: to Ovid she is a *matrona* with a manly spirit: *animi matrona virilis*[1]; to Valerius Maximus she is *dux Romanae pudicitiae* – a leader in Roman sexual propriety – 'who, by a wicked twist of fate, possesses a man's spirit in a female body'[2]. As we will see in the case of Cloelia, *dux* is almost always used to describe a man; where it is used for a woman it signifies brave Cloelia and, more notoriously, two powerful, unnerving foreign women: Dido and Boudica[3].

Further reading

Chrystal, Paul (2023). 'Two Case Studies on Receptions of Sex and Power: Lucretia and Verginia'. In Moore, K. (2023) *The Routledge Companion to the Reception of Ancient Greek and Roman Gender and Sexuality*. London

Donaldson, Ian (1982). *The Rapes of Lucretia: A Myth and Its Transformations*. New York

Cloelia – *a brave leader of men*

Cloelia is described by Livy as *dux* in her courageous escapade, an epithet usually reserved for men, when she demonstrated conspicuous bravery and good military sense. Lars Porsena took some Roman hostages as part of the peace treaty which ended the war between Rome and Clusium in 508 BCE. One of these hostages was a young woman named Cloelia. She managed to flee the Clusian prison camp on horseback, at the head of a group of Roman girls. According to Valerius Maximus, they then swam across the Tiber back to the Romans. Porsena demanded that she be returned, and the Romans consented. When she arrived back at Clusium, Porsena was so impressed by her bravery that he allowed her go free and to select half the remaining hostages to be liberated with her. She picked the Roman boys, because she knew that they could be useful fighting in the war[1].

Another version has Cloelia and the other the female hostages went to the river to bathe. Having persuaded their guards to leave them alone at the river, in order

to remain modest, they took the opportunity to swim across the river into Roman territory.

Either way, the Romans gave Cloelia an honour usually reserved for men: an equestrian statue, located at the top of the Via Sacra[2].

Tullia – *she gave her name to the Vicus Sceleratus, street of infamy and wickedness, in memory of her atrocity*

Tullia stands in stark contrast to Lucretia and Cloelia, on a number of levels: Tullia was the younger of the two daughters of Rome's sixth king, Servius Tullius, and the last queen of the Roman Kingdom. She married Lucius Tarquinius and, in league with her husband, plotted the overthrow and murder of her father, thus securing the throne for Lucius Tarquinius. Naturally, this made her an infamous and reviled figure in ancient Roman culture.

After gaining backing of a large number of senators, through lies and bribery Tarquinius went to the senate house with an armed guard and, in an inflammatory and treasonable manner proceeded to seat himself on the Roman throne (Livy 1, 47). When Servius Tullius protested, Tarquinius hurled him into the street, where he was murdered by Tarquinius' assassins, apparently at Tullia's bidding. Tullia then drove in her carriage to the senate house, where she hailed her husband as king. Lucius Tarquinius ordered her to go home, to avoid the ensuing chaos. She drove along the Cyprian Street where she discovered her father's mutilated remains and, in a mad frenzy, drove the carriage over his body. The desecration led to the street earning the name the *Vicus Sceleratus,* street of infamy and wickedness, in memory of her atrocity.

The Bacchantes – *excited the sexual emotions in women and disrupted all Roman norms of behaviour and morality*

Introduced into Rome from southern Italy, the Bacchanalia were at first held in secret, attended by women only, on three days of the year. The cult of Bacchus was notorious for the frenzy and shrieking of its adherents, the cacophonous beating of drums and the clashing of cymbals. It had huge popular appeal even before men were admitted: Livy described its spread as an epidemic; it apparently excited the sexual emotions in women and disrupted all Roman norms of behaviour and morality.

Later, admission was extended to men, and celebrations took place by night as often as five times a month. The reputation of these orgies led in 186 BCE to a decree that prohibited the Bacchanalia throughout Italy, except in certain special cases.

There were clandestine initiatory rites which at first were revealed to a select few, but they soon began to be known among men and women generally. To the religious element inherent in the rites were added the delights of wine and feasting in order to attract increasingly more adherents. During a rite, when wine had taken its effect, and night-time and the mingling of males with females, youth with the aged, had destroyed every ounce of modesty, all sorts of vice took place: the

promiscuous intercourse between free men and women, perjured witnesses, forged seals and wills and unreliable evidence, all were contrived here. Likewise, there were frequent poisonings and secret murders, so covert that sometimes the bodies were never found for burial. Crimes remained hidden because, amid the howlings and the crash of drums and clash of cymbals, you could not hear the cries of victims suffering while the debauchery and murders went on and on…many victims were women, because they are the cause of this mischief.

Plutarch gives us some interesting details regarding the role of women in the rites:

> for example, frenzied women made straight for the ivy and chewed on it to bring on "a wineless drunkenness and joyousness; [it] has an exciting and distracting smell of madness, deranges people, and agitates them"[1].

Further reading

Takács, Sarolta A. (2000). 'Politics and Religion in the Bacchanalian Affair of 186 BCE'. *Harvard Studies in Classical Philology.* 100: 301–310

Walsh, P.G. (1996). 'Making a Drama out of a Crisis: Livy on the Bacchanalia'. *Greece & Rome.* 43 (2): 188–203

Hispala Faecina

Something had to be done. The anti-social rites were tearing at the very fabric of Roman society, undermining law and order and destabilising the foundation of Roman society, the *familia.*

It all came to a head in 186 BCE when Publius Aebutius was targetted by his greedy stepfather who, with the boy's mother, Durenia, conspired to dispose of him by enrolling him in the Bacchanalia. Aebutius' girlfriend, Hispala Faecina, a reforming prostitute who had witnessed the orgiastic rites as an initiate, was horrified when she heard this and dissuaded Aebutius from going along with it. Such was the notoriety of the cult and the hazards involved: routine ritual male rape while any opposition resulted in summary sacrifice.

On the advice of his aunt, Aebutia, Aebutius reported the matter to the consul, Spurius Postumius whose wife Sulpicia then interviewed both Aebutia and Hispala to establish their integrity; Hispala, understandably reluctant at first, eventually agreed to reveal all, taking up residence in Postumius's house for safety. The outcome was that, according to Livy, 7,000 Bacchantes were prosecuted under the *Senatus Consultum de Bacchanalibus*, many of whom fled Rome or committed suicide[1]. A manhunt ensued and imprisonments and executions followed; many of the convicted women were handed over to their *paterfamilias* for the family to dispense justice; most of the Bacchic shrines in Rome and throughout Italy were then destroyed. Both whistle-blowers were handsomely rewarded: a measure of the deep concern the rite caused the authorities and of their determination to stamp it out[2].

Further reading

Watson, Alan (2005). 'Bacchanalian Rewards: Publius Aebutius and Hispala Faecenia' (PDF). *Fundamina.* 411–412

Verginia (449 BCE) – *is abducted on her way to school, and killed by her father*

The death of Verginia in 449 BCE has not dissimilar causes and ramifications to the tragedy that befell Lucretia. It occurred at a highpoint of the Conflict of the Orders – the struggle between the patricians and the plebeians – during the decemvirate – an ultimately unsuccessful attempt to reorganise the Roman administration and codify the law (which had found voice as the enduring *Twelve Tables*) while all other magistracies were suspended and decisions were not subject to appeal. Democracy was, in effect, on hold.

The reactions of Verginius, father of Verginia, provoked a secession of the plebeians, and precipitated the abolition of the *decemvirate* and the restoration of the consulship and tribunate of the peoples, and with it the right of appeal. The *decemvirs* had become increasingly tyrannical and refused to give up power, even though their tenure was limited to two years. Such corruption and despotism was eerily reminiscent of the rule of the kings, overthrown some sixty years earlier and due, as we have seen, in no small part to Lucretia.

Members of the second decemvirate either committed suicide or were exiled. John Webster and Thomas Heywood (in *Appius and Verginia,* an early 17th-century tragedy), sum up the political influence of Lucretia and Verginia very neatly:

> Two lades fair, but most unfortunate/Have in their ruins rais'd declining Rome,/Lucretia and Virginia, both renowned/For chastity.

Livy tells us how Appius Claudius had conceived a guilty passion for Verginia, a girl of plebeian birth. The girl's father, L. Verginius, held a high rank in the army of Algidus; he was a man of exemplary character both at home and in the field. His wife had been brought up on equally high principles, and their children were being raised in the same way. He had betrothed Verginia to L. Icilius, a former tribune…

> This is the girl, now in the bloom of her youth and beauty, who excited Appius' passions, and tried to prevail on her with presents and promises. When he found that her virtue was proof against all temptation, he had recourse to unscrupulous and brutal violence when he commissioned a client, M. Claudius, to claim the girl was his slave, and to bar any claim on the part of her friends to retain possession of her until the case was tried, as he thought that the father's absence on military service afforded a good opportunity for this illegal action.
>
> As Verginia was going to her school one morning in the Forum the decemvir's stooge touched her, declaring that she was the daughter

of a slave of his, and a slave herself. He then ordered her to follow him, and threatened, if she hesitated, to carry her off by force. While the girl was stupefied with terror, her maid's shrieks, invoking "the protection of the Quirites," drew a crowd. Later, when Verginius had returned, dressed in mourning, he brought his daughter, similarly attired, and accompanied by a number of matrons, into the Forum. A large body of sympathisers stood round him. He went amongst the people, took them by the hand and appealed to them to help him, not just out of compassion but because they owed it to him because he was at the front day by day defending their children and their wives; of no man could they recount more numerous deeds of endurance and of daring than of him. What good was it all, he asked, if while the City was safe, their children were exposed to what would be their worst fate? The women who accompanied him made a greater impression by their silent weeping than any words could have made... Verginius, seeing no prospect of help anywhere, turned to the tribunal. He took the girl and her nurse aside to the booths near the temple of Venus Cloacina, now known as the "New Booths," and there, snatching up a butcher's knife, he suddenly plunged it into her breast, saying, "In this the only way I can, I vindicate, my child, thy freedom." Then, looking towards the tribunal, "By this blood, Appius, I devote thy head to the infernal gods."

Alarmed at the outcry which arose at this terrible deed, the decemvir ordered Verginius to be arrested. Brandishing the knife, he cleared the way before him, until, protected by a crowd of sympathisers, he reached the city gate. Icilius and Numitorius took up the lifeless body and showed it to the people; they deplored the villainy of Appius, the ill-starred beauty of the girl, the terrible compulsion under which the father had acted. The *matronae*, who followed with angry cries, asked, "Was this the condition on which they were to rear children, was this the reward of modesty and purity?" with other manifestations of that womanly grief, which, owing to their keener sensibility, is more demonstrative, and so expresses itself in more moving and pitiful fashion. The men, and especially Icilius, talked of nothing but the abolition of the tribunitian power and the right of appeal and loudly expressed their indignation at the state of public affairs.

– Livy 3, 44–48; Livy. *History of Rome.*
Trans. Rev. Canon Roberts. New York

Further reading

Chrystal, Paul (2023). 'Two Case Studies on Receptions of Sex and Power: Lucretia and Verginia' in Moore, K.R. (ed.) *The Routledge Companion to the Reception of Ancient Greek and Roman Gender and Sexuality*. London

McClure, Laura (1959). *Sexuality and gender in the classical world: readings and sources*. Oxford

Paulina Busa – *a model of bravery, generosity and patriotism*

Female bravery, generosity and patriotism is evidenced by the actions of Paulina Busa of Canusium (Canosa di Puglia) in 216 BCE after the catastrophe that was Cannae. Stragglers from the battle made their way to Canusium in Apulia where the wealthy Busa fed, clothed and provided them with money; she summoned doctors and medical supplies and took care of the casualties.

Eventually a force of some 10,000 men was assembled which Publius Scipio was able to turn into a viable fighting unit to face Hannibal again. Busa's great loyalty and beneficence was seen by some with envy, to the extent that the nearby town of Venusia, not to be outdone, themselves recruited a force of cavalry and infantry. Busa was honoured by the senate for her action. To this day a house can still be seen in the city centre of Canosa, known to the locals as belonging to Paulina Busa. She features in Boccaccio's *De Mulieribus Claribus*.

Teuta – *pirate queen*

Teuta was the queen regent of the Ardiaei tribe in Illyria; she reigned from about 231 BCE to 227 BCE when she succeeded her alcoholic husband Agron (250 BCE – 230 BCE), acting as regent for her young stepson Pinnes. Polybius, somewhat disparagingly says that she ruled 'by women's reasoning'. The trouble started when Teuta backed the piratical raids carried out by her subjects against neighbouring states (Polybius 2, 4, 1).

Things began to escalate when Teuta captured and later fortified Dyrrachium and Phoenice; while off the coast of Onchesmos, her ships raided a flotilla of Roman merchant vessels. After this Teuta's forces extended their piratical operations further southward into the Ionian Sea, defeating the combined Achaean and Aetolian fleet in the battle of Paxos and capturing the island of Corcyra. This enabled Teuta to attack the crucial trade routes between mainland Greece and the Greek cities in Magna Graecia. Teuta had now become the 'terror of the Adriatic Sea'.

This naturally exercised Rome, concerned as they were about their trade and the protection of that trade. In 230 BCE the Romans protested to Queen Teuta but she glibly told the ambassadors that according to Ilyrian law, piracy was a legal trade and that Rome had no right to interfere in what was effectively private enterprise and that 'it was never the custom of royalty to prevent any advantage its subjects could get from the sea'. One of the envoys allegedly replied that Rome would make it her business to introduce better law among the Illyrians as 'we Romans have an excellent custom of punishing private wrongs by public revenge'. Teuta then imprudently sanctioned the murder of one of the Roman envoys, Coruncanius, and imprisoned the other.

The Romans reacted on a massive scale when they mobilised and set sail with an army of 20,000 troops, 200 cavalry, and the entire Roman fleet of 200 ships,

under the command of consuls Lucius Postumius Albinus and Gnaeus Fulvius Centumalus. This was the first time Roman armies had crossed the Adriatic.

Significantly, they set up Demetrius of Pharos as a client king to challenge Teuta's power. Demetrius had previously enjoyed a similar position under Teuta, and was himself renowned as a pirate. The Romans took Corcyra, Apollonia, Epidamnus, and Pharos, and finally laid siege to Scodra, Teuta's capital city. She surrendered ignominiously in 227 BCE, and was subjected to restrictions on military and naval activity, most crucially not to sail outside a restriction zone south of Lissa, while her territory was confined to the region around Scodra. However, the Romans did not quash the Illyrians but set up a protectorate instead. This meant that the Illyrians, as *amici* (friends), remained free, unoccupied, and untaxed, but had a moral obligation to show gratitude to Rome in the shape of military support as required.

Our sources are, of course, written by male historians who are hostile to the Illyrians and to Teuta in particular. In his *Histories*, Polybius opens the story of the reign of Teuta as follows:

> [Agron] was succeeded on the throne by his wife Teuta, who left the details of administration to friends on whom she relied. As, with a woman's natural myopia, she could see nothing but the recent success and had no eyes for what was going on elsewhere...[1]

Cassius Dio is no less misogynistic: he describes the queen as:

> ...woman-like, in addition to her innate recklessness, she was puffed up with vanity because of the power that she possessed ... In a very short time, however, she demonstrated the weakness of the female sex, which quickly flies into a passion through lack of judgment, and quickly becomes terrified through cowardice.[2]

According to legend Teuta ended her life in grief by throwing herself from the Orjen mountains at Lipci in modern Montenegro.

Further reading
Chrystal, Paul (2018). *Women at War in the Classical World.* Barnsley
Jackson-Laufer (1999). *Women Rulers throughout the Ages: An Illustrated Guide.* New York
Jones, David E. (2000). *Women Warriors: A History.* Brassey's
Grant DePauw, Linda (2000). *Battle Cries and Lullabies: Women in War from Prehistory to the Present.* University of Oklahoma Press
Meijer, Fik (1986). *A History of Seafaring in the Classical World.* St. Martin's Press
Prodanović, Nada Ćurčija (1973). *Teuta, Queen of Illyria.* Oxford
Šašel Kos, Marjeta (2012). 'Teuta, Illyrian queen'. In *The Encyclopedia of Ancient History.* Wiley-Blackwell

Sophonisba – *an active political agent for Carthage*

Sophonisba (*fl.* 203 BCE) was a Carthaginian noblewoman who lived during the Second Punic War; she was the daughter of Hasdrubal Gisco. She influenced the Numidian political landscape, convincing king Syphax to change sides during the war, and later, in a supreme act of dignity and courage, she poisoned herself rather than be humiliated in a triumph celebrated by Publius Cornelius Scipio (Scipio Africanus) after the battle of Bagbrades (203 BCE).

Renowned for her beauty, Sophonisba had been betrothed to King Masinissa, leader of the Massylii, or eastern Numidians. But when Masinissa allied himself to Rome he severed his links with Carthage and was replaced in Hasdrubal's favour by Syphax, king of the Masaesyli (or western Numidians). Sophonisba was part of the package.

Unfortunately, Syphax was defeated and captured in 203 BCE by Masinissa and Scipio Africanus at Bagradas. Masinissa then married Sophonisba but Scipio, suspicious of her loyalty, insisted that he give her up so that she could be taken to Rome and headline in his triumph. Masinissa feared the Romans more than he loved Sophonisba, admitting to her that he was not able to free her from captivity or the Romans. He asked her to die like a true Carthaginian princess: she then cooly drank the poison he offered her. Her story can be found in Polybius (14, 4ff.); Livy (30, 12.11–15, 11), Diodorus (27, 7), Appian (*Punica* 27–28), and Dio (Zonaras 9, 11).

Unlike Teuta, Sophonisba escapes the misogyny of the classical historians who in fact praise her: Diodorus Siculus called her 'attractive to look at, a woman of many varied moods, and one gifted with the ability to bind men to her service,'[1] while Cassius Dio states she had a good education in music and literature and was 'clever, ingratiating, and altogether so charming that the mere sight of her or even the sound of her voice sufficed to impress every one, even the most indifferent.'[2] Polybius also emphasizes her youth, calling her a 'child' bride, something which Diodorus also mentions. Nevertheless, those traits have led modern historians to consider her an active political agent for Carthage instead of a mere pawn of the war.

The Vestal Virgins – *and the terrible fate which awaited them if they lost their viginity*

As female symbols of the classical world go, the Vestal Virgins must be one of the most enduring and revered. They were one of the keystones of official state Roman religion, they were central to all things relating to the Roman *familia* and household, and they were crucial to the well-being and preservation of Rome itself. The privileges of Vestal Virginity, however, came at a price: the Vestals were finally disbanded in 394 CE but not before a small number had been entombed alive, the awful penalty for a Vestal who mislaid her virginity (*incestum*), or was suspected of having lost it. *Incestum* was tantamount to treason.

Dionysius of Halicarnassus records that the first Alba Longa Vestals were whipped to death for breaking their vows of celibacy, and that any resulting infant offspring was thrown into the nearest river. Dionysius attributes live burial or entombment to Tarquinius Priscus (fifth king of Rome) and says that the first victim was Pinaria. Opimia followed, confessing under torture. Sometimes the immuration was preceded by whipping (and possibly rape), as endured by Urbinia in 471 BCE. Previously, the punishment of choice for Numa Pompilius (second king of Rome) was death by stoning for wayward Vestal Virgins.

Entombment was in a cellar under the Campus Sceleratus; the male partner was flogged to death in the Comitium like a slave, *sub furca*. The reasoning behind entombment was that the goddess Vesta would still have time to rescue the 'Virgin' if she were proven innocent. Vesta never did. Plutarch wonders if entombment was decided upon because the Romans thought it somehow inappropriate that one charged with looking after the sacred flame of Rome should endure death by fire, cremation, the usual penalty, or indeed that one so sacrosanct should be murdered.

He graphically describes the solemn process where the condemned Vestal is bound and gagged, dressed as if a corpse at burial and carried to her subterranean prison in a curtained litter; there she is unbound and, after a prayer, the *Pontifex Maximus* puts her on a ladder which leads down to the small chamber below.

Plutarch adds more horrible detail:

> Then the culprit herself is placed in a litter, over which coverings are thrown and fastened down with cords so that not even a cry can be heard from within, and carried through the forum. All the people there silently make way for the litter, and follow it without uttering a sound, in a terrible depression of the soul. No other spectacle is more appalling, nor does any other day bring more gloom to the city than this. When the litter reaches its destination, the attendants unfasten the cords of the coverings. Then the high-priest, after stretching his hands toward heaven and uttering certain mysterious prayers before the fatal act, brings forth the culprit, who is closely veiled, and places her on the steps leading down into the chamber. After this he averts his face, as do the rest of the priests, and when she has gone down, the steps are taken up, and great quantities of earth are thrown into the entrance to the chamber, hiding it away, and make the place level with the rest of the mound. This is what awaits those Vestals who break their vow of virginity.
>
> For minor offences the virgins were punished with flogging, the Pontifex Maximus sometimes scourging the culprit on her bare flesh, in a dark place, with a curtain drawn. But she that has broken her vow of chastity is buried alive near the Colline gate…a small chamber is constructed, with steps leading down from above. In this are placed a couch with its coverings, a lighted lamp, and very small

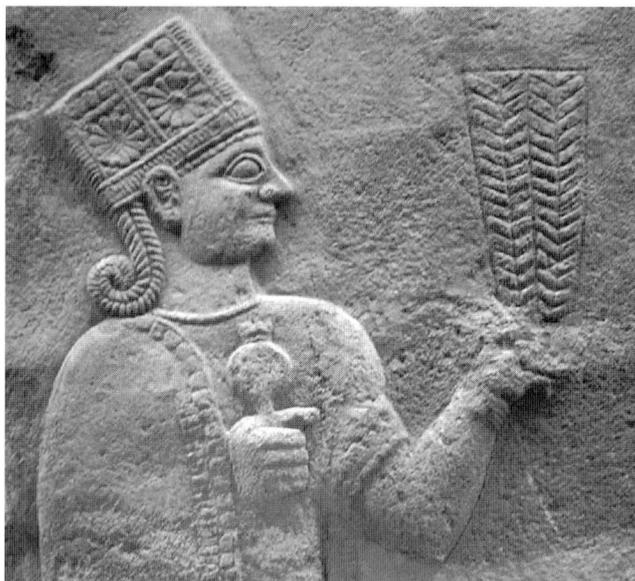

Above left: Queen Tabur-Damu, last queen of Ebla and wife of the last king of Ebla, 2300 BCE. Made from wood, silver, soapstone and jasper. National Museum of Damascus.

Above right: A relief portrait of Ku-Baba in the Museum of Anatolian Civilizations Ankara.

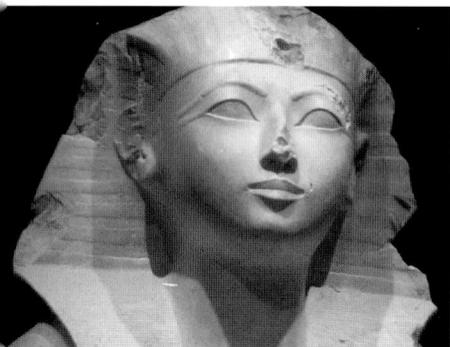

Above: Indurated limestone and paint detail from seated statue of Hatshepsut in the Metropolitan Museum of Art, New York. From Thebes, Deir el-Bahri & el- Asasif, Senenmut Quarry, MMA excavations, 1926–28/ Lepsius 1843–45.

Right: A Young Daughter Of The Picts, attributed to Jacques Le Moyne De Morgues.

The KV60A mummy, thought to be that of Hatshepsut. In 2007, the unidentified body was found in the Valley of the Kings. It contained two female mummies: one identified as Hatshepsut's wet nurse and the other unidentified. Called KV60A, it was removed by Dr. Zahi Hawass and taken to Cairo's Egyptian Museum for testing. This mummy was missing a tooth, and the space in the jaw perfectly matched Hatshepsut's existing molar, found in the DB320 "canopic box".

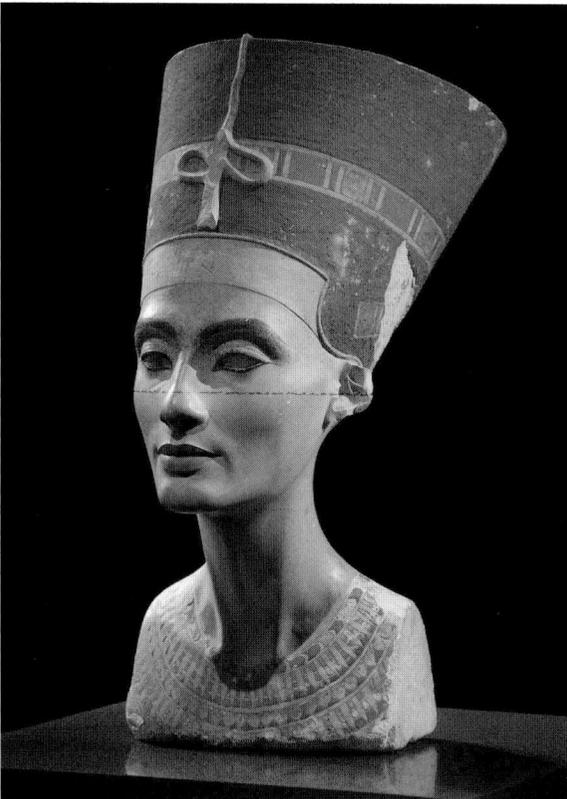

The Nefertiti bust is one of the star exhibits of the Neues Museum, Berlin. The colourfully painted bust was created around 1340 BCE. 'The timeless appearance of the face has become an icon of beauty over the past 100 years'.

Inset: Detail with serpent close up.

Right: *Lilith* (1887) John Collier.
Atkinson Art Gallery and Library,
Southport. 'Collier portrayed Lilith
as a golden-haired, porcelain-skinned
beautiful nude woman who fondles
on her shoulder the head of a serpent,
coiled around her body in a passionate
embrace'.

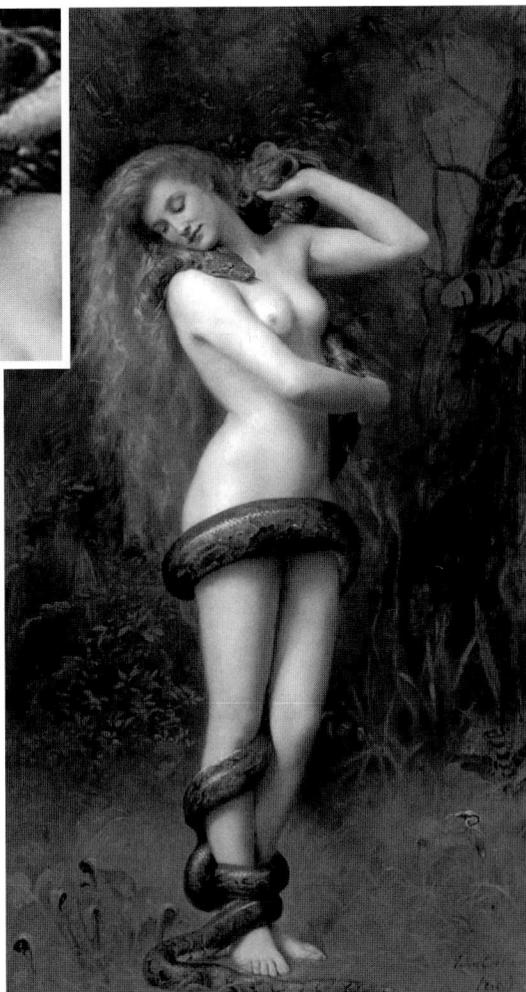

Judith and Holophernes, by Michelangelo,
Sistine Chapel ceiling, Vatican City.

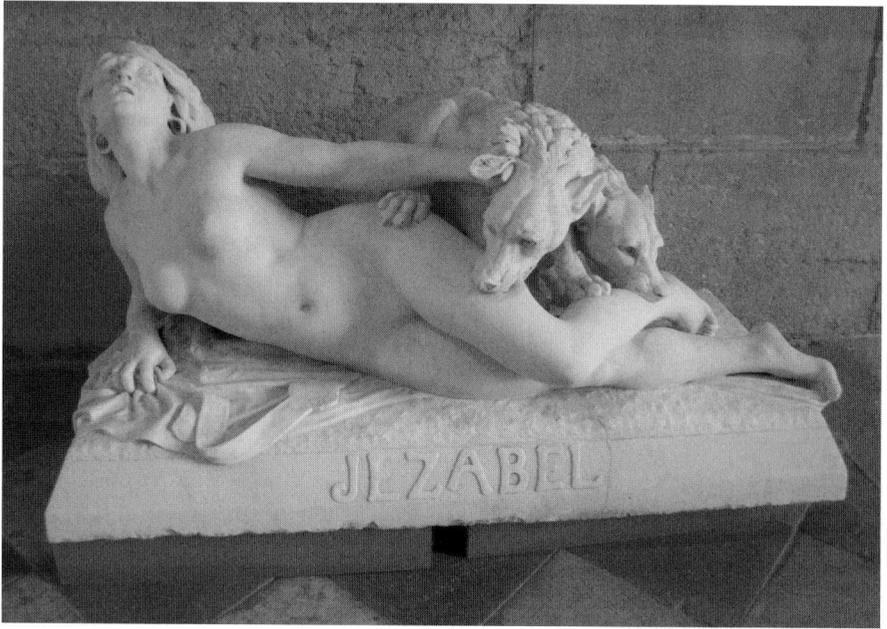

Jezebel being eaten by her dogs following her defenestration; by Léon Auguste Perrey (1841–1900), Musée des Beaux-Arts et d'Archéologie de Besançon.

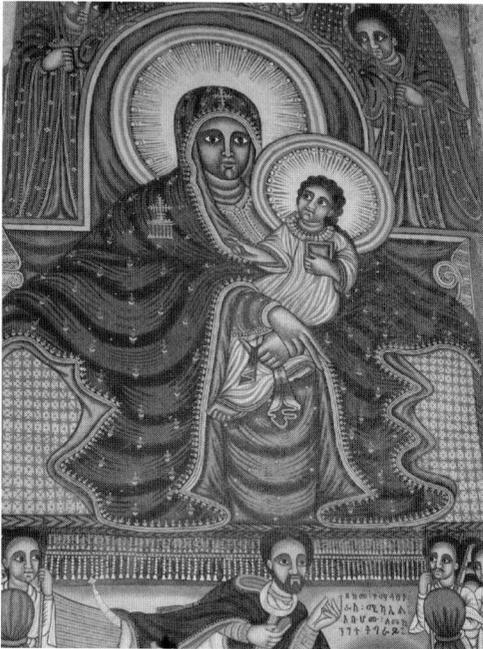

Above left: A fresco of a black Madonna and Jesus at the Church of Our Lady Mary of Zion in Axum, Ethiopia.

Above right: Detail of Mary Magdalene weeping at the crucifixion of Jesus, as portrayed in The Descent from the Cross (c. 1435).

Rogier van der Weyden or Roger de la Pasture (1399 or 1400 – 18 June 1464) Museo Nacional del Prado.

Above: Circe – Wright Barker (1864–1941), Cartwright Hall Art Gallery, Bradford. Circe as musician (1889).

Right: Athena Mattei in the Louvre. Roman copy from the 1st century BCE/CE after a Greek original of the 4th century BCE attributed to Cephisodotos or Euphranor. Note the Medusa prominent on her breast.

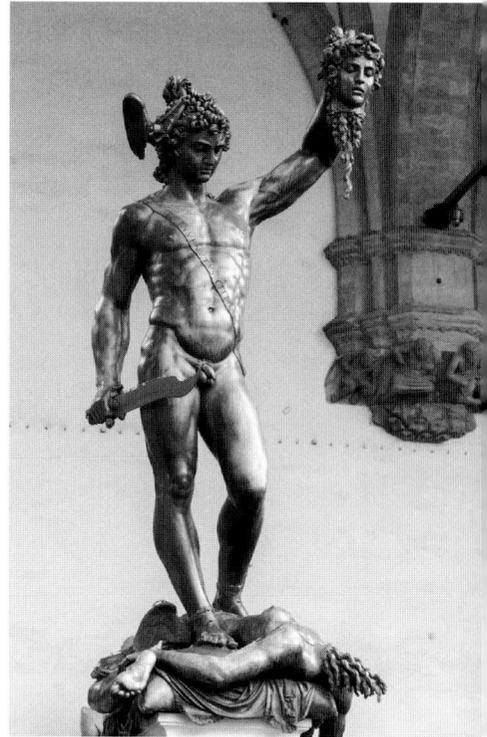

Above left: Exekias: Greek amphora depicting Achilles slaying Penthesilea. Achilles slaying Penthesilea, the queen of the Amazons, Attic black-figure amphora signed by Exekias, c. 530–525 BCE; in the British Museum, London. Courtesy of the trustees of the British Museum.

Above right: "Perseus with Head of Medusa," a bronze sculpture by Benvenuto Cellini, 1545. The sculpture is considered a masterpiece of Italian Mannerism. Displayed at the Loggia dei Lanzi, Florence, Italy. Photograph by Kenneth Murray.

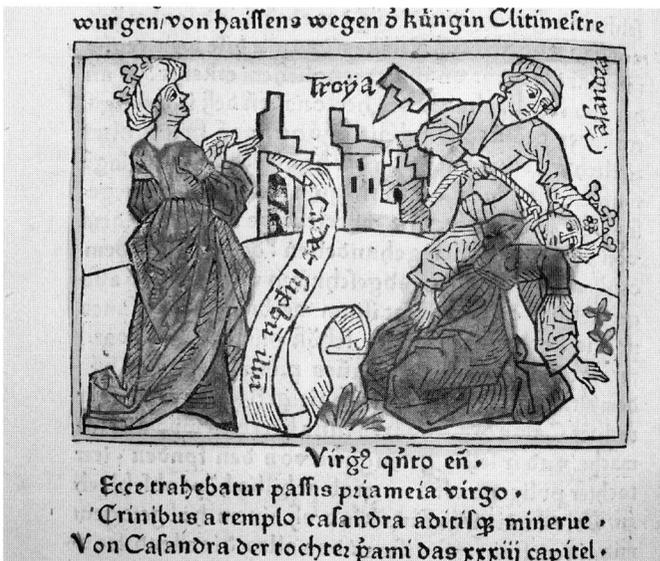

Woodcut illustration of Cassandra's prophecy of the fall of Troy (left) and her death (right), hand-coloured in red, green, yellow and black, from an incunable German translation by Heinrich Steinhöwel of Giovanni Boccaccio's *De mulieribus claris,* printed by Johannes Zainer at Ulm ca. 1474.

Right: Sappho, Auguste Charles Mengin 1853–1933. Manchester Art Gallery. '*Full length figure of Sappho, a bare-breasted woman standing on a rocky promontory against an iron grey sky and dark sea. She leans her left arm at shoulder height on the rock and gazes down and to the right. Her dark eyes have shadows beneath them*'.

Below: Purported skeleton of Ada, Bodrum Museum of Underwater Archaeology – the biggest museum of its kind devoted to underwater archaeology.

Mercer University Opera Presents

DIDO AND AENEAS
BY HENRY PURCELL

Oct. 21-23 at 7:30 p.m.
Oct. 24 at 3 p.m.

M*ERCER*
UNIVERSITY
SCHOOL OF MUSIC

Fickling Hall
General admission at the door only. $15 Adult or FREE with
Mercer ID or any student ID. *Information:* 478-301-2748

Left: Dido lives on: 'MACON – Mercer University Opera will present the Henry Purcell opera *Dido and Aeneas* on Oct. 21–23, 2021'. Mercer University is in Macon GA.

Below: 'The Intervention of the Sabine Women' (1799) by Jacques-Louis David, showing a legendary episode after the abduction of the Sabine women by the founding generation of Rome. Work on the painting began in 1796, after his estranged wife visited him in jail. Louvre Museum, Paris.

Above: Party time in Rome: Konstantin Makovsky, Spring Bacchanalia, 1891.

Right: The striking statue of Verginia murdered by her own father after being abducted on her way to school by the tryrannical Appius Claudius. It is in the Walker Art Gallery, Liverpool but languishes in the cafeteria with no plaque, although information is available on request.

A miniature showing Paulina Busa from *De Mulieribus Claris*. (1488–1496)
http://www.enteboccaccio.it/s/casa-boccaccio/item/5257

Dedication of a new Vestal Virgin by Alessandro Marchesini 1663–173 showing the elaborate and revered procedure. A classic example of Baroque art, this features a virgin being offered to a goddess in the Temple of Vesta. A cauldron emerges from a cloud populated with gods and goddesses.

The Great Cameo of France, depicting The Julio-Claudian dynasty, including Agrippina the Elder, and Agrippina the Younger, 23 CE, or 50–54 CE, Bibliotheque Nationale, Paris.

In the upper level are its deceased or deified members including Divus Augustus. The surrounding figures may be Drusus the Younger (son of Tiberius), and Drusus the Elder (brother of Tiberius) flying on Pegasus.

In the middle are Tiberius flanked by his mother Livia; standing in front with Germanicus in front together with his wife Agrippina the Elder, behind them the future emperor Nero and the figure of Providentia (Foresight); behind Livia and Tiberius are Claudius and his wife Agrippina the Younger.

The majestic statue in Cardiff City Hall of a humiliated but dignified Boudica (known in Welsh as Buddug) and her violated daughters. Courtesy Geoff Cook, Cardiff City Hall. Boudicca is appealing to the Britons to avenge the wrongs done to her country and her home by the Roman occupiers. Sculpted by J. Havard Thomas, from Serravezza marble.

The beautiful marble statue of Messaline (1884) by Eugène Cyrille Brunet (1828–1921): *Musée des beaux-arts de Rennes.*

Pamphile in Boccaccio's *De Mulieribus Claris.*

Father Time Outwitted

Time cannot leave his marks on the woman who takes care of her complexion with Pompeian Massage Cream. Wrinkles and crow's-feet are driven away, sallowness vanishes, angles are rounded out and double-chins reduced by its use. Thus the clear, fresh complexion, the smooth skin, and the curves of cheek and chin that go with youth, may be retained past middle age by the woman who has found what

Pompeian Massage Cream

will do. The use of this preparation keeps skin, flesh, muscles and blood-vessels in a healthy, natural condition, which resists the imprints of time, work, worry and care.

FREE SAMPLE TO TEST

Simply fill in and mail us the coupon and we will send you a large sample, together with our Illustrated book on Facial Massage, an invaluable guide for the proper care of the skin.

Pompeian Mfg. Co., 28 Prospect St., Cleveland, Ohio

Suggest to your brother or husband that he try Pompeian Cream after shaving; by cleansing the pores of soap it allays irritation, does away with soreness. All leading barbers will give a massage with Pompeian Cream — accept no substitutes.

Gentlemen:— We prefer you to buy of your dealer whenever possible, but do not accept a substitute for Pompeian under any circumstances. If your dealer does not keep it, we will send a 50-cent or $1.00 jar of the cream, postpaid to any part of the world, on receipt of price.

Name......................

Address...................

POMPEIAN MFG. CO., 28 Prospect St., Cleveland, O.

Pompeian Massage Soap is appreciated by all who are particular in regard to the quality of the soap they use. For sale by all dealers — 25c. a cake; box of 3 cakes, 60c.

It may not be Poppaea's Cream but this advertisement (*Good Housekeeping* October 1907) shows how cosmetics purportedly associated with the Roman past are still very popular. How? In 1901, Fred W. Stecher registered the name Pompeian Massage Cream and Skin Food for a cream he had spent many months formulating. By the end of the decade Pompeian Massage Cream was the best-selling face cream in the United States. See their fascinating site at https://cosmeticsandskin.com/companies/pompeian.php

Detail from "Sextus Pompeius consulting Erichtho before the Battle of Pharsalia" by John Hamilton Mortimer (1740–1779).

'Memnonis crus dexterum'. The right leg of Memnon.

Originally published in Richard Pococke *A Description of the East, and some other Countries* (1743), London, W. Bowyer, MDCCXLV (1743–1745).

Sarah Bernhardt as Théodora in Victorien Sardou's *Théodora*, 1882. Photograph by Nadar (1884).

portions of the necessaries of life, such as bread, a bowl of water, milk, and oil, as though they would thereby absolve themselves from the charge of destroying by hunger a life which had been consecrated to the highest services of religion.

> – Plutarch, *Numa* 10; The Parallel Lives,
> Loeb Classical Library

In 420 BCE, according to Livy, the Vestal Postumia was innocent of fornication but was tried for sexual misdemeanour because of her elegant, bright and flamboyant dress sense and her precocious wit. Postumia was acquitted but warned by the Pontifex Maximus to curb her sense of humour and to dress more modestly: he 'gave her warning to leave her sports, taunts and merry conceits; and in her raiment to be seene not so deft as devout, and weare her garments rather saintly than sightly'.

Dionysius of Halicarnassus says that Minucia, the first plebeian Vestal, also aroused suspicion with her fashionable attire, and was arrested solely on the evidence of a slave. She was found guilty of unchastity and buried alive in 337 BCE; her fate was as likely to have been determined more by her plebeian birth as an ill-judged dress sense. Livy, matter of factly, tells how in 273 BCE *Sextilia, virgo Vestalis, damnata incesti viva defossa est* – 'Sextilia, a Vestal Virgin, was accused of *incestum* and buried'; Orosius adds *viva*, 'alive'. Caparronia hanged herself in 266 when accused of *incestum*; her slaves and her defiler were executed; an anonymous Vestal was entombed in 236 BCE.

Confirmed cases of Vestal *incestum* are 'extremely rare'. Most occurred during military or religious crisis. Some Vestals were undoubtedly used as scapegoats; their political connections and alleged failure to observe oaths and duties were conveniently given as the cause of disturbances, wars, famines, plagues and other signs of divine displeasure.

Further reading

Beard, Mary (1980). 'The Sexual Status of Vestal Virgins'. *The Journal of Roman Studies*. 70: 12–27

Chrystal, Paul (2014). *Women in Ancient Rome*. Barnsley

Erdkamp, Paul (2020). 'War, Vestal Virgins, and Live Burials in the Roman Republic'. In M. Dillon (ed.), *Religion and Classical Warfare. II: The Roman Republic*. Barnsley

Kroppenberg, Inge (2010). 'Law, Religion and Constitution of the Vestal Virgins'. *Law and Literature*. 22 (3): 418–439.

Parker, Holt N. (2004). 'Why Were the Vestals Virgins? Or the Chastity of Women and the Safety of the Roman State'. *American Journal of Philology*. 125 (4): 563–601.

Sawyer, Deborah F. (1996). 'Magna Mater and the Vestal Virgins.' In *Women and Religion in the First Christian Centuries*. London

Staples, Ariadne (1998). *From Good Goddess to Vestal Virgins: Sex and Category in Roman Religion*. Routledge

Wildfang, Robin Lorsch (2006). *Rome's Vestal Virgins*. Oxford
Wyrwińska. (2021). 'The Vestal Virgins' Socio-political Role and the Narrative of Roma Aeterna'. *Krakowskie Studia z Historii Państwa i Prawa*. 14 (2): 127–151

Cornelia Scipionis Africana (*c.* 180 BCE – *c.* 105 BCE) – *model Roman matrona*

Cornelia Scipionis Africana represents the ideal Roman *matrona*. She was one of four children, the second daughter of the illustrious Scipio Africanus and Aemilia Paulla; she was wife of Tiberius Sempronius Gracchus whom she married around 175 BCE and mother of the rebel brothers Gracchi – Tiberius and Gaius – and of Sempronia. She came from a celebrated patrician family, the Cornelii Scipiones, and she married into a celebrated plebeian family; the families were rivals.

Plutarch's biography of Gaius Gracchus reveals

> There are on record also many things which Caius [Gracchus] said about her ... when he was attacking one of his enemies: "What," said he, "do you abuse Cornelia, she who gave birth to Tiberius?" And since the one who had spoken the abuse was previously charged with effeminate practices, "With what effrontery," said Caius, "can you compare yourself with Cornelia? Have you borne such children as she did? And indeed all Rome knows that she refrained from contact with men longer than you have, though you are a man..."
>
> Cornelia is reported to have borne all her misfortunes in a noble and magnanimous spirit, and to have said of the sacred places where her sons had been slain that they were tombs worthy of the dead which occupied them. She resided on the promontory called Misenum, and made no change in her usual way of living. She had many friends, and kept a good table that she might show hospitality, for she always had Greeks and other literary men about her, and all the reigning kings exchanged gifts with her. She was indeed very agreeable to her visitors and associates when she discussed them the life and habits of her father Africanus, but most admirable when she spoke of her sons without grief or tears, and narrated their achievements and their fate to anyone who asked as if she were speaking of men of the early days of Rome.

> – Plutarch *Gaius Gracchus* 4,3; 19, 1–3. Translation adapted from Ian Scott-Kilvert in *Plutarch, Makers of Rome*.

In her widowhood Cornelia remained *unavira*, a one-man woman even despite a proposal of marriage from the very eligible Ptolemy VIII (Physkon).

Dripetrua – *devoted daughter of Laodice and Mithridates VI of Pontus.*

At 9, 1.8 ext.13 Valerius tells of Dripetrua (*fl.* 1st century BCE, also known as Drypetina) who was the devoted daughter of Laodice and Mithridates VI of Pontus. Dripetrua was born with a double row of teeth (hyperdontia), and lived with the resulting facial deformity and lifelong challenging self-image issues. She is noted for staying at her father's side after his defeat by Pompey the Great in the Third Mithridatic War (75 BCE – 65 BCE), providing, no doubt, considerable moral support.

According to Ammianus Marcellinus, during the same war a seriously ill Drypetina, was left behind in the fortress of Sinora under the protection of the eunuch Menophilus. When the Roman forces under Mallius Priscus besieged the fortress, Menophilus killed the princess to prevent her from being captured by the Romans and then committed suicide himself (Amm. Marc. XVI.7.10).

Boccaccio includes her in his *De Mulieribus Claris*.

Praecia – *a beauty and a wit – and something of a political and military fixer*

From Plutarch we learn about Praecia – a beauty and a wit – and something of a political and military fixer; she was instrumental in helping Lucius Licinius Lucullus win the governorship of Cilicia in 74 BCE, and subsequently the much sought-after command against Mithridates.

Praecia, though little more than a prostitute according to Plutarch, wielded great influence and power. Anise Strong tell us how

> She was known for her wide net of high-profile clients among the political elite, and for using her contacts to benefit the political careers of her clients, which made her a popular and valuable figure in contemporary political life[1]. She began an affair with the equally influential, and dissolute, Publius Cornelius Cethegus, arch-enemy of Lucullus. She was soon controlling everything Cethegus did: "nothing important was done in which Cethegus was not involved, and nothing by Cethegus without Praecia". Lucullus saw his chance and proceeded to insinuate his way successfully into Praecia's affections to the extent that Cethegus was soon backing Lucullus for the governorship. Lucullus won his command and soon dispensed with the services of Praecia and Cethegus (Plutarch, *Lucullus* 6).

Chelidon (*fl.* 74 BC) was another Roman courtesan, notable for the influence she exerted during the praetorship of Gaius Verres.

Her influence was used against Gaius Verres by his enemies, who accused him of allowing her an excessive interference in state affairs when he allowed her to make decisions within civil cases and prepare laws and political reforms.

Volumnia Cytheris (*fl.* late 1st century BCE) was an ancient Roman actress and dancer. She is best known as the mistress of several famous Romans. She was originally a slave and later freedwoman; her stage name was Cytheris. The name derived from 'Cythera' – a nickname for Aphrodite. She had relationships with Brutus and Mark Antony which caused a stir in Rome when the presence of a courtesan in social-political events was uncommon, and considered shocking.

Her rejection of Cornelius Gallus reportedly provided the source for Virgil's tenth *Eclogue*. Gallus refers to her in his work under the name Lycoris.

Sempronia – *cultured woman or whore?*

During the Catiline Conspiracy (63 BCE) a brave, gifted and powerful woman upset the powerful conservative factions in Rome. The historian Sallust (a supporter of Julius Caesar) grudgingly admits that Sempronia, a conspirator and adherent of Lucius Sergius Catilina, exhibited a boldness worthy of a man; that she was well married with children; she was versed in Latin and Greek, accomplished in the lyre and a good dancer; she was an excellent and a convivial conversationalist: in short her social and artistic skills and abilities were highly commendable.

That said, though, an ambivalent Sallust adds that, marriage and good motherhood apart, she displayed few of the qualities expected of the conventional *matrona*: she was impulsive, louche, passionate, a perjurer, an accessory to murder, a liar and a spendthrift. Sempronia to Sallust was a kind of anti-*matrona*: while undoubtedly brave and gifted, for him she broke the mold and stepped far beyond the traditional boundaries laid down for Roman women. It is significant, however, that Sallust cannot resist simultaneously praising her motherhood while denigrating her alleged sexual decadence and permissiveness.

Here is Sallust in his own words, illustrating masculinisation and sexual slurs:

> Among those women was Sempronia, a woman who had committed many crimes *just like a man*. In birth and beauty, in her husband and her children, she was extremely fortunate; she was skilled in Greek and Roman literature; she could sing, play, and dance, with greater elegance than became a woman of virtue, and possessed many other accomplishments that tend to excite the passions. *But nothing was ever less valued by her than honour or chastity*. Whether she was more prodigal of her money or her reputation, it would have been difficult to decide. Her desires were so ardent that she more often made advances to men than waited to be asked. She had frequently previously broken her word, forsworn debts, been privy to murder, and hurried into the utmost excesses by her extravagance and poverty. But her abilities were not totally despicable; she could compose verses, jest, and join in conversation either modest, tender, or licentious.

In a word, she was distinguished by much refinement of wit, and much grace of expression.

–Sallust, *Conspiracy of Catiline* 25.
Trans Rev. John Selby Watson, New York, 1899.

Sempronia and women like her ushered in a type of 'new woman' in Rome – the *doctae puellae* of Catullus and the elegists at the end of the Republic with cultural abilities and political interests that would become increasingly common for women in later years, a contrast to classical Roman women like Cornelia who stood for values from the earlier Republican period, the *mos maiorum*.

Further reading
Boyd, Barbara Weiden (1987). 'Virtus Effeminata and Sallust's Sempronia.'
 Transactions of the American Philological Association (1974-) 117: 183–201. ·

Cleopatra VII – *in 'a get-up that beggared description'*

Of all the women described in this book, Cleopatra is probably the most well known and celebrated. Her life is recounted in numerous books, articles and in famous films, novels and plays. For that reason, we will describe only a few of the more unconventional episodes in her varied life.

In 41 BCE Cleopatra finally met with Mark Antony in Cilicia after a number of previous invitation requests had gone ignored by the queen; ostensibly Antony wanted to question her about the money she had allegedly paid to the wealthy Cassius, and to win her, Egypt's, support in his planned campaign against Parthia. Cleopatra arrived for the rendezvous in a blaze of astonishing extravagance and ceremony on the sumptuous royal barge, 'a get-up that beggared description' Plutarch spluttered (Plutarch, *Anthony* 25, 3)

Dio records another high level meeting:

> For she was a woman of surpassing beauty, and at that time, when she was in the prime of her youth, she was most striking; she also possessed a most charming voice and a facility to make herself agreeable to every one. Being brilliant to look upon and to listen to, with the power to subjugate every one, even a love-sated man already past his prime, she thought that it would be in keeping with her rôle to meet Julius Caesar… She asked therefore to be allowed to meet him and on receiving this adorned and beautified herself so as to appear before him in the most majestic and at the same time pity-inspiring guise.
>
> – Dio, *Roman History* 42.34.4–6

Cleopatra as an amateur toxicologist and in vivo human and animal experimenter:

> Plutarch also records that a prescient Cleopatra carried out toxicological research to establish the least painful, efficacious and

elegant way to commit suicide. This involved experimentation with various toxic herbs (*pharmaka*) which were cruelly tested on human guinea pigs: namely condemned prisoners of war. When this failed to produce a solution she resorted to intensive animal experimentation, pitting venomous creatures against each other and observing the results. This is how she hit upon the famous asp.

She found that the bite of the asp alone induced a sleepy torpor and sinking, where there was no spasm or groan, but a gentle perspiration on the face, while the faculties were relaxed and dimmed, and resisted all attempts to rouse and restore, as is the case with those who are soundly asleep.

> – Plutarch, *Life of Antony* 71; trans. Bernceotte Perrin,
> Vol. IX of the Loeb Classical Library edition

The *Laudatio Turiae* – *benchmark description of the best of women*

The Laudatio Turiae is a 1st century BCE tombstone engraved with an epitaph, a husband's eulogy of his wife, Turia. It provides the gold standard of wifely conduct and was erected in Rome by her husband, Quintus Lucretius Vespillo. At 180 lines, the *Laudatio Turiae* is currently the longest surviving personal inscription from Classical Rome.

The *laudatio* celebrates, at some length, the life of a dutiful and exceptional wife and gives a catalogue of those qualities expected of the good *matrona: pietas*, wool-working, looking after the household and its gods, modesty of dress and physical and verbal elegance, financial acuity, bravery, loyalty and, on a personal level, shrewdness in the face of her husband's enemy, Lepidus, in 46 BCE when Vespillo was proscribed.

According to the inscription, her first praiseworthy accomplishment was avenging her parents' murder, which gives a revealing glimpse into the possible roles of women within the family and society. The husband also says the marriage was unusual, because it lasted forty years with her dying first while he was much older. This is all the more poignant because the emperor Augustus is on record as deploring the fact that the long-lasting marriage was a thing of the past. One of the few named figures in the inscription is Marcus Lepidus, who refused to reinstate the husband despite Caesar's order to do so. The husband praises his wife's willingness to endure verbal and physical abuse from Lepidus on his behalf when she attempted to plead the husband's case publicly. Turia concealed him in their roof space and convincingly acted out the role of the bereft wife, dressing in rags, looking dishevelled and grieving over an apparently lost husband. While Vespillo was in exile she moved in with her mother in law and valiantly defended the house against the violence of Milo, the renegade former owner who had not reckoned on Turia's bravery and determination.

The Laudatio Turiae is currently housed in the Museo Nazionale Romano at the Terme di Diocleziano (Baths of Diocletian) in Rome.

Hypsicratea (*fl.* 63 BCE) – *a story of undying love in a woman who could not bear to be without her husband*

This is a story of undying love in a woman who could not bear to be without her husband, even to the point of following him into battle armed to the teeth. Hypsicratea was a queen of Pontus, ruling over a number of states with Mithridates VI.

Evidently, she was so devoted to Mithridates that she dressed up in men's clothes, cropped her hair, learned combat skills, and followed him into exile. She rode with him into battle, putting down rebellions and fighting tooth and nail against the Romans – doing battle with axe, lance, sword, and bow and arrow.

During Mithridates' defeat by Pompey, Hypsicratea escaped from Pompey's blockade and was one of only three comrades who remained by the king's side. According to Plutarch she was

> ...always manly (*androdes*) and extremely bold, the king consequently liked to call her Hypsicrates... she neither flagged physically over the distances they ran nor did she tire of tending the body and horse of the king, until they came to a place called Sinor, which was full of the king's coins and treasures.

Valerius Maximus says:

> The Queen Hypsicratea too loved her husband Mithradates… and for his sake she thought it a pleasure to change the outstanding splendour of her beauty for a masculine style. For she cut her hair and habituated herself to horse and arms, so that she might more easily participate in his weaponry and danger. Indeed when he was defeated by Cn. Pompey, and fleeing through wild peoples, she followed him with body and soul equally indefatigable. Her extraordinary fidelity was for Mithridates his greatest solace and most pleasant comfort in those bitter and difficult conditions, for he considered that he was wandering with house and home because his wife was in exile along with him.

Further reading

Facella, Margherita (2017). *TransAntiquity: Cross-Dressing and Transgender Dynamics in the Ancient World*. Routledge. pp. 114–116

Shopland, Norena (2021). *A History of Women in Men's Clothes*. Barnsley

Hortensia – *the classical world's most famous female orator*

Hortensia is perhaps the most famous female orator in the classical world. She was the daughter of Quintus Hortensius Hortalus (114 – 50 BCE,) himself a celebrated speaker, *bon viveur*, friend, rival and sometime colleague of Cicero. Hortensia became something of an academic: she was untypical because she spent her

adolescence studying rhetoric and the speeches of her father, Cicero and the Greek orators. Her time was not wasted.

In 42 BCE the three members of the Second Triumvirate, Lepidus, Octavian and Mark Antony, were casting around for funds to finance their wars against the assassins of Julius Caesar; the money procured from their campaign of ruthless proscriptions was running out. An easy, apparently vulnerable, target was women's wealth: accordingly the triumvirs levied a supertax on the 1,400 most affluent women in Rome. The triumvirs had seriously miscalculated, however. Unsurprisingly, these financially comfortable women were incensed and, in a rare example of public demonstration by women, they marched on the Forum to vent their anger.

Here Hortensia delivered a passionate and eloquent speech at a *contio*, a public assembly, before the triumvirs. Hortensia demanded to know why women, who had neither say in nor direct benefit or glory from the wars, should be required to finance those wars. Attempts to disperse the women failed. Hortensia's passion won the day and the taxable cohort was radically reduced to 400 women; better still, men with over 100,000 sesterces were obliged to make good the shortfall by loaning money to the triumvirate; immigrants, *peregrini*, were similarly taxed. Appian, in a classic back-handed compliment, says that the speech was so good that one would never know that it had been written and delivered by a woman. Valerius Maximus adds that Hortensia's father henceforth 'lived and breathed through the words of his daughter'.

Hortensia was not the first intelligent woman to use her education for political or legal ends. Men were not the only lawyers; the woman skilled in the law, the *iurisperita* (women trained in the law), was alive and well from at least the 2nd century BCE, not least in two fragmentary plays by the comic playwright Titinius; we can glean that the hero of the *Iurisperita* was a legally trained woman. Titinius pokes fun at the heroine here, interfering as she is in a man's world, and through his Barbatus he attacks women's luxury and the repeal of the Lex Oppia. In the *Hortensius*, he has women outrageously demand membership of the Senate. Titinius anticipates Juvenal, whose withering attack on clever women includes *causadici*, suggesting that women lawyers had been active for at least 250 years.

The 151 BCE case of **Manilia** may be our first real-world example of a female lawyer. Manilia appealed to the tribunes after Hostilius Mancinus launched an action after turning up on her doorstep, drunk, and demanding entry and no doubt more besides that (as an *exclusus amator*, locked out lover); she pelted him with stones. It is possible that the tribunes rejected Hostilius's case on the grounds of his unreasonable behaviour, as argued by Manilia. And then there was the eloquence of **Laelia**, the daughter of the famous orator Gaius Laelius, and mother and grandmother to girls who were all eloquent orators, able to boast knowledge of Roman law. Valerius Maximus tells us how **Fannia** conducted her own defence when Caius Titinius, her unscrupulous husband, made a claim to retain her dowry when he divorced her on the grounds of her alleged *stuprum*. The judge, Caius Marius, knew that Titinius had foreknowledge of Fannia's questionable morals and had only married her in order to illicitly procure her dowry. Fannia was handed

down a nominal fine of one sesterce, while Titinius was obliged to swallow a fine equal in value to the dowry. Fannia was able to return the favour to Marius when she later concealed him during his flight from Sulla.

Valerius Maximus has more examples of female lawyers: firstly, there is **Maesia of Sentium**, who conducted her own defence and, through her forensic expertise, secured her own acquittal in 77 BCE – Maesia became known as Androgyne because she had excelled in the work apparently of a man, rather than that of a woman[1]. Then there is **Afrania**, the wife of Licinius Bucco, whose enthusiasm for the law and constant recourse to litigation actually brought about a change in the law. Male lawyers had had enough. They were so irritated and distracted by Afrania and her overzealous passion for legal matters with her yapping and barking that they enacted legislation prohibiting women from pleading in courts of law (*pro allis postulare*). It was, after all, man's work, and it was somewhat immodest of women to practice at the bar – a *prima facie* case of deficient *pudicitia*, no less, and of sexism.

Further reading
Best, Edward (1970). 'Cicero, Livy, and Educated Roman Women'. *The Classical Journal*. 203

Hallett, Judith P. (1984). *Fathers and Daughters in Roman Society: Women and the Elite Family*. Princeton

Leon, Vicki (1995). *Uppity Women of Ancient Times*. Conari

Lesbia, Claudia Metelli, or Clodia (*c.* 95 BCE – 44 BCE) – *the Medea of the Palatine*

In the late Republic better-off women began to enjoy more and more social independence, allowing them more freedom outside the confines of the home. This coincided with the emergence of a coterie of male poets who were able to eschew the traditional *mos maiorum* (the way their ancestors did things), rejecting the *cursus honorum* (the traditional road to the top politically and militarily) for a life of *otium (*decadent leisure) in which they could spend their time penning poetry and pursuing the women of their desire and devotion. Among these languid young men we can recognise such poets as Licinius Calvus, Varro of Atax, Valerius Cato, Furius Bibaculus, Helvius Cinna, Cornificius, Ticidas, and, most famously, Catullus. Collectively, they went under the name of *poetae novi, neoteroi,* or *Cantores Euphorionis*. Traditionalists regarded them with suspicion, and saw their otiose lifestyles as frivolous and decidedly un-Roman. As a champion of the *mos maiorum,* and contemptuous of anything Greek, Cato the Elder (234–149 BCE) had a century or so before spoken angrily against what he saw as a time of moral decline, and an erosion of the robust principles on which Rome was built.

The growing independence of the women of Rome was an ominous factor in all of this. The defeat of Hannibal at Zama in 202 BCE, the victory over the Macedonians at Pydna in 168 BCE, and the final extinguishing of the Carthaginian

threat in 146 BCE all allowed Rome to relax more, leading to an unprecedented influx of Greek and eastern influences and luxuries into an increasingly receptive Rome. The arrival of large numbers of slaves from conquered or annexed territories meant that women had more help and time on their hands, as they delegated domestic duties to their slaves in the more well-off households.

Traditional, restrictive marriage *cum manu* (the legal power of a husband over his wife) had virtually died out, leaving women to marry in a much freer arrangement, where love and affection were sometimes nothing more than a fortunate by-product. Divorcing was more or less a formality, and adultery was on the increase. Widowhood, free marriage, and divorce often left women financially better-off, or at least more independent.

The poetry of Catullus is redolent with allusions to the urbane permissive society in which he moves, the sophisticated company – male and female – which he elects to keep, and the elegant, polished verses that he and his friends penned. This is the milieu in which Catullus and his contemporaries flourished, and these are the *mores* which they espoused. Their educated women could mix with whomsoever they chose at the games, at festivals, dinner parties, or in the theatre. They enjoyed, if they wanted to, a degree of sexual freedom not dissimilar to that enjoyed by a prostitute (*meretrix*), but with little of the usual social stigma.

Catullus' Lesbia, the wife of Q. Caecilius Metellus Celer – and brother to the notorious Publius Clodius Pulcher – typifies the unattached or readily detachable, sophisticated, rich, intelligent, and urbane women of the day. They could exert considerable influence – sexual, psychological, and sometimes political – on their male friends. Independent men of means were, for the first time, able to shrug off their traditional allegiance to the bar and the battlefield, and to write personally and subjectively about independent women of means, talent and sex appeal. Amongst the many women he writes about, Catullus reserves the highest praise for Lesbia. She has the grace (*venustas*) and elegance (*salis*) other women lack.

With Lesbia we go from unqualified love and gentle affection, through unrequited love, to obscene vituperation, where we find a truculent Catullus bitterly describing Lesbia masturbating the grandees of Rome in the city's backstreets (*nunc in quadriviis et angiportis glubit magnamini Remi nepotes*). Lesbia has the power to elevate Catullus to the ecstasies of love and adoration, and then reduce him to a quivering, hateful, wreck of a man. There is nothing particularly unusual about that, but what is significant is that Catullus felt empowered by her, and empowered enough by the changing times to record and publish this rollercoaster of emotion. In doing so, he (and she through him) paved the way for the equally personal work of the elegiac poets and their sophisticated ladies (the *doctae puellae*). This opened the door for Gallus and Lycoris, Propertius and Cynthia, Tibullus and Delia, Sulpicia and Cerinthus, and for the love poetry of Horace and Ovid.

Marilyn Skinner tells how

> Clodia was married to Quintus Caecilius Metellus Celer, her first cousin, with whom she had a daughter Caecilia Metella. The marriage was not happy. Clodia had several affairs with married men (probably

124

including the poet Catullus) and slaves. Arguments with Metellus Celer were constant, often in public. When he died in strange circumstances in 59 BC, Clodia was suspected of poisoning him[1.]

She never remarried, but is said to have engaged in a number of affairs. One of these affairs was with a man named Marcus Caelius Rufus, but the two fell out when Caelius became involved in some questionable political dealings.

In 56 BCE, the state took Caelius to court for his crimes. The charges were the attempted murder of Clodia Metelli and the successful assassination of an Egyptian ambassador. Clodia was a witness for the prosecution, testifying that she had knowledge of Caelius' guilt.

Cicero, represented the defence[2]. *Ancient Origins* tells us that

> In his speech, Cicero played on sexist stereotypes to convince the jury that Clodia had coerced Caelius into having an affair and was only now making accusations because he had rejected her. Cicero portrayed Clodia as promiscuous and dominant, everything a Roman woman should not be. He even compared her to Medea [Medea of the Palatine][3], a mythical witch and murderess [of her own children]. To ruin her reputation further, Cicero insinuated that Clodia was having an affair with her own brother and that she had killed her husband. Cicero's arguments were successful; Caelius was acquitted[4].

Further reading

Hejduk, Julia Dyson (2008). *Clodia: A Sourcebook.* Norman, OK

Rankin, H.D. (1969). 'Clodia II'. *L'Antiquité Classique.* 38 (2): 501–506

Skinner, Marilyn (2011). *Clodia Metelli: The Tribune's Sister.* New York: Oxford University Press

Wiseman, T.P. (1987). *Catullus and His World: A Reappraisal.* Cambridge

Aurelia Cotta (120 BCE – 54 BCE) – *and the lute girl with a penis*

Aurelia Cotta was from a family of consular rank, and was the mother of three children – Julia Caesaris Major, Julia Caesaris Minor, and Julius Caesar. She was the wife of Marcus Atius, and the grandmother of the Emperor Augustus. Tacitus[1] regarded her as an ideal *matrona* like Cornelia, largely because she looked after her sons' education during her husband's extended absences away on active service. To Plutarch, she was strict and respectable[2].

Aurelia was clearly a particularly strong-willed, brave, and gifted woman. When the dictator Sulla demanded that her son divorce his wife, Cornelia Cinna (97–69 BCE), the eighteen-year-old Caesar refused; Aurelia defended her son, alongside her brother Gaius Aurelius Cotta, in the courts. When Cornelia Cinna died in childbirth, Aurelia took on the responsibility of raising her son's infant daughter, Julia.

Aurelia had the misfortune to be implicated, however innocently, in the Bona Dea scandal of December 62 BCE. All men were debarred from these rites, and even male animals and pictures or statues of men had to be covered over. Only *matronae* and the Vestal Virgins were permitted to attend – according to Cicero, any man caught observing the rites could be punished by having his eyes put out.[3]

The Vestals brought Bona Dea's image to the venue and a meal of sow's entrails was eaten, sacrificed to the goddess on behalf of the Roman people. The fun lasted all night, with female musicians, games, and wine – euphemistically called 'milk', and drunk from a 'honey jar'. This was not a feeble attempt to conceal drinking, but rather a tradition which came about when Fannus, who was married to Bona Dea, caught her surreptitiously drinking and beat her to death with a myrtle branch. Myrtle was also associated with Aphrodite and sex – as such, it was foreign to the rites and banned. The attending *matronae* refrained from sex in the run-up to the festival to ensure their purity, or so they said.

Bona Dea was jealously protected by its adherents; when the rites of 62 BCE – which were being held at Caesar's house as he was that year's Pontifex Maximus – were infiltrated by a high-profile man, the ensuing scandal was huge. This was not least because of the celebrities involved: Aurelia Cotta, Pompeia Sulla (Caesar's wife at the time), Aurelia's daughter Julia, and the Vestals were all there. According to Juvenal, any sexual propriety that remained in Rome evaporated that night: Publius Clodius Pulcher, Juvenal's 'lute girl with a penis' (*psaltria penem ... intulit*), had sacrilegiously gate-crashed the rites. His apparent objective was to pursue his ongoing affair with Pompeia; the scandal led to Caesar divorcing her, even though she had been innocently implicated in the outrage – Caesar could not have his wife under suspicion, could he? Aurelia Cotta testified at the trial.

Porcia – *self-harmer who swallowed hot coals*

Suetonius described Porcia as brave because of an incident in her second marriage, to Brutus. Immediately before the assassination of Julius Caesar, it became apparent to Porcia that her husband was unduly distracted and anxious. She determined to share his concerns and, to get Brutus' attention, proceeded to slash her thigh with a knife, causing substantial loss of blood. Brutus was alarmed; she told him in no uncertain terms, that she was much more than just a sex partner in their marriage, indeed 'a partner in your joys and a partner in your sorrows' – for better or for worse. She, by virtue of her ancestry and her demonstrable bravery, claimed that she was above the usual weakness of women and was worthy of his confidence in anything that may be troubling him. Seeing Portia's wound, Brutus told Porcia everything.

Porcia had proved to him that she could conquer pain and would not, therefore, yield under torture if taken in after the planned assassination: Brutus could confide in her with absolute confidence. Valerius Maximus concludes that Porcia was assessing for herself how well she would be able to face suicide in the event of Brutus' death.

After Caesar's murder Porcia and Brutus parted. Brutus showed how fully he appreciated Porcia's courage: Plutarch says that she was distraught on seeing a painting of Hector leaving Andromache (see above) for war; when Brutus heard this he, out of respect, declined to repeat Hector's parting words to Andromache but paraphrased it as follows:

> work at your loom and your distaff, and give your commands to your servants. She may not have the strength for the same exploits as are expected of a man, but she has the spirit to fight as nobly for her country as any of us.

Plutarch's source is Bibulus, their son; it is remarkable because it is the first example we have of an enlightened man enjoining his wife to relegate the wool-working and fight for her country like a man. When Brutus was killed in 43 BCE Porcia committed suicide by swallowing hot coals, an act which Valerius Maximus describes as 'her woman's spirit equal to her father's manly death'[1].

There is controversy over this, however: historians have obsessed over the means of Porcia's death. Modern historians find this implausible, and one popular speculation has Porcia taking her life by burning charcoal in an unventilated room, thus succumbing to carbon monoxide poisoning.

Further reading
Beneker, Jeffrey (2020). *The Discourse of Marriage in the Greco-Roman World*. University of Wisconsin Press. pp. 199–218
Holiday, Ryan, (2020). 'Porcia Cato the Iron Woman'. In *Lives of the Stoics*. New York

Terentia (98 BCE – 4 CE) – *taking over responsibilities which were normally the preserve of the man of the household*

Cicero, as we know, was a key player and important commentator during the tumultuous, dangerous, and world-changing events of 1st century BCE Rome. What is less well-known, however, is the crucial part that Cicero's wife, Terentia, played in supporting him politically, financially, and emotionally. In this respect, she can be said to have influenced to some degree Cicero's political thinking, policy, behaviour, and – as a result – some of the major political developments and speeches of the time.

The 'new women' we have described above trod a very fine line, acting somewhat independently of men but without obviously encroaching beyond what was considered to be respectable behaviour by a woman. Cicero himself records how it was now quite usual for women to discuss politics outside the confines of the family.[1]

Terentia was the elder of two sisters, and inherited the family's wealth; this included blocks of apartments in Rome, in the Argiletum, and on the Aventine,

woodlands in the suburbs, and a large farm – all generating considerable income. She had other investments, and owned a small village[2]. Her dowry amounted to 400,000 sesterces – precisely and conveniently the amount of money Cicero needed to run for senator. She married him in 79 BCE, when she was about nineteen years old and he was twenty-seven. Her new husband was a *novus homo,* not an aristocrat, but a 'new man' on the Roman political stage, with political and financial potential. The dowry would have passed to Cicero's family, but Terentia seemed to have kept control of things with the help of Philotimus – the freedman family financial advisor – whom Cicero disliked and distrusted. Terentia seems to have performed all the usual domestic duties required of a *matrona* – running the household, managing the slaves, and overseeing the family's religious activity[3]. Their daughter, Tullia Ciceronis, was born in 78 BCE, and their son Marcus Tullius Cicero Minor in 65 BCE.

The house buzzed with intellectuals and professionals; Diodotus, the Stoic philosopher, spent a lot of time there, as did Alexio, a physician. Cicero would have been surrounded by staff to help him with his writing and speeches, including researchers, readers, archivists, and secretaries. Terentia, therefore, would not have been short of the company of clever people and stimulating conversation.

At the end of 63 BCE we begin to see evidence of Terentia's influence over Cicero. While sacrificing at the Bona Dea (which was held in their house that year), the flames shot up; the Vestals were in attendance, and they interpreted this as a good omen. Terentia informed Cicero, telling him to carry on with his current policies for the good of the state; if Cicero had been in any doubt as to how to proceed with the grievous issue of the Catiline conspirators in the Senate, then this was now expelled. In social, religious, and political terms, hosting the Bona Dea was a high point in any elite Roman woman's life, reflecting as it did her status as the wife of one of Rome's senior politicians, surrounded by the cream of female Roman society.

However, Terentia became implicated with Cicero in accusations of corruption following the trials of the Catiline conspirators; this clearly demonstrates that she was a regular go-between in political and financial matters for her husband and various petitioners. It all came to a head in 58 BCE, when Cicero was exiled on charges of illegally executing the conspirators. The charges were brought by Publius Clodius Pulcher, whose aim was to exact revenge on Cicero for shattering his alibi in the 62 BCE Bona Dea scandal (see above). Plutarch uncharitably records that Terentia made Cicero testify against Clodius to prove to her that he was not having an affair with Clodius's sister, Clodia (Catullus's Lesbia). However, Plutarch was working to an agenda: he was intent on portraying Terentia as an overbearing wife, and Cicero as a weak man, browbeaten by her; Plutarch describes her as having 'a violent will of her own, [and that] she had gained ascendancy over Cicero'.[4]

Cicero relied heavily on the support of Terentia during his exile in Thessalonika and Dyrrachiumin in 58 and 57 BCE. His letters to her reflect his isolation, homesickness, and affection for Terentia and their daughter, Tullia. Terentia is the 'most faithful and best of wives … light of [his] life' (*fidissimaatque optima uxor … mea lux*)[5]. Both she and Tulliola (as Cicero affectionately called his daughter) interceded bravely on his behalf during the tortuous exile[6]. They also had to deal

with his onerous business affairs, the slaves, and the household, as well as the upbringing of their young son.

Terentia remained faithful and supportive even though her husband was now a non-citizen, and she was no longer his legal wife (*uxor iusta*). There was considerable stigma attached to the wife of an exile: we know this from the relegated Ovid, who tells us that his wife visibly blushed when the subject was raised and that she was ever reminded of the shame attached to being married to a man in exile. Cicero wrote that he envisaged Terentia day and night doing everything she possibly could to win his reprieve. In actuality, the two women demonstrated ostentatiously by wearing their hair unkempt and donning black mourning clothes, visiting friends in Rome in order to canvas support for Cicero's return. When their house on the Palatine was torched by Clodius's mob, Terentia sought sanctuary with Fabia in the house of the Vestal Virgins. Terentia kept Cicero up-to-date with the situation in Rome and the progress in their efforts to secure his rehabilitation. Nevertheless, she sensitively spared Cicero the worst news; he was already severely depressed, and she clearly saw little point in revealing to him that she had been dragged from the Temple of Vesta to the Valerian Bank. Cicero later found out about this from a friend, Publius Valerius, and later intimates that Terentia was also physically abused[7]. Due largely to the valiant efforts of Terentia, Tullia, Atticus, and others, Cicero was able to return to Rome in 57 BCE.

Plutarch records how Cicero himself said that Terentia was no shrinking violet, and that she was more active in his political life than she ever was in her domestic affairs.[8] This is a good example of the Roman wife and *matrona* taking over responsibilities which were normally the preserve of the man of the household.

Despite all Terentia's support, and Cicero's appreciation of it, things between them started to turn sour by 48 BCE. Whatever happened, by 46 BCE the couple were divorced; it seems unlikely that Terentia ever saw her substantial dowry again[9]. It is hard to tell how far the breakdown was due to Terentia's micro-management of their finances – a large portion of which came from her dowry – or due to Cicero's venality. The fact that Cicero married soon after their divorce, in December 46 BCE, to a rich young girl – Publilia – may suggest the latter. Plutarch says that Terentia believed Cicero to be enchanted by Publilia, but that Tiro (Cicero's freedman editor) ascribed the match to Cicero's need for money to pay off his debts.[10]

Terentia went on to marry again, twice. Her second marriage was said to be to the historian Sallust, while her third was to Messalla Corvinus. She lived to the age of 103, dying in 4 CE.[11]

Terentia was a rare example of a Republican Roman woman who was very much in control of events and of her destiny. While she exhibited many of the traits of the good *matrona* – a good manageress of the household and the slaves, a competent and frugal financial controller, and a devoted mother to Tullia and Marcus – she also demonstrated characteristics that would have been considered outrageous and decidedly unmatronly a few years beforehand. She was never going to spend all night working the wool like Lucretia in the lamplight, and she was not going to sit quietly by, politely listening to Cicero, his friends, and his enemies, like Cornelia. She was conspicuous in her support for her exiled husband and was

immodest enough to demonstrate that support publicly, bravely, ostentatiously, and vocally. She clearly thrived on the part she played in Cicero's political life, despite the obvious risks this held at such a volatile time.

Fulvia Flacca Bambula – *a woman in body alone, mutilating Cicero*

The ambitious, military-minded and assertive Fulvia Flacca Bambula (*c*. 83 BCE – 40 BCE), is infamous for gleefully and sadistically pricking the decapitated Cicero's tongue with a hairpin: she took exception and sought revenge after Cicero had insinuated that Mark Antony, her third husband, only married her for her money. Cicero's head was put on public display on the Rostra in the Forum after his proscription and execution in 43 BCE.

Fulvia, like other prominent and flamboyant women before her, is likened to a man – 'a woman in body alone' – by Velleius Paterculus (*Histories* 2, 74, 3) who evidently regarded her vengeful and gruesome act as unladylike and, by implication, the sort of thing only a man should do. The mutilation was significant – Cicero's tongue was the part of his body which gave him his fame as an orator; moreover it was his tongue which had delivered that slur regarding Mark Antony.

This is Dio's graphic account:

> Fulvia took the head into her hands before it was removed, and after abusing it spitefully and spitting on it, put it on her knees, opened the mouth, and pulled out the tongue, which she pierced with the pins that she used for her hair, at the same time telling many brutal jokes.
> – Dio, *Roman History* 47, 8, 4

Pomponia, the widow of Cicero's brother, Quintus Tullius, and sister of Atticus was even more sadistic: when Philologus, the freedman who betrayed the Ciceros, was brought to her she ordered him to cut off strips of his own flesh, cook them and then eat them. (Plutarch, *Cicero* 49).

In the Perusine War Octavian faced Antony's younger brother, Lucius Antonius, and Fulvia. Velleius Paterculus records that she 'was creating general confusion by armed violence' while Octavian's troops tied obscene messages to stones and fired them directly at Fulvia. Two were aimed at her clitoris with the unmistakeable suggestion that she was a tribade, a lesbian. Fulvia and Antony were invited to open their arses wide to receive the projectiles. They in turn responded by calling Octavian a cock-sucker and wide-arsed, suggesting that he too was open to penetration: the ultimate insult for a free-born man.

Martial preserves for us the lascivious epigram which Octavian reputedly composed for Fulvia:

> Because Antony is shagging Glaphyra, Fulvia has decided that my punishment will be that I shag her too. Me fuck Fulvia? What if

Manius begged me to bugger him? Would I? I think not, if I had any sense. "Fuck or fight", she says. Doesn't she know that I love my prick more than life itself? Let the battle trumpets sound!
– Martial, *Epigrams* 11, 20

Martial's Octavian is implying that the ensuing civil war was caused because Fulvia was put out by his rejection of her.

With Octavian's victory at Actium in 31 BCE over Antony and Cleopatra the Roman Republic effectively drew to a close and the Roman empire dawned under Octavian. He adopted the title of Princeps ('first citizen'), and in 27 BCE was awarded the title of Augustus ('revered') by the Roman Senate. The spotlight of woman's history inevitably swivelled, by and large, towards the women of the Principate, initially those of the Julio-Claudian dynasty (27 BCE – 68 CE).

Further reading

Babcock, Charles L. (1965). 'The Early Career of Fulvia'. *The American Journal of Philology.* 86 (1): 1–32.

Brennan, T. Corey (2012). 'Perceptions of Women's Power in the Late Republic', *A Companion to Women in the Ancient World.* Chichester

Delia, Diana (1991). 'Fulvia Reconsidered'. *Women's History and Ancient History.* 197–217.

Schultz, Celia, E. (2021). *Fulvia: playing for power at the end of the Roman republic.* Oxford

Weir, Allison (2007). 'A Study of Fulvia'. (Master's thesis, Queen's University, Kingston, Ontario)

Empire Women

Octavia the Younger – *diplomat par excellence*

Octavia the Younger (69 BCE – 11 BCE) is one of history's first female shuttle diplomats. Her credentials and lineage are impeccable. This summary gives us some idea of the rampant intermarriage inherent in the Julio-Claudian dynasty and in the aristocracy.

She was the sister of Octavian, and fourth wife of Mark Antony. She was the great-grandmother of Caligula and Agrippina the Younger, maternal grandmother of Claudius, and both paternal great-grandmother and maternal great-great grandmother of Nero. Born in Nola, she was the daughter of Gaius Octavius (Octavian's father) and Atia Balba Caesonia (85 BCE – 43 BCE), the niece of Julius Caesar.

As Mark Antony's fourth wife Julia's marriage made Antony and Octavian brothers-in-law, and as such was one of the most politically sensitive unions in

a society where political marriages had almost become *de riguer* amongst elite families – Octavia was pregnant with her late husband's third child, Claudia Marcella the Younger. Things went well at the start: Antony minted a coin bearing Octavia's portrait, making her only the second Roman woman to feature on a coin after Fulvia, her immediate predecessor in Antony's affections. The couple travelled together, with Octavia happily residing with her husband in Athens during the winter of 39–8 BCE[1].

Octavia was a generous and public-spirited woman. Evidence for this comes in a curious incident in 43 BCE when she helped the proscribed Titus Vinius: he had been hidden in a chest by his wife, **Tanusia**, concealing him in the house of a freedman, telling everybody that he was dead. In doing so this brave woman herself risked death for harbouring a proscribed person. Octavia agreed to help and arranged for Tanusia to deliver the chest to a festival attended by Octavian (without the other triumvirs) where Titus Vinius was dramatically sprung from the chest. Octavian, when he learned of the ruse, was so impressed by the couple's ingenuity and nerve that he pardoned Vinius and Tanusia and promoted the freedman to the equestrian order[2].

Early signs of Octavia's influence over, and diplomacy with, brother and husband came in 37 BCE when she was able to use her unique position as sister and wife to good ends. Octavia travelled with Antony to Italy where he won over a number of Octavian's allies, including Maecenas and Agrippa – the equivalent of Octavian's Home Secretary and Foreign Secretary, pleading the pointlessness of conflict between her two kinsmen. Her intercession led to the of Treaty of Tarentum and a five-year extension of the Triumvirate. Other triumphs included persuading Antony to increase the size of the fleet he was despatching to Octavian in the fight against Sextus Pompey off Sicily, and winning a 1,000 strong bodyguard from Octavian to augment the army he was loaning Antony for the Parthian campaign[3]. Her *pièce de résistance* came when she nearly arranged the betrothal of Octavian's young daughter, Julia, to Mark Antony's son by Fulvia, M. Antonius Antyllus. The marriage never happened because Antyllus was executed after the battle of Actium.

Things continued to go well: Octavia had established herself as an influential and respected diplomat, astute enough to capitalise on her unique position as wife and sister to the benefit of both Antony and Octavian, and, ultimately, to a Rome weary with internecine warring.

This, however, did not take into account Antony's unpredictable and mercurial nature when it came to the treatment of his wives in relation to wider political or personal considerations. Just as he had spurned Fulvia so he eventually snubbed Octavia: their journey together to the Parthian theatre of war was cut short when Antony abruptly sent her back to Rome. Octavia's personal safety was the pretext but everyone knew that Cleopatra was the real reason[4]. Octavia's resulting unhappiness can only have been heightened when in 36 BCE she learnt that Antony had admitted to the paternity of Cleopatra's children. Despite it all, Octavia remained loyal, and won from Octavian permission to deliver much-needed reinforcements and ordnance to Antony; she got as far as Athens where letters waiting from her husband told her to go home: Octavia meekly responded by asking what she was now to do with the men and supplies she had organised.

The insult was not lost on Octavian, her brother. Antony's treatment of his sister was a growing cause of resentment and he advised Octavia to divorce Antony; she refused and remained the steadfast *matrona*, her main concern being that growing enmity might just lead to more civil war, despite the fragile peace won by the Treaty of Tarentum[5]. Antony finally divorced Octavia in 32 BCE.

Octavia was a competent diplomat who for many years ensured a degree of non-aggression between her brother and her husband. Despite her loyalty and patience she was treated shabbily by Mark Antony who showed little appreciation of her calming influence and competence during one of the most fractious times in Roman history when many others around her were anything but calm.

Further reading

Freisenbruch, Annelise (2010). *The First Ladies of Rome: The Women behind the Caesars*. London

Moore, Katrina (2017). 'Octavia Minor and the Transition from Republic to Empire' (PDF). Clemson University, Clemson, SC

Livia Drusilla – *powerful wife of powerful Augustus*

Livia Drusilla (58 BCE – 29 CE) was born on 30 January 58 BCE. She married Octavian, and was the mother of Tiberius, Octavian's successor. She was paternal grandmother of the emperor Claudius, paternal great-grandmother of Caligula, and maternal great-great-grandmother of Nero: a foot in every camp. Her parents were Marcus Livius Drusus Claudianus and Aufidia; Marcus Livius Drusus was her adopted brother. Her father committed suicide after backing Brutus and Cassius at the Battle of Philippi in 42 BCE.

Livia first married Tiberius Claudius Nero, her cousin, in 43 BCE; he had misguidedly sided with Caesar's assassins after the Ides of March. Tiberius, Livia's son and Augustus' successor, was born in 42 BCE. While she was pregnant, Livia divined the sex of her baby by keeping a hen against her breast, passing it to a nurse to maintain warmth whenever necessary. A cockerel was born of the hen, and Tiberius was born of Livia[1]. Two years later, her husband joined Lucius Antonius (Antony's brother) and Fulvia at Perusia, in opposition to Octavian. After the fall of Perusia the couple fled to Naples, where Tiberius Nero unsuccessfully attempted to spark a slave revolt; he later joined Sextus Pompeius (Pompey's younger son) in Sicily, but he received short shrift there and moved on to Sparta – possibly because he had been proscribed by Octavian at this point[2]. The inhospitable treatment shown by Sextus Pompeius may be because he had noted Tiberius Nero Claudius' fallibility, and his growing reputation for injudicious, career-limiting decisions – traits which a wily Livia had surely also detected in her husband by now. Nevertheless, she stood by him and joined him in exile, where they were well-received by the Spartans. The couple would soon have to move on, however. One of Livia's abiding memories from this time would be the forest fire which nearly engulfed her, setting fire to her hair and clothes as she fled Octavian's soldiers[3]. The

amnesty agreed by the triumvirs and Sextus Pompeius at the Treaty of Misenum allowed the hapless Tiberius Nero (and his long-suffering wife and child) to return to Rome in mid-39 BCE.

Livia obviously benefitted from a good education. Philo of Alexandria (*c.* 20 BCE – 50 CE) tells us that she was exceptional because her education lent virility to her powers of reasoning – another good example of how men in the Roman world ascribe masculine characteristics to women who excelled[4]. Horace describes Livia as 'rejoicing in that unique husband of hers' (*unico gaudens ... marito*), and in so doing gives us an instance of how women of even exceptional achievement were defined through the actions or reputations of their husbands or fathers[5]. One example, though, where a mother got all the credit – albeit with obvious extenuating circumstances – was Faustus Cornelius Sulla, son of the dictator, who was lionised by his schoolmates because of the reputation of his mother, **Caecilia Metella Dalmatica**.

Back in Rome, Livia was six months pregnant with her second child by Tiberius Nero: he would be named Nero Claudius Drusus. We know him better as Nero.

In 40 BCE **Scribonia** had been forced to divorce her second husband, Publius Cornelius Scipio, so that Octavian could marry her; the rationale behind this being that it would forge a political alliance with Sextus Pompeius. The marriage may have always been doomed, because Octavian was reputedly irritated by Scribonia's constant nagging over his infidelities. In this respect she failed the test of the true *matrona*, who was expected to turn a blind eye to her husband's infelicities. However, she compensated by being a devoted mother and aunt; when Julia, their daughter, was later exiled by Augustus, Scribonia volunteered to go with her.

It was around this time that Livia would have met the charismatic leader Octavian, still in his early twenties but with obvious ability and promise. Dio writes that they were having an affair in 39 BCE, around the time of the party he arranged to celebrate the symbolic shaving of his beard as a symbol of manhood[6]. They were betrothed in the autumn of 39 BCE even though Octavian was still married to Scribonia. His previous wife had been Clodia Pulchra – whom he sent back to her mother, Fulvia, still the virgin she was the day that he married her. Octavian, reputedly smitten by Livia, divorced Scribonia on the day that Scribonia gave birth to their daughter, Julia[7]. At the beginning of his *Life of Galba*, Suetonius describes how the couple tried to mitigate the potential scandal caused by their unseemly haste to wed while Scribonia was in labour by peddling the tale that their relationship was sanctioned by another divine omen. They claimed that, while *en route* to her country villa in Veii, an eagle dropped a white hen chick into Livia's lap, holding a sprig of laurel in its mouth. According to Dio, Livia saw significance in this sign; she kept the chick for breeding, and planted the twig in her garden. Remarkably – as white hens were thought to be sterile – the hen gave birth to a number of white chicks. A grove of laurels also sprang up from the twig; thenceforth, all *triumphatores* cut laurel from these trees to make up their triumphal wreaths[8]. The fable had obvious symbolism for those who cared to look for it; it neatly suggested that the marriage was divinely sanctioned, by portending fertility in Livia and associating the couple with military victory. However, Dio has an

alternative, more prosaic explanation: that Livia had the power of the Emperor, rather than a hen, in her lap[9].

Octavian's expeditious marriage to Livia was typical of the swing doors swinging which characterised many political marriages. Although the women were often little more than pawns in these arrangements, they did play a significant role in some highly political and prestigious families. By the same token, the desire for successful political advancement was sufficient grounds for casual divorce. We have seen how the orator Hortalus tried to cement his links with Cato by requesting the hand of Porcia, Cato's daughter, who was already married to Bibulus. Cato refused, but he did agree to divorcing his own pregnant second wife, Marcia, so that Hortensius (whom he also presumably wanted to favour) could marry her instead[10]. Julia, Octavian's daughter, was married off three times: to Marcellus, (a mere boy); the son of Octavian's sister Octavia; to Marcus Agrippa, who was already married and had children by one of Marcellus' sisters; and then to Tiberius in 11 BCE, whom Octavian (by then Augustus) had forced to divorce his pregnant wife.

So Octavian and Livia married on 17 January 39 BCE; Livia was nineteen. Livia's former husband until very recently, Tiberius Claudius Nero, gave her away 'just like a father would', according to Dio[11]. Tacitus, probably relying on vindictive correspondence from the stylus of Mark Antony, claims that Livia was forcibly abducted (*abducta Neroni uxor* and *aufert marito*), but this hardly chimes with a wedding ceremony in which the former husband gives the bride away.

From the beginning of the fifty-two years of marriage that followed, Livia acted in consort with her husband, advising him on policy decisions while running her own affairs, and agenda. At the same time, however, she was very much the model *matrona*, dressing modestly in the *stola* (long dress), working the wool, wearing little jewellery, and having her hair done conservatively, often in the *nodus* or 'club' style, with its old Republican overtones (as championed by Octavia, her sister-in-law). She attended to her relatively modest household on the Palatine, striving for a child, an heir for her husband and for Rome. The only result of their efforts was a miscarriage, but the marriage survived, although it would not have been an unusual elite practice to divorce in such stressful circumstances. Livia's modesty would draw comparison with Cornelia (see above), whose real jewels were her children.

Her general lack of ostentation, her unobtrusiveness, set her in stark contrast not only to contemporary fashion amongst privileged women, but also, more crucially, to Cleopatra – the bejewelled queen whom Lucan would later describe as being freighted with the booty of the Red Sea, and so despised by Octavian. From the beginning, Octavian was probably attracted to what Tacitus describes as Livia's affability (*comitas*); he and Velleius Patrculus describe Livia's beauty (*forma*), while Tacitus adds that Octavian was motivated by passion and 'by desire for her body' (*cupidine formae*)[12]. In time, this settled down into what we might assume to be love and affection; even sensationalist Suetonius concedes that Augustus' love for Livia was 'special and enduring' (*unice et persevanter*). There is little doubt that she was a powerful force in her lifetime and thereby in the life of the Roman people. Scribonia complains of her 'no little power' (*nimiam Livia Drusilla potentiam*) – power in the political rather than the emotional sense – and Tacitus

hints at coquettishness when he reports that she was not an unwilling player in Octavian's seduction (*incertum an invitam*). Seneca calls her *maxima femina*, the greatest woman[13].

On 16 January 27 BCE the Senate voted to give Octavian the titles of Augustus and Princeps. Octavian was now Augustus, the first Emperor of Rome, and Livia Drusilla was right by his side[14].

Augustus was intent on restoring some degree of moral rectitude in his citizens. The resulting moral legislation was generally very unpopular, and caused public demonstrations. The laws amounted to what we would today describe as the meddlings of a nanny state. Consequently, they were somewhat diluted by the Lex Papia Poppaea in 9 CE – named after the consuls of that year, who, incidentally, were both childless and unmarried. It was, of course, all blamed on women. In *Noctes Atticae*, Aulus Gellius summed up the public (or, rather, the male) mood when he quotes Augustus' speech in the Senate in 17 BCE. Playing to the gallery, Augustus grudgingly declaims:

> ...if we could survive without a wife, citizens of Rome, all of us would do without that nuisance, but since nature has decreed that we neither manage comfortably without them, nor live in any way without them, we must plan for our lasting preservation rather than our temporary pleasure.

The same sigh of resignation can be heard coming from Varro: ...

> a husband must either put a stop to his wife's faults or else he must put up with them. In the first case he makes his wife a more attractive woman, in the second he makes himself a better man.

Livia, then, was in many respects the epitome of a good Roman *matrona*, but at the same time she enjoyed an independence which left her largely free from the power wielded by her husband – the man with the *patria potestas*. She demonstrated that she could be tolerant, even-handed, and open-minded. Dio records how she pardoned a number of men who were sentenced to death for inadvertently appearing naked before her; she explained that, to a modest and chaste *matrona*, naked men were no different from statues – and just as unattractive. One of the great (but few) putdowns by a woman on men that have survived. When asked how she managed to have such an influence over Augustus, she, somewhat disingenuously, pointed to her own scrupulous chastity, happily doing what pleased him, apparently keeping out of his business affairs, and conniving at his extramarital affairs. She was therefore an accommodating wife (an *uxor facilis*), in the words of Tacitus; another hallmark of the male ideal of the compliant *matrona*. In around 5 CE she persuaded Augustus to spare Gnaeus Cornelius Cinna Magnus and Aemilia Lepida, who were on trial for plotting against him. In doing so, she exhibited a rare sense of mature political acuity, arguing that revenge would serve considerably less purpose than rehabilitation, and that the absence of clemency in previous cases (she provides

a list) had only sparked subsequent plots. She self-deprecatingly excuses all her enlightened thinking as *muliebrum consilium* – 'a woman's advice'[15].

Dio neatly sums it all up: he asks Augustus what more he could want than a wife who is faithful, looks after the home, raises her children, makes him happy, nurses him when he is ill, shares his good luck and his misfortune, and restrains youthful passion while militating against the ravages of old age. On the other hand, a letter from Mark Antony to Octavian (reported by Suetonius) would suggest that Livia had much to put up with. Antony asks Octavian why he was so exercised by his affair with Cleopatra, when Octavian had reportedly slept with Tertullia, Terentilla, Rufilla, Salvia Titisenia, and the rest of them[16]. Moreover, according to Suetonius, Livia was present at the notorious and scandalous Feast of the Divine Twelve, and was apparently involved in procuring virgins for her husband to deflower, well into his old age[17].

Augustus made it his business to restore the increasingly moribund religious fabric of Rome, as manifested in his refurbishment or rebuilding of eighty-two shrines and temples. Livia was similarly occupied, restoring the shrines of Plebeian and Patrician Chastity, centres of moral rectitude which were exclusively female. She followed this by financing work on the temples of Fortuna Muliebris and Bona Dea Subsaxena – again, both very closely associated with women.

We have Livia to thank for some of the architecture in Ancient Rome and promoting its sponsorship by women. She was one of a number of influential women who financed other, non-religious public buildings around the Roman Empire. **Polla**, the sister of Marcus Agrippa, built a racecourse, and began the construction of the Porticus Vipsaniae on the Campus Martius – later completed by Augustus, and home to Agrippa's map of the world[18]. Women may not have had the vote in the legislative assemblies, the *comitia* and the *concilium*, but graffiti in Pompeii shows that they took an active interest in local politics and electioneering with examples of *programmata*, posters on which they endorsed candidates. Of the 2,500 *programmata* discovered, Savunen indicates that fifty-four (2.16%) were posted by women supporting twenty-eight candidates.

There is, though, one striking example of women exercising real, tangible, political influence. In 1955 an inscription dating from around 6 CE was found in Akmoneia (modern day Ahat in central Turkey) by Michael Ballance, the English archaeologist. The inscription is now lost but luckily Ballance had photographed it and copied it down. What it tells us is that 'the women, both Greek and Roman, honoured Tatia daughter of Menokritos...the High Priestess who acted as their benefactoress under all circumstances, in recognition of all her virtue'; there then follows the names of the three men responsible for financing the statue. Remarkably, we have here a unique example of women taking the initiative in, and responsibility for, an act of civic administration within local government, voting to finance and raise the statue to one of their own. We cannot know if this political emancipation was a one-off or if there were other isolated instances now lost to us. What is important is that the women of Akmoneia proved beyond all doubt that women could have been actively involved in politics at the highest level where the will existed to allow them[19]. **Eumachia** was a priestess (*sacerdos publica*) who

had married into one of the leading Pompeiian families after inheriting property from her father, a successful brick manufacturer. She was a patroness of a guild of fullers – a prestigious position in one of the most important local industries. During the reign of Tiberius, Eumachia gifted the fullers a large building for their head office, dedicated to Augusta and Pietas; it survives today, as the Building of Eumachia[20]. The timing of the gift may not have been accidental, as it coincided with her son's campaign for public office.

Another Pompeiian woman, **Julia Felix**, owned a local estate which comprised baths, shops with rooms above them, and flats on the second floor – all available for rent on a five-year lease. In 43 CE, **Junia Theodora** is fondly commended by the citizens of Corinth for her largesse[21]. Likewise, **Flavia Publicia Nicomachis** was commended for her virtue, as benefactoress and founder of the city of Phocaea in the 2nd century CE[22]. **Modia Quinta**, a priestess in Africa Proconsularis, was honoured with a statue to recognise her provision of a marble patio in the portico, ceilings and columns, and an aqueduct[23].

At the imperial level, **Octavia** was a sponsor of Vitruvius, who dedicated his *De Architectura* to her. Livia herself was presumably involved in the design of the Porticus Liviae, given to the nation by Augustus, and of the Theatre of Marcellus. According to Ovid's *Fasti*, Livia certainly paid for the temple (*aedes*) within the Porticus. Strabo also credits Livia for some of the new buildings springing up in Rome. She was probably also involved in the *macellum Liviae*, a market complex, and in the restoration of Verginia's shrine of Pudicitia Plebeia. In the *Fasti*, Ovid tells us that Livia restored the Temple of Bona Dea Subsaxana, traditionally dedicated by a Vestal Virgin – both associate Livia closely with chastity (*pudicitia*)[24]. Livia also restored the Temple of Fortuna Muliebris, on the Via Latina. Her patronage extended to include literary festivals – for example at Corinth, Chalcis, Mouseia, and Thespiae in Boeotia. The city of Augusta, in Cilicia Pedias, was named after her, as was Liviopolis on the Black Sea coast. Throughout Europe, divination came thick and fast for Livia. Octavia, Julia, and Antonia were also honoured, setting the stage for subsequent Emperor and empress cults. In around 20 BCE, the divine Julia appears on a coin from Thessalonica, and she is also celebrated on an Athenian coin with Julia. At a Corinthian festival, the poetry of Flaccus Syracusius was dedicated to the goddess Julia Augusta, and on Lesbos she had her own sanctuary as Livia Providentia. A huge bust of Livia has been found at Leptis Magna, associated with the Temple of Augustus and Roma there; a similarly colossal statue, over three metres in height, was discovered in the theatre. Livia enjoys numerous associations with goddesses – notably Vesta, Juno and Hera, and Ceres.

As time passed, and as the prospect of producing an heir to Augustus gradually receded, Livia's attitudes and behaviour began to be influenced by an increasingly toxic mix of her devotion to her sons Tiberius and Drusus, her desire to see them do well, and the vicarious power that brought her. At one extreme, historians insinuate that Livia's hand is evident in the deaths of all the possible aspirants to Augustus' title. Conversely, she may have been innocent on all counts, and the eventual accession of Tiberius in 14 CE could have simply been the culmination of a series of coincidences. Years later Livia's grandson Caligula was sceptical, although

he begrudgingly admired her, calling her *Ulixes stolatus* – Odysseus in a *stola*, alluding to the mental agility and duplicity that she shared with the *polutropos* or 'complicated' hero – a 'man of many ways' or a bit 'shifty' and capricious. However, in a letter Caligula wrote to the Senate, he also described her as being of low birth (*desidero*)[25].

So Livia was one of Rome's first female celebrities, appearing on statuary and provincial coinage from 16 BCE. More iconography followed, including a series of coins minted with her portrait – depicting and celebrating not only her changing fashions in hairstyle over the years, but also her evolving role as an ideal *matrona*, mother, consort, and dowager. By the end of her life, Livia had received virtual apotheosis on coinage, as represented by her association with Pietas and Concordia; she paved the way for the numismatic propaganda enjoyed by subsequent empresses. Claudius, her grandson, deified her in 42 CE; he produced coins bearing the inscription DIVA AVGVSTA, with the reverse showing a seated Livia holding a torch in her left hand and wheat in her right – both indicative of Ceres.

As time wore on, relations between the Imperial mother and Tiberius started to cool. The Senate wanted to bestow upon Livia the unprecedented title of 'Mother of the Fatherland' (*Mater Patriae*) to mirror Augustus' title, *Pater Patriae*. Tiberius vetoed this, refusing to accept the title of Pater Patriae himself.

It is impossible to say how far Livia and Tiberius were implicated in the death of Germanicus; Suetonius believed they definitely were and Dio implies as much, but Tacitus is non-committal. Two of Livia's other friends were both called **Marcia**. The first was an informer for Livia; her most significant act, and her last, was to apprise Livia of the resurgent relationship between Augustus and Agrippa Postumus – a threat to the succession of Tiberius. Marcia's information was obtained through her husband and friend of the Emperor, Fabius Maximus, who it seems was in cahoots with Agrippa. For one reason or another, Marcia committed suicide – it is thought she was stricken by grave reservations about her actions.

The other Marcia is famous for the *Consolatio ad Marciam*, written in her honour by Seneca around 40 CE, in consolation for the death of Metilius – one of four of her children, two of whom died young. This Marcia was the daughter of the historian Cremutius Cordus, author of a history of a 'Civil War' down to 16 BCE. His praise for the assassins of Julius Caesar, Brutus and Cassius, earned him the wrath of Sejanus, who charged him with treason in 25 CE; Cremutius took his own life. His writings were burnt, but not before Marcia bravely had copies made, which were eventually republished during Caligula's reign. Seneca tells of the friendship between Livia and Marcia, an *amicitia* (friendship) which may well have resulted in the priesthood accorded to Metilius[26]. Tacitus noticed the notable and ill-advised absence of Livia and Tiberius from the funeral of Germanicus as the point at which the mantle of 'state *matrona*' passed from Livia to Agrippina, the grieving widow. Livia must have been appalled to hear Agrippina being hailed as 'the glory of her country' (*decus patria*), 'a unique exemplar of the good-old-days' (*unicum antiquitatis specimen*), and 'the last member of the line of Augustus'[27].

The circumstances surrounding the death of Germanicus remain a mystery. Some suspected black magic – a suspicion confirmed when workmen searching his quarters made a sinister discovery under the floor and between the walls. They found human remains, spells (*defixiones*) inscribed with Germanicus' name, bloody ashes, and other magical paraphernalia associated with death. In a related story, the Syrian witch **Martina** – famous for her potions, *veneficia,* was summoned to Rome by those preparing charges against Piso and Plancina. Before she could get there, however, she was found dead at Brundisium. There was no sign of suicide; it seems she was killed by her own poison, knotted in her hair[28]. The *Tabula Siarensis* has further significance because it reveals that Livia, Agrippina the Elder, and the sister of Germanicus, Livilla, were given the responsibility of drawing up the shortlist of honours to be voted to Germanicus. While Tiberius would have the final word on this, it is an important sign of the growing power of early Imperial women[29].

Tiberius was irritated when Livia reinstated the morning Imperial *salutatio*, previously abandoned by the increasingly infirm Augustus, where the Roman public could lobby the senators on issues of concern; this was a kind of Roman politician's constituency surgery. Livia had no official place here, nor a remit to perform this very male and privileged function. In 22 CE, Livia independently dedicated a statue to Augustus, inscribing her own name before that of Tiberius – thereby deeply insulting him again.

By 26 CE Tiberius had had enough of what he, with some justification, considered his meddlesome, bullying mother, and of all the other shenanigans that characterised Roman political life and Imperial domestic discord. He retired to the splendid isolation of Capri for some peace and quiet and to indulge some repellent sexual perversions[30]. Suetonius avidly records the quarrels between mother and son; one notable spat occurred when Livia urged Tiberius to include the name of one of her favourites in his lists of jurors. Tiberius agreed to this, but only if he could add a footnote which said the entry was forced on him by his mother. At this, an outraged and spiteful Livia showed her son letters she had received from Augustus, in which his stepfather hurtfully called him miserable and obstinate.

The historians lose interest in Livia as she neared the end of her long life, preferring instead to report the activities (salacious and otherwise) of Tiberius, and the political intrigues of the time. What we do know is that by now Livia was an extremely wealthy woman, cash-rich and the owner of a lucrative portfolio of properties and land.

Livia's predilection for healthy living and natural herbal remedies survives in two of her recipes, which were still in use in the 4th century CE by Marcellus Empiricus of Bordeaux – *magister officium* for Theodosius and author of *De Medicamentis Liber.* One of the recipes was for a sore throat, and comprised opium, split alum, saffron, cinnamon, coriander, and myrrh; the other was for anxiety and chills, comprising marjoram, rosemary, olive oil, and Falernian wine. Livia was an avid gardener, with impressive displays at her Primaporta villa; she developed her own species of fig, the Lavinia, praised by Columella and Athenaeus. She also originated an Egyptian papyrus, the superior grade of which was the 'Augustus' – followed by the 'Livia'. She cultivated wine by the amphora[31]. In 22 CE, the eighty-

year-old Livia became ill. Her recovery was publicly marked by thanksgivings (*supplicia*) and games on a grand scale.

However, when Livia fell ill again and died in 29 CE, Tiberius remained aloof on Capri, using the excuse of work-related pressure, and sent Caligula to deliver the funeral oration. Livia's corpse remained unburied for a number of days; putrefaction forced an unsentimental Tiberius to order her burial. Tiberius denied her any divine honours, saying that this was what she wanted. Tiberius was mean-spirited to say the least; the generous honours voted to her by the Senate after her death were vetoed and the execution of her will was annulled, while the funeral was a decidedly modest affair. The year-long period of mourning was cut short and the unprecedented honorific arch never saw the light of day. The five million sesterces she planned to leave to Galba was reduced to 500,000 sesterces, due to some spurious confusion over the zeros. Tiberius seems to have been out of step with the popular mood: Velleius, hagiographically perhaps, described Livia as 'a woman who in every respect was more like a goddess than a human' (*per omnia deis quam hominibus similora femina*)[32]. It was not until 42 CE that all her honours were restored by Claudius and she was deified with the name Diva Augusta; in the celebrations, an elephant drawn chariot carried her image to all the public events. A statue was erected in the Temple of Augustus, to accompany that of her husband, races were held in her honour, Vestals made sacrifices to her, and women could henceforth invoke her name in oaths, including the marriage vow. In 410 CE, during the Sack of Rome, her ashes were scattered to the four winds when the tomb of Augustus was pillaged by the Visigoths.

Livia was something of an enigma, a living paradox. Publicly (at least), she embodied *pudicitia* and modestly played the role of the ideal Roman *matrona*, but privately she was involved in some hands-on policy making on behalf of the world's biggest superpower. This was a massive shift from any power wielded by women of the Republic; by and large they had remained excluded from public office, taking a back seat, but with Livia the centre of power had moved from the Senate house to the Imperial residence – well within the reach of Imperial mothers and wives. To Tacitus, she was a woman who exhibited *virtus*, that quality of masculinity with its overtones of strength, bravery, and virtue – qualities shared by Roman men and woman alike, but strongly rooted in manliness rather than femininity. To Ovid, she was the personification of the perfect wife and princeps *femina*; for Seneca, she was 'a woman who was most careful about protecting her reputation' (*feminam opinionis suae custodem diligentissimam*). In the view of Tacitus, she exceeded ancient standards; her private life was conducted with old-fashioned rectitude, sanctity and propriety (*sanctitate domus priscum ad morem, comis ultra quam antiquis feminis probatum*). She was a compliant (*facilis*) wife, but an oppressive (*impotens*) mother, who could deal with her husband's guile and her son's simulation (*cum artibus mariti, simulatione filii bene composita*)[33].

Dio records how Augustus was blissfully unaware of the control Livia exerted over him; when some senators asked him how he controlled Livia (with more than a touch of irony), his response clearly showed that he believed he was the dominant partner in the marriage. She astutely knew where to draw the line with Augustus,

and not to overstep it. With Tiberius, on the other hand, she did requently overstep the mark, taking her own power, influence, and authority to extremes never before attempted by a Roman woman. She was anxious for that power (*anxiam potentiae*), and altogether a despotic mother (*impotentia matris*). The author of the *Consolatio ad Liviam*[34] was possibly too close to events to appreciate just how much Livia intruded in public and political affairs during the reign of Tiberius. She may have been largely discreet and discrete under Augustus, and 'she did not stray into the exclusively male world of the Campus Martius or the Forum, dutifully 'establishing her household on the right side of what is allowed' (*nec vires errasse tuas campove forove quamque licet citra constituisse domum*) – the same cannot be said for her actions under Tiberius. She did not deliver the heir that her husband and Rome needed, but her marriage lasted fifty-two years despite this. Horace, Ovid, Tacitus and the other historians are of course writing to their own agenda, and they each have personal axes to grind, but the inescapable truth they concede about Livia Drusilla is that she was the most influential woman Rome had ever seen. She was at once the perfect *matrona* while at the same time helped to govern the Roman Empire, in consort with her husband and in competition with her son.

Further reading

Barrett, Anthony A. (2001). 'Tacitus, Livia and the evil stepmother'. *Rheinisches Museum für Philologie*. 144 (2): 171–175

Barrett, Anthony A. (2002). *Livia: First Lady of Imperial Rome*. Cambridge

Bertolazzi, Riccardo (2015). 'Depiction of Livia and Julia Domna by Cassius Dio' (PDF). *Acta Antiqua Academiae Scientiarum Hungaricae*. 55 (1–4): 413–432

Dennison, Matthew (2011). *Livia, Empress of Rome: A Biography*. New York

Kleiner, D.E.E. (2000). 'Livia Drusilla and the Remarkable Power of Elite Women in Imperial Rome: A Commentary on Recent Books on Rome's First Empress' [Review of *Portraits of Livia. Imaging the Imperial Woman in Augustan Rome*; *Livia, Octavia, Julia. Porträts und Darstellungen*; *Imperial Women. A Study in Public Images, 40 B.C. – A.D. 68*, Mnemosyne, by E. Bartman, R. Winkes, & S. Wood]. *International Journal of the Classical Tradition*. 6 (4): 563–569

Mudd, Mary (2012). *I, Livia: The Counterfeit Criminal. the Story of a Much Maligned Woman*. Trafford Publishing

The Cult of Isis – *she made the power of women equal to that of men*

The oriental cult of Isis spread to Italy from Egypt at the end of the 2nd century BCE and had immediate appeal to women, not least because Isis was associated with a number of other female deities such as Athena, Aphrodite, Hera, Demeter and Artemis. She was also seen as being caring and compassionate, making time for each of her initiates. Moreover, Isis was flexible and versatile: she was all things to all men, and all thing to all women: one inscription describes her perfectly: 'goddess Isis, you who are one and all'[1].

Isis was a woman and a mother who had known grief and bereavement, and she had seen life when she worked as a prostitute in Tyre; she therefore appealed to the whole gamut of female Roman society. She was beneficent and came to be associated with fertility – every year when she saw famine encroaching on Egypt, she wept in sorrow so that her tears replenished the Nile and irrigated the flood plains. She was responsible for the Egyptian practice of honouring queens above kings, as exemplified by Cleopatra; most crucially, 'she made the power of women equal to that of men'[2]. Women would have sympathised with Isis' role as a mother, depicted as she often is with a baby in her arms,

Not surprisingly, men did not like her or her influence over their women. The elegiac poet Tibullus is frustrated with the time Delia, his coquettish mistress, spends worshipping Isis – all that clean-water bathing, and sleeping alone in clean sheets[3]; Contemporary Propertius too is indignant and resents the fact that Isis keeps him apart from Cynthia[4]. Ovid hints at the freedom women enjoyed when pretending to be out celebrating the cult, out of bounds to men, when they were really living it up at the races or the theatre[5]. Elsewhere he recommends to his women readers that Isis be given as an excuse for a headache, and no sex[6]. Juvenal[7] mocks and ridicules women adherents to this and to other oriental cults. Apuleius has a colourful description of the initiation of Lucius into the rites of Isis in his *Metamorphoses*[8].

Men and women of every age and rank participated in the cult of Isis. The women, all dressed in white, sprayed their hair with perfume; they strewed the road with flowers and perfumes (notably balsam) and affixed mirrors on their backs to reflect Isis as she approached; with ivory combs they would pretend to comb her hair.

The inclusiveness of the cult set it apart from official Roman religion: it allowed women to aspire to high religious office and become priestesses. One inscription shows us six female Isis *sacerdotes* (out of twenty-six), one of which was a woman of senatorial rank, another the daughter of a freedman, **Usia Prima**[9]. Around one third of Isis devotees mentioned in Roman inscriptions are women.

As the popularity of the cult spread and grew, so did official suspicion and paranoia. Augustus saw in Isis a worrying reincarnation of Cleopatra and a threat to his license-curbing, moral legislation: in 28 BCE he banned the building of temples of Isis within the city of Rome and in 21 BCE extended this to an exclusion zone outside the city.

The anti-Isis fever reached its zenith under Tiberius after a scandal involving a well-to-do *matrona*, **Paulina**, and the equestrian Decius Mundus. The priests of Isis had told Paulina that Anubis, the Egyptian god, wanted to have sex with her in the temple; Anubis, of course, was played by none other than Decius Mundus who had paid the priests to assist him. However, the tactless equestrian boasted of his conquest and word inevitably reached Tiberius: Mundus was exiled, the priests were crucified and thousands of Isis worshippers were expelled from the city to Sardinia[10].

The scandal is interesting because it not only shows that it was now quite usual for a Roman *matrona* to visit a temple of Isis but also it vindicates, to some extent, Juvenal's scorn for the gullibility of women participating in such cults. Caligula was the first to spot the political kudos to be gained from support for such a popular

cult: he built a temple to Isis in the Campus Martius within the walls of Rome and the goddess never really looked back.

Further reading

Walters, Elizabeth J. (1988). *Attic Grave Reliefs that Represent Women in the Dress of Isis.* American School of Classical Studies at Athens

Witt, R.E. (1997) [Reprint of *Isis in the Graeco-Roman World*, 1971]. *Isis in the Ancient World.* Johns Hopkins University Press

Woolf, Greg (2014). 'Isis and the Evolution of Religions'. In Bricault, Laurent (eds). *Power, Politics and the Cults of Isis.* Proceedings of the Vth International Conference of Isis Studies, Boulogne-sur-Mer, October 13–15, 2011. Brill. pp. 62–92

Julia the Elder – *the difficult daughter*

Julia Augusti, or Julia Caesaris, was the only blood child of Octavian, later Augustus, the only child from his politically motivated marriage with Scribonia, his second wife; Julia was born in 39 BCE, step-sister and, later, second wife of Tiberius, maternal grandmother of Caligula and Agrippina the Younger, grandmother through marriage of Claudius, and maternal great-grandmother of Nero. Livia, then, was Julia's stepmother. Julia's birthday could not have been less auspicious: she was born the day on which Octavian divorced Scribonia to marry Livia Drusilla.

The 5th century *Saturnalia* of Macrobius (2, 5; based on Domitius Marsus' contemporary *De Urbanitate*) shows us a thirty-eight-year-old Julia ensconsed in Julia's world: a world of putting on make-up ready to go out, tweezing grey hairs, of attending gladiator fights in the company of fashionable young men, of dressing provocatively. Macrobius illustrates the impacts of such behaviour:

> One day she stood before Augustus wearing a daring costume which upset her father although he kept quiet; the following day she came in dressed much more modestly, at which he expressed his delight that she was now dressed appropriately for a daughter of Augustus.
> – Macrobius, *Saturnalia* 2, 5

Julia had wittily responded by saying that today she dressed for her father, yesterday for her husband. Her modish dress sense was, of course, in direct contrast to the simple, modest homespun clothing Augustus was trying to promote to his subjects. In reply to those people who wondered why she did not conform to her father's prudence and frugality she pointedly answered that 'He forgets that he is Caesar but I never forget that I am Caesar's daughter'.

But things started to go wrong when Julia began to assert her own individuality, reacting, no doubt to a greater or lesser extent, to the oppressed childhood she had endured, the increasingly liberal society around her and the sexual hypocrisy of her father and his legislation. The reports, *vulgo existimabatur* ('it was commonly thought'), of Julia's serial adultery with Sempronius Gracchus, described by

Tacitus as *pervicax adulter, persistent adulterer,* and rumours of an unhealthy relationship with her stepbrother, Tiberius. Suetonius describes Julia's, and her sister's, behaviour as 'all kinds of vice'.[1]

In 2 BCE Augustus actually denounced Julia and her deteriorating behaviour to the Senate; he had her arrested for adultery and treason, and annulled her marriage. To a sensationalist Velleius Paterculus, a storm erupted in the Augustus household 'disgusting to describe, repellent to remember'. Augustus had found out about his daughter's all too public fornication:

> Julia...scandalously left nothing lustful or lavish undone that a woman could when prostituting herself, and quantified her good fortune by her dissolute sin, claiming she could rightfully do whatever she liked.

According to Seneca, whose vocubulary and imagery is even more immoderate, Julia's sins were for Augustus *ulcera*, 'sores'; which when excised, felt as if he was cutting off his own limbs, limbs which, Tityos-like, kept growing back. Julia's nocturnal adventures even took in prostitution and, ironically, sex on the statue of Marysas in the Forum – *indicium libertatis*, a symbol of liberty and freedom of speech. More galling for Augustus must have been the report by Seneca that Julia regularly fornicated on the very rostra on which he had delivered his moral legislation, struggling to restore family values and outlawing adultery, the *Leges Juliae,* with a sentence of insular exile.[3] And so did Julia arrive in the splendid isolation of Pandateria.

Julia may not have been totally without male company on her island, though, if Suetonius's story[2] that she gave birth to a child there is to be believed; Augustus, exercising his rights as *paterfamilias* and *ius patrium, ius vitae necisque* had the baby exposed.

Velleius Paterculus describes Julia as 'stained by sex or excess', adding a list of her lovers[4]. Seneca says she had 'adulterers by the herd': *admissos gregatim adulteros;* Pliny the Elder calls her an *exemplum licentiae*, the epitome of licentiousness with her night time frolics on the statue of Marsyas which groans under the weight of her *luxuria*, her lewdness. Dio Cassius records 'night time orgies and drinking parties in the Forum, even on the Rostra'.

Julia was clearly very much her own woman. When asked how her children all resembled Agrippa despite her wayward behaviour, she is alleged to have quipped that being pregnant allowed her to pursue her extra-maritial affairs without fear of getting pregnant: 'I never take on a passenger unless the ship is full'. Unfortunately for Julia, a somewhat less accommodating ship was to take her into insular exile on Pandateria.

Further reading
Chrystal, Paul (2015). *Roman Women: The women who influenced the history of Rome.* Stroud
Chrystal, Paul (2017). *In Bed with the Romans.* Stroud

Agrippina the Elder

Vipsania Agrippina, Agrippina Major or Agrippina the Elder was born in 14 BCE, daughter of Julia Augusti and Agrippa, sister of Julia, the second grand-daughter of Augustus, sister-in-law, stepdaughter and daughter-in-law of Tiberius, mother of Caligula, maternal second cousin and sister-in-law of Claudius and the maternal grandmother of Nero. She married Germanicus around 5 CE when she would have been eighteen or so.

Tacitus records that in 14 CE soon after Tiberius succeeded Augustus, Agrippina, with Caligula and pregnant with Agrippina Minor, accompanied Germanicus to Germany to suppress a mutiny amongst some disaffected legions. During this German campaign the soldiers showed how they appreciated Agrippina's qualities as a *matrona*: they admired her fertility, her renowned chastity and the fact that she visited their camps with Germanicus, even giving birth to Agrippina Minor in the field: *ipsa insigni fecunditate, praeclara pudicitia; iam infans in castris genitus...* Agrippina cleverly exploited her popularity, and her condition, by pretending to leave reluctantly and evoking pity and not a little shame among the troops with the result that the mutiny fizzled out and the ringleaders were executed.

Pliny the Elder, author of the lost *German Wars,* who served under Germanicus, told how, in 15 CE, Germanicus made a determined push towards the Elbe; the plan failed when he overreached himself by advancing as far as the Teutoburger Wald, the very place where in 9 CE Varus and his legions were ignominiously annihilated by Arminius. Arminius was still successfully attacking the Romans with his guerrilla units; one detachment of Romans was trapped: memories of Teutoburger Wald loomed large. In panic the Romans rushed to the Rhine bridge at Castra Vetera (Xantem), their objective to destroy it and prevent the Germans from crossing. A wise and perceptive Agrippina realised that this would maroon many Roman soldiers on the wrong side of the river, exposing them to the mercy of the Germans.

> Meanwhile a rumour had spread that our army was cut off, and that a furious German army was marching on Gaul. And had not Agrippina prevented the bridge over the Rhine from being destroyed, cowards as some of them were, would have fled. A woman of heroic spirit, she assumed during those days the duties of a general, and distributed clothes or medicine among the soldiers, when they were destitute or wounded.

> According to Pliny the Elder, the historian of the German wars, she stood at the extremity of the bridge, and heaped praise and thanks on the returning legions. This made a deep impression on Tiberius. "Such enthusiasm," he thought, "could not be genuine; generals had nothing left to them when a woman went among the companies, attended the standards, ventured on bribery, as though it showed but slight ambition to parade her son in a common soldier's uniform, and wish him to be called Caesar Caligula. Agrippina had

now more power with the armies than officers, than generals. A woman had quelled a mutiny which the sovereign's name could not check." All this was inflamed and aggravated by Sejanus, who, with his thorough understanding of Tiberius, sowed for the future hatreds which the emperor might store up and reveal when fully matured.

– Tacitus, *Annals* 1, 69[1]

Germanicus died in Antioch in 19 CE. As we have seen, in 26 CE, Tiberius left Rome and retired to Capri. He severed all ties with the factions altogether and abandoned politics, leaving Rome in the care of Sejanus. Richard Alson tells us how this allowed Sejanus to attack his rivals with impunity leading to a rise of politically motivated trials against Agrippina and her associates. Many were subsequently accused of *maiestas* ('treason') by the growing number of accusers; charges of sexual misconduct and corruption were common. In 27 CE, Agrippina was placed under house arrest in her suburban villa outside Herculaneum.

Sejanus did not launch his final attack on Agrippina until after the death of Livia in 29 CE. Tacitus records that a letter was sent to the Senate from Tiberius denouncing Agrippina for her arrogance and pride, and Nero Julius Caesar for engaging in disgusting sexual activities. Despite a public outcry, Agrippina and Nero were declared public enemies (*hostes*) following a reiteration of the accusations by Tiberius. They were both exiled; Nero to Pontia where he was killed or encouraged to commit suicide in 31 CE, and Agrippina to Pandateria, the very place her mother, Julia, had spent her exile years.

Suetonius says that while on the island of Pandateria, Agrippina lost an eye when she was beaten up by a centurion. She would remain on the island until her death in 33CE. Accounts of her death vary. She is said to have died from starvation, but it is not certain whether or not it was self-imposed. Tacitus says food was withheld from her in an effort to make her death seem like a suicide.

Further reading

Adams, Geoff W. (2007). *The Roman Emperor Gaius 'Caligula' and His Hellenistic Aspirations.* BrownWalker Press

Adams, Henry Gardiner (ed.) (1857). *'Agrippina'.* In *A Cyclopaedia of Female Biography*

Alston, Richard (1998). *Aspects of Roman History AD 14–117.* London

Cornelia Sabinus

A tragic illustration of what happens when a woman infiltrates an army barracks occurred in 39 CE during the reign of Caligula. Gaius Calvisius Sabinus had been accused of *maiestas*, treason, in 31 CE after the fall of Sejanus – but he had survived the purge; now he was under suspicion from Caligula. Unfortunately for Sabinus, Cornelia, his wife, was allegedly in the weird, voyeuristic habit of watching soldiers doing their exercises; less innocently, she also visited sentries at night dressed up

in military uniform offering her body. One such night in 39 CE she was caught *in flagrante* in the headquarters. Cornelia was accused of entering the camp at night dressed as a soldier, 'interfering' with the guard, and committing adultery in the general's headquarters.

Her partner in crime was Titus Vinius (12 CE – 69 CE) – a general who later became very powerful in the reign of Galba, and who was having this risky affair with his commander's wife on what was his very first campaign. Cornelia and husband Sabinus committed suicide before they could be brought to trial. Propaganda, perhaps, to deter women from fraternising with the military? Vinius' reward was imprisonment by Caligula, but after Caligula was assassinated he was freed. Tacitus called him 'the most worthless of mankind'.

Cartimandua – *queen of the troublesome Brigantes*

In 43 CE, after a century of Roman indecision and vacillation with aborted invasions planned and cancelled first by Julius Caesar and then Caligula, the emperor Claudius invaded Britain, ostensibly to help the client king Verica of the Atrebates who had been exiled after a revolt by the Catuvellauni[1].

When we think of fighting women in the early days of Roman Britain, we automatically think of Boudica; Boudica, however, was preceded by another powerful British warrior woman: Cartimandua, queen of the Brigantes tribe.

The area corresponding to modern day Wales proved particularly intractable to the Romans with fierce resistance coming from the Silures, Ordovices and Deceangli. Caratacus and his guerrilla attacks were a real problem; the Brigantes and the Iceni were also proving troublesome. In 51 CE things came to a head when Publius Ostorius Scapula finally defeated the Silures under Caratacus, capturing Caratacus' wife and daughter and taking his brothers prisoner. Caratacus himself fled to the Brigantes seeking asylum but, unfortunately for Caratacus, the duplicitous queen Cartimandua, had him bound in chains and handed over to the Romans. Caratacus' reputation preceded him, he became a reluctant star in Claudius' triumph: all Rome was anxious to see the man who had defied and irritated Rome for so long. His dignified speech saved his life: Claudius pardoned him, his wife, daughter and brothers.

The Silures, however, would still not lie down and Cartimandua's former husband Venutius, a hater of the very name of Rome, *Romani nominis odium,* took over the mantle of leader of British resistance against the Romans[2].

Cartimandua had probably been leader of the Brigantes well before Claudius invaded and may well be one of the eleven monarchs who surrendered to Rome without a fight, as depicted on Claudius' triumphal arch[3]. She could now consider herself considerably wealthy, due to her shrewd support of Rome and her betrayal of Caratacus; however, Venutius attacked the Brigantes, only failing to defeat them when the Romans sent Caesius Nasica and the Legio IX Hispana, to reinforce Cartimandua[4].

Cartimandua had married Vellocatus, former armour-bearer to Venutius, and installed him as her king. Although Tacitus records that Cartimandua was a good ally

of Rome's and acknowledges her *nobilitas*, he savages her in much the same way as Horace, for example, had destroyed Cleopatra (*fatale monstrum*). He describes her treatment of Caratacus as *per dolum*, malicious, and highlights her wealth and luxurious lifestyle; her liaison with Vellocatus is adulterous and driven by rage and lust: *pro adultero libido reginae et saevitia*, it is a disgraceful act, *flagitium,* which shook the very foundations of her dynasty. She is a queen, *regina* – a dirty word in Rome, thanks to Cleopatra – and is duplicitous in her behaviour towards Venutius and his family: *callidisque Cartimandua artibus*; Tacitus disparages the power that she wields as being ignominious to men.

The next powerful woman, the next British queen the Romans encountered, was to prove even more belligerent and somewhat less compliant...

Further reading

Braund, David (1996). *Ruling Roman Britain: Kings, Queens, Governors, and Emperors from Julius Caesar to Agricola*. New York
Chrystal, Paul (2019). *The Romans in the North of England*. Darlington
Howarth, Nicki (2008). *Cartimandua, Queen of the Brigantes*. Stroud
Markdale, Jean (1986). *Women of the Celts*. Rochester, VT

Boudica (60 CE) – *'possessed of greater intelligence than often belongs to women'*

Boudica, like Cleopatra, has been more than well catered for in the literature, ancient and modern. Tacitus describes Boudica as a woman of royal and noble birth, pointing out that it was, unlike in the Roman Empire, not unusual for a Celtic woman to command a British army. Another description we have of Boudica comes from Cassius Dio writing at the end of the 2nd century BCE; he describes her vividly, if condescendingly, as follows:

> All this ruin[the revolt of the Iceni] was brought upon the Romans by a woman, a fact which in itself caused them the greatest shame... the person who was chiefly instrumental in rousing the natives and persuading them to fight the Romans, the person who was thought worthy to be their leader and who directed the conduct of the entire war, was Boudica, a British woman of the royal family and possessed of greater intelligence than often belongs to women.... In stature she was very tall, in appearance most terrifying, in the glance of her eye most fierce, and her voice was harsh; a great mass of the tawniest hair fell to her hips; around her neck was a large golden necklace; and she wore a tunic of divers colours over which a thick mantle was fastened with a brooch. This was always how she dressed. She now grasped a spear to aid her in terrifying all beholders...
>
> – Dio Cassius, *Roman History* 62, 2

So what was the reason for Boudica's call to arms? One of the ways in which local tribes could guarantee peaceful coexistence with Rome was to bequeath to the Romans their lands on the death of the king or queen. Prasutagus, prosperous king of the Iceni (inhabiting what is roughly today's East Anglia), did just that, citing Nero as heir but with a not unreasonable codicil naming his daughters as co-heirs. The Iceni had been on friendly terms since the early days of the invasion. On the king's death in 60 CE, however, the Romans chose to ignore the small print in the king's will and proceeded to take over the kingdom and plunder it. The Iceni's status as *civitas peregrine*, 'foreign state', was annulled.

Perhaps it was naive of the Iceni to expect an extension of the special relationship after Prasutagus's death, but the aftermath of the decision was shocking, brutal and highly provocative: Prasutagus's daughters were raped, *filiae stupro violatae sunt*, Queen Boudica, his wife, was humiliatingly and painfully flogged; the family was treated like slaves and his Roman creditors called in their loans, loans which the Iceni had hitherto been led to believe were gifts. According to Dio, Seneca the Younger was one such creditor, demanding payment of loans to the tune of 40 million sesterces. Boudica was outraged.

The Iceni and other tribes had been disarmed by Ostorius Scapula, *legatus* from 57–62 CE, a cause of great resentment to the Iceni who believed they were a client kingdom and therefore immune from such atrocious treatment. The Roman veterans in Camulodunum (Colchester) behaved with contempt and arrogance towards the natives. The Britons had had enough: they began to plan a violent response. The Iceni under Boudica marched on Camulodunum, with its Temple of Claudius, a citadel symbolic of oppressive Roman rule and the seat of their servitude, *sedes servitutis*.

The *colonia* was duly sacked and the temple fell after two days; the *saevitia*, savagery, served out by Boudica's forces was uncompromising. The Roman occupiers were in utter disarray. The IX Legion under Petillius Cerealis rushed to relieve the defenders but was annihilated. Catus Decianus, the rapacious procurator fled to Gaul. Gaius Suetonius Paulinus, the governor, reached Londinium – an important but undefended trading port – he calculated that it was impossible to defend with the meagre forces at his disposal. Londinium was abandoned and those left behind were slaughtered in the carnage that ensued. Euphoric and drunk on their easy successes, the Britons then devastated Verulamium (St Albans), a stronghold of the pro-Roman Catuvellauni. According to (an exaggerating) Tacitus, up to 80,000 men, women and children were slain in the orgy of destruction visited on the three towns. The Britons were not in the habit of taking prisoners: they had no interest in selling slaves: they showed no quarter: the only options were slaughter, hanging, burning alive and crucifixion – *caedes, patibula, ignes, cruces*. Dio's account is even more graphic: he says that the noblest women were impaled on sharpened spikes the length of their bodies and that their breasts were hacked off and sewn onto their mouths, 'to the accompaniment of sacrifices, feasts, and obscene behaviour' sacrilegiously performed in sacred places, like the groves of Andraste, a British goddess of victory.

Suetonius Paulinus hurriedly assembled a force of around 10,000 men and prepared for battle, the battle of Watling Street. His army included his own Legio

XIV Gemina and units from the XX Valeria Victrix; Legio II Augusta under Poenius Postumus, near Exeter, did not respond. The 10,000 was massively outnumbered by Boudica's 230,000 – no doubt another huge exaggeration but Boudica undoubtedly had a substantial superiority; as Dio says, even if the Romans were lined up one deep, they would not have reached the end of Boudica's line. However, complacency was setting in: so casual, so confident was Boudica's army of victory that women were allowed to attend as spectators in wagons on the edge of the battlefield. Boudica herself rallied her troops from a chariot, her raped daughters before her, in a rousing speech. Unfortunately for the Britons, there was to be no victory; Boudica was soundly defeated. The Britons were hampered by their poor manoeuvrability and inexperience of disciplined open-field tactics. The narrowness of the battlefield restricted the numbers Boudica could deploy at any one time, thus diminishing her numerical advantage. Moreover, the Britons were felled in their droves by the Roman javelins that rained down on them. Women and domestic animals were slaughtered while Boudica's retreating warriors were hampered by the wagons nearby, full of spectators.

According to Tacitus (exaggerating again), 80,000 Britons died that day to the Romans' loss of 400. No doubt there was more rape; it is not known what happened to her daughters. Boudica committed suicide by poisoning: *Boudica vitam veneno finivit*. Dio disputes this, or at least paraphrases the detail out of the same story, and claims that Boudica fell ill and died, and was buried at great expense and with full honours.

In Chapter 5 ('Dux Femina') of her *Boudica: Warrior Woman of Roman Britain*, Caitlin Gillespie interestingly reveals how Boudica's gender is all important strategically in her role as a commander of her male army[1]:

> Chapter 5 analyzes Tacitus's image of Boudica as a warrior woman and considers the challenges she poses to Roman conceptions of masculinity. Whereas other women and wives become observers, placed on the outskirts of the battlefield, Boudica is a commander woman (dux femina), comparable to Vergil's Dido. Several models and antimodels emerge from Roman history and myth to color a Roman reader's interpretation of Boudica as a dux femina, including Camilla, Cleopatra, and the women of Tacitus's ethnographic work, the Germania.

Gillespie goes on to say that unlike other Roman female leaders, including Fulvia, Agrippina the Elder, and Agrippina the Younger, Boudica spurs on men to prove their masculinity. She interprets Boudica's revolt as an insurrection not only against servitude, but also against Roman notions of masculinity and femininity, and leadership without morality. Boudica's sex becomes a powerful tool to rouse her troops to fight for just vengeance, and to promise to win or die trying.

Further reading
Chrystal, Paul (2015). *Roman Military Disasters*. Barnsley
Chrystal, Paul (2019). *The Romans in the North of England*. Darlington

Gillespie, Caitlin C. (2018). *Boudica: Warrior Woman of Roman Britain.* Oxford

Macdonald, Sharon (1988). 'Boadicea: warrior, mother and myth'. In Holden, Pat (ed.). *Images of Women in Peace and War: cross-cultural and historical perspectives.* Madison, WI

Vandrei, Martha (2018). *Queen Boudica and Historical Culture in Britain: An Image of Truth.* Oxford

Webster, Graham (1978). *Boudica, the British revolt against Rome AD 60.* Totowa, NJ

Agrippina the Younger – *dealing with one of the most significant farts in history*

Agrippina was the daughter of the Roman general Germanicus and Agrippina the Elder, granddaughter of Augustus. Her father, Germanicus, was the nephew and heir apparent of the second emperor, Tiberius. Agrippina's brother Caligula became emperor in 37 CE. After Caligula was assassinated in 41 CE, Germanicus' brother Claudius took the throne. Agrippina married Claudius in 49 CE and allegedly assassinated him[1].

Agrippina could be described as something of a smooth operator, working purposefully and quietly in the political background to engineer her son's succession to the imperial throne. She clearly exerted a commanding influence in the early years of Nero's reign. Both ancient and modern sources describe Agrippina's personality as ruthless, ambitious, violent and domineering. Physically, she was beautiful; according to Pliny the Elder, she had a double canine in her upper right jaw, a sign of good fortune.

In Caligula's reign she and her sisters saw a further significant elevation of the status of women in the Imperial family: – Agrippina and her younger sisters Julia Drusilla and Julia Livilla; these included

- receiving the rights of the Vestal Virgins, such as the freedom to view public games from the upper seats in the stadium;
- being honoured with a new type of coinage, depicting images of Caligula and his sisters on opposite faces;
- having their names added to motions, including loyalty oaths (e.g., 'I will not value my life or that of my children less highly than I do the safety of the Emperor and his sisters') and consular motions (e.g., 'Good fortune attend to the Emperor and his sisters').

Caligula and his sisters were accused of having incestuous relationships. Furthermore, in 39, Agrippina and Livilla, with their maternal cousin, Drusilla's then widower Marcus Aemilius Lepidus, were complicit in an obscure failed plot to murder Caligula, the Plot of the Three Daggers, which was to make Lepidus the new emperor. According to Aloys Winterling (2011), Lepidus, Agrippina and Livilla were arraigned for being lovers. At the trial of Lepidus, Caligula had no problem denouncing his surviving sisters as adulteresses, producing handwritten

letters detailing how they were going to kill him. The three were found guilty as accessories to the crime.[2]

Lepidus was executed. According to the fragmentary inscriptions of the Arval Brethren, Agrippina was compelled to carry the urn containing Lepidus' ashes back to Rome. Agrippina and Livilla were exiled to the Pontine Islands while Caligula sold their furniture, jewellery, slaves and freedmen. In January 40 CE Agrippina's husband, Domitius, died of edema (dropsy) at Pyrgi.

When Claudius allowed Agrippina and Livilla to return from exile, a gossipy Suetonus tells us that after the death of her first husband, Agrippina tried to make shameless advances to the future emperor Galba, who showed no interest in her, devoted as he was to his wife Aemilia Lepida. On one occasion, Galba's mother-in-law gave Agrippina a public reprimand and a slap in the face in front of a whole crowd of married women.

In Roman society, an uncle (Claudius, now rid of the subversive Messalina) marrying his niece (Agrippina) was considered incestuous and immoral, but that did not stop the two marrying on New Year's Day 49 CE. As empress, Agrippina started her reign with the ruthlessness which was to characterise it for the length of her reign: she eliminated anyone from the imperial court whom she thought was loyal and dedicated to the memory of the late Messalina. She did likewise with anyone she considered was a potential threat to her position and the future of Nero, her son.

In 50, Agrippina was granted the honorific title of Augusta. She was only the third Roman woman (Livia Drusilla and Antonia Minor were the others) and only the second living Roman woman (the first being Livia) to receive this title.

In her capacity as Augusta, Agrippina quickly became a trusted advisor to Claudius, and by 54 CE, she exerted a considerable influence over the decisions of the emperor. Statues of her went up in many cities across the Empire, her portrait appeared on coins, and, in the Senate, her supporters were assisted along the *cursus honorum* with public offices and governorships. A submissive Claudius allowed her to decide on foreign policy, sign government documents and deal with foreign ambassadors. She also claimed *auctoritas* (power of commanding) and *autokrateira* (self-ruler as empress) in front of the Senate, the people and the army[3].

Ancient sources say she poisoned Claudius on October 13, 54 CE by getting him to eat a plate of deadly mushrooms at a banquet. In the aftermath of Claudius's death, Agrippina, who initially kept the death secret, tried to consolidate power, and immediately ordered that the palace and the capital be locked down. All the gates were blockaded and leaving the capital was forbidden. She introduced seventeen-year-old Nero first to the soldiery and then to the senators as emperor of Rome.

Agrippina inherited some of her mother's militaristic tendencies. In Judaea she flexed power and influence when she became involved in a dangerous uprising there. Judaea, while ruled by Herod Agrippa – personal friend to Caligula and Claudius – had enjoyed self-rule until Herod's death in 44 CE when it reverted to being a Roman province, much to the dismay of the Judaeans. A riot ensued when, allegedly, a Roman soldier, guarding the temple precinct, dropped his trousers and ostentatiously broke wind at worshippers celebrating the Passover – undoubtedly one of the most significant farts in history as many as 30,000 people died in the subsequent fighting.

Even more seriously, in 51 CE a revolt sprang up in Judaea after Galilean pilgrims were murdered by a band of Samaritans; the Roman procurator, Ventidius Cumanus, sided with the aggressors. The situation was complicated by the involvement of Felix, brother of Pallas and procurator of Samaria, a position he gained, no doubt, with the complicity of Agrippina. According to Josephus the governor of Syria, Ummidius Quadratus, held two inquests, after which a number of Jews and Samaritians were beheaded; he then passed this intractable issue over to Claudius. Claudius came down on the side of the Samaritans but Herod's successor, Agrippa II, appealed to Agrippina who managed to persuade Claudius to take a different, more pro-Jewish view. Three Samaritans were executed and Cumanus was exiled for maladministration. Former slave Felix took over as procurator of Judaea, the first freedman to attain such a senior provincial post. Felix repaid his debt to Agrippina, in part, by minting coins in her honour.

Back in Rome, when Claudius was dealing with Caratacus, Agrippina had impertinently seated herself on the platform on a chair next to Claudius – with the result that Caratacus had no option but to pay her the same respect and homage he paid to the Emperor, of course thinking nothing of the fact that a woman had equal authority with an emperor of Rome. This was hardly surprising to a warrior from a country where women chieftains were not unusual: Cartimandua and Boudica are famous examples. What is remarkable though to a Roman is Agrippina's audacity in taking up an unprecedented position on the dais before the Roman military standards, effectively assuming joint power with the Emperor of Rome. Both Dio and Tacitus gasp at the impudence of it all.

The circumstances of Agrippina's death in March 59 CE age forty-three remain mired in controversy, mystery, fantasy and speculation.

Further reading

Chrystal, Paul (2017). *Roman Women: The Women who Influenced the History of Rome*. Stroud

Dawson, Alexis (1969). 'Whatever Happened to Lady Agrippina?' *Classical Quarterly*. 64 (6): 253–267

Godolphin, F.R.B. (1934). 'A Note on the Marriage of Claudius and Agrippina'. *Classical Philology*. 29 (2): 143–145

Grimm-Samuel, Veronika (1991). 'On the Mushroom that Deified the Emperor Claudius'. *The Classical Quarterly*. 41: 178–182.

Rogers, Robert Samuel (1931). 'The Conspiracy of Agrippina'. *Transactions and Proceedings of the American Philological Association*. 62: 141–168

Thompson, James Westfall (1919). 'Lost Memoirs of Antiquity'. *The Sewanee Review*. 27 (2): 176–218

Perilla – *'a lucky survivor from the wreck of ancient literature'*

Ovid's step-daughter, if she ever existed[1], obviously benefitted from a sound education: in a letter from exile (*Tristia* 3, 7), Ovid envisages Perilla sitting with

her mother, 'her nose in a book and amongst the Muses', when his letter arrives. He refers to her *docta carmina*, clever poems, and how only Sappho is more gifted; he recalls how proud father and gifted daughter used to read each other's poetry to each other, how he was her critic and teacher; Perilla is obviously *doctissima*. Ovid urges her to keep on writing because, come what may, she like him, will always be read by successive generations.

Further reading
Ingleheart, J. (2012). 'Ovid's Scripta Puella: Perilla as Poetic and Political Fiction in Tristia 3.7.' *The Classical Quarterly*. 62 (1): 227–241

Antiochis – *discoverer of effective drugs for sciatica and rheumatism*

Most doctors in the Roman period were men, but there were female doctors, *medicae*, many of them slaves or freedwomen. We know a number from the funeral and inscriptional evidence; many of them came from medical families. In the 1st century CE Antiochis, daughter of a physician, Diodotus, was so highly appreciated for her medical expertise by the people of Tlos in Lycia that they set up a statue celebrating her; Galen credits her with the discovery of effective drugs for sciatica and rheumatism.

Aurelia Alexandria Zosime was also honoured with a statue by her doctor husband in Adada, Pisine. There is also **Primilla**, a physician who died at the end of the 1st century CE at the age of forty-four in Rome; here are more Roman doctors: Iulia Pye, Minucia Asste and Venuleia Sosis, all freedwomen, and a slave, Melitine; and Secunda Livilla and Terentia Prima.

Wealthy *medicae* include Metilia Donata from Lyons[2]. Indeed, there is evidence of female physicians from all over the Empire: Hulia Sabina from Italy; Flavia Hedone from Gaul, Asylla Polia from Africa, Himertos of Marathon, and Iulia Saturnina from Merida in Iberia – she was not only a wife beyond compare but the best doctor[3]. The husband of Pantheia, a 2nd century CE physician from Pergamum, is generous in praise for his doctor wife: apart from being 'the rudder of life in our home', she did much to enhance the family's medical reputation: 'even though you were a woman you were just as accomplished as me'. Naevia Clara was also married to a doctor, in Rome in the 1st century BCE. Later in the 2nd century CE Domnina from Neoclaudiopolis in Asia received virtual apotheosis because she 'saved her native fatherland from disease'. Theodore Priscianus[4] in the 4th century CE, dedicated his book on gynaecology to Victoria, the sweet teacher of my art. Aspasia, as we have seen, was a 2nd century obstetrician and gynaecologist; we have an inscription referring to a *medica a mammis* – breast disease specialist[5].

Messalina – *sexual athlete*

Valeria Messalina was the third wife of Claudius, paternal cousin of Nero, second cousin of Caligula, and great-grandniece of Augustus.

Despite the honorifics heaped on her, Messalina received a very bad press from the writers: Juvenal alluded to this when he described Messalina as 'the whore Augusta' (*meretrix Augusta*), itself an allusion to Propertius' description of Cleopatra as the 'whore queen' (*meretrix regina*). To Dio, Messalina was little more than

> an adulteress and harlot … for in addition to her shameless behaviour in general, she at times sat as a prostitute in the Imperial palace, and compelled other women of the highest rank to do the same.

But Dio does have a reputation throughout his work as being 'suspicious of women'.

According to Adam Kemezis, *The Bryn Mawr Classical Review*, 2005, Messalina's reputation proceeded her:

> After her accession to power, Messalina enters history with a reputation as ruthless, predatory, and sexually insatiable, while Claudius is painted as easily led by her and unaware of her many adulteries. The historians who pedalled such stories, mainly Tacitus and tabloid Suetonius, wrote some 70 years after the events in a climate hostile to the imperial line to which Messalina had belonged. There was also the later Greek account of Cassius Dio who, writing a century and a half after the period described, was dependent on the received accounts of those before him. It has also been observed of his attitude throughout his work that he was "suspicious of women".

Pliny the Elder (*Natural History* 10) relates the unedifying story of Messalina's epic orgy in which she challenged a prostitute to a twenty-four hour sex marathon. The Empress won hands down with twenty-five partners – an average of just under one client per hour. The context for inclusion in Pliny's encyclopedia is an expatiation on the mating of animals and Pliny's revelation that man is the only animal for which copulation is insatiable: Messalina's victory provides clear evidence:

> The only one among the bipeds that is viviparous is man. [Viviparity is development of the embryo inside the body of the mother]. Man is the only animal that repents of his first sex; sad augury, indeed, of life, that its very origin should thus cause repentance! Other animals have fixed times in the year for sex; but man, as we have already observed, employs for this purpose all hours both of day and night; other animals become sated with sexual pleasures, man hardly knows any satiety. Messalina, the wife of Claudius Cæsar, thinking this a palm quite worthy of an empress, selected, for the purpose

of deciding the question, one of the most notorious of the women who followed the profession of a hired prostitute; and the empress outdid her, after continuous intercourse, night and day, at the twenty-fifth embrace. In the human race also, the men have devised various substitutes for the more legitimate exercise of passion, all of which outrage Nature; while the females have recourse to abortion. How much more guilty than the brute beasts are we in this respect! Hesiod has stated that men are more lustful in winter, women in summer.

– Pliny the Elder *Natural History* 10, 83 adapted from the translation by John Bostock, 1855

A litany of machinations ensued, designed largely to promote the accession of Messalina's son, Britannicus in opposition to the potential claim by Agrippina the Younger for her son, the future emperor Nero. Along the way we learn of a second exile enforced on Agrippina's sister Julia Livilla, her death due to a hunger strike, the death of Livilla's husband, Marcus Vinicianus, who was implicated in the conspiracy against Claudius led by Lucius Arruntius Camillus Scribonianus. It came to nothing – Scribonianus was murdered in sanctuary on Issa, and Vinicianus committed suicide. Pompeius Magnus (30–47 CE), the husband of Claudius's daughter Antonia, was stabbed while in bed with a favourite catamite. This catalogue of murders clearly illustrates Messalina's dangerous power and the evil body of support she had assembled around her.

Messalina's biggest and most bizarre *faux pas*, of course, was her bigamous marriage to Gaius Silius in 48 CE, and the discovery of the couple's plot to kill Claudius. According to Tacitus, who was himself taken aback by the incredibility of it all – her adulterous affairs had become so routine and casual that she drifted, trance-like, into 'unheard-of lust' (*incognitas libidines*). Messalina forced Silius to divorce his wife, Junia Silana, while furniture and possessions were moved from the Imperial Palace to Silius's house, with an infatuated Messalina showering Silius with gifts.

The partying and fantasy came to an abrupt end, however, when Messalina realised that she had been betrayed by Narcissus. Claudius reacted to the news of the coup with incredulity, asking time and again in consternation if he was still Emperor. The farcical nature of the incident was heightened further when Messalina attempted to forestall the Emperor and win sympathy by hijacking a lift on a cart full of garden refuse. By now, Claudius was 'incandescent, exploding with threats' (*incensumque et ad minas erumpentem*). Soldiers proceeded to arrest and execute Silius, other guilty equites, and guards. Messalina was joined by her mother, Domitia Lepida the Younger. Claudius's soldiers arrived and Lepida advised her daughter to commit suicide. Messalina botched the attempt; she was then run through with a soldier's sword.

Claudius received the news while dining and reacted with indifference, continuing his meal. Suetonius, in an illustration of Claudius's 'absent-mindedness and myopia' (*meteoria* and *ablepsia*), adds that Claudius actually asked where Messalina was when she had failed to join him that night.

Further reading

Barrett, Anthony A. (1996). *Agrippina: Sex, Power and Politics in the Early Roman Empire*. New Haven

Chrystal, Paul (2018). *The Emperors of Rome: The Monsters*. Barnsley

Minaud, Gérard (2012). 'La vie de Messaline, femme de Claude'. In *Les vies de 12 femmes d'empereur romain – Devoirs, Intrigues & Voluptés*.

The Fat, Hairy Women of Pompeii – *not always as beautiful as they often look*

Recent research has revealed that, contrary to the pleasant and pleasing images conveyed by many of the frescoes discovered in Pompeii, around ten per cent of the local women were obese and hirsute; furthermore, they have been found to have suffered from headaches and diabetes. Skeletal examinations revealed a small bony growth on the inside of their skulls behind the forehead, indicative of a hormonal disorder, hyperostosis frontalis interna (HFI), which causes these symptoms.

> Today, HFI occurs mostly in postmenopausal women. If the same was true in the first century, it suggests that the people of Pompeii lived well into their 50s and 60s and not, as widely believed, only to their 40s. Lazer [Estelle Lazer, archaeologist and physical anthropologist at the University of Sydney] told a medical symposium in Sydney that tell-tale signs on other bones also suggest that people lived to a ripe old age. She found marks on some bones similar to those produced by diffuse idiopathic skeletal hyperostosis, a form of arthritis that sets in during old age.
>
> – Leigh Dayton, 'The Fat, Hairy Women of Pompeii', *New Scientist* 1944, 24 September 1994

Pamphile of Epidaurus (*fl. c.* **60** CE) – *one of the first known female historians*

She was an Egyptian historian who lived in Greece during the reign of Nero (r. 54 – 68 CE). She is the first known female Greco-Roman historian and, with Ban Zhao, one of the first known female historians. She is best known for her lost *Historical Commentaries*, miscellaneous historical anecdotes in thirty-three books, which is frequently cited by Aulus Gellius (*c.* 125 – after 180 CE) in his *Attic Nights* and by the Greek biographer Diogenes Laërtius in his *Lives and Opinions of Eminent Philosophers*. She is also referenced in the 10th century Byzantine encyclopedia, the *Suda*, and by the Byzantine writer Photios (*c.* 810/820 – 893 CE).

According to the *Suda*, she wrote multiple epitomes of the works of other historians as well as treatises on disputes and sex. She may be the author of the anonymous *Tractatus de mulieribus claris in bello.*

Epicharis – *'she acted more nobly than many a noble eques'*

Epicharis is tortured by Nero but bravely outwits him by committing suicide: Tacitus describes the episode:

> She was, however, kept in custody. Subsequently, when the conspiracy was discovered, Nero ordered her to be tortured on the rack because she refused to name any of the accomplices; but neither blows, nor fire, nor the increased fury of her tormentors, could extort any confession from her. When on the second or third day after she was carried in a sedan chair – for her limbs were now broken – to be tortured a second time, she throttled herself on the way with her belt, which she fastened to the chair. She thus acted more nobly than many a noble eques or senator, who without even being tortured betrayed even their nearest relatives.
>
> – Polyaenus, *Strategemata* 8, 62;
> Tacitus, *Annals* 15, 57

Poppaea Sabina – *her predilection for bathing in asses' milk started a craze*

In 58 CE, Agrippina and Rome were threatened by another *impudicitia*, this time in the person of Poppaea Sabina (30 CE – 65 CE, also known as Ollia). Tacitus tells us that she was the woman who had everything – everything, that is, apart from honesty[1]. She inherited glory and good looks from her exceptionally beautiful mother; she was rich, and a *docta puella (sermo comis nec absurdum ingenium)*. She preached modesty *(modestia)* but practiced salaciousness *(lascivia)*. She was something of a recluse, but when she did go out she wore a veil – either to tantalise men or to accentuate the allure of her beauty.

She cared nothing for her reputation, and made no distinction between married men and adulterers; she never lost her self-control, and she was never controlled by a man. Where there was a chance of advancement, her lust followed. Nero composed a poem which celebrated her striking auburn hair, and this triggered a fashion amongst the women of Rome. Her predilection for bathing in asses' milk also started a craze, as did 'Poppaea's Cream' – an anti-aging lotion which eradicated wrinkles. It is irresistible to make comparisons between her and Cleopatra. According to Dio, Poppaea believed it when someone told her that in milk 'lurked a magic which would dispel all diseases and blights from her beauty'.

Poppaea was first married to Rufrius Crispinus, and they had a son together[2]. She later had an affair with the libertine Otho, Nero's very good friend, which ended in divorce for Crispinus and marriage to Otho. Tactlessly, Otho would praise Poppaea to the emperor, ever reminding him of her beauty and elegance and going on about her nobility and fine looks (*dictitans nobilitatem pulchritudinem*). Excited by this, Nero and Poppaea were inevitably attracted to each other, and an affair ensued. She coquettishly led him on, coaxing him, 'I'm a married woman; you still love Acte, your serving concubine.'[3] He grew increasingly frustrated. Poppaea emphasised the difference between her fine lifestyle, with her boring Otho, and Nero's grubby, low-life, servile relationship. Otho was soon removed from the scene, posted to a governorship in far-off Lusitania to contemplate his tactlessness[4].

The following year, in 59 CE, Nero's passion for Poppaea grew all the more intense. She had hopes of marrying the emperor, but realised that this was unrealistic while Agrippina was still around. Accordingly, she set about nagging him, accusing him of being under his mother's thumb. An artful adulteress, she cited her own beauty, lineage, fertility, and sincerity in contrast to his mother's arrogance and greed. Poppaea's aim was to persuade Nero to assassinate his mother, and marry her. According to Dio, Seneca also urged Nero to commit matricide.

Dio describes Poppaea's extravagance and vanity: she shod the donkeys which pulled her carriage with golden shoes, and milked daily 500 asses that had recently foaled so that she could bathe in their milk. One day, she caught sight of herself in a mirror and thought that maybe she did not look quite so beautiful; she then prayed that she would die before she passed her best.

Further reading
Schubert, Paul (17 August 2021). "To Heaven on a Chariot: The Incredible Story of Poppaea Sabina". *Antigone* 8. A recently published papyrus provides the remnants of a Greek poem where Poppaea Sabina is taken away by Aphrodite to heaven (an apotheosis). She parts from Nero with sorrow and assures him that she will care for their dead children for ever.

Pythias – *not sucking up to Sabina*

Pythias was a slave in the household of Octavia, the first wife of the Emperor Nero, who divorced Octavia in 62 CE to marry Poppaea Sabina. To fabricate evidence that could be used to justify murdering Octavia after the divorce, Poppaea and Tigellinus, the Prefect of the Praetorian Guard, attempted to compel Octavia's maids to make false claims of her adultery during her marriage to Nero.

Dio Cassius describes a woman who heroically defends another woman's virtue when he records how Pythias, under interrogation and torture, faithfully stands up for Nero's wife, Claudia Octavia, in 63 CE.

All of Octavia's other slaves except Pythias had sided with Sabina in her character assassination of Octavia, despising Octavia because

she was in trouble and sucking up to Poppaea Sabina because she was very powerful. Pythias alone had refused, though cruelly tortured, to tell lies against her mistress, and finally, as Tigellinus continued to goad her, she spat in his face, saying: "Tigellinus, my mistress's cunt is cleaner than your mouth."

> – Dio Cassius 62, 13, 4. Translation adapted from
> Loeb edition (1925)

As far as imperial domestic abuse goes, Nero is probably one of the most guilty of all the emperors. He was alleged to have arranged for his first wife (and stepsister) Claudia Octavia to be murdered, after he had subjected her to torture and incarceration (Tacitus, *Annals* 16, 6). Nero kicked Poppaea Sabina, his second wife, to death when she was heavily pregnant:

> [Nero] loved Poppaea dearly; he married her twelve days after his divorce from Octavia, yet he killed her too by kicking her when she was pregnant and ill. She had rebuked him for coming home late from the races. He had a daughter by her, Claudia Augusta, but lost her when she was still a baby.
>
> – Suetonius, *Nero* 35, 3.

Further reading
Chrystal, Paul (2018). *The Emperors of Rome: The Monsters*. Barnsley

Erichtho (68 CE)

In 61 CE, just over a century after the battle of Pharsalus (48 BCE), the epic poet Lucan (39 CE – 65 CE) began work on his *Bellum Civile* during the reign of Nero. Eight thousand lines later the poem, in ten books, remained unfinished on Lucan's suicide, but by then Lucan and Nero had had a bitter falling out.

Lucan's poem is notable for its exclusion of Olympian gods – characters which were central to Virgil's *Aeneid* and its action. The gods may be absent but the poem is replete with the supernatural; omens, prophecies, dreams, portents and eschatology are all there to add to the pervasive sense of doom and gloom. Indeed the supernatural serves to highlight and reflect 'Rome's turmoil on the supernatural plane'; it 'contributes to the atmosphere of sinister foreboding'. Such is the message Lucan wanted to convey about the civil war years; they were horrific and dangerous days. Nowhere else is this more evident than in Lucan's vivid and repellent portrayal of Erichtho – one of the vilest witches in all literature. By pushing back the boundaries, Lucan employs her as a vehicle to emphasise just how odious and evil the civil wars were.

In Book 6 Sextus Pompey, driven by fear, wants to know in advance the outcome of the impending battle; he rejects conventional forms of divination, electing instead to deploy the ungodly, 'the mysteries of the furious enchantress'.

Being in Thessaly he is local to the world's most dreadful witches and their *herbae nocentes,* pernicious herbs; when the witches here cast their spells even the gods above pause to take note, and can sometimes be persuaded to do the witches' will.

Wild Erichtho takes even their evil excesses to new extremes: Erichtho is just the witch for Pompey, and he seeks her out. She communes with the dead and is expert in all things underworldly; where she goes contagion follows; she buries the living and brings the dead back to life; she snatches burning babies from their pyres for occult research and experimentation and mutilates the corpses of the dead, gouging out eyeballs and gnawing at their nails. She tears flesh from decaying corpses crucified on crosses, harvests the black putrid congealed gore suppurating from the limbs of the putrefying; she hijacks the meat ripped off rotten bodies by rapacious wolves. She is a serial murderess, performing crude caesarean sections on pregnant women whenever a baby is required for the pyre; she rips the faces off young boys; at funerals she opens the mouths of the dead with her teeth, bites their tongues and thereby communicates with Hell.

Once Pompey finds her she prepares her squalid necromancy and Pompey duly learns his impending fate at the imminent battle of Pharsalus. Erichtho would be a fine role model for any of the black arts, but it is in reanimation that she excels. Here is reanimation the Erichtho way:

> At length the witch selects her victim with pierced throat agape for her purpose. Gripped by a pitiless hook over rocks she drags him to the mountain cave accursed by her foul rites, that shall restore the dead man's life... First she pours still foaming blood through his gaping chest washing the gore from his wounds. Then copious poisons from the moon distilled from all the monstrous things which Nature's pangs bring to miscarriage: the salivating froth from dogs stricken with madness, foaming at the stream; a lynx's entrails: and the knot that grows on the evil hyaena; flesh of stags fed upon serpents; and the sucking fish...dragon's eyes; and stones that sound beneath the brooding eagle's wings. Nor Araby's viper, nor the ocean snake who in the Red Sea waters guards the shell, are wanting; nor the slough cast on Libyan sands by horned reptiles; nor ashes snatched from an altar where the Phoenix died. And she adds viler poisons without a name – many of which she herself has made, pestiferous leaves pregnant with magic chants and blades of grass which in their early growth her cursed mouth had slimed. Last came her voice more potent than all the herbs to charm the underworld gods who rule in Lethe...
>
> Such prayers she uttered; then lifted her head and slavering lips to see the ghost. He stood nearby, beside the corpse he hated – his ancient prison, and loathed to enter in. There was the gaping chest where fell the blow which killed him...Then the blood grew warm and runny, and with softening touch nurtured the stiffened wounds and filled the veins until they throbbed once more, the pulse returned

and every fibre trembled – as with death life was commingled. Then…rising at a bound the living man leaped from the earth. His open eyes glared fiercely: the life was dim, and still upon his face remained the pallid hues of recently parted death. Amazement seized him, to have been returned to the earth… "Speak," said the hag...

– Lucan, Pharsalia 6, 633ff

In her horrific reanimation of the soldier, Erichtho may well have been the inspiration for Mary Shelley's *Frankenstein* some 1,750 years later: she would have been familiar with the episode through her husband, the poet Shelley, who was a great admirer of Lucan.

Arria – *she continued to play the mother when she had just lost her son*

After the rebellion against Claudius led by Lucius Arruntius Camillus Scribonianus in 42 CE, Scribonianus was killed and Caecina Paetus, Arria's husband, was taken to Rome as a prisoner for conspiring with him. Arria begged the captain of the ship to allow her to join him on board. She argued that if a consular Roman man was allowed slaves to take care of him, then she should save them the trouble and look after him herself. The captain refused, so Arria followed the great ship in a small fishing boat, all the way to Rome.

In a letter to Maecilius Nepos, Pliny the Younger gives an example of a *matrona*'s exceptional devotion to her husband[1]. Arria, 'a shining example and comfort', does everything she possibly can to convince her husband Aulus Caecina Paetus that his impending suicide, ordered by Claudius, will not be painful. 'Paetus, it doesn't hurt, (Paete, non dolet); and this after she has bravely shielded the news of their son's recent death from her husband and organised his funeral to spare him additional grief:

> Whenever he asked how the boy was doing she responded: "He's had a good rest and is ready to eat something". Then, when she couldn't hold her tears back any longer, she left the room and burst into tears, succumbing to her anguish. Her grief sated, she dried her eyes, composed herself and went back into the room almost as if she had left her bereavement outside. It was a glorious thing for her when she pulled out a dagger, plunged it into her breast, withdrew the dagger and offered it to her husband with the immortal, almost divine, words: "Paetus, it doesn't hurt." By doing what she did and saying what she said she was looking glory and immortality straight in the eye. On the other hand, it was an even greater thing when, without the reward of immortality and without the reward of glory, she hid her tears and concealed her grief and continued to play the mother when she had lost her son.

Later in the letter we learn of Arria's earlier brave determination to end her own life:

> "It's no use" she said: "you can have me die a horrible death but you can't stop me dying". As she said this she leapt from her chair, banged her head really hard against the wall opposite and slumped to the ground. When she came round she said: "I told you that I would find a hard way to die if you denied me the easy way out."

Martial too honours *casta* Arria's bravery; he, perceptively, has her say that her wound *non dolet* but the one that Paetus is about to inflict on himself certainly will hurt her'[2].

Further reading
Syme, Ronald (1968). 'People in Pliny'. *The Journal of Roman Studies*. 58

Fannia – *doubtful that the world will see the like of her again*

Such courage ran in the family: Arria's grand-daughter, Fannia, had been married to Helvidius Priscus, an agitator against Vespasian who had him executed in 75 CE. Fannia is recorded in the writings of Pliny the Younger as a woman of fortitude and respectability[1]. Fannia is described as a political rebel in her own right like her grandmother. She followed her husband twice into exile, once ordered by Nero then by Vespasian for opposing his reign.

Pliny extols the virtues of Fannia, doubting very much whether the world will see the like of her again – the perfect model of a wife with the rare qualities of charm and amiability. When her possessions were seized, Fannia managed to save the diaries and biography of her husband and even took them with her into exile despite orders to burn his books.

Fannia has displayed *fortitudo, sanctitas* and *castitas, gravitas* and *constantia*: bravery, purity of mind, purity of body, dignity and self-control. Tacitus sees this loyalty as an example of female *virtus*. Fannia later died from tuberculosis contracted from a consumptive Vestal Virgin whom she had volunteered to nurse.

Laronia – *a rare woman's voice*

In Juvenal's second satire we get a rare chance to hear a woman's voice when Laronia joins the poet to criticise a hypocritical male homosexual, Hispo[1]. To Juvenal nothing is as it first seems: *frontis nulla fides* (l. 8); he opens his homophobic attack on these *cinaedi*, pathics, these sad perverts (*tristes obsceni*) in grand style calling them stupid (*indocti*), noting their buggery-induced haemorrhoids.

Enter Laronia to lend support; she ridicules Hispo's effeminacy, invoking the *lex Scantinia*: look at the men first, they do the worst things, she argues: women

don't tongue each other yet but Hispo submits to young boys; women don't involve themselves in mens' matters – litigation, wrestling and the like. On the other hand, men do women's things – they work the wool (that badge of good wifely behaviour), *lanam faciunt*! Laronia's advice to Hispo's *puella* (still a virgin?) is to stay quiet about her husband's grubby proclivities and keep taking the jewels. To Juvenal this was all *vera manifesta* – blindingly obvious, and Laronia provided powerful support to his invective.

It is obviously difficult to reconcile this with Juvenal's excoriating attack on women in Satire 6 where he savagely contradicts much of what he has Laronia say here. The important point is that Laronia's eloquent and reasoned arguments constitute a point of view which Juvenal obviously realised was the sort of thing a woman might say in a situation like this: a woman like Laronia might well be indignant about the hypocrisy and duplicity of men like Hispo, and she, as a *docta puella* perhaps, is clearly quite capable of expressing those views so eloquently. There is no need to marginalise or even erase Laronia (as some have done): Laronia is of course used and created by Juvenal, but her opinion would seem to be quite plausible and possibly echoed amongst certain women of Juvenal's day.

Claudia Severina and the Vindolanda Tablets (90–120 CE) – *'come make my day'*

The Vindolanda Tablets are a fascinating record of daily military life at the edge of empire, the northern-most edge of Britannia. These 752 writing tablets were discovered in 1973 and 1993; they gave us a hitherto unknown papyrus substitute, thin postcard-sized leaves of wood on which were inscribed with pen and carbon-based ink day-to-day book-keeping records and letters, themselves somewhat mundane in their minutiae but historically of seismic importance.

Soldiers were not officially permitted to marry on service but many, no doubt, did, building relationships with local women and starting families with them. One of the most fascinating Vindolanda Tablets shows that wives of officers clearly did accompany their husbands overseas: **Claudia Severina** sent that birthday party invitation to her sister **Lepidina** asking her to make her day special by coming along on 11 September. The body of the letter is written by a scribe but the postscript is written by Claudia and is the oldest example of a woman's handwriting in Latin in existence.

> Claudia Severa to her Lepidina greetings. On 11 September, sister, for the day of the celebration of my birthday, I give you a warm invitation to make sure that you come to us, to make the day more enjoyable for me by your arrival, if you are present. Give my greetings to your Cerialis. My Aelius and my little son send him their greetings. [2nd hand] I shall expect you, sister. Farewell, sister, my dearest soul, as I hope to prosper, and hail. [Back to 1st hand] To Sulpicia Lepidina, wife of Cerialis, from Severa.
>
> – Tablet No. 291

Claudia's handwriting also appears in Nos 292 and 293; here, she seeks permission to visit **Sulpicia Lepidina**:

> ... greetings. Just as I had spoken with you, sister, and promised that I would ask Brocchus and would come to you, I asked him and he gave me the following reply, that I was always allowed... to come to you for whatever reason. For there are certain important things from which you will know what I am going to do ... when you receive my letters. ...I will remain at Briga. Greet your Cerialis from me. [Back to 2nd hand] Farewell my sister, my dearest and most longed-for soul. [1st hand] To Sulpicia Lepidina, wife of Cerialis, from Severa, wife of Brocchus.
>
> – Tablet No. 29252

Further reading

Vindolanda Tablets Online http://vindolanda.csad.ox.ac.uk/

Birley, Robin (2005). *Vindolanda: extraordinary records of daily life on the northern frontier.* Roman Army Museum Publications.

Bowman, Alan K. (1983). *Vindolanda: The Latin Writing Tablets.* Society for the Promotion of Roman Studies.

Bowman, Alan K. (1994). *Life and letters on the Roman frontier: Vindolanda and its people.* British Museum Press.

Chrystal, Paul (2018). *The Romans in the North of England.* Darlington

Chrystal, Paul (2024). *The Book: How the Wisdom of the Classical World Was Preserved.* Barnsley

Julia Balbilla – *royal correspondent to Hadrian*

Around 130 CE Julia Balbilla accompanied Hadrian and the Empress Vibia Sabina on tours of the Nile valley, as court poetess and as a kind of royal correspondent.

To record their visit she inscribed on the left leg and foot of one of the Colossi of Memnon in Thebes (a monumental statue of the pharaoh Amenophis III) four epigrams in ancient Aeolic dialect – as used by Sappho some 800 years earlier. In so doing, Julia was following a time-honoured tradition celebrating Memnon's amazing early morning 'singing' – an audible phenomenon emanating from fractures to the statue made by an earthquake.

Her first three epigrams dutifully commemorate the royal visit; the fourth Julia's personal experience. Julia's erudition is clearly evident from these inscriptions: she is not only familiar with a long-obsolete ancient Greek dialect and metre, but she displays a working knowledge of relevant Egyptian and Greek mythology. Vibia Sabina added an inscription of her own on the instep of the left foot.

Further reading

Brennan, T.C. (1998). 'The Poets Julia Balbilla and Damo at the Colossus of Memnon'. *The Classical World.* 91 (4): 215–234

Chrystal, Paul (2024). *The Book: How the Wisdom of the Classical World Was Preserved.* Barnsley

Hemelrijk, Emily Ann (2004). Matrona Docta: *Educated Women in the Roman Élite from Cornelia to Julia Domna.* Psychology Press

Keegan P. (2014). *Graffiti in Antiquity.* London

Plant I.M. (2004). *Women Writers of Ancient Greece and Rome: An Anthology.* University of Oklahoma Press

Rosenmeyer, Patricia A. (2018). *The Language of Ruins: Greek and Latin Inscriptions on the Memnon Colossus.*

Speller E. (2004). *Following Hadrian: A Second-Century Journey Through the Roman Empire.* Oxford

Stevenson J. (2005). *Women Latin Poets: Language, Gender, and Authority, from Antiquity to the Eighteenth Century.* Oxford

'A List of Women Authors from the Ancient World'. (March 2018). *Sententiae Antiquae*

Some images of the epigrams are available at

https://egiptomaniacos.foroactivo.com/t4845-colosos-de-memnon-graffiti and http://nefertiti-returns.blogspot.com/2009/09/graffiti-carved-on-foot-of-memnon.html

Julia Maesa (*c.* 160 CE – *c.* 224 CE) – *a pivotal player in the Severan dynasty (193 CE – 235 CE)*

Julia Maesa was a highly influential and a pivotal player in the Severan dynasty (193 CE – 235 CE): she was the grandmother of emperors Elagabalus and Severus Alexander, elder sister of Empress Julia Domna, and mother of Julia Soaemias and Julia Mamaea. She wielded influence during the reigns of her grandsons as Augusta of the Empire from 218 to her death, especially when they became emperors.[1]

She was born in Emesa, Syria (modern day Homs), to an Arab family of priests of the deity Elagabalus. Michael Grant (1996, p.47) tells us that through her sister's marriage, Maesa became sister-in-law to Septimius Severus and aunt of Caracalla and Geta, who all rose to become emperors. She married another Syrian Julius Avitus, of consular rank.[2] They had two daughters, Soaemias and Mamaea, who became mothers of Elagabalus and Severus Alexander, respectively.

As one of the Severan dynasty's prominent women, Maesa was determined to regain power after her sister's suicide. While in Rome, Maesa and her family amassed great wealth, and rose to lofty positions in the Roman government and court of Septimius Severus and later, of his son and successor, Caracalla[3]. She helped raise her grandson, the monstrous Elagabalus and after his murder, another grandson, Severus Alexander, as emperors, which resulted in the restoration of the Severan dynasty after the assassination of Caracalla and the usurpation of the throne by Macrinus[4]. In 217 CE, after the murder of emperor Caracalla and the usurpation of the throne by Macrinus, Maesa's sister Domna, now suffering from breast cancer and without the power and influence she had held during the reigns

of her husband and her son, having lost both of her children, took her own life by starvation[5].

Maesa and her family, who had resided in Rome for the last two decades, were spared and banished by Macrinus and returned to Emesa.

After Severus Alexander's accession (r. 222–235), she died in Rome and was later deified in Syria along with her sister.

Further reading

Burns, Jasper (2006). *Great Women of Imperial Rome: Mothers and Wives of the Caesars*. London

Chrystal, Paul (2018). *Emperors of Rome: The Monsters*. Barnsley

Grant, Michael (1996). *The Severans: The Changed Roman Empire*. Psychology Press

Icks, Martijn (2011). *The Crimes of Elegabalus: The Life and Legacy of Rome's Decadent Boy Emperor*. I.B. Tauris

Levick, Barbara (2007). *Julia Domna: Syrian Empress*. Routledge

Lightman, Marjorie (2008). *A to Z of Ancient Greek and Roman Women*. Infobase Publishing

St Blandina – *a role model for all Christians*

Saint Blandina (*c.* 162–177 CE) was an early Christian martyr who was murdered in Lugdunum (modern Lyon) during the reign of Marcus Aurelius for converting to Christianity. What we know about Blandina is given by Eusebius in his *Historia Ecclesiastica* who in turn sources a letter sent from the Church of Lyon to the Churches of Asia Minor[1].

Blandina belonged to the band of Martyrs of Lyon who, after some of their number had endured atrocious tortures, suffered martyrdom in 177. The Roman populace in Lyon had been worked up against the Christians so that the latter, whenever they ventured out, were routinely harassed and molested.[2]

A number of Christians, who confessed their faith, were imprisoned and brought to trial. Among these Christians was Blandina, a slave, who had been taken into custody along with her master, also a Christian. Her companions greatly feared that on account of her physical frailty she might not endure the torture. But although the Romans abused her horribly, so that even the executioners became exhausted 'as they did not know what more they could do to her', she remained obdurate and repeated to every question 'I am a Christian, and we commit no wrongdoing.'

Marcus Aurelius commanded the Roman citizens who persisted in the faith to be executed by beheading, but those without citizenship were to be tortured. Blandina was therefore subjected to new atrocities with other companions in the town's amphitheatre (now known as the Amphitheatre of the Three Gauls) during the public games.

Further reading

Goodine, Elizabeth (2014). *Standing at Lyon: An examination of the Martyrdom of Blandina of Lyon*. Piscataway, NJ

Faustina the Younger – *bathing in the blood of a slaughtered gladiator*

Annia Galeria Faustina Minor or Faustina the Younger (*c.* 130 CE – 176 CE) was a daughter of Antoninus Pius and Roman empress Faustina the Elder; she was a Roman empress herself and wife to her first cousin emperor Marcus Aurelius. Faustina was very popular with the army and was awarded divine honours after her death.

Despite this, Dio and the *Augustan History* slur her when they accuse Faustina of ordering deaths by poison and execution, and of instigating the revolt of Avidius Cassius against her husband. *The Augustan History* slanders her with reports of casual adultery with sailors, gladiators, and 'men of rank'; however, despite putting up with the classical equivalent to the gutter press, Faustina and Aurelius seem to have been devoted to each other.

Faustina accompanied her husband on various military campaigns and enjoyed the devotion and reverence she received from the Roman troops. Aurelius gave her the title of *Mater Castrorum* or 'Mother of the Camp'. Between 170 CE – 175 CE, she travelled to the north of the empire, and in 175, she accompanied Aurelius to the east.

Faustina has another, somewhat less glorious, connection with the world of combat: smitten by desire for a gladiator, she finally confessed this passion to her husband, the emperor Marcus Aurelius. On consulting the Chaldean magic men the gladiator in question was executed and Faustina was made to bathe in his blood, and then have sex with her husband while still covered in that blood. All passionate thoughts of the gladiator apparently disappeared.

Faustina died in 175 CE, after an accident at the military camp in Halala in Cappadocia. A devastated Aurelius buried her in the Mausoleum of Hadrian in Rome. She was deified: her statue was placed in the Temple of Venus in Rome and a temple was dedicated to her. Halala's name was changed to Faustinopolis and Aurelius opened charity schools for orphan girls called *Puellae Faustinianae* or 'Girls of Faustina'.

Source: Life of Marcus Aurelius, *Historia Augusta*, 26, 4–9).

Further reading
Levick, Barbara (2014). *Faustina I and II: Imperial Women of the Golden Age.* Oxford

Julia Domna – *'We have sex openly with the best men while you are seduced in secret by the worst'*

Julia Domna is famous for the encounter reported by Dio between Julia Domna, empress of Septimius Severus, and the wife of a Caledonian chieftain in Eboracum (York). Julia Domna remarked primly on how the tribal women are somewhat free with their sexual favours; the barbarian woman replied tartly 'We satisfy our desires in a better way than you Roman women do. We have sex openly with the best men while you are seduced in secret by the worst'. That was probably the end of that particular edge of empire tête-à-tête.

Julia Domna (170 CE – 217 CE) was Empress and wife of Emperor Lucius Septimius Severus and mother of Emperors Geta and Caracalla; Julia was renowned for her prodigious learning and her extraordinary political influence, and for her expertise in and patronage of philosophy. As a gifted and intelligent women, Julia had her fair share of political enemies, who accused her of treason and adultery, none of which was proven.

She and Severus were very close; he insisting she accompany him in the campaign in Britannia from 208. Julia too was awarded the title of *Mater Castrorum*, in 195 CE. When Severus died in 211 CE at Eboracum Julia became mediator between their two disputatious sons, Caracalla and Geta, destined to rule as joint emperors. Geta was murdered by Caracalla's soldiers in the same year.

Her surviving son Caracalla acceded to the imperial throne as sole emperor, a tense situation because of his involvement in Geta's murder. Nevertheless, Julia accompanied Caracalla in his campaign against the Parthians in 217 CE. The following year Caracella was assassinated by a disaffected soldier. Julia took her life by starving to death at Antioch, due in part to a breast cancer diagnosis.

Further reading
Chrystal, Paul (2018). *Emperors of Rome: The Monsters*. Barnsley
Chrystal, Paul (2021). *A Historical Guide to Roman York*. Barnsley
Levick, Barbara (2007). *Julia Domna: Syrian Empress*. London

Vibia Perpetua and Felicitas

In 203 CE Vibia Perpetua, delivered an impassioned and inspirational speech before her execution in the Roman amphitheatre in Carthage during the games celebrating Septimius Severus's birthday. As well as showing a good knowledge of Roman literature she gave a personal eloquent account of her life leading up to her martyrdom that day.

Vibia Perpetua was just married and a well-educated noblewoman, about 22 years old at the time of her death, and mother of an infant son she was nursing. Felicity, a slave woman imprisoned with her and pregnant at the time, was martyred with her.

The Passion of Perpetua and Felicity tells the story of their death. Perpetua's account opens with conflict between her and her father, who wishes her to recant her Christianity. Perpetua refuses, and is soon baptized before being moved to prison in the days leading up to her martyrdom. Perpetua suffered physically due to the heat, rough prison guards, and the cessation of regular breastfeeding. She also described how conditions improved after she was able to bribe the guards so that she and the other martyrs were moved to another part of the prison, with her infant. Her physical torment was also eased after she was able to breastfeed her child. Perpetua details her physical ailments: the most common was the cycle of pain and relief she would feel in her breasts.

Perpetua received a vision, in which she climbs a dangerous ladder to which various weapons are attached. At the foot of a ladder is a serpent, which she confronts but the serpent does not harm her, and she ascends to a garden where Perpetua realizes that the martyrs will suffer. The day before her martyrdom, Perpetua envisions herself defeating a savage Egyptian and interprets this to mean that she would have to do battle not just with wild beasts, but with the Devil himself.

Further reading

Dova, Stamatia (2017). 'Lactation Cessation and the Realities of Martyrdom in the Passion of Saint Perpetua'. *Illinois Classical Studies*. 42: 245–265

Gold, Barbara K. (2018). *Perpetua: athlete of god*. Oxford

Heffernan, Thomas J. (2012). *The passion of Perpetua and Felicity*. Oxford

Women of [the Anonymous] *Tractatus de Mulieribus* – an *obscure but important source for outstanding women*

[The Anonymous] *Women Intelligent & Brave in War* is a literal translation of the title of this somewhat obscure catalogue of women: we do not know the author, when it was written, what genre it was intended to be in and what the real title was.

Despite the difficulties, the *Tractatus* remains a valuable adjunct to Plutarch, Polyaenus and to the other primary sources of women war warriors.

The fourteen women are Semiramis; Zarinaea; Nitocris the Egyptian; Nitocris the Babylonian; Argeia; Dido; Atossa; Rhodogune of Parthia; Lyde; Pheretime; Thargelia; Tomyris; Artemisia I of Caria; and Onomaris. They are all described in short, pithy thumbnail sketches.

Zarinaea, Nitocris of Egypt, Argeia, Theiosso (Dido), Atossa, Lyde and Thargelia are of particular interest because they do not feature in Plutarch or Polyaenus, although we do, of course, know them from other sources; **Onomaris** is more interesting still as the *Tractatus* is the only surviving source for her.

The popularity of catalogues and specialist handbooks of one kind or another have received comparatively little attention from scholars and authors even though they seem to have been much sought after in their day and provided invaluable primary source material for later writers; perhaps they reflected a Graeco-Roman desire for orderliness, recording, and categorisation? They took the form either of random lists and catalogues of specific information, or 'reference books' that collected particular information united by a specific theme, or of encyclopedias.

Catalogues, including those concerning women, are dealt with in detail in Chrystal, *The Book: How the Wisdom of the Classical World Was Preserved*.

Theophrastus (371 – *c*. 287 BCE), successor to Aristotle in the Peripatetic school, had a number of interests ranging from biology, physics, ethics and metaphysics and was an ardent cataloguer. In frr. 625–7 he gives us a list of women who caused wars or destroyed houses – home-wreckers as opposed to the more stereotypical homebuilders.

Further reading

Chrystal, Paul, (2024). *The Book: How the Wisdom of the Classical World Was Preserved.* Barnsley

Gera, D.L. (1997). *Warrior Women: The Anonymous Tractatus De Mulieribus.* Leiden

Zenobia – *'the most lovely as well as the most heroic of her sex'*

> *'I am a queen; and as long as I live I will reign'* – attributed to Zenobia by Gibbon

Julia Aurelia Zenobia (240 – *c.* 275 CE) was a queen of the Palmyrene Empire in Syria and is famous for her revolt against the Roman Empire. She became queen as the second wife of king Septimius Odaenathus, following Odaenathus' death in 267 CE. Zenobia was nothing if not industrious and ambitious: by 269 she had expanded her empire by conquering Roman-held Egypt; when the Roman prefect, Tenagino Probus, tried to recover the territory, he was beheaded for his troubles. Zenobia ruled over Egypt as queen until 271, when she was defeated and paraded as a hostage in Rome by the emperor Aurelian.

Zenobia's father, Amr ibn al-Zarib, was the sheikh of the Amlaqi; when members of the rival Tanukh tribal confederation killed him, Zenobia became chief of these nomadic Amlaqis, cutting her teeth in leadership skills over men, according to the Arabic version of her story told by the 9th century Al-Tabari. Unsurprisingly, Zenobia claimed descent both from Dido, queen of Carthage and Cleopatra VII of Egypt which if nothing else gives us an indication of how women regarded these two famous queens, despite the reproval they received from male authors. The historian Callinicus dedicated a ten-book history of Alexandria to a "Cleopatra", namely Zenobia.

The picture we are left with from the literature gives us a singularly impressive woman. Some of it comes from the notoriously unreliable *Historia Augusta* and has been paraphrased for eternity by Gibbon in his *Decline and Fall of the Roman Empire*[1]. Gibbon says of her:

> Zenobia is perhaps the only female whose superior genius broke through the servile indolence imposed on her sex by the climate and manners of Asia... Zenobia was esteemed the most lovely as well as the most heroic of her sex.

The Scriptores Historiae Augustae is a collection of biographies from the 4th century CE which details the Roman emperors from 117 CE to 284 CE. Though the *Scriptores* was apparently authored by six men, only two, Trebellius Pollio and Flavius Vopiscus, are credited with the period of the queen's rule[2].

Zenobia was reputedly beautiful, with a dark complexion, white teeth, and black eyes – more beautiful even than Cleopatra although she differed markedly from the Egyptian in her reputation for chastity. Zenobia only had sex for the

purposes of procreation of children and, after her marriage, refused to sleep with her husband except for that purpose. Apparently, she carried herself like a man, riding, hunting and enjoying, responsibly, a drink with her officers; she became known as a 'Warrior Queen' and would routinely march three or four miles with her infantry. 'Her voice was clear and like a man's; her sternness, when required, was that of a tyrant, her clemency ... that of a good emperor'.

Highly educated and fluent in Greek, Aramaic, and Egyptian, with a smattering of Latin, she hosted literary salons and surrounded herself with philosophers and poets, the most famous of these being the sophist Cassius Longinus. Comparisons could be drawn with aspects of Cleopatra and earlier with Cornelia from the 2nd century BCE, mother of the Gracchi and paragon of feminine virtue, equally famous for her côteries.

Amid the chaos that was The Imperial Crisis, Zenobia conquered Anatolia as far east as Ancyra (Ankara) and Chalcedon, followed by Syria, Judea and Lebanon; in so doing she snatched vital trade routes from the Romans, severing grain supplies to the empire and causing a bread shortage in Rome. Zenobia controversially issued coins – those potent symbols of Roman *imperium* and propaganda – depicting her likeness and others with her son's; this may well have provoked the Romans although the coins do acknowledge Rome's sovereignty, for example, with an image of Vaballathus on one side and Aurelian on the other as joint rulers of Egypt. Others describe her title, *Augusta*, and show her with a diadem on a crescent; the reverse depicts Juno Regina. She also negotiated trade agreements with the Sassanid Persians, and annexed territories to her empire without consulting Rome or considering Rome's interests. By 271 CE she ruled over an empire which stretched from modern-day Iraq, across Turkey and down through Egypt.

The emperor Aurelian (reigned 270 CE – 275 CE) soon initiated a mighty campaign to restore the Roman empire in 272–273. He destroyed every town and city loyal to Zenobia until he reached Tyana, home of the famous philosopher Apollonius of Tyana whom Aurelian admired. Aurelian's initial reaction to the fact that he was locked out from there did not bode well for the inhabitants: he declared: 'In this city, I will not leave even a dog alive'. Aurelian then dreamed that Apollonius appeared and advised him to show clemency if he wanted victory, and so Aurelian spared the city and marched on. Other cities then recognized the good sense in surrendering to an emperor who was merciful rather than incurring his wrath and extermination by resisting. After Tyana, no more cities opposed him.

Aurelian and Zenobia clashed at Daphne near Antioch; Zenobia's forces were crushed. She was then besieged at Emesa, site of her treasury; Zenobia and her son, Vaballathus, escaped by camel, assisted by the Sassanids, but she was captured on the Euphrates. Those remaining Palmyrenes who refused to surrender were executed. Zenobia blamed her advisors for her disloyalty to Rome, particularly Cassius Longinus, who was executed. Aurelian, despite it all, showed respect for Zenobia but he was undoubtedly embarrassed by the fact that a woman had overrun one third of his empire. He sought to mitigate this in a letter:

> Those who speak with contempt of the war I am waging against a woman, are ignorant both of the character and power of Zenobia.

It is impossible to enumerate her warlike preparations of stones, of arrows, and of every type of missile, weapons and military engines.

Adding in other correspondence, 'the Romans are saying that I am merely waging a war with a woman' and, in a letter to the senate: 'I have heard, Conscript Fathers, that men are reproaching me for having performed an unmanly deed in leading Zenobia to triumph'.

This male diffidence, arrogance even, alleged by Aurelian in Latin literature goes all the way back at least to Virgil and beyond when the poet has Aeneas articulate how little consequence there was in defeating a mere woman, Helen of Troy in this case: 'There's no great glory in a woman's punishment, and such a conquest wins no praise'[3].

During the siege there was, apparently, an exchange of letters between Aurelian and Zenobia: 'I bid you surrender, promising that your lives shall be spared.' She replied, 'You demand my surrender as though you were not aware that Cleopatra preferred to die a queen rather than remain alive.'

Palmyra was sacked after a second revolt. Aurelian, in a letter to Bassus, one of his staff officers, bewailed the fact, in an all too familiar refrain, that 'The swords of the soldiers should not proceed further…. We have not spared the women, we have slain the children, we have butchered the old men, we have destroyed the peasants'.

Fittingly, perhaps, the accounts of Zenobia's death are as confusing as Cleopatra's death. According to Zosimus, she and her son died in the Bosporus *en route* to Rome[4]. The *Historia Augusta* has it that in 274 CE, Zenobia reportedly starred in golden chains in Aurelian's triumph in Rome; ironically, free bread was handed out to the crowds. Bread and circuses all on the same day.

According to Vopiscus who witnessed the triumphal possession:

It was a most brilliant spectacle. Chariots, wild beasts, tigers, leopards, elephants, prisoners, and gladiators paraded through the streets. Each group was labelled with a placard identifying captives and booty from 16 conquered nations for the spectators. One placard identified Odainat's chariot, another that of Zenobia. But, as she had often walked with her soldiers on foot, Zenobia did not ride that fateful day. Rather, she walked, without a placard, though the expectant crowd had no trouble recognizing her, "adorned with gems so huge that she laboured under the weight of her jewelry."

Pollio adds:

This woman, courageous though she was, halted often, saying that she could not bear the weight of the jewels. Furthermore, her feet were bound with shackles of gold and her hands with golden fetters, and even on her neck she wore a chain of gold, the weight of which was borne by a Persian buffoon.

Some say she died soon after through illness, hunger strike or beheading. An alternative outcome is that Aurelian, taken by her beauty and dignity, gifted her a smart villa in Tibur (modern Tivoli) where she lived out her life in luxury and became a leading philosopher, salonnière, socialite and surrogate Roman *matrona*. On the other hand Zonaras claims she was taken back to Rome, never appeared in any triumph and was not paraded through the streets in chains; instead, she married a wealthy Roman husband, while Aurelian wed one of her daughters[5]. In Al-Tabari's account, Zenobia murdered a tribal chief named Jadhima on their wedding night. When his nephew sought revenge he pursued her to Palmyra where she escaped on a camel and fled to the Euphrates. She had earlier ordered a tunnel to be dug beneath the river in case she needed to escape and was just entering this tunnel when she was caught. She then either killed herself by drinking poison or was executed.

To Arab historians such as Al-Tabari, Zenobia was a tribal queen of Arab, rather than Greek, descent, whose original name was Zaynab, or al-Zabba[6]. According to *The New Yorker*, among Muslims she is 'a herald of the Islamic conquests that came four centuries later', a view shared by the odious Syrian Assad regime which has featured Zenobia on its currency, and 'which also resonates within radical Islamic circles'. Palmyra itself is celebrated as the place where Zenobia stood up to the Roman emperor[7].

Further reading

Andrade, Nathanael J. (2018). *Zenobia: Shooting Star of Palmyra*. Oxford
Kelly, Sarah E. (2004). 'Zenobia, Queen of Palmyra'. In Pearson, Gail A. (ed.). *Notable Acquisitions at the Art Institute of Chicago*. Vol. 2. University of Illinois Press
Macurdy, Grace Harriet (1937). *Vassal-Queens and Some Contemporary Women in the Roman Empire*. The Johns Hopkins Press
Southern, Patricia (2008). *Empress Zenobia: Palmyra's Rebel Queen*. London

St Catherine of Alexandria – *converted at 14, martyred at 18*

Catherine of Alexandria was a Christian saint and virgin, martyred in the early 4th century under the emperor Maxentius (r. 306–312 CE). She was both a princess and a noted scholar who became a Christian around the age of 14, and converted hundreds of people to Christianity before she met her death around age eighteen. More than 1,100 years later Joan of Arc named her as one of the saints who appeared to and counselled her.

Some modern historians argue that Catherine was probably based on the life and murder of the virgin Saint Dorothea of Alexandria and the Greek philosopher Hypatia.

In her *The Cult of St Katherine of Alexandria in Early Medieval Europe* (p.143*)*, Christine Walsh discusses 'the historical Katherine':

> As we have seen, the cult of St Katherine of Alexandria probably originated in oral traditions from the 4th-century Diocletianic

Persecutions of Christians in Alexandria. There is no evidence that Katherine herself was a historical figure and she may well have been a composite drawn from memories of women persecuted for their faith. Many aspects of her *Passio* are clearly legendary and conform to well-known hagiographical topoi.

Her main symbol is the spiked wheel, which has been hijacked by the firework industry as the Catherine Wheel.

The primary goal was the agonizing mutilation of the body, not death. Therefore, the most common form would start with breaking the leg bones where the executioner dropped the execution wheel on the shinbones of the convicted person and then worked his way up to the arms. To increase its effect, often sharp-edged timbers were placed under the convict's joints.

Then the body was braided into another wooden spoked wheel, which was possible through the broken limbs, or tied to the wheel. The wheel was then erected on a mast or pole, like a crucifixion. After this, the executioner could decapitate or garrotte the convicted if need be. Alternatively, fire was kindled under the wheel, or the 'wheeled' convict was simply thrown into a fire. Since the body remained on the wheel after execution, left to scavenging animals, birds and putrifaction, this form of punishment, like the ancient crucifixion, had a sacral function beyond death which would hinder transition from death to resurrection.

Medieval hagiographies, such as the *Legenda sanctorum*, record St Catherine's ordeal on the wheel when the wheel miraculously broke when she touched it; she was then beheaded. As an attribute it is usually shown broken in a small version beside her, or sometimes as a miniature she holds in her hand; the sword then used is also often shown.

Further reading

Walsh, Christine. (2007). *The Cult of St Katherine of Alexandria in Early Medieval Europe.* Aldershot

Hypatia (*c.* 360 CE – 415 CE) – *Neoplatonist polymath*

Hypatia lived in Alexandria, then part of the Eastern Roman Empire, where she was a prominent thinker and teacher of philosophy and astronomy. Although preceded by Pandrosion, another Alexandrine female mathematician[1], she is the first female mathematician for whose life we have a viable record.[2] She wrote a commentary on Diophantus's thirteen-volume *Arithmetica* interpolated into the original text, and another commentary on Apollonius of Perga's lost treatise on conic sections. Many believe that Hypatia may have edited the surviving text of Ptolemy's *Almagest*. She designed and built scientific equipment including the astrolabe which revolutionised navigation for ships and a device for measuring fluid density.

Hypatia was influential with the political elite in Alexandria. When she tried to pacify the Jewish and emerging Christian communities and welcomed both

Christians and pagans to her lectures she, in 415 CE, was ambushed, stripped and beaten to death by a baying mob of Christians[3]. Kate Mosse suggests that part of the cause of her death was that she was a woman operating in a traditionally male space[4].

Hypatia's murder 'rocked the empire' and transformed her into a "martyr for philosophy", leading future Neoplatonists such as the historian Damascius (*c.* 458 – *c.* 538 CE) to become increasingly anti-Christian. During the Middle Ages, Hypatia became a symbol of Christian virtue and in the Enlightenment she was a symbol of opposition to Catholicism. In the 19th century Charles Kingsley's 1853 novel *Hypatia*, romanticized her as "the last of the Hellenes". In the 20th century, Hypatia became an icon for women's rights and a precursor to the feminist movement.

The Christian historian Socrates of Constantinople, a contemporary of Hypatia, describes her in his *Ecclesiastical History*:

> There was a woman at Alexandria named Hypatia, daughter of the philosopher Theon, who made such attainments in literature and science, as to far surpass all the philosophers of her own time... she not infrequently appeared in public in the presence of the magistrates. Neither did she feel shy in going to an assembly of men. For all men on account of her extraordinary dignity and virtue admired her the more.

Further reading

Berggren, J. L. (2009). 'The life and death of Hypatia'. *Metascience* 18 (1): 93–97

Deakin, Michael A.B. (1992). 'Hypatia of Alexandria' (PDF). *History of Mathematics Section, Function* 16 (1): 17–22

Deakin, Michael A.B. (1994). 'Hypatia and her mathematics'. *American Mathematical Monthly* 101 (3): 234f

Deakin, Michael A.B. (2007). *Hypatia of Alexandria: Mathematician and Martyr.* Amherst, NY

Dzielska, Maria (2008). 'Learned women in the Alexandrian scholarship and society of late Hellenism'. In el-Abbadi, Mostafa (ed.), *What Happened to the Ancient Library of Alexandria?*. Leiden, pp. 129–148

Melania the Elder – *influential Desert Mother*[1]

Melania the Elder (*c.* 350 – *c.* 417) was a Desert Mother with considerable influence in the Christian ascetic movement (the Desert Fathers and Mothers) that emerged not long after Constantine declared Christianity a legal religion in the Roman Empire. Daughter of the consular Marcellinus, she became one of the Empire's wealthiest citizens.

Her husband and two of her three sons had died by the time she was twenty-two when she became a Christian in Rome and set off to Alexandria, to join other Christian ascetics and visit the monks in the desert at Nitria near Alexandria.

She stayed with the monks for about six months. When persecution broke out after the death of Bishop Athanasius in 373 CE and many of the monks were exiled to Diocaesaraea in Palestine, Melania followed and supported them financially. She is noted for the convent she built in Jerusalem and the monastery on the Mount of Olives for the monk and theologian Rufinus of Aquileia – one of the first Christian communities; and because she promoted asceticism which she, as a follower of Origen, considered indispensable for salvation.

Due to her involvement as a pro-Origenist in the controversy over Origen in the 390s, Jerome was especially critical of her, cheaply punning on her name and calling her 'black in name and black in nature.' In desperation he tried to expunge his earlier praises of her from his writings. On the positive side Palladius of Galatia described her as 'a very learned lady who loved the world'.

Origen of Alexandria (*c.* 185 – *c.* 253) was an early Christian scholar, ascetic, and theologian – a prolific writer who wrote roughly 2,000 treatises in multiple branches of theology, including textual criticism, biblical exegesis and hermeneutics, homiletics, and spirituality. He was one of the most influential and controversial figures in early Christian theology, apologetics, and asceticism. He has been described as 'the greatest genius the early church ever produced'.

Further reading

Clark, Elizabeth A. (1999). 'Melania, Elder'. In Fitzgerald, Allan (ed.) *Augustine Through the Ages: an Encyclopedia*

Ruether, Rosemary. '*Mothers of the Church: Ascetic Women in the Late Patristic Age*'.

Ruether, Rosemary (ed.). *Women of Spirit: Female Leadership in the Jewish and Christian Traditions*. New York

Southon, Emma (2023). *A History of the Roman Empire in 21 Women*. London

Mavia – *guerilla commander*

Mavia (r. 375–425 CE) was a pugnacious Arab warrior-queen, who ruled over a confederation of semi-nomadic Arabs in southern Syria. She led her troops in rebellion against Roman rule, riding at the head of her army into Phoenicia and Palestine. Having repeatedly defeated the Romans, the Romans finally struck a truce with her on conditions stipulated by Mavia when she reached the borders with Egypt. The Romans later called on her for assistance when under attack by the Goths, to which she responded by despatching cavalry.

Mavia was considered 'the most powerful woman in the late antique Arab world after Zenobia'. She and the Tanukhids forsook Aleppo for the desert, leaving the Romans wrong-footed without a standing target to attack. Mavia's highly mobile units, using classic guerilla warfare tactics, mounted numerous raids and thwarted Roman attempts to subdue the revolt – an early version in some respects of the nimble and highly mobile British Long Range Desert Group and early SAS which operated in north Africa in World War II. Mavia defeated the first attempt to quell

her and when a second attempt, led no less by the Roman military commander of the East himself, was sent out to meet Mavia's forces in open battle, she defeated him too.

Mavia led her armies from the front and proved to be not only a very astute political leader but also a highly competent field tactician. Her army, deploying Roman battlefield strategy and tactics and their own traditional, unconventional fighting methods, had a massive impact; her agile cavalry units armed with long lances were used with deadly effect. Valens could do nothing, other than surrender.

Mavia successfully negotiated to regain the Tanukh's allied status and the privileges they had enjoyed before Julian's reign. At the end of the war Mavia's daughter, Princess Chasidat, was married to a devout Nicene commander in Rome's army, Victor, to cement the alliance. Mavia had delivered to the Arabs a just peace. Things, however, started to go wrong: as part of the peace treaty, Mavia sent her troops to Thrace to help the Romans in the fight against the Goths. Her forces proved ineffective while the Goths pushed the Romans back to Constantinople, killing Valens, the emperor, in the process.

Mavia's forces returned home dejected and depleted in number. Theodosius I, the new emperor, favoured the Goths over the Arabs who felt betrayed; they mounted another revolt in 383 CE which was quickly suppressed.

In 425 CE Mavia died in Anasartha, east of Aleppo where there is an inscription recording her passing.

Further reading

Bowersock, Glen (1994). 'Mavia, Queen of the Saracens.' In *Studies on the Eastern Roman Empire*. Keip

Cameron, Averil (1998). *The Cambridge Ancient History: The Late Empire, A.D. 337–425*. An excellent overview of Mavia's reign

Jensen, Anne (1996). *God's Self-Confident Daughters: Early Christianity and the Liberation of Women.*

Mark, Joshua J. 'Mavia'. *World History Encyclopedia*

Sefsci, Sue M. 'Zenobia'. *Women's History*

Serena – *and women as victims of war*

Serena was niece and adoptive daughter of emperor Theodosius I and wife of Stilicho, whom she married in 384 CE. Stilicho was a German Vandal who rose to the position of general and the most powerful man in the Western Roman empire. He was regent for the young Honorius, Serena's cousin, and was finally deposed, arrested and executed in 408 CE.

Theodosius had seen that Stilicho could be a useful ally so, to bring him closer and guarantee his loyalty, he arranged the marriage with Serena who gave birth to a son, Eucherius, and two daughters, Maria and Thermantia; they both married Honorius. Serena picked a bride for the poet laureate, Claudian, and looked after Honorius' half-sister, her cousin Galla Placidia. After Stilicho's death, Serena was

falsely accused of conspiring with the Visigoths during the siege of Rome and was executed with Galla Placidia's consent.

Claudian's *In Praise of Serena* portrays, somewhat obsequiously, her as the typical army wife, despairing that her husband is leaving for war in Thrace and overjoyed when he eventually returns:

> How you trembled and wept when the cruel bugles summoned your warrior to arms! With a face wet with tears you saw him leave home praying for his safe return after snatching the final hasty kiss from between the bars of his crested helmet's visor. But again what joy when he finally returned, preceded by the clarion of victory and you could hold his still armoured body in your loving arms again! How sweet the long hours of the chaste night when you asked him to tell in safety the story of his battles. When he was away at the wars you didn't comb your shining hair nor wear your usual jewels. You spent your time in worship and in prayer...

But Serena was not just an unhappy war wife; she put her time alone to good use, acting as Stilicho's eyes and ears, alert for any sign of opposition or conspiracy against him, maintaining his presence at court *in absentia*. Indeed, Claudian tells us how she once warned him of a 'foul conspiracy' organised by Rufinus 'who sought means to destroy his master by traitorously stirring up the Getae against Rome'.

Claudian touches on a number of other issues relating to women in war. In his *Bellum Geticum*, he references the unhappy fate of women in war, whatever side they are on: 'He [Alaric] who targeted the women of Rome as victims of his lust has seen his own wives and children led away captive'. He attacks Alaric's wife as mad, *demens,* with greed for Roman booty: '[she] demanded in her madness the jewelled necklaces of Italian matrons for her proud neck and Roman girls for her slaves!' She is in stark contrast to the modesty and frugality, loyalty and chastity displayed by Serena.

His personification of Africa bewails the pillage and rape endured by the women of Carthage – discarded by Gildo's troops when they had satisfied their lust – and then handed on to the Moors. Gildo (died 398 CE) was a Berber Roman general in Mauretania who revolted against Honorius but was defeated and committed suicide.

Galla Placidia (389–450 CE) – *another woman of prodigious talents*

She was daughter of the Roman emperor Theodosius I, was a mother, tutor, and advisor to emperor Valentinian III. She was queen consort to Ataulf, king of the Visigoths from 414 until his death in 415, briefly empress consort to Constantius III in 421, and managed the government administration as a regent during the early reign of Valentinian III until her death[1].

Meaghan McEvoy tells us that Galla Placidia started what can only be called her adult life at an early age[2]: her father granted her her own household in the early 390s making her financially independent while a young girl. She was summoned to the court of her father in Mediolanum (Milan) during 394, and was present at Theodosius' death on 17 January 395. She was granted the title of *nobilissima puella* ('most noble girl') while still a child.[3]

Mathison describes how Placidia spent most of her early years in the household of Stilicho and his wife, Serena, where she probably learned weaving and embroidery and may have also received a classical education. Stilicho was *magister militum* of the Western Roman Empire.

Placidia was captured by Alaric before the fall of Rome, and accompanied the Visigoths from Italy to Gaul in 412. Their ruler Ataulf, having succeeded Alaric, entered an alliance with Honorius against Jovinus and Sebastianus, rival Western Roman emperors located in Gaul, and defeated and executed both in 413.

When the heads of Sebastianus and Jovinus arrived at Honorius' court in Ravenna they were sent for display among other usurpers on the walls of Carthage; relations between Ataulf and Honorius improved enough for Ataulf to cement them by marrying Galla Placidia at Narbonne in 414 CE. Ataulf was killed in his bath in 415 by the well-named Dubius. Galla Placidia, was forced to walk more than twelve miles on foot among the crowd of captives driven ahead of the mounted Sigeric. After seven days in the job, Sigeric, Ataulf's successor was assassinated and replaced with Wallia, Ataulf's kinsman.

Placidia intervened in the succession crisis following the death of Pope Zosimus in 418. In 421, Constantius was proclaimed Augustus, becoming co-ruler with the childless Honorius. Placidia was proclaimed an Augusta. According to historian Olympiodorus of Thebes, the public grew concerned about the increasingly scandalous and inappropriate touching she allegedly received from her brother Honorius after her husband's death. However, the siblings' relationship suddenly turned sour, and she may have plotted against him. After her soldiers clashed with those of Honorius, Galla Placidia herself was now forced to flee to Constantinople with her children. After much internecine warring, procrastination and confusion, Galla Placidia became a regent of Western Roman Empire for her son, Valentinian, in 425 until Aetius' rise[4].

A devout Christian, she restored and expanded the Basilica of Saint Paul Outside the Walls in Rome and the Church of the Holy Sepulchre in Jerusalem. She built San Giovanni Evangelista, Ravenna in thanks for the sparing of her life and those of her children in a storm while crossing the Adriatic Sea.

Her Mausoleum in Ravenna was one of the UNESCO World Heritage Sites inscribed in 1996. However, the building never served as her tomb, but was initially erected as a chapel dedicated to Lawrence of Rome.

Further reading

Holum, Kenneth G. (1982). *Theodosian empresses: women and imperial dominion in late antiquity*. University of California Press

Oost, Stewart Irvin (1968). *Galla Placidia Augusta: a biographical essay*. University of Chicago Press

Rebenich, S. (1985). 'Gratian, a Son of Theodosius, and the Birth of Galla Placidia.'
 Historia: Zeitschrift für Alte Geschichte 34
Salisbury, Joyce E. (2015). *Rome's Christian Empress: Galla Placidia Rules at the
 Twilight of the Empire.* Johns Hopkins University Press
Sivan, Hagith (2011). *Galla Placidia: The Last Roman Empress.* Oxford

Theodora – *decisive leader, dancer and prostitute and champion of oppressed women*

Theodora (*c.* 500–548 CE), the wife of Justinian I and powerful empress of the Byzantine empire, acted as a virtual co-regent with her husband. Procopius is our main source, but perplexingly he gives us three wildly varying accounts in three separate works. *The Wars of Justinian* is complimentary and describes a brave and influential empress; his *De Aedificiis, Buildings of Justinian,* is a panegyric which shows Justinian and Theodora as a virtuous couple. In his *Anekdota* ('unpublished works') or *Secret History*, published a thousand years later, Procopius describes a woman who is vulgar and characterised by unquenchable lust – quite unrecognisable from his descriptions in the earlier works.

Theodora comes to prominence with her leading role in the Nika riots in 532 CE when she urged her dithering husband with a stirring speech to stand and fight the rebels instead of taking the popular option to flee. The riots went on for a week in Constantinople and were the most violent in the history of the capital, with nearly half the city being burned or destroyed and tens of thousands of people killed.

They were caused by what can only be called chariot racing hooliganism: in 531 CE members of the Blues and Greens factions were arrested on charges of murder in connection with deaths that occurred during rioting after a recent chariot race. Hanging was the sentence and many were duly strung up, but in January 532, two of them, a Blue and a Green, escaped and took refuge in the sanctuary of a church surrounded by a baying mob.

Justinian's feeble and indecisive reaction was to declare that a chariot race would be held on January 13th and commuted the sentences to imprisonment. By race twenty-two, the chanting had changed from 'Blue' or 'Green' to 'Níκα' meaning 'Win!' or 'Conquer!' as the angry crowds stormed the palace which, for the next five days was under siege.

Inevitably, the vexed question of taxation became a rallying cry and, as we have said, a terrified Justinian considered fleeing – that is until a defiant and decisive Theodora advised otherwise saying, 'Those who have worn the crown should never survive its loss. Never will I see the day when I am not saluted as empress.' Although an escape route across the sea beckoned, Theodora insisted that she would remain in the city, quoting an ancient saying, 'Royalty is a fine burial shroud," or "the Purple makes a fine winding sheet'. Justinian pulled himself together and the rebels were eventually quelled. Procopius says that about thirty thousand rioters were slaughtered and the senators who had supported the riot were exiled. He rebuilt Constantinople, including the Hagia Sophia.

Unsurprisingly Theodora was not just a capable and decisive leader of men: she, like many women before her, comes with the predictable sexual baggage.

According to Procopius' *Secret History*, Theodora followed her older sister, Comito, and worked in a Constantinople brothel, serving low and high-status customers alike. Later, she performed on stage. In his account of Theodora in his *Decline and Fall*, Gibbon wrote:

> Her venal charms were abandoned to a promiscuous crowd of citizens and strangers of every rank, and of every position; the fortunate lover who had been promised a night of enjoyment was often driven from her bed by a stronger or more wealthy favourite; and when she passed through the streets, her presence was avoided by all who wished to escape either the scandal or the temptation.

Procopius wrote that Theodora made a name for herself with her pornographic stage portrayal of Leda and the Swan.[1] Employment as an actress at the time would have included performing 'indecent exhibitions' on stage and providing sexual services off stage. During this time, she may have met Antonina, the future wife of Belisarius who also became a member of the women's court led by Theodora.

The accuracy of Procopius's portrayal of Theodora's early career is unclear. Sexual promiscuity ascribed to female actresses and performers was commonplace at the time and the *Secret History*'s lengthy and pornographic descriptions of Theodora's behaviour are now dismissed as slanderous and unreliable. However, some contemporary authors, such as John of Ephesus, also describe Theodora as having come 'from the brothel.' Consistent with the Christian principles of repentance and forgiveness, John wrote of her redemption as a positive story.[2]

Theodora was involved in helping underprivileged women, sometimes 'buying girls who had been sold into prostitution, freeing them, and providing for their future.' She established a convent on the Dardanelles called the *Metanoia* (Repentance), where the ex-prostitutes could support themselves

In his *Secret History* Procopius maintained uncharitably that instead of preventing forced prostitution (as in *Buildings* 1.9.3ff), Theodora is said to have 'rounded up' 500 prostitutes, confining them to a convent. They sought to escape 'the unwelcome transformation' of their lives by clambering over the walls (*Secet History* 17). On the other hand, chronicler John Malalas wrote more positively about the convent, declaring that Theodora 'freed the girls from the yoke of their wretched slavery.'[3]

Justinian and Theodora's enlightened and philanthropic legislation also expanded the rights of women in divorce and property ownership, instituted the death penalty for rape, forbade exposure of unwanted infants, gave mothers some guardianship rights over their children, and forbade the killing of a wife who committed adultery.

In *Wars*, Procopius tells us that Theodora was naturally inclined to assist women in misfortune and, according to *Secret History*, she was accused of unfairly championing the wives' causes more so when they were charged with

adultery (*SH* 17). Procopius sourly describes Theodora as making women 'morally depraved' due to her and Justinian's legislation.[4]

Further reading
Evans, James A.S. (2002). *The empress Theodora. Partner of Justinian*. Austin, TX.
Evans, James A.S. (2011). *The Power Game in Byzantium. Antonina and the Empress Theodora*. London
Garland, Lynda (1999). *Byzantine Empresses: Women and Power in Byzantium, AD 527–1204*. London.
Potter, David (2015). *Theodora. Actress, Empress, Saint*. Oxford

Antonina (*c.* 484 CE – after 565 CE)

Flavius Belisarius (*c.* 505 – 565 CE) was a successful general and faithful supporter of Justinian, largely responsible, with Theodora, for suppressing the Nika riots. His wife, the duplicitous Antonina, brought with her a reputation just as racy as Theodora's, her long-standing friend. Among other scandals, she was alleged to have had an affair with her adopted son, Theodosius.

Sex for Antonina often took place in front of her slaves with Antonina herself 'a slave to her lust'; even when Belisarius caught them in the act he was unwilling to believe what he was seeing with his own eyes. Antonina was a schemer and a fixer of the first order, playing a prominent role in the downfalls of Pope Silverius and John the Cappadocian, 'making Silverius appear a pro-Gothic traitor' and implicating John 'in a conspiracy to gain the throne.'

Antonina zealously followed Belisarius on campaign so that she, according to Procopius, could exert control over her husband: 'she had taken care to travel all over the world with him'. Her first foray into his military world was during the Vandalic War (533–4), during which, while crossing the Adriatic Sea, the water supplies of the navy were polluted. But not on Belisarius' own ship: Antonina had slyly stowed their water in jars in a darkened room protecting them from contamination.

When in 537 CE Belisarius sent Antonina to Naples, allegedly for her own safety, she helped Procopius, then secretary to Belisarius, to raise a fleet which was used to transport grain and reinforcements to Rome through Ostia. She may also have been implicated in the death of Constantinus in late 537 CE by persuading Belisarius to kill him.

A derogatory Procopius bluntly sums up Antonina's murky background: both her father and grandfather were charioteers:

> 'Her mother was one of the prostitutes attached to the theatre… [Antonina] having in her early years lived a lewd sort of a life and having become dissolute in character. She not only consorted a lot with the cheap sorcerers who surrounded her parents, but also acquired knowledge of what she needed to know from them. She

later became the wife of Belisarius, after having been the mother of many children.

After joining her husband in the Lazic War, the cuckolded Belisarius eventually arrested Antonina on evidence provided by bedchamber servants; but he vacillated and was unable to bring himself to exact punishment – due, according to Procopius, to Antonina's skillful use of the black arts. The informants were deemed to be lying: Antonina performed what seems to have been her favourite punishment: she had their tongues cut out and their bodies chopped up; the body parts were dumped in the sea.

When Justinian caught the plague it obviously prompted discussions about his succession[1]. Belisarius swore to oppose any emperor chosen without his consent. Theodora took offense at this and had them recalled to Constantinople where Belisarius was relieved of his command. Procopius credits Antonina with getting him restored to imperial favour. However, she prevented him from taking up his old job – *magister militum per orientem*: chief of the eastern army. Belisarius was sent back to the Gothic War and Antonina went with him. She was at Portus in 546 CE, Croton in late 547, and Hydruntum in 548. Then she was posted to Constantinople to muster reinforcements for the Gothic War. When she arrived she found that Theodora had died and convinced Justinian to recall Belisarius.

Endnotes

◇◇

Introduction

1. Beard, Mary (2018). *Women and Power: A Manifesto*. London, p. xiii

Chapter 1: Before and beyond the Classical World

1. See Carreiras, *Gender and the Military: Women in the Armed Forces of Western Democracies*
2. See, for example, Brownmiller, Susan, *Against Our Will: Men, Women and Rape,* London, 1976

Vishpala
1. The Vedic Period was the next major civilization in ancient India after the decline of the Indus Valley Civilization by 1400 BCE.
2. Vanderwerker, E.E., *A Brief Review of the History of Amputations and Prostheses*

Pheretima (*c.* 500 BCE)
1. *Pheretima* is a genus of earthworm found in New Guinea and other parts of Southeast Asia; the worms are used as a medicine in China and carry biological agents efficacious in the treatment of epilepsy. The *Pheretima aspergillum* worm contains hypoxanthine, a herb used as an antipyretic, sedative, and anticonvulsant. It lowers blood pressure and contains a platelet-activating factor.
2. Herodotus 4, 205
3. https://en.wikipedia.org/wiki/List_of_women_warriors_in_folklore
4. https://en.wikipedia.org/wiki/Women_in_warfare_(15001699)#Timeline_of_ women_in_warfare_from_1500_to_1699

Queen Tomyris of the Massagetae (*c.* 500 BCE)
1. 'They fight both on horseback and on foot,' Herodotus wrote of the Massagetae in his *Histories*. 'They use bows and lances, but their favourite weapon is the battle-axe.' Cf the Amazons.
2. Gera, Deborah Levine (2018). *Warrior Women: The Anonymous Tractatus De Mulieribus*. Leiden, pp. 187–199

Atossa (*fl.* 486 BCE – 476 BCE)

1. Hellanicus (*FGrH* 4 F 178a). She too features in the *Tractata*.
2. See https://www.iranchamber.com/history/atossa/atossa.php

The anonymous warrior woman of the Isles of Scilly – and Pictish warrior women

1. Mays, S., et al, 'Sex identification of a Late Iron Age sword and mirror cist burial from Hillside Farm, Bryher, Isles of Scilly, England', *Journal of Archaeological Science*: Reports,104099,202
2. Davies, Caroline, 'Isles of Scilly Remains are Iron Age Female Warrior, scientists say', *The Guardian* July 27 2023
3. https://explorersweb.com/warrior-sword-mirror-woman/; August 7 2023
4. https://www.digitscotland.com/sword-wielding-women-and-scottish-archaeology
5. Russell, Violet (1914). *Heroes of the dawn.* London; MacKillop, James

Chapter 2: Ancient Egypt

Sobekneferu or Neferusobek ('beauty of Sobek') (*c.* 1800 BCE)

1. Cooney, 2018, pp. 12–14
2. Gillam, 2001, p. 301; Robins 2001, p. 108
3. Zecchi 2010, pp. 84–85
4. Cooney, op cit., pp. 9–13
5. Cooney, op. cit, p. 30
6. Roth 2005, p. 12
7. Roth, 2005, p. 12; Ryholt, 2000, p. 92; Cooney, 2018, pp. 9–10

Ahhotep I (*c.* 1560 BCE)

1. A dynasty of Palestinian origin that ruled northern Egypt as the 15th dynasty (*c.* 1630–1523 BCE). *Hyksos* was probably an Egyptian term for "rulers of foreign lands", and it almost certainly designated the foreign dynasts rather than an ethnic group. Modern scholarship has identified most of the Hyksos kings' names as Semitic.

 The rise of the Hyksos kings in Egypt came about by an influx of immigrants from Palestine into Egypt beginning about the 18th century BCE. The immigrants brought with them new technologies, including the horse and chariot, the compound bow, and improved metal weapons. Most of them settled in the eastern portion of the Nile Delta, where they achieved a dominant role in trade with western nations.

Hatshepsut (d. 1458)

1. This erasing from history may partly be on account of the simple fact that Hatshepsut was a woman in a man's world. However, Akhenaten and Ay both suffered the same fate. We see it again, of course, as *damnatio memoriae* – social

overthrow or historical negationism – in the Roman empire when all traces and heritage were wiped from the public record, coinage and architecture and from literature. Caligula, Nero, Domitian and Commodus were all victims, in theory paying the price for deeds past in the present and for eternity.

Nefertiti (*c.* 1370 – *c.* 1330)
1. Talatat are limestone blocks of standardized size used during the 18th Dynasty reign of the Pharaoh Akhenaten in the building of the Aton temples at Karnak.
2. Redford, Donald B. (1987). *Akhenaten, the Heretic King*. Princeton. Redford shows how various writers have depicted this strange ruler of the 14th century BCE. as a disguised woman or a eunuch, a mentor of Moses.

Arsinoe III Philopator
1. That is as far as she was able to under Sosibius (*fl.* 221–204), the chief minister of Ptolemy IV Philopator (221–204 BCE), king of Egypt. He is first attested immediately after the accession of Ptolemy IV in 221 BCE, exercising great influence over the twenty-two-year-old king alongside Agathocles, the brother of Ptolemy IV's mistress Agathoclea. He remained a major force throughout the reign and helped ensure the smooth succession of Ptolemy V Epiphanes in 204 BCE.
2. Antiochus III the Great was a Greek Hellenistic king and the 6th ruler of the Seleucid Empire, reigning from 223 to 187 BCE. He ruled over the region of Syria and large parts of the rest of western Asia towards the end of the 3rd century BCE.
3. Pennington, Reina (2003). *Amazons to Fighter Pilots: A Biographical Dictionary of Military Women.* Westport, CT
4. Meyers, Carol et al (eds). (2000). *Women in Scripture: A Dictionary of Named and Unnamed Women in the Hebrew Bible, the Apocryphal/Deuterocanonical Books, and the New Testament.* New York
5. Bennett, Chris (14 Sep 2006). *"Arsinoe III"*. Ptolemaic Dynasty. Tyndalehouse

The Kandakes of Kush
1. Adams, W. Y. (1994). "Big Mama at Meroe: Fact and Fancy in the Candace Tradition". *Conference of the Sudan Studies Association,* Boston.
2. "The Royal Cemetery of Kurru". qsap.org.qa.
3. "The Candaces of Meroe". *World History Encyclopedia*
4. Kuckertz, Josefine (2021). "Meroe and Egypt". *UCLA Encyclopedia of Egyptology*: 5, pp. 11–13.
5. Strabo, *Geographia* XVII, 1, 25–54

Chapter 3: Exceptional women in the Bible

1. Craven, Toni ed. (2000). *Women in Scripture: A Dictionary of Named and Unnamed Women in the Hebrew Bible, the Apocryphal/Deuterocanonical Books and New Testament.* Houghton Mifflin. p. xii.

2. Freeman, Lindsay Hardin (2014). *Bible Women: All Their Words and Why They Matter* (3rd ed.)

Eve

1. McDonald, Beth E. (2009). "In Possession of the Night: Lilith as Goddess, Demon, Vampire". In Sabbath, Roberta Sternman (ed.). *Sacred Tropes: Tanakh, New Testament, and Qur'an As Literature and Culture*. Brill. pp. 175–178
2. "Blood, Gender and Power in Christianity and Judaism". www2.kenyon.edu.
3. See Chrystal, Paul (2013). *Women in Rome*. Stroud

Miriam

1. Exodus 2:1–10; Exod. 15:20–21
2. Num. 12:1–6
3. *Tzaraath* (Hebrew: צָרַעַת *ṣāra 'aṯ*), variously transcribed into English and frequently translated as leprosy (though it is apparently not Hansen's disease, the disease known as 'leprosy' in modern times[4]), is a term used in the Bible to describe various ritually impure disfigurative conditions of the human skin, clothing, and houses. Skin *tzaraath* generally involves patches that are white and contain unusually coloured hair. Clothing and house *tzaraath* consists of a reddish or greenish discoloration. And Kaplan, D.L. "Biblical leprosy: an anachronism whose time has come", *J Am Acad Dermatol* 1993 Mar;28(3):507–10.

Deborah

1. Judges 4, 6–10; 5, 23–27; the 'Song of Deborah' is at 5, 24.
2. Niditch, Susan (2008). *Judges: A Commentary*. Westminster John Knox Press

Judith

1. Michael D. Coogan (ed.) (2010). *The New Oxford Annotated Apocrypha: New Revised Standard Version* (4th ed.). Oxford. pp. 31–36.

Jezebel

1. Hackett, Jo Ann et al (2004) (ed.). *The Oxford Guide to People & Places of the Bible*. Oxford. pp. 150–151.

Delilah

1. The Midrash is an ancient commentary on part of the Hebrew scriptures, attached to the biblical text. The earliest Midrashim come from the 2nd century CE, although much of their content is older.
2. Hecker, Eugene (2005). *A Short History of Women's Rights*. pp. 58–59.
3. Guillory, John (1986). "Dalila's House: *Samson Agonistes* and the Sexual Division of Labor". In Ferguson, Margaret; Quilligan, Maurren; et al (ed.). *Rewriting the Renaissance: The Discourses of Sexual Difference in Early Modern Europe*. Chicago, IL

Mary, mother of Jesus
1. Miravalle, Mark (2008). *Mariology: A Guide for Priests, Deacons, Seminarians, and Consecrated Persons.* p. 178
2. Perry, Tim S. (2006). *Mary for evangelicals.* p. 142
3. Hillerbrand, Hans Joachim (2003). *Encyclopedia of Protestantism, Volume 3*

Chapter 4: Ancient Greece and Sparta

1. Aristotle, *Politics*
2. Demosthenes, *Apollodorus Against Neaera*, 3, 122
3. A school exercise attributed to the Athenian 4th century BCE playwright Menander.
4. Phaedra, in *Hippolytus*
5. Andromache, in *Andromache*
6. *Ibid.*
7. Hipponax Fr 68 (West)
8. Hypereides, Fr. 204.
9. Thucydides, 2, 45, 2
10. Semonides 7, 115–118
11. Xenophon, *Oeconomicus* 7, 6
12. Gomme, *The Position of Women in Athens in the Fifth and Fourth centuries*
13. Kitto, H.D.F. *The Greeks,* especially pp 219–36
14. Chrystal, Paul, 2017, *Women in Ancient Greece*; Seltman, C. *The Status of Women in Athens* and *Women in Antiquity,* especially Chapter IX: The New Woman
15. Soranus, *Gynaecology* 34
16. Beard, Mary, *Women and Power*, p.59

Women in Greek mythology
1. Meehan, Dessa (2017) "Containing the Kalon Kakon: The Protrayal of Women in Ancient Greek Mythology," *Armstrong Undergraduate Journal of History*: Vol. 7; at: https://digitalcommons.georgiasouthern.edu/aujh/vol7/iss2/2

Penelope
1. Homer, *Odyssey* 1, 330–359; 360–364; 21, 56, 330

Circe
1. Homer, *Odyssey* 10, 203–47

Helen of Troy
1. Somewhat similar to the principle of collective defence as enshrined in Article 5 of NATO's North Atlantic Treaty
2. Homer, *Odyssey* 4, 277–289; Virgil, *Aeneid* 6, 515–519
3. Virgil, *Aeneid* 6, 494–512

4. Euripides, *Andromache* 629–31
5. Aristophanes, *Lysistrata* 155
6. Stesichorus, fr. 201 PMG.
7. *Cypria*, fr. 1; Hesiod, *Catalogues of Women and Eoiae*, fr. 204.96–101

Penthesilea
1. Herodotus 6, 86; Walcot, *Greek Attitudes towards Women* p. 42
2. *Naturalis Historia* 6, 3, 10
3. Hippocrates, *Airs, Waters, Places* 17
4. Herodotus 4, 110–17
5. Hippocrates, *Airs, Waters, Places* 17
6. Justinus, *Historiae Phillippicae ex Trogo Pompeio* 2, 4
7. Strabo, *Geographia* 11, 503; Hellanicus fr. 17
8. For details see Quintus of Smyrna, *Posthomerica* Books 1–4
9. Virgil, *Aeneid* 1, 490–5. The twelve are Antibrote, Ainia, Clete, Alcibie, Antandre, Bremusa, Derimacheia, Derinoe, Harmothoe, Hippothoe, Polemusa, and Thermodosa.
10. Diodorus Siculus *Library of History* 2, 46
11. *Bibliotheca* 5, 1
12. Propertius 3, 11
13. Pausanias, *Description of Greece* 10, 31, 1 and 5, 11, 2

Medusa
1. Garber (2003), p.1; Wilk (2000), pp. 217–8. The name 'Medusa' itself is often used in ways not directly connected to the mythological figure but to suggest the gorgon's abilities or to connote malevolence; despite her origins as a beauty, the name in common usage 'came to mean monster.' The book *Female Rage: Unlocking Its Secrets, Claiming Its Power* by Mary Valentis notes that 'When we asked women what female rage looks like to them, it was always Medusa, the snaky-haired monster of myth, who came to mind ... In one interview after another we were told that Medusa is "the most horrific woman in the world" ... [though] none of the women we interviewed could remember the details of the myth'
2. *Woman and Power*, pp. 69–71

Myrina
1. Homer, *Iliad* 2, 814; 2, 45–46; 3, 52–55; Diodorus Siculus 3, 54–56. See also Strabo, *Geography* 12, 8, 6 and Tzetzes on Lycophron, 243
2. Stephanus of Byzantium, s. v. Myrina
3. See also Strabo, *Geography* 11, 5, 5 = 12, 3, 22
4. Diodorus Siculus 2, 45; trans. Loeb Classical Library edition, 1935

Greek tragedy and comedy
1. Syropoulos, Spyros (2012). 'Women vs Women. The denunciation of female sex by female characters in drama'. *Agora – Estudos Classicos em Debate*. 14. pp. 27–46.

Andromache
1. *Iliad* 1, 320–325
2. *Iliad* 6, 425; 22, 470–72
3. *Iliad* 6, 450–465
4. *Iliad* 6, 485ff; *Odyssey* 1, 356–9; 21, 350–3
5. *Iliad* 6, 370–373; 6, 433–439

Aristophanes' *Lysistrata*
1. Ptolemy, Hephaeston 5. It is, of course, impossible to know how many Greek or Roman women ever dressed up as men in order to fight in the lines. Unlikely as it may seem, we should nevertheless remember Hua Mulan in China, Joan of Arc, the conquistador Catalina Erauso in 16th century Mexico and Deborah Sampson wounded in the American Civil War, and one of a thousand or so women who fought in that war dressed as men. See Shopland, Norena (2021). *A History of Women in Men's Clothes*, Barnsley; Facella, Margherita (2017). *TransAntiquity: Cross-Dressing and Transgender Dynamics in the Ancient World*. Routledge
2. Pausanias 4, 1, 1–2
3. Suda and Hesychius of Alexandria, *s.v.* Ἄγραυλος; Ulpian *ce Demosth. de fals. leg.;* Plutarch, *Alcibiades* 15; Philochorus, *Fragm.* p. 18, ed. Siebelis

Medea
1. See Chrystal, Paul (2017). *Women in Ancient Greece*. Stroud
2. See Chrystal, Paul (2014). *Women in Ancient Rome*. Stroud
3. Diodorus Siculus, 4, 50, 6; see also Diodorus 4, 45, 1; 4, 54, 5; Statius, *Thebaid* 4, 536 ff
4. Euripides, *Medea*, 112
5. Hyginus *Fabulae* 25; Ovid *Metamorphoses* 7, 391ff.
6. Pythagoreanism *Metamorphoses* 15, 75ff; Orpheus' *katabasis, ibid* 10; Medea's witchcraft *ibid* 7.159–351 and *Heroides* 6, 83–94; *Fasti* 2, 572–583: the rites of Tacita; *Amores* 3,7, 27–36, 73–84: Circean witchcraft; Dipsas the witch ibid 1,8, 1–20, 105–14. Quintilian (10, 1, 98) praises his lost tragedy, *Medea;* see also Tacitus *Dialogus* 12. Quintilian found it rather indulgent.
7. Ovid *Heroides* 6, 83–94
8. *idem, Metamorphoses* 7, 1–351.
9. Seneca, *Medea* 6–23; 670–843.

Philomena and Procne
1. Apollodorus, *Library* 13.14.8

Agnodice
1. Scholars today mostly doubt that Agnodice was a real historical figure, eg Retief (2006) p. 178. Issues with accepting Agnodice as historical include questions over her date, and the implausibility of Hyginus' claim that there

were no *obstetrices* in Athens before Agnodice, when literary and epigraphic evidence shows that midwives were known. See King (1986, 2013).

2. Hyginus claims that Agnodice was taught medicine by 'a certain Herophilus' – generally identified with Herophilus of Chalcedon, an ancient physician known for his work on gynaecology who was credited with the discovery of the ovaries. If this is the case, Agnodice would have lived in the late 4th or early 3rd century BCE.

Cynisca

1. Herodotus 6, 7
2. Xenophon, *Minor Works, Agesilaus* 9, 1, 6; *idem.* 20, 1
3. Pausanias, *Description of Greece* 3, 8, 1–3

Timycha

1. Kahn, David (1996). *The Codebreakers: The Story of Secret Writing.* New York. p. 82

Artemisia I

1. Some say it was Khana's father-in-law, a fellow astronomer called Varahamihira.

Hipparchia

1. See Fabre-Serris, Jacqueline (2015). *Women and War in Antiquity.* JHU Press. p. 236

Chapter 5: Ancient Rome and her enemies

1. John Chrysostom, *The Type of Women Who Ought to be Taken as Wives*
2. Livy 34.7. 2.
3. Philo, *De Specialibus Legibus* 172–175. Translation by C. D. Yonge: A Treatise on Those Special Laws Which Are Referrible to Two Commandments in the Decalogue, the Sixth and Seventh, Against Adulterers and All Lewd Persons, and Against Murderers and All Violence, (London 1854).
4. Plautus, *Bacchae* 41.
5. Cicero, *Pro Murena* 12, 27

The Sibyl of Cumae (*c.* early 500 BCE)

1. Dionysius of Halicarnassus, *Roman Antiquities* 4, 62 (repeated by Aulus Gellius I.19); Varro, according to a remark in Lactantius I.6; Pliny's *Natural History* XIII.27. Of these sources, only Lactantius' Varro claims specifically that the old woman selling the books was the Cumaean Sibyl.
2. Hyenas: Pliny, *op cit* 28, 106. Virgil, *Aeneid* 6, 71–74. Dionysius of Halicarnassus, *Roman Antiquities* 4, 62, 5–6. Virgil, *Eclogue* 4, 6, 24, 31.

Camilla

1. Virgil, *Aeneid* 11, 648
2. *Op. cit.* 7, 803ff

3. *Op. cit.* 11, 603–7
4. *Op. cit.* 11, 552–66
5. *Op. cit.* 11, 581–2
6. *Op. cit* 11, 651–63

Argia
1. Statius, *Silvae* 12.177–86
2. Seneca, *Consolatio Ad Helviam* 16.5. *Consolatio Ad Marciam* 16.1
3. Ibid, 12.312–13

Lucretia (510 BCE)
1. *Fasti* 2, 721–852.
2. 6,1,1.
3. Virgil, *Aeneid* 1, 364; Tacitus, *Agricola* 16, 1; 31, 4.

Cloelia
1. Valerius Maximus, *Factorum ac dictorum memorabilium,* 3.2.2
2. Livy 2,13

The Bacchantes
1. Plutarch, *Roman Questions* 104; *Moralia* 288–289; trans F.C. Babbitt, 1936 Vol 4.

Hispala Faecina
1. Livy 39, 17.
2. Livy 39, 19–22.

Teuta
1. Polybius 2010, 2:4:6–2:4:8.
2. Cassius Dio 1914, 12, Zonaras 8, 18.

Sophonisba
1. Diodorus Siculus, XXVII, 7
2. Cassius Dio, *H. R.*, XVII, 51–52

Cornelia Scipionis Africana (*c.* 180 BCE – *c.* 105 BCE)
1. Strong, Anise K. (2016). *Prostitutes and matrons in the Roman World.* Cambridge

Hortensia
1. Valerius Maximus, *Facta* 8, 2–3

Lesbia, Claudia Metelli, or Clodia (*c.* 95 BCE – 44 BCE)
1. Skinner, Marilyn B. (1983). "Clodia Metelli", *Transactions of the American Philological Association* 113 (1983), pp. 273–287
2. *Pro Caelio* on 4 April 56 BCE

3. *Pro Caelio,* 13, 32
4. https://www.ancient-origins.net/myths-legends/infamy-clodia-metelli-002022

Porcia
1. Tacitus, *Dialogus de Oratoribus* 28.
2. Plutarch, *Caesar* 9. 29.
3. *De Haruspicum Responsis* 17, 37–18, 38.

Terentia (98 BCE – 4CE)
1. Cicero, op. cit. 2, 4; *Ad Fam.* 14, 1. 17
2. *Idem, Ad Fam*, 14, 4.
3. Cicero, *De Divinatione* 1, 18.
4. Plutarch, *Cicero* 29. The translation is Rex Warner's in Plutarch: *Fall of the Roman Republic.*
5. Cicero, *Ad Att.* 15, 11.
6. *Idem, Ad Fam.* 14, 4–6; 14, 2. Ovid, *Tristia* 4, 56–66. Ovid was actually relegated, rather than exiled.
7. Plutarch, op. cit. 20. Translation by Warner, op. cit
8. Cicero *Ad Att.* 6, 6, 1 and *Ad Fam.* 8, 6, 2 for his sanguine resignation.
9. Idem *Ad Att.* 1, 3, 3 and 6, 6, 1; *Ad Q. Fratrem* 2, 4, 2; 2, 6, 2.
10. Idem, *Ad Fam* 14, 3.
11. Plutarch, op. cit. Endnotes 173 32. Pliny, NH, 8, 48; Valerius Maximus, 8, 13.

Octavia the Younger
1. Dio Cassius, *Roman History* 47, 8, 4
2. Plutarch, *Cicero* 49
3. *Phillipics* 13, 18
4. Appian *Bellum Civile* 3, 8, 51
5. Dio 48, 4, 1–6.

Livia Drusilla
1. Pliny, *NH* 10, 154; Suetonius, *Tiberius* 14, 2.
2. Tacitus, *Annals* 6, 51, 1.
3. Suetonius, op. cit. 6, 2–3; Dio, 54, 7. 2.
4. Philo, *Legatio ad Gaium* 319–20. Pliny, *NH* 3, 127; 14, 60; 17, 31.
5. Horace, *Odes* 3, 14.
6. Dio 48, 34, 3.
7. Dio, 48, 34, 3.
8. Suetonius, *Galba* 1. Pliny, op. cit. 15, 136–7; Dio, 48, 52, 3–4; 63, 29, 3.
9. Dio 41, 39, 2; 43, 43, 1.
10. See above. Plutarch, *Cato Minor* 25, 52. Lucan, *de Bello Civile* 2, 326–80.
11. Dio 48, 44, 1–3.
12. Velleius Paterculus 2, 75, 3; Tacitus, op. cit. 5, 1, 2.
13. Suetonius, *Augustus* 69, 1; Tacitus, op. cit. Seneca, *Consolatio ad Marciam* 3, 4. 14. Dio 54, 7, 2. 17. IG 3, 316.

15. Seneca, *De Clementia* 1, 9; Dio, 55, 14–22.
16. Dio, 48, 34, 3; Suetonius, op. cit. 64; Macrobius, *Saturnalia* 2, 5, 1–10. Livia, Suetonius, Caligula 23.
17. Suetonius, *Augustus* 70–71.
18. Pliny, *NH*. 3, 17; Martial 4, 18, 1; Dio, 55, 8, 4.
19. For Tatia see Thonemann, *The Women of Akmoneia*; the translation of the inscription is by Thonemann. See *CIL* 4, 207; 171; 913; 3291; 1083; 6610; 3678; 3684; 3527; Savunen, *Women and Elections*.
20. *CIL,* 10, 810.
21. *CIL,* 10, 810.
22. Pleket 8G.
23. Pleket 19G.
24. Ovid *Fasti* 5, 148–58
25. Tacitus, op. cit. 1, 10, 7; Suetonius, *Tiberius* 21, 4–7.
26. Seneca, *Cons. Marciam* 1; Tacitus, op. cit. 4, 34–35; Suetonius, *Augustus* 35, 2; *Tiberius* 61, 3; *Caligula* 16, 1; Dio 57, 24, 4.
27. Tacitus op.cit. 3, 1, 2–4.
28. Tacitus, op. cit. 2, 74; 3, 7; 2,
29. See González, J. (1999). 'Tacitus, Germanicus, Piso, and the Tabula Siarensis'. *The American Journal of Philology*, 120(1), 123–142.
30. Tacitus, op. cit. 4, 67; 4, 57.
31. Pliny, op. cit. 13, 74; 14, 11.
32. Velleius 2, 130, 5.
33. Tacitus, op. cit; 5, 1; Dio 58, 2; Suetonius, op. cit. 51. Seneca, *Ad Marciam* 4, 3. Tacitus, op. cit. 5, 1, 3. 74. Dio, 54, 16, 4. Velleius 2, 130, 5.
34. A poem of condolence in 474 elegiac lines, addressed to Livia Drusilla, on the death of her son Nero Claudius Drusus on campaign in Germany in 9 BCE.

The Cult of Isis

1. *CIL* 10, 3800.
2. *P.Oxy* 11, 1380, 214–216.
3. I, 3, 23–34.
4. 2, 33, 1.
5. *Ars Amatoria* 635f.
6. *Amores* 1, 8, 73.
7. Juvenal 6, 511–541.
8. 11, 9–10.
9. *CIL* 6, 224.
10. Tacitus, *Annals* 2, 85; Suetonius, *Tiberius* 36.

Julia the Elder

1. Suetonius, *Tiberius 7; Augustus 65*
2. Suetonius, *Augustus,* 64–5
3. Seneca, *De Beneficiis* 6.32. Pliny *NH* 21, 8–9.
4. Velleius Paterculus, 2, 100.

Agrippina the Elder

1. Adapted from *The Complete Works of Tacitus*. Alfred John Church, edited for Perseus. New York; reprinted 1942.

Cartimandua

1. Dio Cassius, *Roman History* 60, 19–22
2. Tacitus, *Histories* 3, 45; *Annals* 14, 32; 14, 34
3. Suetonius, *Vespasian* 4; Tacitus, *Agricola* 14
4. Tacitus, *op. cit.* 12, 13; 13, 22. Suetonius, *Nero* 35, 4. Dio, *op.cit* 61, 30. Suetonius, *Claudius* 24, 2

Boudica 60 CE

1. Abstract at Gillespie, Caitlin C., 'Dux Femina', *Boudica: Warrior Woman of Roman Britain*, Women in Antiquity (New York, 2018; online edn, Oxford Academic, 21 June 2018). https://academic.oup.com/book/9968/chapter-abstract/157328109?redirectedFrom=fulltext

Agrippina the Younger

1. Tacitus, *Annals* XII.66; Cassius Dio, *Roman History* LXI.34; Suetonius, *Claudius* 44; Josephus is less sure, *Antiquities of the Jews* XX.8.1.
2. Winterling, Aloys (2011). *Caligula: A Biography.* Berkeley. p. 110
3. After *autokrator* (Greek: αὐτοκράτωρ, lit. "self-ruler," "one who rules by himself," whence English "autocrat," from αὐτός, *autós*, 'self') – a Greek epithet applied to an individual who is unrestrained by superiors. It has been applied to military commanders-in-chief as well as Roman and Byzantine emperors as the translation of the Latin title *imperator*.

Perilla

1. Witczak, Krzsztof Tomasz (2018) 'Ovid's letter to Sulpicia', *Živa Antika*

Antiochis

1. Pliny, *NH* 13, 250. On female doctors and the issues surrounding them, see Flemming, *op cit* p. 35ff.
2. *CIL* 13, 2019.
3. *CIL 2,* 497.
4. *Euporista* 3, 1, 13.
5. Baader, *Spezialarzte* p. 233, fn 62.

Poppaea Sabina

1. Tacitus, *Annals* 13, 45.
2. Tacitus, op. cit. 12, 28; Dio 62, 28
3. Tacitus, op. cit. 13, 36.
4. Tacitus op. cit. 13, 20–22

Arria
1. Pliny the Younger, *Letters* 3.16.
2. Martial, *Epigrams. Book 1.*

Fannia
1. Pliny the Younger, *Letters* 7.19

Laronia
1. See https://www.loebclassics.com/view/juvenal-satires/2004/pb_LCL091.147.xml

Julia Maesa (*c.* 160 CE – *c.* 224 CE)
1. Birley, Anthony R. (2002). *Septimius Severus: The African Emperor*, p. 222
2. Burns (2006), p. 207.
3. Burns (2006), p. 217.
4. See Chrystal, Paul (2018). *Emperors of Rome: The Monsters.* Barnsley
5. Birley (2002), p. 192

St Blandina
1. Eusebius, *Historia Ecclesiastica*, 5.2.
2. Kirsch, Johann Peter (1907). "St. Blandina." *The Catholic Encyclopedia. Vol. 2.* New York

Vibia Perpetua and Felicitas
1. Dova (2017)

Zenobia
1. Gibbon, E., *Decline and Fall of the Roman Empire,* Chapter 11. 128–9. For a more up to date assessment see also M. Bragg, *Queen Zenobia In Our Time* http://www.bbce.co.uk/programmes/b01snjpp
2. *Scriptores Historiae Augustae,* 107
3. Virgil, *The Aeneid,* 2, 559–87
4. Zosimus, *Historia Nova* Book I
5. Zonaras, *The History of Zonaras* 27
6. Al-Tabari, *The History of al-Tabari* Volume IV, 124
7. Lawrence Wright, 'Homage to Zenobia', *The New Yorker*, www.newyorker.com/magazine/2015/07/20/homage-to-zenobia

Hypatia (*c.* 360–415 CE)
1. O'Connor, John J., "Pandrosion of Alexandria", MacTutor History of Mathematics Archive, University of St Andrews
2. Deakin (2012).
3. Watts, Edward Jay (2006). "Hypatia and pagan philosophical culture in the later fourth century". In *City and School in Late Antique Athens and Alexandria.* University of California Press
4. Mosse, Kate (2022). *Warrior Queens and Quiet Revolutionaries.* pp. 60–61

Melania the Elder

1. We learn from Francine Cardman (2000) that 'Desert Mothers' is a neologism, coined in feminist theology as an analogy to Desert Fathers, for the *ammas* or female Christian ascetics living in the deserts of Egypt, Palestine, and Syria in the 4th and 5th centuries CE in the monastic communities that began forming during that time, though sometimes they lived as hermits. Monastic communities acted collectively with limited outside relations with lay people.

Theodora

1. Procopius, *Secret History* 9
2. Claudine M. Dauphin (1996) "Brothels, Baths, and Babes: Prostitution in the Byzantine Holy Land". *Classics Ireland.* 3: 47–72
3. John Malalas, *The Chronicle of John Malalas*, 18.440.14–441.7
4. Cameron, Averil (1996). *Procopius and the Sixth Century*. London. pp. 81–82

Antonina (*c.* 484 CE – after 565 CE)

1. See Chrystal, Paul (2021). *A History of the World in 100 Pandemics, Plagues and Epidemics*. Barnsley for a full discussion of the plague.

Further Reading

Adams, J.N. 'Latin Words for Woman and Wife', *Glotta* 50 (1972), 234-255
_____ 'The Latin Sexual Vocabulary' (London 1982)
_____ 'Words for Prostitute in Latin', *RhM* 126 (1983), 321-358
Allason-Jones, L. 'Women in Roman Britain' (London 1989)
_____ 'Women in Roman Britain in James, Companion' (2012), 467-477
Andre, J.M. 'L'Otium dans la Vie Morale et Intellectuelle Romaine des Origins a la Epoque Augusteenne' (Paris 1966)
Ankerloo, B. 'Witchcraft and Magic in Europe Vol 2: Ancient Greece and Rome' (London 1998)
Archer, L.J. (ed) 'Women in Ancient Societies' (London 1994)
Ash, R. 'Women in Imperial Roman Literature' in James, *Companion* (2012), 442-452
Babcock, C. 'The Early Career of Fulvia', *AJP* 86, (1965), 1-32
Balsdon, J.P.V.D. 'Roman Women' (London 1962)
_____ 'Life and Leisure in Ancient Rome' (London 1969)
Bauman, R.A. 'Women and Politics in Ancient Rome' (London 1992)
_____ 'Crime and Punishment in Ancient Rome' (London 1996)
Beard, M. 'The Sexual Status of the Vestal Virgins', *JRS* 70 (1980), 12-27
_____ 'Rome in the Late Republic' (London 1985)
_____ 'Literacy in the Roman World' (Ann Arbor 1991)
_____ 'Re-Reading (Vestal) Virginity in Hawley' (1995), 166-177
_____ 'Religions of Rome: A Sourcebook' (Cambridge 1998)
Belofsky, Nathan, 'Strange Medicine: A Shocking History of Real Medical Practices through the Ages' (New York, 2013)
Boatwright, M.T. 'Women and Gender in the Forum Romanum', *TAPA* 141 (2011), 107-143
Bodel, J. 'Epigraphic Evidence: Ancient History from Inscriptions' (London 2001)
Bouvrie, S. 'des Augustus' Legislation on Morals', *SO* 59 (1984), 93-113
Bowman, A.K. 'Life and Letters on the Roman Frontier: Vindolanda and its People' (London 1994)
Bradley, K.R. 'Wet Nursing in Rome in Rawson, The Family' (1986)
_____ 'Discovering the Roman Family: Studies in Roman Social History' (New York 1991)
Braund, S. 'Juvenal: Misogynist or Misogamist?' *JRS* 82 (1992), 61-76
_____ 'A Woman's Voice? Laronia's Role in Juvenal 2' in Hawley, *Women* (1995) 207-219

Brennan, T.C. 'Perception of Women's Power in the Late Republic: Terentia, Fulvia and the Generation of 63 BCE' in James, *Companion* (2012), 354-366

Brown, R. 'Livy's Sabine Women and the Ideal of concordia', *TAPA* 125, (1995), 291-319

Burns, J. 'Great Women of Imperial Rome' (London 2007)

Cameron, A. (ed) 'Images of Women in Antiquity' (London 1983)

Cantarella, E. 'Pandora's Daughters: The Role and Status of Women in Greek and Roman Antiquity' (London 1987)

Carlon, J.M. 'Pliny's Women: Constructing Virtue and Creating Identity in the Roman World' (Cambridge 2009)

Carp, T. 'Two Matrons of the Late Republic', *Women's Studies* 8 (1981), 189-200 in Foley, *Reflections*, 343-353

Catelli, G. 'Behind Lesbia's Door: Her Slave-Girls' Shocking Revelations' (New York 2012)

Chrystal, P. 'Differences in Attitude to Women as Reflected in the Work of Catullus, Propertius, the Corpus Tibullianum, Horace and Ovid' (MPhil thesis, University of Southampton, 1982)

_____ 'Bioterrorism and Biological Warfare: Disease as a Weapon of War' (2023)

_____ 'The Book in the Ancient World: How the Wisdom of the Ages Was Preserved' (2024)

_____ 'Two Case Studies on Receptions of Sex & Power: Lucretia and Verginia' – chapter 16 in 'The Routledge Companion to the Reception of Ancient Greek and Roman Gender and Sexuality' (2023)

_____ 'A History of Britain in 100 Objects' (2022)

_____ 'A Historical Guide to Roman York' (2022)

_____ 'A History of the World in 100 Pandemics, Plagues & Epidemics' (2021)

_____ 'Woman at War in the Classical World' (2020)

_____ 'Reportage in Ancient Greece & Rome' (2018)

_____ 'In Bed with the Ancient Greeks' (2018)

_____ 'In Bed with the Romans' (2017)

_____ 'When in Rome: Everyday Life in Ancient Rome' (2016)

_____ 'Roman Women: The Women Who Influenced Roman History' (2015)

_____ 'Women in Ancient Rome' (2013)

Churchill, L.J. 'Women Writing Latin Vol 1: From Roman Antiquity to Early Modern Europe' (New York 2002)

Clark, G. 'Women in the Ancient World' (Oxford 1989)

Cohen, D. 'Seclusion, Separation and the Status of Women in McAuslan, I. Women in Antiquity' pp. 134-145

Collins, J.H. 'Tullia's Engagement and Marriage to Dolabella', *CJ* 1952, 164-168

Cooper, Kate (2023) 'Queens of a Fallen World: The Lost Women of Augustine's Confessions', London

Colton, R.E. 'Juvenal and Martial on Women who Ape Greek Ways', *CB* 50 (1973), 42-44

Cornell, T.J. *The Beginnings of Rome* (London 1995)

Currie, H. Mac 'The Poems of Sulpicia', *ANRW II*, 30.3, 1751-1764

Daehner, J. (ed) 'The Herculaneum Women: History, Context, Identities' (Los Angeles 2007)

—————— 'The Herculaneum Women and the Origins of Archaeology' (NewYork 2008)

D'Ambra, E. 'The Cult of Virtues and the Funerary Relief of Ulpia Epigone'

—————— 'Latomus' 48 (1989), pp. 392-400

—————— 'Roman Women' (Cambridge, 2007)

—————— 'Women in the Bay of Naples' in James, *Companion* (2012), 400-413

D'Ambrosio, A. 'Women and Beauty in Pompeii' (New York 2002)

D'Avino, M. 'The Women of Pompeii' (Naples 1967)

Davies, C. 'Poetry in the 'Circle' of Messalla', *G&R* 20 (1973), 25-35

Dayton, L. 'The Fat, Hairy Women of Pompeii', *New Scientist* 1944 24 September 1994

Deacy, S. (ed) 'Rape in Antiquity' (London 1997)

Dean-Jones, L. 'The Politics of Pleasure: Female Sexual Appetite in the Hippocratic Corpus' in Stanton 1992, *Discourses* 48-77

—————— 'Medicine: The 'Proof' of Anatomy' in Fantham, *Women in the Classical World* 183-215: 1994

Debakcsy, Dale (2022) 'A History of Women in Medicine and Medical Research', Barnsley

del Castillo, A. 'The Position of Women in the Augustan Age', *LCM* 2 (1977), 167-173

DeHaan, Peter, 'Women of the Bible', 2020

Delia, D. 'Fulvia Reconsidered' in Pomeroy, *Women's History and Ancient History* (1991), 197-217

Demand, N. 'Women and Slaves as Hippocratic Patients' in Joshel, *Women* (1998), 69-84

Deslauriers, M. 'Women, Education and Philosophy' in James, *Companion* (2012), 343-353

Deutsch, M. 'The Women of Caesar's Family', *CJ* 13 (1918), 502-514

Dixon, S. 'The Family Business: Women and Politics in the Late Republic', *C&M* 34 (1983), 91-112

—————— 'Family Finances: Tullia and Terentia', *Antichthon* 18 (1984), 78-101

—————— 'Polybius on Roman Women and Property', *AJPh* 106 (1985), 147-170

—————— 'The Roman Mother' (London 1988)

—————— 'The Roman Family' (Baltimore 1992)

—————— 'Reading Roman Women' (London, 2001)

—————— 'Exemplary Housewife or Luxurious Slut: Cultural Representations of Women in the Roman Economy' in McHardy, *Women's Influence* (2004)

—————— 'Cornelia: Mother of the Gracchi' (London 2007)

Edwards, C. 'Putting Agrippina in her Place: Tacitus and Imperial Women', *Omnibus 63* (2012), 22-24

Evans, J.K. 'War, Women and Children in Ancient Rome' (London 1991)

Facella, Margherita (2017). 'TransAntiquity: Cross-Dressing and Transgender Dynamics in the Ancient World'. Routledge

Fantham, E. 'Virgil's Dido and Seneca's Tragic Heroines', *G&R* 22 (1975) 1-9

_____ 'Stuprum: Public Attitudes and Penalties for Sexual Offences in Republican Rome', *EMC 35* (1991), 267-291

_____ 'Women in the Classical World: Image and Text' (New York, 1994)

_____ 'Amelia Pudentilla or the Wealthy Widow's Choice' in Hawley R. *Women in Antiquity* (1995), 220-232

Fau, G. 'L'Emancipation Feminine a Rome' (Paris 1978)

Ferrill, A. 'Augustus and his Daughter: A Modern Myth', *Latomus* 168 (1980), 332-346

Filbee, M. 'A Woman's Place' (London 1980)

Finley, M.I. 'The Silent Women of Rome' in Finley, *Aspects* pp. 124-137

_____ 'Studies in Ancient Society' (London 1974)

Fitton, J.W. 'That was No Lady, That Was', *CQ* 64 (1970), 56-66

Flemming, R. 'Quae corpora quaestum facit: The Sexual Economy of Female'

_____ 'Prostitution in the Roman Empire', *JRS* 89 (1999), 38-61

_____ 'Medicine and the Making of Roman Women' (Oxford 2000)

_____ 'Women, Writing and Medicine in the Classical World', *CQ* 57 (2007), 257-279

Foley, H. (ed) 'Reflections of Women in Antiquity' (London 1981)

_____ 'Women in Ancient Epic' in Foley, J.M. (ed) *A Companion to Ancient Epic*, 105-118 (Chichester 2008)

Frank, R.I. 'Augustus' Legislation on Marriage and Children', *CSCA* 8 (1975), 41-52

Fraschetti, A. (Ed) 'Roman Women' (Chicago 2001)

Frederick, D.C. 'Reading Broken Skin: Violence in Roman Elegy' in Hallett, *Roman Sexualities* (1998), 172-193

Freisenbruch. A. 'The First Ladies of Rome' (London 2010)

French, V. 'Midwives and Maternity Care in the Roman World' in M. Skinner, *Rescuing Creusa* (1987), 69-84

Furst, L.R. (ed) 'Women Physicians and Healers' (Lexington 1997)

Gage, J. 'Matronalia', *Latomus* 60, 1963

Galinsky, K. 'Augustus' Legislation on Morals and Marriage', *Philologus* 125 (1981), 126-144

Gardner, J. F. 'The Roman Household: A Sourcebook' (London 1991)

_____ 'Women in Roman Law and Society' (Bloomington 1995)

_____ 'Family and Familia in Roman Law and Life' (Oxford 1998)

Garlick, B. (ed) 'Stereotypes of Women in Power' (New York 1992)

George, M. (Ed) 'The Roman Family in the Empire: Rome, Italy, and Beyond' (Oxford 2005)

_____ 'Family Imagery and Family Values in Roman Italy in George, The Roman Family' 37-66

Giacosa, G. 'Women of the Caesars' (Milan 1980)

Gold, B.K. 'The House I Live In Is not My Own: Women's Bodies in Juvenal's Satires', *Arethusa* 31 (1998), 368-386

Golden, M. 'Did the Ancients Care When their Children Died?' *G&R* 35, 1988, 152-163

_____ 'Sex and Difference in Ancient Greece and Rome' (Edinburgh 2008)

Gourevitch, D. 'Women Who Suffer from a Man's Disease' in Hawley, *Women* (1995), 149-165

Green, M.H. 'Making Women's Medicine Masculine: The Rise of Male Authority in Pre-Modern Gynaecology' (Oxford 2008)

Greene, E. 'The Erotics of Domination: Male Desire and the Mistress in Latin Love Poetry' (Baltimore 1998)

Griffin, J. 'Augustan Poetry and the Life of Luxury'. *JRS* 66 (1976), 87-105

Grubbs, J.E. 'Women and the Law in the Roman Empire: A Sourcebook on Marriage, Divorce and Widowhood' (London 2002)

Gruen, E.S. 'M. Antonius and the Trial of the Vestal Virgins', *RhM* 111 (1968), 63

Hallet, J.P. 'The Role of Women in Roman Elegy: Cross-Cultural Feminism', *Arethusa* 6 (1973), 103-124

_____ 'Perusinae Glandes and the Changing Image of Augustus', *AJAH* 2 (1977), 151-171

_____ 'Fathers and Daughters in Roman Society: Women and the Elite Family' (Princeton 1984)

_____ 'Martial's Sulpicia and Propertius' Cynthia', *CW* 86 (1992), 99-123 (ed) *Roman Sexualities* (Princeton 1997)

_____ 'The Eleven Elegies of the Augustan Poet Sulpicia in Churchill, Women Writing' (2002), 45-65

_____ 'Women Writing in Rome and Cornelia, Mother of the Gracchi' in Churchill (2002), 18-29

_____ 'Feminae Furentes: The Frenzy of Noble Women in Virgil's Aeneid and the Letter of Cornelia' = Anderson (2002), 159-167

_____ 'Matriot Games? Cornelia and the the Forging of Family-oriented Political Values' in McHardy, Women's *Influence* (2004) 26-39

_____ 'Women in Augustan Rome' in James, *Companion* (2012), 372-384

Hamilton, G. 'Society Women Before Christ', *North American Review* 151 (1896)

Harkness, A.G. 'Age at Marriage and at Death in the Roman Empire', *TAPhA* 27 (1896) 35-72

Harlow, M. 'Galla Placida: Conduit of Culture?' in McHardy, *Women's Influence* (2004) 138-150

Hawley R. (ed) 'Women in Antiquity: New Assessments' (London 1995)

Hejduk, J.D. 'Clodia: A Sourcebook' (Norman OK 2008)

Helzle, M. 'Mr and Mrs Ovid', *G&R* 36, (1989), 183-193

Hemelrijk, E. 'Women's Demonstrations in Republican Rome in Blok, Sexual Asymmetry', 217-240

_____ 'Matrona Docta: Educated Women in the Roman Elite from Cornelia to Julia Domna' (London 1999)

_____ 'Public Roles for Women in the Cities of the Latin West' in James, *Companion* (2012), 478-490

Hermann, C. 'Le Role Judicaire et Politique des Femmes sous la Republique Romain', *Latomus* 67 (1964)

Hershman, Tania (2021) 'On This Day She: Putting Women Back Into History, One Day At A Time', Metro Publishing

Heyob, S.K. 'The Cult of Isis Amongst Women of the Graeco-Roman World' (Leiden 1975)

Heyworth, S.J. 'Cynthia: A Companion to the Text of Propertius' (Oxford 2009)

Hillard, T. 'Republican Politics, Women and the Other Evidence', *Helios* 16 (1989), 165-182

Hinds, S. 'The Poetess and the Reader: Further Steps Towards Sulpicia', *Hermathena* 143 (1987), 29-46

Hoffsten R, 'Roman Women of Rank in the Early Empire As Portrayed by Dio, Paterculus, Suetonius and Tacitus' (Philadelphia 1939)

Holland, L.L. 'Women and Roman Religion in Companion to Women' (2012), 204-214

Hopkins, K. 'The Age of Roman Girls at Marriage, Population Studies' 18 (1965), 309-327

_____ 'Elite Mobility in the Roman Empire in Finley, Ancient Society' (1974), 103-120

Horsfall, N. 'Allia Potestas and Murdia: Two Roman Women', *Ancient Society* 12 (1982), 27-33

Jackson, Guida M. 'Women Rulers Throughout the Ages: An Illustrated Guide', Santa Barbara CA, 1999

James, S.L. 'Learned Girls and Male Persuasion: Gender and Reading in Roman Love Elegy' (Berkeley 2003)

_____ 'Companion to Women in the Ancient World' (Chichester 2012)

_____ 'Virgil's Dido in James, Companion' (2012), 369-371

Janan, M. 'The Politics of Desire: Propertius IV' (Berkeley 2001)

Johnson W.H. 'The Sister-in-law of Cicero', *CJ* 1913, 160-165

Joshel, S.R. 'The Body Female and the Body Politic: Livy's Lucretia and Verginia in Women and Slaves in Graeco-Roman Culture' (London 1998)

Kajanto, I. 'On Divorce among the Common People of Rome', *REL* 47 1969, 97-113

_____ 'Family Fictions in Roman Art' (Cambridge 2009)

Kapparis, K.A. 'Abortion in Antiquity' (London 2002)

Keith, A. 'Tandem Venit Amor: A Roman Woman Speaks of Love' in Hallet, *Sexualities* (1997), 295-310

_____ 'Engendering Rome: Women in Latin Epic' (Cambridge 1999)

_____ 'Critical Trends in Interpreting Sulpicia', *CW* 100 (2006), 3-10

_____ 'Women in Augustan Literature in James, Companion' (2012), 385-399

Kenyon, F.G. 'Books and Readers in Ancient Greece and Rome' (Oxford 1932)

Kiefer, O. 'Sexual Life in Ancient Rome' (London 1934)

King, H. 'Hippocrates' Woman: Reading the Female Body in Ancient Greece' (London 1998)

_____ 'The Disease of Virgins: Green Sickness, Chlorosis and the Problems of Puberty' (New York 2004)

Kleiner, D. 'I Claudia: Women in Ancient Rome' (New Haven, 1996)

_____ 'I Claudia II: Women in Roman Art and Society' (Austin, 2000)

Knapp, R.K. 'Invisible Romans: Prostitutes, Outlaws, Slaves, Gladiators, Ordinary Men and Women ... the Romans that History Forgot' (London 2013)

Kokkinos, N. 'Antonia Augusta: Portrait of a Great Roman Lady' (London 1992)

Kraemer, R.S. 'Women's Religions in the Greco-Roman World: A Sourcebook' (New York, 2004)

Laidlaw, W.A. 'Otium', *G&R* 15 (1968), 42-52

Langlands, R. 'A Woman's Influence on a Roman Text' in McHardy, *Women's Influence* (2004) 115-126

_____ 'Sexual Morality in Ancient Rome' (Cambridge 2006)

Larson, J. 'Greek and Roman Sexualities: A Sourcebook' (London 2012)

Larsson, L.L. (ed) 'Aspects of Women in Antiquity' (1997)

_____ 'Lanam fecit: Woolmaking and Female Virtue' in Larsson, *Aspects of Women in Antiquity* (1997), 85-95

Leen, A. 'Clodia Oppugnatrix: The Domus Motif in Cicero's *'Pro Caelio'.' CJ* 96 (2000) 142-160

Lefkowitz, M.R. 'Heroines and Hysterics' (London 1981)

_____ 'Women's Life in Greece & Rome 3rd Ed.' (London 2005)

Lightman, M. 'A to Z of Ancient Greek and Roman Women' (New York 2008)

Lilja, S. 'The Roman Elegists' Attitude to Women' (Helsinki, 1965)

Liveley, G. 'Who's that Girl? The Case of Ovid's Corinna', *Omnibus* 54 (2007), 1-3

_____ 'Latin Love Elegy 2/e' (London 1969)

Lyne, R.O.A.M. 'The Latin Love Poets from Catullus to Ovid' (Oxford 1980)

Macmullen, R. 'Women in Public in the Roman Empire', *Historia* 29 (1980), 208-218

_____ 'Women's Power in the Principate', *Klio* 68 (1986), 434-443

Manning, C.E. 'Canidia in the Epodes of Horace', *Mnemosyne* 23 (1970), 393-401

Mantle, I. 'Violentissimae et Singulares Mortes', *CA News* 39 (2008), 1-2

_____ 'Women of the Bardo', *Omnibus* 65, January 2013, 4-6

Marshall, A.J. 'Roman Women and the Provinces', *Anc Soc* 6 (1975), 109-129

_____ 'Tacitus and the Governor's Lady, A Note on Annals' 3, 33-34, *G&R* 22 (1975), 11-18

_____ 'Roman Ladies on Trial: The Case of Maesia of Sentinum', *Phoenix* 44(1990), 46-59

Massey, M. 'Women in Ancient Greece and Rome' (Cambridge 1988)

McAuslan, I. (ed) 'Women in Antiquity' (Oxford 1996)

McDermott, W.C. 'The Sisters of P. Clodius', *Phoenix* 24 (1970), 39-47

Miles, Gary B.. 'Chapter 5. The First Roman Marriage and the Theft of the Sabine Women'. *Livy: Reconstructing Early Rome*, Ithaca, NY: Cornell University Press, 1997, pp. 179-219

Mohler, S.L. 'Feminism in the CIL'. *CW* 25 (1932) 113-116

Moore, T.J. 'Morality, History and Livy's Wronged Women', *Eranos* 91 (1993), 38-46

Moreau, P. 'Incestus et prohibitae nuptiae: L'inceste à Rome' (Paris 2002)

Morel, W. 'Fragmenta Poetarum Latinorum' (Leipzig 1927)

Mosse, Kate 'Warrior Queens and Quiet Revolutionaries', London 2022

Motto, A.L. 'Seneca on Women's Liberation', *CW* 65 (1972), 155-157

Myers, S. 'The Poet and the Procuress: the lena in Latin Love Elegy', *JRS* 86 (1996), 1-21

Neils, J. 'Women in the Ancient World' (London 2011)

Nikolaidis, A.G. 'Plutarch on Women and Marriage', *WS* 110 (1997), 27-88

Noy, D. 'Wicked Stepmothers in Roman Society and Imagination', *Jnl of Family History* 16 (1991), 345-361

Ogden, D. 'Magic, Witchcraft and Ghosts in the Greek and Roman Worlds' (Oxford 2002)

_____ 'Greek and Roman Necromancy' (Princeton 2004)

_____ 'Night's Black Agents: Witches Wizards and the Dead in the Ancient World' (London 2008)

_____ 'Polygamy, Prostitutes and Death: The Hellenistic Dynasties' (Swansea 2010)

Oliensis, E. 'Canidia, Canicula and the Decorum of Horace's *Epodes*', *Arethusa* 24 (1991), 107-138

_____ 'Sons and Lovers: Sexuality and Gender in Virgil's Poetry' in Martindale (2007)

Olsen, K. 'Dress and the Roman Woman: Self-Presentation and Society' (London 2008)

O'Malley, C.D. (ed) 'The History of Medical Education' (Berkeley 1970)

Pantel, P.S. 'A History of Women from Ancient Goddesses to Christian Saints' (Cambridge MA 1992)

Parke, H.W. 'Sibylls and Sibylline Prophecy in Classical Antiquity' (London 1998)

Parker, H. N. 'Love's Body Anatomized: The Ancient Erotic Handbooks and the Rhetoric of Sexuality in Richlin, Pornography' (1992)

_____ 'Loyal Slaves and Loyal Wives in Women Physicians'

_____ 'Women Physicians in Greece, Rome and the Byzantine Empire' in Furst (2004), 134-150

_____ 'Why Were the Vestal Virgins?' *AJP* 125 (2004), 563-601

_____ 'Women and Medicine in James, Companion' (2012), 107-124

Paul, G.M. 'Sallust's Sempronia: the Portrait of a Lady in Cairns, Papers' (1986), 9-22

Pearcy, L.T. 'Erasing Cerinthus; Sulpicia and Her Audience', *CW* 100 (2006), 31-36

Pellison, N. 'Women and Marriage During Roman Times' (New York 2008)

Petrocelli, C. 'Cornelia the Matron in Fraschetti, Roman Women' (1993), 34-65

Phang, S.E. 'The Marriage of Roman Soldiers (13 B.C.-A.D. 235): Law and Family in the Imperial Army' (Leiden 2001)

Phillips, J.E. 'Roman Mothers and the Lives of their Adult Daughters', *Helios* 6 (1978), 69-80

Plant, I.M. 'Women Writers of Ancient Greece and Rome' (Norman 2004)

Pollard, E.A. 'Witch-Crafting in Roman Literature and Art: New Thoughts on an Old Image', *Magic, Ritual, and Witchcraft* 3 (2008)

Pomeroy, S.B. 'Selected Bibliography on Women in Antiquity', *Arethusa* 6 (1973) 125-157

_____ 'The Relationship of the Married Woman to Her Blood Relatives in Rome', *Ant. Soc.* 7 (1976), 215-227

_____ 'Women in Roman Egypt: A Preliminary Study Based on Papyri' in Foley pp. 301-322

_____ (ed) 'Women's History and Ancient History' (Chapel Hill, 1991),

_____ 'Goddesses, Whores, Wives and Slaves' (New York 1995)

_____ 'Spartan Women' (Oxford 2002)

Purcell, N. 'Livia and the Motherhood at Rome', *PCPhS* 212 (1986), 78-105

Raia, A. 'Women's Roles in Plautine Comedy' (paper delivered October 1983 www.vroma.org/~araia/plautinewomen)

_____ (ed) 'Marriage, Divorce and Children in Ancient Rome' (Oxford 1986)

_____ 'Villains, Wives and Slaves in the Comedies of Plautus in Joshel, Women' (1998), 92-108

_____ 'The Worlds of Roman Women: A Latin Reader' (Newburyport, MA 2001)

Rankin, H.D. 'Catullus and the Beauty of Lesbia', *Latomus* 35, 1 (1976)

_____ 'Clodia II', *AC* 38 (1969), 501-506

Rapsaet-Charlier, M.-Th. 'Ordre Senatorial et Divorce sous le Haut Empire', *ACD* (1981) 17-18, 161-173

Reiss, W. 'Rari Exempla Femina: Female Virtues on Roman Funerary Inscriptions' in James, *Companion* (2012), 491-501

Ricci, J.V, 'The Development of Gynaecological Surgery and Instruments' (Philadelphia 1949)

Richlin, A. 'Carrying Water in a Sieve: Class and the Body in Roman Women's Religion' in King, *Women and Goddess Traditions* (1997), 330-374

_____ 'Sulpicia the Satirist', *CW* 86 (1992), 125-140

_____ 'Julia's Jokes, Galla Placidia and the Romans Use of Women as Political Icons' in Garlick, *Stereotypes* (1992), 65-91

Rist, J.M. 'Hypatia', *Phoenix* 19 (1965), 214-225

Roisman, H.M. 'Women in Senecan Tragedy', *Scholia* 14 (2005), 72-88

Rowlandson, J. 'Women and Society in Greek and Roman Egypt: A Sourcebook' (Cambridge 1998)

Rudd, N. 'Romantic Love in Classical Times?' *Ramus* 10 (1981), 140-158

Santirocco, M.S. 'Sulpicia Reconsidered', *CJ* 74 (1979), 229-239

Santoro L'Hoir, F.S. 'Tacitus and Women's Usurpation of Power', *CW* 88 (1994), 5-25

Savunem, 'Women and Elections in Pompeii' in Hawley, *Women* (1995), 194-206

Scafuro, A. (ed) 'Studies on Roman Women Part 2', *Helios* 16 (1989)

_____ 'Livy's Comic Narrative in the Bacchanalia in Scafuro' (1989), 119-142

Schaps, D.M. 'The Women Least Mentioned: Etiquette and Women's Names', *CQ* 27 (1977), 323-330

Scheid, J. 'The Religious Roles of Roman Women in Pantel' (1992), 377-408

_____ 'Claudia the Vestal Virgin in Fraschetti, Roman Women' (1993,) 23- 33

Scheidel, W. 'The Most Silent Women of Greece and Rome: Rural Labour and Women's Life', *G&R* 42 and 43 (1995-1996), 202-17, 1-10

Schulz, C.E. 'Women's Religious Activity in the Roman Republic' (Chapel Hill NC 2006)

Sharrock, A.R. 'Womanufacture', *JRS* 81 (1991), 36-49

Shaw, B.D. 'Age of Roman Girls at Marriage: Some Reconsiderations', *JRS* (1987), 30-46

Shelton, J-A. 'Pliny the Younger and the Ideal Wife', *C&M* 61 (1990), 163-186
_____ 'As the Romans Did 2nd Ed' (New York 1998)

Shepherd, G. 'Women in Magna Graecia' in James, *Companion* (2012), 215-228

Skinner, M.B. (ed) 'Rescuing Creusa', *Helios* 13 (1987)

Shopland, Norena, 'A History of Women in Mens' Clothes', Barnsley (2021)
_____ 'Clodia Metelli: The Tribune's Sister' (New York 2011)

Smith, W.S. (ed) 'Satiric Advice on Women and Marriage: From Plautus to Chaucer' (Ann Arbor 2005)

Snyder, J.M. 'Lucretius and the Status of Women' *CB* 53, (1976), 17-20
_____ 'The Woman and the Lyre: Women Writers in Classical Greece and Rome' (Carbondale, Ill 1989)

Southon, Emma (2023) 'A History of the Roman Empire in 21 Women', London

Spaeth, B.S. 'The Roman Goddess Ceres' (Austin 1996)

Spearing, Sinéad 'A History of Women in Medicine: Cunning Women, Physicians and Witches' (Barnsley 2019)

Staden, H. von 'Women, Dirt and Exotica in the *Hippocratic Corpus*', *Helios* 19 (1992), 7-30

Staples, A. 'From Good Goddess to Vestal Virgins: Sex and Category in Roman Religion' (London 1998)

Stehle, E. 'Venus, Cybele and the Sabine Women: The Roman Construction of Female Sexuality in Scafuro', (1989), 43-64

Stevenson, J. 'Women Latin Poets: Language, Gender, and Authority from Antiquity to the Eighteenth Century' (Oxford 2008)

Stirrup, B.E. 'Techniques of Rape: Variety and Art in Ovid's Metamorphoses', *G&R* 24 (1977), 170-184

Syme, R. 'Princesses and Others in Tacitus', *G&R* 28 (1981), 40-52

Tacaks, S. 'Vestal Virgins, Sibyls, and Matrons' (Austin 2008)

Thonemann, P. 'The Women of Akmoneia', *JRS* 100 (2010) 163-178

Treggiari, S. 'Libertine Ladies', *CW* 64 (1971), 196-198
_____ 'Terentia, Tullia and Publilia: The Women of Cicero's Family' (New York 2007)

Trimble, J. 'Women and Visual Replication in Roman Imperial Art and Culture' (Cambridge 2011)

Veyne, P. (Ed) 'A History of Private Life Vol I' (Cambridge, Mass 1987)

Viden, G. 'Women in Roman Literature: Attitudes of Authors under the Early Empire' (Goteborg 1993)

Villers, R. 'Le Statut de la Femme a Rome jusqu'a la Fin de la Republique'. *Recuei de la Societe Jean Bodin II* (1958), 177-189

Virlouvet, C. 'Fulvia the Woman of Passion' in Fraschetti, *Roman Women* (1993), 66-81

Watson, P.A. 'Ancient Stepmothers', *Mnemosyne* 143 (1995)

Wildfang, R.I. 'Rome's Vestal Virgins' (London 2006)

Will, E.L. 'Women in Pompeii', *Archaeology* 32 (1979), 34-43

Woodhull, M.L. 'Matronly Patrons in the Early Roman Empire: the Case of Salvia Postuma in McHardy, Women's Influence' (2004) 75-91

Worsfold, T.C. 'The History of the Vestal Virgins of Rome' (London 1934)

Wyke, M. 'Written Women: Propertius' *scripta puella*', *JRS* 77, (1987), 47-61

_____ 'The Elegiac Woman at Rome', *PCPhS* 213 (ns 330) (1987), 153-178

_____ 'Mistress and Metaphor in Augustan Elegy', *Helios* 16 (1989), 25-47

_____ 'Augustan Cleopatras: Female Power and Poetic Authority in Powel Roman Poetry' (1992), 98-140

_____ 'The Roman Mistress' (Oxford 2002)

https://en.wikipedia.org/wiki/List_of_women_warriors_in_folklore

Index

◇◇